The René von Schleinitz Collection
of the Milwaukee Art Center

The René von Schleinitz Collection of the Milwaukee Art Center

Major Schools
of German Nineteenth-Century Popular Painting

RUDOLF M. BISANZ

MILWAUKEE ART CENTER
THE UNIVERSITY OF WISCONSIN PRESS

Published 1980

in Milwaukee: Milwaukee Art Center
750 North Lincoln Memorial Drive
Milwaukee, Wisconsin 53202

elsewhere: The University of Wisconsin Press
114 North Murray Street
Madison, Wisconsin 53715

The University of Wisconsin Press, Ltd.
1 Gower Street
London WC1E 6HA, England

First printing

Printed in the United States of America

For LC CIP information see the colophon

ISBN 0–299–07700–4

The publishers wish to thank the Milwaukee Public Library
for making possible the inclusion of Spitzweg's *The Bookworm*
in this catalogue.

To my parents and my wife, Ingeborg

Contents

Acknowledgments

Tracy Atkinson, formerly Director of the Milwaukee Art Center, had the foresight to implement my plan for a comprehensive publication featuring the René von Schleinitz Collection and other related paintings at the Center. Michael Danoff, Associate Director and Curator of the Center, collaborated with him and me in general planning and in coordinating innumerable business details; throughout that period and during his tenure as Acting Director he gave me constant personal encouragement. Gerald Nordland, Director of the Center, continued the support given to the project by his predecessor. Thomas Beckman, Registrar of the Center, performed valuable service in clarifying and updating registration data and in assisting my systematic survey of the collection. He also deserves credit for conscientiously reviewing the manuscript to ensure its conformity with the Center's catalogued information. Rosalie Goldstein, Curatorial Assistant, and the capable library staff at the Center did what they could to help me. June Edlhauser, Fine Arts Coordinator at the Milwaukee Public Library, shared specific information with me. The Center's loan of a large portion of the von Schleinitz library, containing important source materials, for my personal use proved particularly useful in my research. To the wise patronage of the heirs of the late collector goes special credit for making the plan an actuality.

Among the several individuals in the Federal Republic of Germany who aided my work by their generous offer of access to their libraries or through useful suggestions, I cite the following distinguished scholars: Professor Siegfried Wichmann, of the University of Karlsruhe; Hauptkonservator Eberhard Ruhmer, of the Zentralinstitut für Kunstgeschichte, Munich; Oberkonservator Thomas Lersch, of the same institute; Hauptkonservator Hans-Joachim Ziemke, of the Städelsches Kunstinstitut, Frankfurt am Main; and Wilhelm Arntz.

My wife, Ingeborg Bisanz, assisted me in part of the research and typed the manuscript in its several stages of completion. The Academic Deans' Fund and the Graduate School Fund of Northern Illinois University granted me welcome financial aid during the production phase of the manuscript.

Richard Eells, of Pictorial Research Enterprises in Milwaukee, commendably performed the task of shooting and preparing the photographs for the plates on these pages.

Rudolf M. Bisanz

DeKalb, Illinois
March 1978

Foreword

Early in 1974, Professor Rudolf Bisanz took the initiative of inquiring whether the Milwaukee Art Center might be interested in his writing a catalogue and introduction to the paintings in the René von Schleinitz Collection. This collection, which also includes over 775 steins (mostly Mettlach) and 240 pieces of porcelain (mostly Meissen) is a major asset of the Milwaukee Art Center and an integral part of its collections. The paintings have an important relationship to French academic art of the nineteenth century and to German art of the twentieth century, both of which are particular strengths of the Art Center's collections.

Because little information exists on German art of the nineteenth century—especially academic genre art—the Milwaukee Art Center's curatorial staff could not itself properly undertake the scholarly research which the collection needs and merits. Thus, Professor Bisanz's inquiry was most fortunate. As a student and subsequently a teacher and author, he has concentrated on German art of the nineteenth century. Through the publication of this book, he serves as the collection's ambassador to general art audiences and art historians.

The reasons why so little modern scholarship has been focused on the types of paintings in the von Schleinitz collection are complex, but two that are important can be isolated. First, modern art historians held French art of the nineteenth century in higher esteem than German art of the same period, and the relative amount of literature on the two subjects reflects this preference. Second, the paintings in the von Schleinitz collection are in the academic tradition, and paintings of this kind, from no matter which country, generally were out of favor with living historians until the second half of the 1960s. But recently academic art has been receiving a significant measure of the same interest and admiration which it enjoyed at the time of its creation, as evidenced both by its high prices and the interest which museums have shown in exhibiting it.

We are grateful for the opportunity to publish this book with the University of Wisconsin Press. Tracy Atkinson gave the project his enthusiastic support in its crucial initial stages, and we are grateful that he has taken the time to prepare for this volume a profile of René von Schleinitz as a collector.

We are very pleased to acknowledge the continuing interest of the René von Schleinitz Foundation, without whose support this publication would not have been possible. We share the Foundation's pleasure in the appearance of a volume which at last does justice to this important collection.

I. Michael Danoff
Associate Director
Milwaukee Art Center
Milwaukee, Wisconsin

9

René von Schleinitz and His Collection

In collecting German genre painting, René von Schleinitz (1890–1972) was ahead of his time in the sense that when he began bringing these pictures together several decades ago, the sophisticated art world was no longer in tune with those virtues of meticulous detail, intimate scale, and literary content which they so superbly manifest. This gap was definitely closing toward the end of his collecting career, and in fact his collection provided some of the material for the revision of such judgments. But to him this development was beside the point, for his original motivation was quite other than to represent the current state of art criticism.

While subsequent history has confirmed the aesthetic significance of what he achieved, he set out on his collecting course primarily from a desire to record and thus preserve the cultural values of the Germanic society in America at the turn of the century—the values of the generation in Milwaukee immediately preceding his own. It is important to realize this when considering the collection of paintings catalogued in this publication, and it is equally important to realize that the von Schleinitz collection also includes a number of Meissen porcelain figurines and a large collection of Mettlach steins.

The figurines and steins were at first acquired in parallel with the paintings, and they presumably were of equal interest to the collector, but in later years they engaged his attention less and less. In the decade during which I knew him, the last period of his collecting career, I do not recall a single acquisition other than of paintings. While this final preference certainly reveals a growth in sensibility toward the richer and more expressive medium of painting on von Schleinitz's part, the figurines and the steins nevertheless confirm the prevailing impetus which informed all of his collecting activity.

Mettlach steins, although originally made for a fairly lively domestic market, have never been much prized as collectors' items in Germany, in contrast to their great popularity in America. They thus clearly speak more distinctly with the voice of the *Auswanderer*. Coupled with this is the fact that the Meissen figurines are, almost without exception, of nineteenth-century date, representing not the vigorous rococo style of their eighteenth-century origins, but rather the more extreme refinement and technical *élan* of the style known in this country as High Victorian.

René von Schleinitz was himself in many ways a gentleman of the old school. Tall, handsome, urbane, even imperious, he possessed a zestful sense of humor and an enormous enthusiasm. The latter was certainly infectious. Like all collectors, he loved to talk about his collection, and as one stood beside him viewing a painting his conversation was punctuated by a lively clasp of the listener's elbow as a droll point was made. He would frequently lapse into a soft, South German accent when the point to be made defied any but the native language of the artist if it was to have its full meaning. And like so many Germans I have known, he found the point in many instances embedded in an aphorism or folk saying, of which he knew a great many.

He was in fact quite knowledgeable not only about German culture in general, but about matters of art concerning his chosen fields of interest. He had an extensive library, which he consulted frequently and kept up to date. He often traveled in Germany and Austria and corresponded regularly with other collectors, dealers, art historians, and critics, especially in Europe, where professional interest in the Munich School was more intense than in this country.

While he was both methodical and orderly, he was not an archivist. He lived with his collections in an apartment which, because it was built into the side of the high bluff overlooking Lake Michigan, had a great deal of wall space, at the expense of taking maximum advantage of the spectacular view of the lake that the site afforded. Most of the steins were in a windowless room on the lower floor, lined up on shelves that reached from floor to ceiling; the overflow was similarly arranged in his study on the main floor. The Meissen figurines were grouped principally in a large glass case dividing the living-

room from the diningroom, but they overflowed onto the dining table, the sideboard, and indeed every other horizontal surface available. The paintings were absolutely everywhere, begrudging space even for light switches.

Everything had a place, usually determined by juxtapositions which were mutually reinforcing in aesthetic effect, and the challenge of incorporating new acquisitions was a considerable one. Within this vast complex of objects he could instantly locate anything he wished to point out, but somehow he never got around to organizing his records in any very coherent fashion, making the work of compiling the details of this Catalogue yeoman in character.

He would have appreciated this publication very much, not only because it brings to the collection the scholarly research which its outstanding quality so greatly deserves, but because the Catalogue makes the collection more accessible. René von Schleinitz, perhaps more than the average art collector, wanted to share what he had accomplished with the public and particularly with the public of Milwaukee. He was for many years treasurer of the Harnischfaeger Corporation, one of the city's major heavy manufacturing firms, and he was an active participant in the life of the city throughout his lifetime. Particularly during his earlier years, he participated in many German social activities and organizations, now long gone. He made the arrangements for permanent location of his collections in the Milwaukee Art Center some fifteen years before his death and provided for their continuation in his will.

When I was the director of the museum, I occasionally mentioned the possibility of his extending his acquisitions beyond the chronological and stylistic bounds he had set for himself. The museum happened to have considerable strength in German Expressionism of the early twentieth century, and from my art historical viewpoint it seemed logical to connect his mid- and later-nineteenth-century works to those later pictures by adding a few of the German Impressionists who represented a transitional stage. It seemed sensible also to provide background among the German Romantics who preceded the Munich genre styles. My efforts were of no avail, however; he was not collecting the history of art, but manifestations of a particular German attitude expressed at a particular time which had special meaning for him for reasons other than those of art alone. It is just as well, of course, for his single-minded concentration resulted in a unique collection in which his chosen field can be seen perhaps better than anywhere else in the world. (It is noteworthy that he did leave an endowment which can be used to purchase works showing earlier and subsequent currents in German art of the nineteenth century.)

It was clearly the content of the paintings which most fascinated him. He loved the wit expressed by these artists. Whether it was in the rather broad depictions of tippling churchmen so numerously represented in the collection, or in the implications of a sly glance of an elder citizen distracted in his daily rounds by a well-turned ankle—which is the subject of one of his great favorites—it was the

story, superbly well told to be sure, which was always the heart of the matter. He consistently pronounced the word *genre* in its German form, "zhanger," and he had the field of genre largely to himself for a long time.

Although he collected during a period in which Americans had come to dominate the international art market, it was the rebirth of interest in their own recent past by Germans during the 1960s which finally began to give him serious competition. He was a very persistent hunter, however, and a most welcome visitor at the Munich auctions and at the Dorotheum, in Vienna, where he more than once paid record prices. For a time, in fact, he may well have been the single most important factor in setting the market within his specialty. He had great patience, too, in many instances waiting years for a painting to become available after he had once located it in a particular collection.

Both his patience and his persistence paid great dividends in giving Milwaukee a collection of outstanding international distinction. That he more than accomplished his original purposes goes without saying.

Tracy Atkinson
Director
Wadsworth Atheneum
Hartford, Connecticut

Introduction

The René von Schleinitz Collection at the Milwaukee Art Center is unique. No other collection in the United States or Europe so extensively surveys nineteenth-century German genre painting. Complementing this collection at the Center are a small number of excellent paintings which are nearly identical in nature to those of the von Schleinitz collection but which came from other donors. One hundred eighty-eight paintings by over eighty artists constitute the body of German popular art at the Milwaukee Art Center. To reintroduce these artists to scholarship after a long period of neglect and to present their works to a larger audience is the purpose of this book.

The contents of the Catalogue illustrate virtually the full spectrum of German genre painting in the second half of the nineteenth century. Beyond that, the collection extends over a period that begins in the mid-eighteenth century and ends in the early twentieth century. In addition to genre, its largest aspect, the collection contains related categories of painting: landscapes, portraits, paintings of animals, and still lifes, as well as a small number of popular historical or literary subjects. The reputations of the painters vary widely in today's art history. We find here the very famous alongside the less illustrious and even forgotten. Likewise, the quality of the individual exhibits ranges from competent to exceptional to a respectable number of masterworks of European art. On balance, however, the gallery of nineteenth-century German paintings at the Mil-

waukee Art Center is a singular, outstanding, and priceless collection, whether it is judged by museum standards here or by those of its country of origin.

In writing this introduction as well as the entries in the Catalogue, I have been guided by several major considerations. The first of these concerns the position of the collection in the framework of a critical history of art, one focusing on the morphology of form in painting. One crucial issue arising in this context is the relationship of the popular-subject specialists—the painters of genre, landscape, and still lifes—to their influential colleagues at the academies—the painters of historical and religious subjects. Repeated examinations of this question throughout this volume will reveal that, in addition to the now well-researched and widely published art of the major movements and of the academies, there existed in the nineteenth century an important alternative art, now in part neglected, in part forgotten, but in its day immensely acclaimed: the art of the popular city schools.

Another major consideration shaping my interpretations concerns the evolution of content in nineteenth-century art. Specifically, this problem involves the study of iconography and the peculiar iconographic properties of the collection. Fortunately, in most individual cases the subjects of the paintings and their treatment by the artists speak to us in a language far more eloquent than that of any commentator. Far from being obscure or alien to

today's audience—especially the young museumgoer—the pictures in the collection immensely fascinate virtually all who come in contact with them at the Center. By thus transcending their own historical limits and communicating freely with us today, most of these painters have indeed stood the test of time. Therein lies the greatest strength of the collection. I will discuss problems of motif, content, and iconography, therefore, only where abstruse treatment or obscure subject makes the meaning of a painting elusive.

Third, there arises the problem of the history of taste and of social values as they are reflected in art. In a sense the collection is a portrait of popular taste in Wilhelmian Germany and, beyond that, it documents the taste of the German middle and upper-middle classes through the entire nineteenth century. Because the artists themselves were an integral part of middle-class society—they certainly did not espouse a Bohemian lifestyle—their lives also document the aesthetic values, the ethical climate, and the ideas that generally prevailed in their class. The artists' biographies, with their frequent accounts of spectacular rises to contemporary fame, thus attest to the true trajectory of middle-class values in nineteenth-century Germany. In order to amplify these social developments—developments that become at once apparent from a study of the artists' biographies—with expert opinions about their art, I have consulted and quoted chiefly from those critics and art historians who were contem-

poraries of the artists. Their views often stand in sharp contrast to the opinions held by a great many present-day art historians, whose views are frequently cited for the sake of comparison.

Finally, I could not forget that the reader is for the most part looking at black-and-white reproductions of pictures that are actually ablaze with color. To serve his needs, I have furnished brief descriptions of all palettes used in the collection. The following pages and the body of this Catalogue will deal with the problems just outlined in considerable detail and will introduce many other considerations essential to a comprehensive examination of the collection.

The considerations that I have just outlined guided my efforts in compiling this catalogue raisonné. In addition to its critical biographies, analyses, evaluations, and commentary notes, the reader will find here such features as bibliographies on the individual artists, and, in all instances where such data exist or could be uncovered, references to and provenances of individual paintings.

The literature on the individual artists and the exhibitions of their works is very extensive (see bibliographies and documentation in the Catalogue). In the present context I merely wish to cite the following occasional publications dealing in general terms with the collection and its donor. "Malerei deutscher Meister des 19. Jahrhunderts in Milwaukee" (signed "F", *Die Weltkunst*, Vol. XV, November 15, 1956, p. 17, nine illustrations) is a brief article paying respects to the expertise and collecting genius of the late René von Schleinitz. It stresses the outstanding merits of his bequest to the Center relative to museographic criteria in Germany. Karl Strobl's "Die Sammlung von Schleinitz" (*Kunst im Volk*, Nos. 3/4, 1968/69, pp. 80–87, illustrated) expands on these efforts for Austrian and German readerships. Conversely, in "German Genre Paintings from the von Schleinitz Collection" (*Antiques*, November 1969, pp. 712–16, eleven illus-

trations) Tracy Atkinson, former director of the Milwaukee Art Center, honors the genial collector, his special interests in art, and his life's work from the American perspective and usefully assesses the importance of his donation as a testimonial to the German cultural heritage in the United States. *Paintings from the von Schleinitz Collection* (Milwaukee Art Center, Milwaukee, 1968, unpaginated, thirty-three illustrations) with a foreword by Tracy Atkinson and notes by Siegfried Wichmann (of the University of Karlsruhe) is a catalogue of a special exhibition of a portion of the collection in the form of a slim booklet. Its six pages of introductory text by one of Germany's foremost scholars specializing in nineteenth-century German art succeed in sketching in for the reader certain major aspects of the Munich School. Regrettably, the capsule notes provided for a selected few artists lack all documentation; they contain neither bibliographies nor references and provenances for any of the small number of paintings chosen for discussion.

Although the painters represented in the collection hailed from various parts of Germany, the Austrian Empire, and Switzerland, they tended to gravitate for their training and life's work to the major centers of art, especially to the academies, master studios, and, above all, the congenial atmospheres of Munich and Düsseldorf. Of these two, and of the other major schools represented here, (e.g., Berlin, Dresden, Frankfurt, Hamburg, Karlsruhe, Vienna), it is the Munich School that, in the realm of popular painting, is best represented in the collection. Several of the artists count among the great masters of German art: for example, Oehme, Lenbach, Spitzweg, Waldmüller, Defregger, Knaus, and Vautier. In addition to these, such famous names as Achenbach, Hess, Bürkel, Diez, Gauermann, Grützner, Lessing, Eduard Schleich the Elder, Schreyer, F. A. Kaulbach, and Zügel are well represented at the Center. Let me now examine the specific circumstances that aided these painters in

reaching their eminent positions in German art history and that fostered the growth of the popular art that they practiced. Thereafter, I shall present short histories of the Schools of Düsseldorf and Munich, rapidly survey *Biedermeier* art, and finally touch briefly on certain basic considerations needed for a general value judgment of the collection in the context of a critical art history.

Four independent but mutually reinforcing developments were among the major forces that helped shape the nature of German art in the nineteenth century: middle-class patronage; *Gattungskunst* (i.e., division of painting into various categories—landscape, genre, still life, portraiture, etc.); the academies; a humanistic education based on historicism.

Seventeenth-century Protestant Holland furnished the classic historical example of a decentralized bourgeois society, composed of disparate, semi-autonomous cities, which deviated from the "normative" trans-European current in art. It broke with the Baroque—a "universal" style upheld and funded by the central courts, the aristocracy, and the clergy—and proceeded to discover and hold fast its own private, social, and natural worlds in the painted imagery of *Gattungskunst*.

German cultural life in the later eighteenth century increasingly depended on the activities of a rising middle class dispersed in the cities and towns of countless principalities. Because the German middle classes had no immediate recourse to a central tradition—there was no capital city until 1871—and because of its spontaneous appeal to their system of values, they too embraced *Gattungskunst*. According to their various ethnic inflections, legions of artists, some of them self-trained, played out its varieties in numerous tradition-rich and stylistically distinct city schools. (Considerations of the "relative materialism" of *Gattungskunst*, on the one hand, and the "relative spirituality" of historicist art, on the other, deserve

attention. But they would lead beyond the scope of this introduction. Whatever the general merits of that controversy, suffice it to point out here, in anticipation of what will follow, that German artists in the nineteenth century managed to infuse their own *Gattungskunst* with more than ample measures of "idealism"!)

The birth of the modern art academy occurred at the court of an absolutist monarch, King Louis XIV of France. From the very beginning it espoused goals that were universal, "absolutist," Catholic, and historicist. Later academies, including those in Germany, were all chartered by sovereigns and modeled on the principles of the School of Versailles. There can be little question that, by and large, the German middle class, and especially the Protestants, initially viewed these institutions with suspicion. But upon the full emancipation of the bourgeoisie in the nineteenth century, they nevertheless helped regional princes support academies in a considerable number of cities throughout the country. There are several reasons why this happened: the inborn respect of the Germans for systematic learning; their high regard for humanistic wisdom; their faith in "the lessons of history"; their interest that an art enterprise in which they had invested should have stability, continuity, and an authoritative guarantee of value.

Still, unlike the highly centralized academic situations in France or even England, where provincial academies followed the dictates of the capital, the many regional academies in Germany (at Düsseldorf, Munich, Karlsruhe, Leipzig, Stuttgart, Berlin, Dresden, etc.) emphasized differing curricula and competed with each other ideologically as well as for students and for official and public support. This situation, of course, showed the cultural vitality and diversity of the urban middle class as much as it reflected German political disunity. It also enhanced artistic variety while neutralizing the first claim of the academy, the claim on universality. An understanding of these conditions helps explain the two seemingly conflicting but simultaneous developments in nineteenth-century German art: on the one hand, an unprecedented flourishing of the academies and the varieties of historicist art; on the other, an unprecedented burgeoning of popular *Gattungskunst.*

During most of the nineteenth century, German creative motivation, public sentiment, and official sanction coalesced as they seldom had before and never have since. From the 1830s onward this coalescence grew stronger, and, after 1870, the commercial interests of galleries, dealers, and critics dependent on them were added to it. The examples of seventeenth-century Holland and the United States at mid-twentieth century indicate that the splendid productivity of any art sustained by entrepreneur-artists, middle-class patronage, and the mechanics of a profit-motivated, free-enterprise system is always accompanied by the shadier side of business. Germany was no exception to the rule, as the history of the "politics" and exploitative machinations of its art market in the later nineteenth century amply demonstrates. And yet in spite of the mercantile abuses, the remarkable conjunction of German artistic, public, official, and commercial interests bore abundant fruit in the art history of that country.

There has been a good deal of speculation on the reasons for the immense popularity *and* commercial success *and* official recognition that so many German painters and especially so many of those represented in the René von Schleinitz Collection enjoyed during their lifetimes, particularly in the later decades of the nineteenth century, but such speculation has often remained frustratingly inconclusive. To be meaningful, it must begin with the Early Romantics, who spoke for a society in search of national identity, independence, and freedom. They yearned for a genuinely indigenous art, free of cultural interference from countries lying outside the traditional boundaries of the old Holy Roman Empire of the German Nation.

The later Romantics modified these lofty original goals, but, on the whole, continued to move within the thematic bounds staked out by their elders. They popularized subjects from literature, folklore, history, and religion and created a nostalgic dream of German existence for the receptive eyes (and narrowed perspective) of *Biedermeier* society. Subsequent to that "fairytale" interlude, the patriotic drumbeat following the revolutions of 1848 and especially the national unification of 1871 quickened and intensified the felt need of the German citizenry for a literary and didactic art that served special native interests in subject matter.

Conscious of their elite standing as intellectual leaders of society and as spokesmen for an educational establishment founded on humanistic and historicist principles, German artists satisfied their sense of duty by providing the public with ethical guidance through art. In due course, much of German art was affected by a hortatory and "novelistic" tendency that drew on the myths of common German origins and shared spiritual sources. Appealing to prevalent psychological and political trends, it was expository as well as symbolic in method. It also affirmed notions of German cultural autonomy, particularly *vis-à-vis* France.

Most phases of popular art also eventually fell under that poetic spell and, in a manner sometimes not unlike that of *Biedermeier,* evoked memories and love of the native countryside and its peasantry, of "hearth and home," of natural *Sitten* (morals and manners), of childhood and a simpler, more hearty past. Stimulating its home audience with these powerful "subliminal" messages, this art was not merely anecdotal, entertaining, or naively engaging, particularly in its aggregate effect over the decades; it was also didactic, moralizing, and potently emblematic. In many respects, the iconography of this art has no counterpart in the art of any other

country. Its remarkable thematic range and blend of folksiness, wit, irony, and a convivial spirit place it among the most original contributions of Germany to the history of art.

Genre painting in nineteenth-century Germany became a far more important category than it had ever been before. German nineteenth-century practice not only made genre more life-like and entertaining but also rendered it a much more comprehensive vehicle for the subtle conveyance of often significant historical, sociological, and moral insights. Though traditional genre artists (in Holland, for example) far preferred to use a straightforward naturalistic style, the modern Germans drew on a host of historical "Old Master" styles and combined these with their own highly developed sense of "photographic vision." Moreover, they conceived of their work not as an isolated pictorial species but rather as a powerfully expressive, "combination art" (see Wichmann) that drew from virtually the whole spectrum of *Gattungskunst* and frequently from academic historicist painting as well. As a consequence of these practices, they created a whole new field of genre sub-categories. Here is a list of the most prevalent among them and some of their exponents in the René von Schleinitz Collection: literary genre (Grützner), *Sittenbild* (Waldmüller), "landscape-figure" genre (Gauermann), historical genre (Diez), peasant genre (Knaus), peasant history (Defregger), children genre (Meyer von Bremen), animal genre (Voltz), the humoresque (Spitzweg), portrait genre (Kauffmann), the costume set-piece (F. A. Kaulbach), "social-message" genre (Bokelmann), military genre (Hess), the picaresque (Bürkel), "Orient" genre (Schreyer), and other varieties of "exotic" genre (Kowalski, Böhm). (The German language contains two words denoting genre painting: *Genremalerei* and *Sittenbild*. Most standard dictionaries or reference works in art history do not differentiate between the two, but in practice art historians often draw a subtle line of distinction:

Sittenbild denotes pictorial treatment of the more profound phases of civil life, significant "morals and manners," and in particular the social and interpersonal behavior of peasants; *Genremalerei* designates virtually all other categories of genre painting.)

The ferment that resulted from the interaction of elitist and popular artistic developments can best be observed in the art schools themselves. Düsseldorf and Munich, the two prominent art centers in nineteenth-century Germany, had a number of things in common, and their histories are intertwined.

In 1773 Karl Theodor, Grand Elector of the Palatine, founded an Academy of Painting, Sculpture, and Architecture at his Residenz Düsseldorf. The Electoral Art Gallery of this renowned patron was one of the most resplendent collections in all of Europe. When, in 1805, Düsseldorf fell victim to the vagaries of a tug-of-war between Prussia and France, Karl Theodor relocated his capital in Munich, having gained the right of succession to the Bavarian dukes in 1777. And his vaunted art gallery accompanied him to the then still sleepy provincial town, where it was to lend impetus to the rise of Munich as a modern art capital.

In pursuing the fortunes of Düsseldorf as a center of artistic studies and practice after Karl Theodor's departure, we learn that, following a hiatus, the academy was reopened by the ultimately victorious Prussians in 1819. The Nazarene painter Peter von Cornelius, who alternated residence between these two cities, was appointed the new director, a post he resigned in 1825 to take over leadership of the Munich Academy. The following year, Wilhelm von Schadow, a fellow Nazarene, assumed the direction of the institution. The next thirty years were to witness Düsseldorf's rise to world fame as it enjoyed its Golden Age in art.

Unlike the Promethean idealist Cornelius, Schadow was practical and adaptable, a superb administrator, close to his students, and relatively tol-

erant in matters of style. Favoring easel painting over the frescoes preferred by his predecessor, and a form of naturalistic and sentimental religious painting, he subjected the then prevalent academic teaching methods to their first modern reform. Among the major innovations he introduced into the preparatory classes were studies from nature and of the live model. Of the other important faculty members instrumental in building the academy, I may mention Johann Wilhelm Schirmer, Carl Friedrich Lessing (see entry in Catalogue), Theodor Hildebrandt, Eduard Bendemann, and Carl Ferdinand Sohn. Until about 1840, Düsseldorf was distinguished by the breadth of public appeal its art enjoyed in comparison with the aloof approach taken by the Munich Academy during those years.

Schadow's (and similarly Cornelius's) goal of building a "national German school of painting" was based on the practice of monumental art and on the Romantic theory of the mutually complementary and enhancing natures of the various categories of art (i.e., literature, music, art, theater, etc.). He expressed it this way: "Only the perfectly natural completion of a poetic idea in form and color conveys the happy appearance of a beautiful work of art." In 1829 the Düsseldorf artists' association *Kunstverein für die Rheinlande und Westphalen* was founded and constituted as an organization for the promotion of important public art. The unusual fact that a very large portion of its funds was permanently earmarked for expenditure on original monumental paintings provided Schadow with the wherewithal for his ambitious schemes, as well as with considerable funds for artists' commissions. Thus, all the conditions virtually to guarantee Düsseldorf a premier role in the history of "grand art" in nineteenth-century Europe were met: the strong will of its leader to succeed with monumental art; a comprehensive theory based on philosophy, literature, and aesthetics; and ample financial resources. But paradoxically the very success of its program in

conjunction with the growing conservatism of its leadership eventually helped to undermine the position of the academy.

In due course, there developed at Düsseldorf a tendency that led away from French Neo-Classical influences and later from the Early Romanticism of the Nazarenes as well. Swayed by, among other things, an influx of students from Prussia and their preferences, the academy fostered history painting. Among the more pronounced characteristics of the school in its middle years was its penchant for naturalism, dramatic composition, stage-like lighting, and vibrant colorism. Later on, increasingly naturalistic theatrics and strident rhetoric were introduced into painting.

The morphology of art at Düsseldorf essentially falls into four major categories. First, there was religious and historical fresco painting, executed in a style that might best be described as a form of naturalistic classicism. Secondly, and closely related to the first, there developed a more lyrical or broadly poetic phase of easel painting that also emphasized life-likeness, declamatory composition, and historical truth or literary accuracy. Third, standing in opposition to both of these, there emerged realistic landscape painting. In 1827 Karl Friedrich Lessing and Johann Wilhelm Schirmer founded the Association for Landscape Composition that advanced, in distinction to the noble aspirations of the conservative wing of the academy, a more down-to-earth and straightforward art concerned with the immediate condition of man and his natural environment. Fourth, after about 1840, a Dutch-influenced genre and still life art, even more inimical to Schadowian aesthetics, began to infiltrate and vie with the older academic programs.

Academic life at Düsseldorf became increasingly rife with internal conflicts and torn by dissension over artistic goals. Two hostile camps were pitted against each other in a struggle for predominance. On the one hand, there were all the conservative idealists, latter-day Romantics, literary-inspired academics, and all the religious and history painters. On the other hand, there were the "progressives," the liberal *freie Künstler* (free artists), the realists, and all the painters of profane and everyday subjects. This conflict was aggravated by a basic split along political and social lines. Whereas the former group tended to lean toward the Prussians and were cultivated by the aristocracy, the latter drew most of their support from the native Rhinelanders and were favored by the middle class. In 1848, the "free artists" founded an organization named *Malkasten*. In the years to come that union was effectively to represent a kind of "anti-academy."

It was the forces that had gathered under the banner of the *Malkasten* that gave vitality to the later years of the School of Düsseldorf. In fact, they were the best representatives of its name by the 1860s and beyond. The Düsseldorf painters in the René von Schleinitz Collection were, of course, all aligned with that popular movement rather than with the academy narrowly defined. And it was such popular artists as Lessing, Achenbach, Knaus, Vautier, and J. W. Preyer, who, after Schadow's retirement in 1859 and in the final phase of the Düsseldorf School before its gradual decline in the 1870s and eighties, gave the image of that city school its distinguished folksy bent and popular appeal as well as its domestic fame and international luster.

Allowing for transitions between cycles, the modern history of Munich as an artistic capital could be divided into these five major periods: 1790–1825, the Old Munich School; 1825–40, Ludovician Monumentalism; 1840–60, Biedermeier; 1860–80, Realism and Naturalism; 1880–1900, Impressionism and other trends.

Looking back on a distinguished history of art and architecture in the age of the Rococo, the people of Munich had a special relationship with the arts and always welcomed artisans and artists into their midst. In 1770 a School of Drawing, one still modeled on the old crafts guild, was founded, and toward the end of the century painting flourished. Portraiture especially thrived in the art of Johann Georg Edlinger and Josef Hauber. In 1799 Christian Mannlich, the director of the Ducal Painting Gallery, introduced the first "academic program." But it was not until 1808, the year in which the new monarchical constitution was proclaimed and Maximilian I began his rule as king of Bavaria, that the Munich Academy was founded. Johann Peter Langer, an eclectic and Cornelius's predecessor as director of the Düsseldorf Academy, was installed to guide a very dry and conservative teaching program.

From that time onward, artistic life in Munich split into two camps: *hohe Kunst*— an idealistic "high art" centered on classic figure painting— and the *Kleinmaler* or "little painters," who did landscapes, city views, genre, battle pictures, and animals, as well as portraiture. In 1823, six years before its totally different counterpart at Düsseldorf, and twenty-five years before the *Malkasten*, its equivalent there, the Munich *Kunstverein* was founded and all *Kleinmaler* gathered under its protective shield to resist or even to give battle to the academy. Among the major academics of this era who espoused the "historical conception dignified by classic attributes," we may mention Kellerhoven, Seidel, Langer (son of Peter Langer), Zimmerman, Stunz, and Riedel. Among the outstanding *Kleinmaler* we can cite Cogels, Quaglio, Neher, Heydeck, Dillis, Ferdinand and Wilhelm Kobell, Dorner, Wagenbauer, Albrecht Adam, Peter von Hess, and Max Haushofer. The School of Munich was, from its earliest modern beginnings divided on artistic goals, but its strength throughout the nineteenth century came out of the intensity of that conflict. In 1819, Crown Prince Louis called Cornelius to Munich to decorate the Pinakothek with frescoes. "High academic" art was then to celebrate its day in the sun.

The year 1825 witnessed the accession of King Louis I to the throne of Bavaria, the appointment of his trusted minion Peter von Cornelius as director of the academy, and the end of the Old Munich School as a period in German art history. As the next fifteen years unfolded, a city planning and rebuilding program of heroic proportions ensued under the guidance of the architect Leo von Klenze. A feverish pursuit of ever more daring and ambitious decorative projects in fresco, carried out under the leadership of Cornelius and with the aid of his many disciples, intensified and broadened that creative outburst. Nazarene principles were also ably championed at this time by Julius Schnorr von Carolsfeld, the Olivier brothers, and Heinrich Maria Hess. But although landscape in a more classical guise continued to be practiced on the sidelines, other popular tendencies and *Fachmalerei* (specialist painting, i.e., *Gattungskunst*) bode their time at a period in which romantic notions of classicism and universalist ideals triumphed in art and a powerful and ambitious monarch dominated all activities on the scene. It was a time when visionary religious artists, deeply beholden to classic and idealistic values and serving a king longing for apotheosis through building and art, created many noble monuments that today add majesty to Munich. But it was also an artistic period that, in the final analysis, was unpopular with the people and alien to the natural temperament of that city.

Popular art was soon restored to the scene, however. In 1841 Cornelius departed for his new appointment in Berlin, and thereafter the prestige of his disciples began to wane. At the same time, the *Fachmaler*, *Kleinmaler*, and the anti-academic partisans of *Gattungskunst* emerged to celebrate their Golden Age in the period of *Biedermeier*. And when King Louis I abdicated in 1848 and King Maximilian succeeded him to the throne, even though planning and building continued during his reign, virtually all contact with the spirit of the Olympian period in

the history of Munich art had been lost. Several new institutions then arose and added to the conviction that Munich's moment of popular glory as an art capital had now arrived on a grand scale: the establishment of the Neue Pinakothek (1846); founding of the Association of Arts and Crafts (1850); inauguration of the famed international exhibitions at the Glaspalast (1854); the laying of the cornerstone of the Old National Museum (1857); the opening of the gates of the art collections at the Maximilianeum (1864).

As monumental art declined, artists from all German-speaking lands flocked to the city to study and practice a "people's art" whose popularity has yet to show signs of waning. Of the many important masters who made Munich their home during the period of *Biedermeier*, we may mention Schwind and a few important *Kleinmaler*: Morgenstern, Voltz, Spitzweg, Eduard Schleich the Elder, Bürkel, Johann Adam Klein, Lier. Of course, all the von Schleinitz artists whose activities fall in that period in Munich's history helped enrich and diversify that aesthetic "détente" which lay between two hectically "activist" phases in Munich art.

The Munich exhibition of 1858 was perhaps the last one in which Romantic and monumental paintings could still be seen in some strength. The succeeding movements of Realism and Naturalism then advanced inexorably and replaced the romantic, rarefied, and intellectual Cornelian approach to art with much more sensuous and materially compelling methods: eclecticism, painterly effect, patina, *Altmeisterstil* (style of the Old Masters), *Malkultur* (painting culture). Virtuosos of the brush established themselves as *Malerfürsten* (painter princes) on palatial estates, dazzling the public, captivating the powerful, and commanding in their private teaching studios legions of disciples. These had hurried there from all over Germany, Europe, and the rest of the world in order to learn from the masters the deeper secrets of a magical "School of

Munich" after having negotiated their way through the perilous "forecourts" of introductory, intermediate, and advanced classes at the Munich Academy.

To name only the most prominent of these master-studios, there was the Kaulbach School, practicing a late Cornelian manner enriched with the sparkle of lively color and the excitement of Naturalism; the Piloty School, specializing in naturalistic, Neo-Baroque historical melodrama; the Lier School, distinguished for its finely modulated *plein-air* mood landscapes; the Lindenschmit School, excelling in history painting and genre in the Dutch manner; the Diez School, which triumphed in realistic *paysage intime*; the Löfftz School, superior in cabinet pieces in the Old German and Flemish traditions; and, out in the country near Munich, different from all the rest, there was the Leibl School, whose specialty was realistic figure painting. (All these schools are represented in this Catalogue; the Diez School appears here almost in totality.)

Just as this "studio culture" had reached its zenith in terms of artistic brilliance, influence on the younger generation of artists, and manipulative acumen in the national and international art markets, new trends set in and, gathering momentum, aggravated and widened the grand "Battle of Styles." To illustrate the complexity of the situation we may cite Uhde-Bernays's "schedule" of competing and successively victorious tendencies that, in his opinion, prevailed in Munich during the period from 1875 to 1900: "1875 *Altmeisterlich* (Old Master style), 1879 pleinairism or *Stil* Munkácsy [see entry in Catalogue], 1883 Dutch, 1888 Scottish [!], 1892 Impressionism or Böcklin, 1896 Neo-Idealism and Allegorism, 1900 Poster Style [!]."

So far, I have examined the academies and city schools as background for the German painters at the Milwaukee Art Center. But the René von Schleinitz Collection can and should also be

evaluated in the context of *Biedermeier* art. Many of the paintings belong to that period narrowly defined—i.e., the years 1830–50. Others are products of what could be called "late *Biedermeier*," or the decades of the 1850s and 1860s. Still other paintings, those falling even later, even though by then new movements had radically altered the course of art and thereby offset the late Romantic *Biedermeier* status quo in art, might opportunely be described as belonging to the genus "nostalgia-*Biedermeier*." (Surprisingly, there was even a time in German art history that I might call "proto-*Biedermeier*." That is the period of late Rococo *Zopfstil* (pigtail style) painting, falling approximately in the years from 1760 to 1780. Justus Juncker [see entry in Catalogue] exemplifies that style.)

An imprecise and vague term at best, *Biedermeier* calls for two basic definitions. First, there is the generic meaning of a period in German art history, the 1830s and 1840s. In this sense the word is used to designate a chronological time span, contains no qualifying meaning, and encompasses a multitude of different styles and philosophies in art, including *Biedermeier* attitudes. Second, there is the whole body of thought and feeling that makes up the gestalt of these attitudes. These can be found in aspects of German art spanning almost two centuries, or the years 1760 to 1900, and they even appear marginally through the twentieth century. They emerge in their most concentrated form in the years 1830 to 1850, when they are associated primarily with the bourgeoisie and the aesthetics of the popular city schools.

Originally, *Biedermeier* was a designation with a broad meaning in the cultural history of Germany. Later it was applied to the history of literature and, finally, to art history. The period in political history known as *Vor-März* comprised the decades before the March Revolution of 1848, an event that signaled the awaking of political consciousness after a long interval of dormancy that can be traced back to the

end of the *Befreiungskriege* (Wars of Liberation) and the Congress of Vienna of 1815. *Vor-März* is synonymous with *Biedermeier* as a cultural epoch in Germany. *Junges Deutschland* (Young Germany), its literary counterpart, marks the time span from 1825 to 1850 and counts among its ranks the poet Heinrich Heine. *Biedermeier* as a period in German art history was probably first proposed by Richard Hamann in 1914. Here it is equivalent with Late Romanticism and reflects a feeling of "détente" after the emotional strains of the Wars of Liberation and the spiritual concentration of that period's Early Romantic generation. As a period in art history, *Biedermeier* is uniquely German. It has no counterpart in other countries.

The term *Biedermeier* itself stems from a composite of two philistine names (Biedermann and Bummelmeier) conceived by the novelist Victor von Scheffel and used by the editors of the literary journal *Fliegende Blätter* (c. 1856) to lampoon the absurdly naive rhymes of the poet Samuel Friedrich Sauter (who died in 1848). In the narrow sense, *Biedermeier* designates a style in furniture, interior, and utensil design. As such it is characterized by forms derived from a simplified Empire Style (1804–15). Clarity of line, functionalism, lightness of mass, fine quality of materials, solidity of structure, and an ornament based on the scattered-flower motif (*Streublume*) are among its features. More important, in painting the term denotes not a style but, just as does Romanticism, suggests a mood or content. Gemütlichkeit (i.e., a good-natured, snug, and cozy geniality), the milieu of the *Kleinbürger* (little citizen, or *petit bourgeois*), good-natured moralizing, romantic reverie, nostalgia for the "good old days," contemplation and gentle humor are its chief traits. The realistic landscape, genre, and the unheroic psychological portrait are among the finest achievements of *Biedermeier* art.

Whether we prefer to call the years from approximately 1830 to 1850 *Vor-März*, *Junges Deutschland*,

Late Romanticism, or *Biedermeier* does not matter. What matters is whether or not such a distinct period in *art history*, one that bridged the art of the romantic period with Realism, is justified on grounds essential to art itself. For some time now a consensus of critical opinion seems to recommend precisely that—namely, to categorize it as an interim period. I quote Paul Ferdinand Schmidt's prescient view on the subject (but I also caution the reader to take his reactionary anti-academic bias, so characteristic of writers in the 1920s, with a grain of salt):

> A history of German painting in the nineteenth century can, under no circumstances, omit a chapter on "*Biedermeier*." . . . *Biedermeier* is the period of the Epigones between Early Romanticism and a materialistic naturalism, a *Kleinbürger* transition from the Wars of Liberation of the *Vor-März* period. In art it is a period of digestion of romantic classicism and realism whose forms had become stabilized at the beginning of the century. The artistic wealth of the epoch which, on first sight, seems so immense and chaotic, can be divided into two unequal parts: the humble Little Masters of *Biedermeier*, who gave us the lasting values of the art of their times and to whom belong such romantic and poetic artists as Schwind, for example. In the pure forms of their art they expressed abiding spiritual values. On the other hand, there were the Great Masters and powerful men of the academy. Their huge picture formats seem no longer to justify their inner values. Their aspirations were fulfilled by the times in which they lived. But now they seem obsolete and dead. (*Biedermeier Malerei*, pp. 7, 29)

The "Centennial Exhibition of German Art in the Period from 1775 to 1875," held in Berlin in 1906, brought together over two thousand paintings by hundreds of artists, many of whom had been "discovered" and were introduced to the public and

scholarship for the first time. Virtually all subsequent "readings" of the epoch can be traced back to that seminal exhibition. The immense wealth and variety of German painting in the nineteenth century, demonstrated by that retrospective exhibition and since then reaffirmed, is especially evident in the *Biedermeier* period. There, indeed, German art seems almost beyond organized analysis. Still, it is possible for purposes of our rapid survey to bring some order into apparent chaos by sketching in the situation city by city, and by highlighting what seem to me to have been among the main trends. What, then, were these centers and who were some of the important artists of the *Biedermeier* period? But first a glance back to an older period.

As already mentioned, sentiments akin to *Biedermeier* began to surface in German art as early as the 1760s, when they are associated with the *Zopfstil* style. In addition to Juncker, mention should also be made of Daniel Chodowiecki's moralizing "citizens' Rococo" in Berlin, the "citizens' portraiture" emerging in the later work of Johann Georg Ziesenis and Josef Grassi, and, above all, of the soberly objective realism in the portraits of Anton Graff at Dresden and Joseph Georg Edlinger in Munich. A certain *Biedermeier* flavor is also noticeable in the landscapes of the Old Munich School, especially those by Johann Georg Dillis and Ferdinand and Wilhelm Kobell. In these works as a whole, certain characteristics—a study of the Dutch masters and of nature, an increasingly more uncompromising sense of realism in representations of *Heimatlandschaft* (native landscape)—anticipate *Biedermeier* practices.

Among the great masters of Early Romanticism it was, above all, Philipp Otto Runge in Hamburg in whose realistic portraits related attitudes emerge: the serious demeanor of sitters, their intimate proximity to the viewer, the bourgeois proprieties of dress and bearing, the closely rendered textures, the familiar domestic milieu, the native landscape setting. From the immediate circle of artists around Caspar David Friedrich in Dresden—especially in the *Nachtschwärmereien* of a Carl Gustav Carus or an Ernst Ferdinand Oehme (see entry in Catalogue) as well as in Karl Friedrich Blechen's landscapes and cityscapes, conceived as naturalistic and personal slices of life—there surfaces a guileless *Biedermeier* fantasy, or its complement, close encounters with immediate actuality. Of the numerous painters of the first generation of Nazarenes, the generation of the German-Romans, Johann Friedrich Overbeck and Philipp Veit may be singled out as authentic *Biedermeier* artists because of the former's especially pronounced display of overt piety in religious painting, among other traits, and because of the latter's *comme il faut* habits and manners in middle-class costume painting. By about 1830 the pioneering styles of realism, Nazarene classicism, and Romantic lyric treatment of nature had reached their objectives. The situation was stable for the next twenty years, the *Biedermeier* period.

To begin with, there were the Hamburg Nazarenes, a *Biedermeier* circle of artists who, in the main, had studied under Peter von Cornelius and Friedrich Overbeck. Among them we find Julius Oldach, Erwin Speckter, Johann August Krafft, Viktor Emil Janssen, and Friedrich Wasmann. Although they differed from each other in certain respects, they all seem to have been united by the desire to express the humble and religious spirit of the Nazarenes in an art whose style is as unassuming as its technique is fine and often miniature-like. Among their best achievements are small, but lovingly executed, intimate, psychological portraits, biblical scenes, and landscapes, as well as snapshot-like and comfortably informal scenes of everyday life and close views of nature that seem to presage Impressionism. On the negative side, it must also be said that the styles of all these Hamburg *Kleinbürger* intimists of the 1830 generation share a certain dryness, bashfulness, timidity, and lack of imagination that sharply contrast with the daring of the great pioneering generation of 1800 to 1810, the generation of the Early Romantics. Only one among this Hanseatic coterie, Christian Morgenstern (who relocated in Munich and became part of that city school), had taken a different route via the Copenhagen academy and studies at Munich. Consequently, he arrived at a realistic style of mood landscape that seems to echo, albeit on a miniature scale, the depth of feeling and poetic intensity one finds in the *Erdlebenbildkunst* (art of earth life) of, for example, Friedrich or even Carus.

In Berlin we encounter excellent veduta painters and panoramists as well as Nazarene disciples. In the last group, Karl Begas the Elder, whose genre and portraits convey a sense of complacency together with doting affection for fashionable details of dress and manner, is clearly a *Biedermeier* progeny. The staid and pragmatic temper of the Prussian citizenry fostered realism in art. The Berlin School from Chodowiecki to Menzel encouraged its artists in the most faithful, sometimes even slavish, reproduction of reality. And the reality that was most preferred by the Berliners of the *Biedermeier* age consisted of views and prospects of their own city. Its splendid avenues, stately buildings and monuments, its thrifty citizens in all walks of life—at work, at play, watching a parade or on a constitutional *Spaziergang* in their Sunday best, or at congenial get-togethers—make up the *mise en scène* of Berlin art of the period of *Junges Deutschland*. Johann Erdmann Hummel, Eduard Gärtner, and Franz Krüger were the three foremost representatives of this materialistic and often mincing art as a mirror of bourgeois civic life.

In Dresden four artists figure prominently in the panorama of *Biedermeier* art: the incomparable Richter, his pupil and follower Heinrich Dreber, Oehme (see entry in Catalogue), and Ferdinand Rayski, who painted in all varieties of picture categories and whose art showed tendencies sur-

prisingly early in the direction of Impressionism, against which Germany reacted by neglecting him in his lifetime. Ludwig Richter was, alongside Schwind, the most popular painter and book illustrator of the *Biedermeier* period. His power of inventing ever new fantasy creations and pious and historic tableaux was inexhaustible. His drawings—sentimental and cheerful, narrative and anecdotal—enlivened many popular editions of fairy tales, storybooks, and educational and poetry volumes. Richter discovered the charms of his native countryside. He painted its woods, pastures, and mountains in the genre of narrative *Heimatlandschaft* that today still enjoys immense popularity. The abiding contribution of Richter's affectionate manner lies in the gentle poetry and amiable popularity which he lent to the *Biedermeier* spirit in art: to its didactic, moralizing, or humorous intentions; to its flight from reality to storybook fantasy; to its jolly piety, snugness, frugality, and familial joys.

Heidelberg and southwest Germany produced Johann Baptist Seele, a prominent soldier and battle-scene painter of the *Biedermeier* era. The region excelled in the category of *Heimatlandschaft*, especially with George Issel and Georg Philipp Schmitt. Internationally active, Franz Xaver Winterhalter, from the Black Forest, was an outstanding *Biedermeier* portraitist with a special gift for female portraits. His gallery of the great ladies of his day has no equal in timeless elegance, grace, and painterly charm. In his art, the bourgeois style of *Biedermeier* was made to serve the aristocracy; most of his patrons came from that class.

At Düsseldorf, Carl Friedrich Lessing (see entry in Catalogue) stands at the center of *Biedermeier* development, even though his personal style underwent several changes. The main echelon of "academic *Biedermeier*" painting at Düsseldorf was represented by the Late Nazarene Eduard Bendemann, who specialized in religious frescoes, and

by the history painter Theodor Hildebrandt. Heinrich Maria Hess is especially remembered today for his delightfully charming, intimate portraits of young women. Johann Peter Hasenclever belonged to the popular branch of the Düsseldorf School, and he was its leading exponent in humorous *Biedermeier*. His domestic genre, and scenes of busy city streets and rowdy public houses, echo Berlin *Biedermeier* genre. His work anticipated the heyday of naturalistic "late *Biedermeier*" genre painting at Düsseldorf—the art of Benjamin Vautier and Ludwig Knaus (see entries in Catalogue). The still-life painter Johann Wilhelm Preyer (see entry in Catalogue) enjoyed the reputation of being the best technician of all the Düsseldorfers.

At Aachen, Alfred Rethel produced frescoes in a grand figural style not unlike that of Cornelius, whose only true successor he became in the period of *Biedermeier*. A rarity among artists of the 1830 generation, Rethel actually drew upon early German sources of the sixteenth century for inspiration in order to legitimize his heroic but realistic figures and to lend a sense of native credence and solidity to his powerful historical compositions. But, as did so many other German artists of the *Biedermeier* decades, he made what may have been his most eloquent statements in the graphic medium of the woodcut. His deeply pessimistic outlook on life—an attitude that was quite uncharacteristic for the generally affirmative and positive frame of mind of the *Biedermeier* age—focused on the subject of death in several woodcut cycles that form the only viable stylistic link between the German Renaissance (notably Hans Holbein the Younger) and the German Expressionists of the early twentieth century.

Munich *Biedermeier* "as such" was somewhat late in arriving, then flourished longer and more vigorously than elsewhere. Wilhelm von Kaulbach was Lessing's Munich counterpart in history painting. His academic grandiloquence in composition and

his extravagance in staging his actors for their optimally decorative effects was uncharacteristic of the period. By blending Cornelian and Neo-Baroque tendencies of style, he certainly furnished *Biedermeier* with its most opulent dimension. But three painters, above all, were the soul of *Biedermeier* in Munich. They were Moritz von Schwind, Carl Spitzweg, and Eduard Grützner (for the last two, see entries in Catalogue). Schwind's *Biedermeier* moods epitomize the detente of Early Romanticism's militancy and proselytizing zeal, and they suggest *Gemütlichkeit*, gentle humor, nostalgia, anecdotage, detached reverie, erotic fantasy and a sense of abandon. His art typifies *Biedermeier*'s dream-flight from reality. Superficially entertaining, his paintings often challenge the viewer to respond to their contents with profound psychological interpretations originating in subconscious associations of meaning. Schwind's production in graphics was as prodigious as it was brilliant. He figured among the foremost artist-minstrels of his time. In painting, his most memorable contribution to *Biedermeier*'s late Romanticism in southern Germany was to have produced a lively visual counterpart to the fascinating world of German legends and fairy tales. In this accomplishment he was certainly equal and perhaps even superior to Richter. Only Spitzweg was able to render as well as had Schwind the state of mind of those caught in departure and leave-taking, or to intimate the pleasures of the small town milieu and the joyful anticipations of young love or travel, or to create a sense of suspended animation in moments of quiet contemplation.

Victor Müller's paintings were thematically close to Schwind's subject matter of stories and fairy tales, but his stylistic interpretations of those literary subjects differed from Schwind in two respects: his greater partiality for very large-scale presentations, and his dramatic stagings or rhetorical expositions. Among Munich's other *Kleinmaler*, the foremost were the genre painter Heinrich Bürkel and the

landscape painter Eduard Schleich the Elder (see entries in Catalogue). Adam Klein and Adolf Lier specialized in highly expressive *Biedermeier* mood landscapes with genre staffage depicting the regions near Munich. The style of Peter von Hess (see entry in Catalogue) lies in the transition from *Biedermeier* to Naturalism, while that of Wilhelm Diez (see entry in Catalogue) anticipated the Impressionism of the Secessions movement of the 1890s.

Although Nazarene art had originated in Vienna, leadership during the first half of the nineteenth century had largely shifted to Germany. Nevertheless, that same period in Austria was among the most productive in the history of art in the German-speaking lands. For reasons that go beyond classifiable concepts, Austria became the very homeland of *Biedermeier*; or, to put it in other words, regardless of the stylistic idiom used in any specific case, the Austrian inflection of that idiom somehow tends to soften it, make it lighter, more elegant, urbane, and sophisticated as well as more engaging, intimate, and *gemütlich*. On the whole eschewing ideology, characterized by pragmatism and a susceptibility to international trends, the overall development of Austrian art in the *Biedermeier* period moved toward an engrossing, sensual naturalism. It culminated in the work of Ferdinand George Waldmüller (see entry in Catalogue). If there was indeed a *Biedermeier* art, then Waldmüller symbolized its genius.

Peter Krafft was among the older masters of Viennese *Biedermeier*. He painted realistic portraits that reflect an objective and sober citizen's attitude as well as genre scenes from contemporary history that combine well-observed events from the wars with a style that seems to recall "sentimental classicism." Josef Führich was the major younger-generation Austrian Nazarene of the *Biedermeier* period to introduce a note of popularism and congeniality to the restrained moods of religious art of the older Nazarenes. One could say that he liberalized their

art with *Biedermeier* charm. Eduard Jacob von Steinle followed in his footsteps for a while. Among the happiest aspects of his later canvases are his poetical inventions or invocations of legendary themes. He had a genius for objectifying—through the poses he gave to his figures, through his discriminate use of accessories and his harmonious sense of color—the essential lyrical note, revealing a pregnant inflection of mood.

In Vienna Karl Rahl painted, in addition to his warmly patinaed, *altmeisterliche* (old-master style) portraits, colossal allegorical and historical decorations in the neo-Cornelian manner of Wilhelm von Kaulbach. Friedrich Gauermann (see entry in Catalogue) and Rudolf von Alt were two of the best-known landscape painters of their times. The latter did crisp, small-scale views of Vienna and the Austrian and Italian countryside in a style that grew progressively looser and freer in pursuit of luminism. The portrait artist Friedrich von Amerling enjoyed, through his charming and sentimental but luxury-indulging paintings, a very high degree of popularity; both the court and the citizenry eagerly sought his services for those sensuously naturalistic portraits with that ennobling *Altmeister* touch. Peter Fendi and Joseph Danhauser exemplify the very best that was done in naturalistic domestic and in contemporary historical genre, respectively, in the heyday of Viennese *Biedermeier*. As with their counterparts in Germany, the reputations of many of these painters declined with the changing tempo of subsequent developments in art. But by the time of the Berlin Centennial Exhibition of 1906 *Biedermeier* art was experiencing a renascence, and the critical esteem in which it was held then has been steadily rising ever since.

In the preceding paragraphs I have summarized events leading up to and including the heartland of *Biedermeier*. Many of the German paintings at the Milwaukee Art Center belong to that tradition. But there is an even larger body of paintings at the

Center whose dates fall well beyond *Biedermeier*, into the later decades of the nineteenth century, the period labeled *Gründerjahre* ("founding years" of nation and large industries). The opulent styles of these "latter-day" *Biedermeier* artists belonged for the most part to the period of Naturalism of the 1860s, 1870s, and the years beyond. Technically theirs was, on the whole, an advanced approach, and they opposed a humble, old-fashioned *Biedermeier* realism. Their little bravura paintings feature sophisticated eclecticism, refined Old Master touches, involved scenic compositions, exquisite colorism, and an intensified formal illusionism. In addition, they sought maximum photographic verisimilitude to nature in their art. But, paradoxically, they combined these modern virtuoso qualities with literary, historical, or folksy genre subjects from the past or with subjects viewed with the sentiment of former *Biedermeier* times.

These artists looked back uneasily and wistfully at the *Biedermeier* period. In it they perceived what to many of them was the proper cultural environment for fostering the desired state of life, a *Kleinbürger* life of frugality, simplicity, and contentment or of the joy in material goods and of positive *Lebenslust*. They were amply rewarded in their choice by the art-buying middle class, which put its money where its private convictions lay. But in this conflict between a *Gründerjahre* style and a *Vor-März* content, between the cultural or political actuality of their own times and their daydreams, also lies the greatest dilemma of their art. It threatens to render hypocritical, even to vitiate, the art of the lesser among them. Conversely, that unresolved tension results in a remarkably engaging romance with make-believe places, fictional people, pretended actions, wishful times. In short, it is what produces that very special magic of the best works of their rank.

Finally, and briefly, I would like to address the problem of criticism with regard to the artists in the

René von Schleinitz Collection. What I have said so far has referred directly or indirectly to the many outstanding artists there. As for the second echelon of painters in the collection, the many followers of the more distinguished masters, it sometimes appears as if they had sacrificed aspects of their often formidable talents and bridled their originality and individual expressive freedom in order to submit dutifully to the ordained order of things. Conversely, just as with the seventeenth-century Dutch School, for example, these limitations—which can be summed up as a lack of nerve to experiment and thereby evolve—were amply compensated for by traditional virtues: understanding of subject matter, depth of penetration into the thematic material, genuineness of mood, solidity of artistic conception, sophistication of form, brilliance of color, and flawlessness of craftsmanship. These were among the qualities that distinguished the major schools in general and these painters in particular.

As to the third rank of painters in the René von Schleinitz Collection, a small number of artists are represented here with works that would seem to fall under the rubric of souvenir art or *Trivialkunst*. Surprisingly, some of the criteria just named, especially an excellent craftsmanship, still hold true for many of them. Of course, we must place any assessment of their somewhat journeyman-like execution and their relative repetitiveness and lack of aesthetic ambition or stylistic independence in the proper context of a broad historical judgment which takes into consideration the limitations and constraints imposed on them. (All Catalogue entries are written in that critical spirit and take account of each individual artist and painting accordingly.)

While pondering the problem of ordinary art in the nineteenth century, we might pause to consider the plight of the museum-goer one hundred years hence trying to assess our own late-twentieth-century brand of *Trivialkunst*: the myriad look-alike stripes, squares, dots, dribbles, fields, screens, and sundry other colorful shapes deposited—sometimes decoratively, sometimes not—on canvas by our own well-meaning, competent, and representative but equally dependent and unoriginal journeymen-painters. While their nineteenth-century *confrères* struggled with permutations of "character-heads" or sheep, *they* agonize about modifications of stripes or squares. Differences in aesthetic systems aside, in either case the problem is the same: motivic variations upon a theme. If we accept that artistic challenge as worthwhile for one group, surely we cannot fail to follow suit for the other. Only the object's circumstantial data and intrinsic value (if any) should matter for both.

In keeping with the simple logic of things, a fair and humane criticism of the art of the past seeks to establish as the first basis of judgment the hard facts that attended the genesis of its object. Such criticism inquires into the pertinent causes and necessities of that art's existence. It also probes into the reasons for its acceptance or rejection by people contemporary with it. Accordingly, it attempts a sympathetic understanding of the special social forces or particular cultural needs prevailing in art, as well as taking discriminating issue with the aesthetics and art criticism of the time and place in question. If it fails to do so objectively, criticism also fails in its mission to gauge the relative merits of art and quickly deteriorates into a polemic on "cultural history." But if these conditions are met as the *sine qua non* of value judgment, we can, of course, complement them by cautiously introducing our private likes and dislikes into the balance without much fear of upsetting it. However, the greatest reservations should always govern the use of value systems that have emerged after the work of art was completed, lest our perception of it be clouded by issues that are beside the point. Finally, very nearly all systematic criteria for the present-day valuation of art are by definition extraneous and irrelevant to an objective history of art. They should never be applied for any reason except perhaps for the sake of contrast and comparison.

Whatever the special qualities that distinguish the many outstanding artists in the René von Schleinitz Collection, what seems to be right with most of the lesser luminaries among them is precisely that which also made them so successful in their own time. The same qualities still make them diverting and attractive today: their crisp articulation of the time, place, and action of a given event and its affectionate, anecdotal staging; their prompt and ample revelation of meaning; their insouciance for theory or the abstract mechanics of form; their obliviousness to "art for art's sake"; their lack of pretension; their bright, sensuous joy in a modest, descriptive, often eclectic art of abundant colors, sumptuous textures, opulent shadows, mellifluous lights. Conversely, it is, of course, precisely these same qualities that move some exponents of our current institutionalized system of valuation to react to these artists in a jaundiced manner. However, a reappraisal is assured and has already commenced. It is now being continued in the pertinent context of historical facts and data that actually furnished nineteenth-century art with its special *raison d'être*. And as to the proper approach for dealing critically with these artists, we can only concur with Lionello Venturi when he says: "If a fact referred to [in art history] is not considered a function of judgment, it is perfectly useless; if a judgment does not rest upon a knowledge of the historical facts, it is completely false" (*History of Art Criticism*, New York, 1964, p. 20).

Color Illustrations

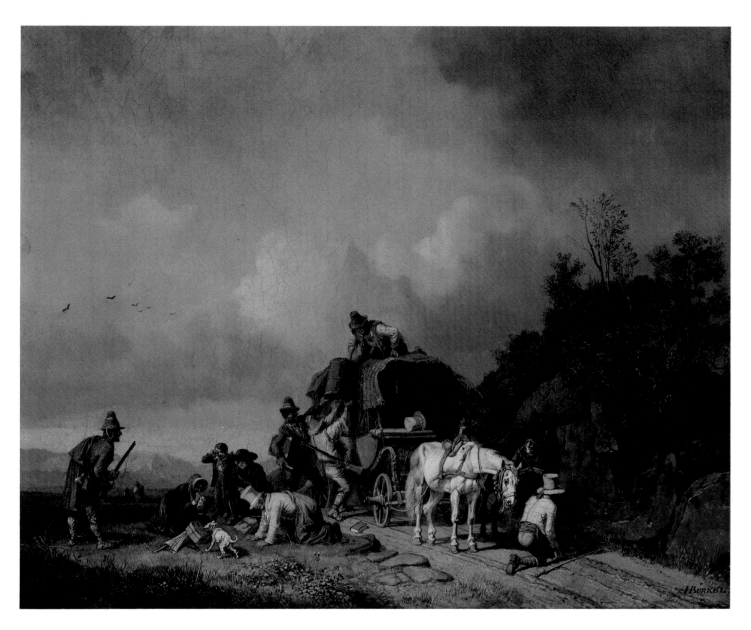

HEINRICH BÜRKEL *The Holdup* Catalogue number 16

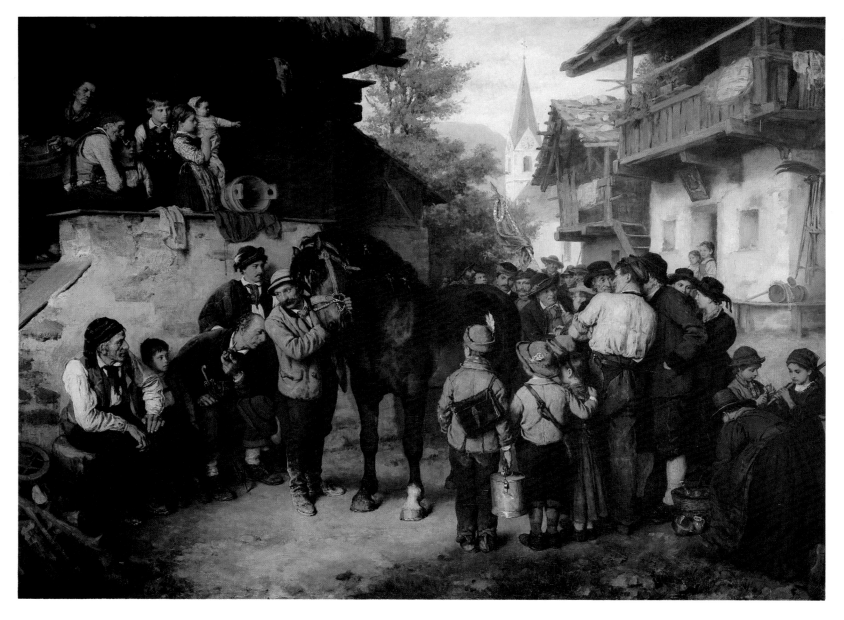

Franz von Defregger *The Prize Horse* Catalogue number 19

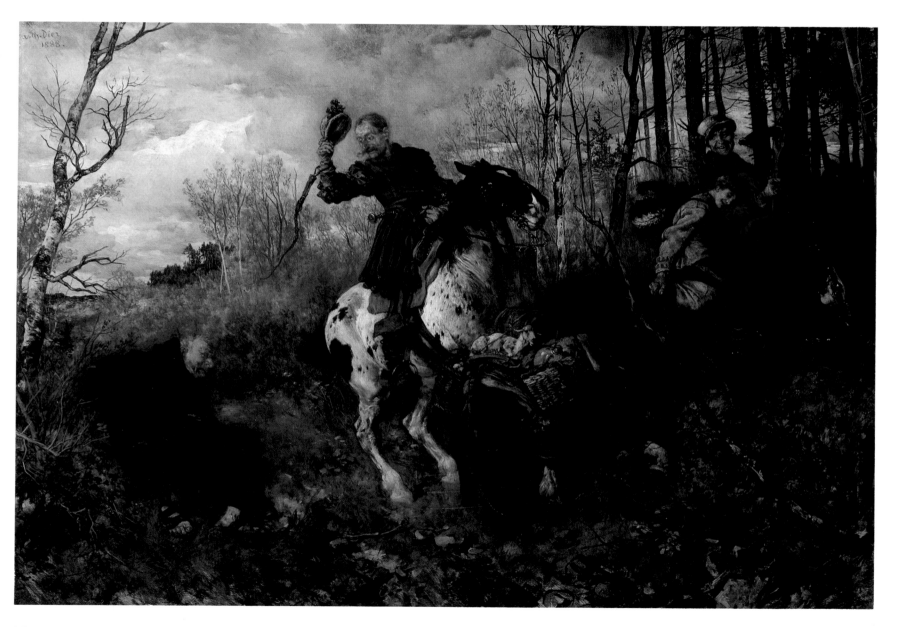

Wᴉʟʜᴇʟᴍ ᴠᴏɴ Dɪᴇᴢ *Highwaymen* Catalogue number 22

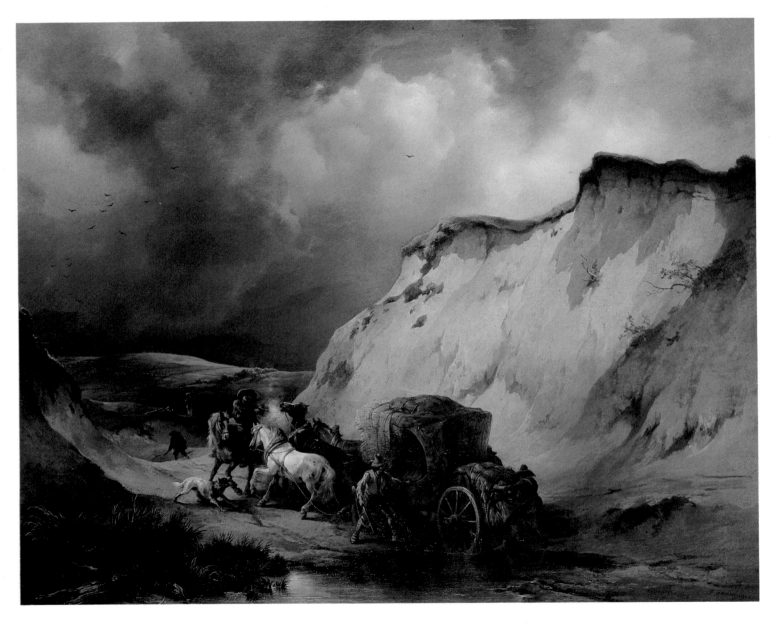

28

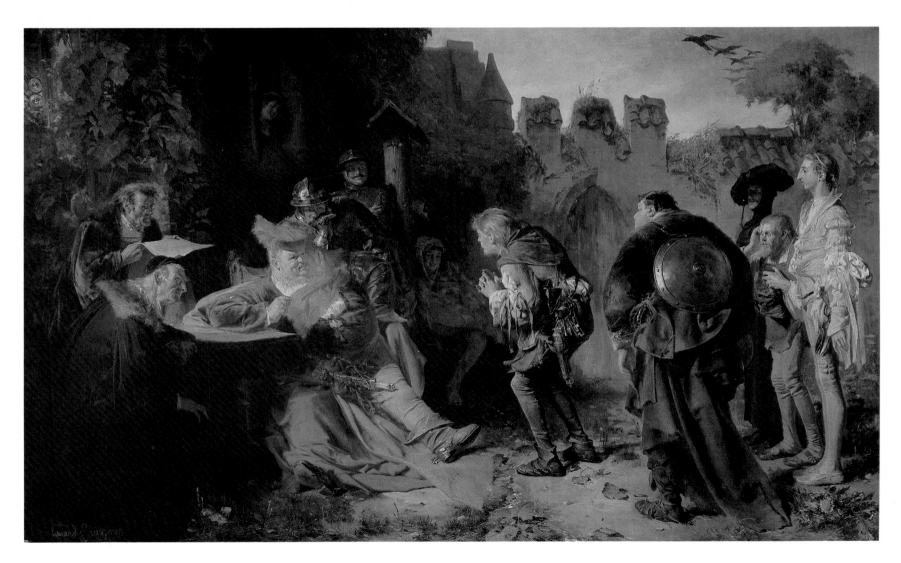

EDUARD GRÜTZNER *Falstaff Mustering Recruits* Catalogue number 37

29

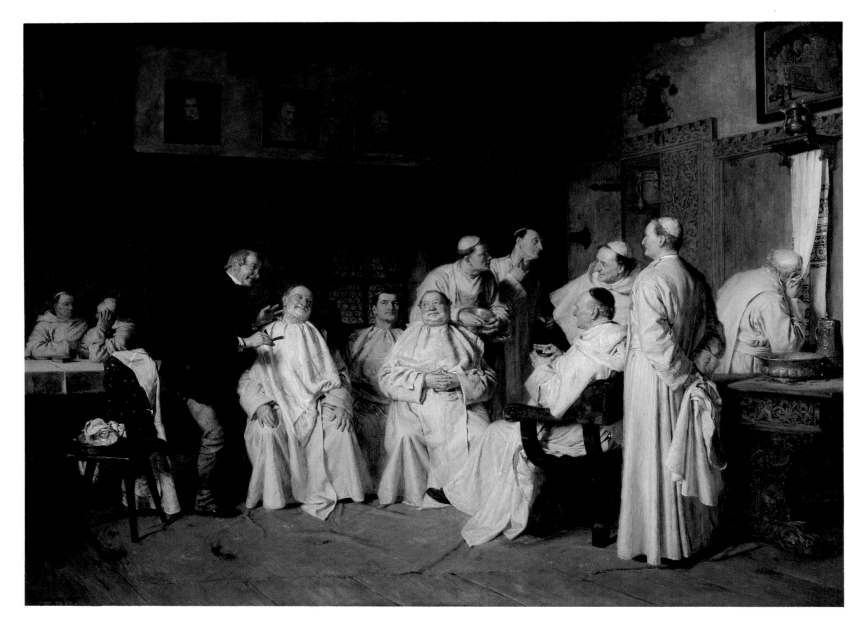

Eduard Grützner *Shaving Day at the Monastery* Catalogue number 42

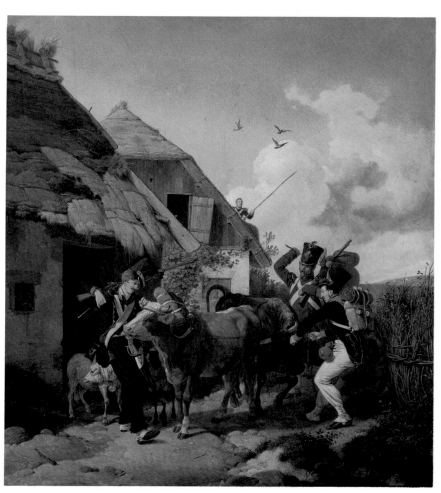

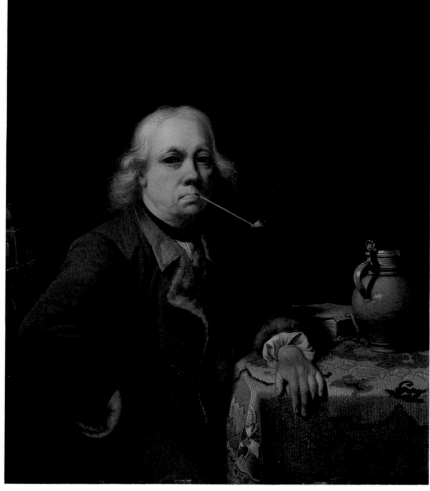

Peter von Hess *Plundering Cossacks* Catalogue number 53

Justus Juncker *The Smoker* Catalogue number 57

31

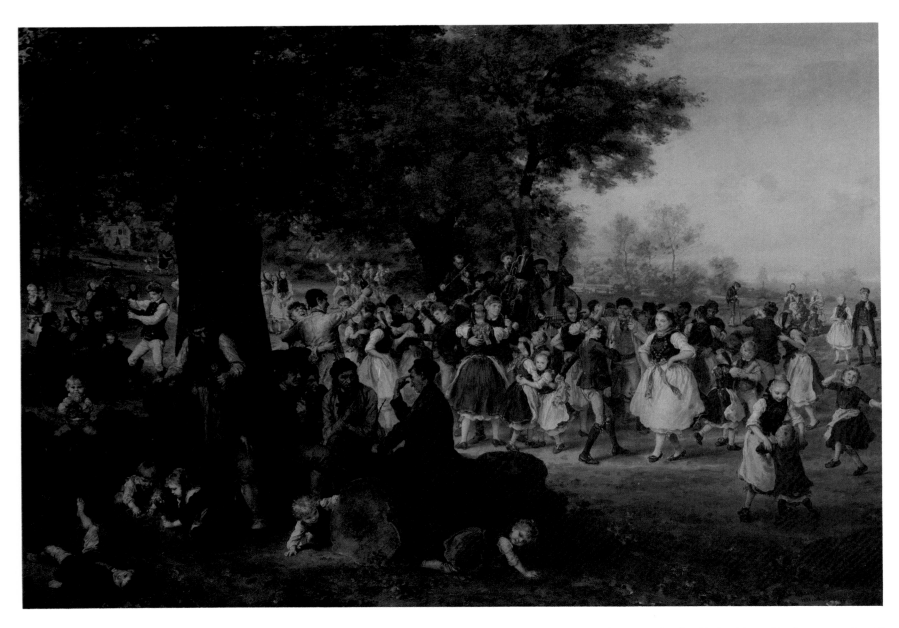

32 LUDWIG KNAUS *Dance under the Linden Tree* Catalogue number 85

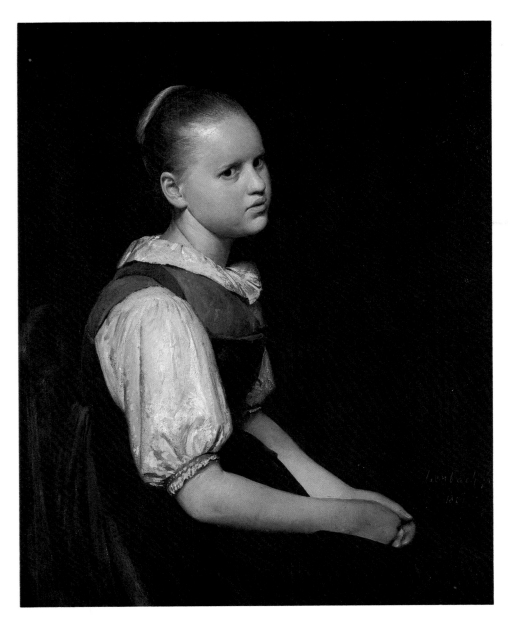

Franz Seraph von Lenbach *Bavarian Peasant Girl* Catalogue number 111

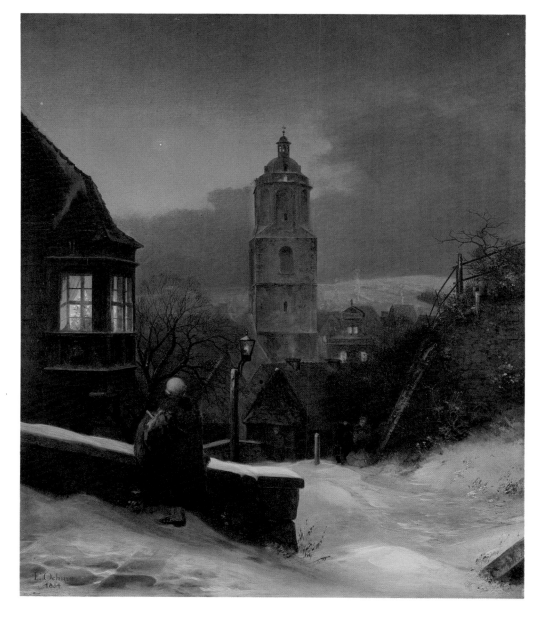

ERNST FERDINAND OEHME *Meissen in Winter* Catalogue number 130

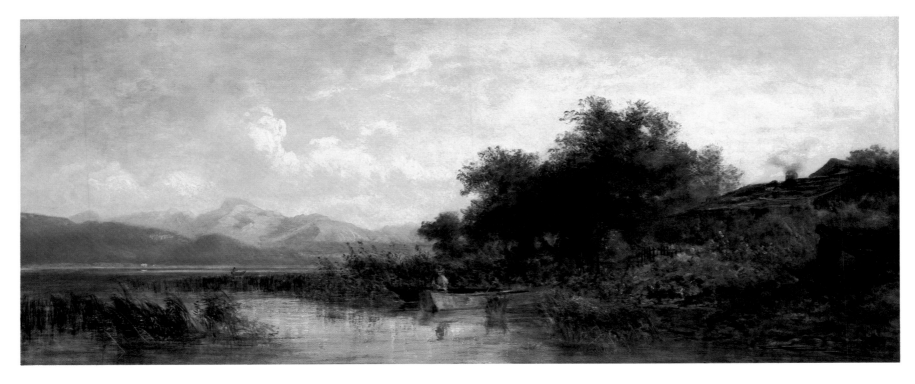

EDUARD SCHLEICH THE ELDER *Lake Chiem* Catalogue number 136

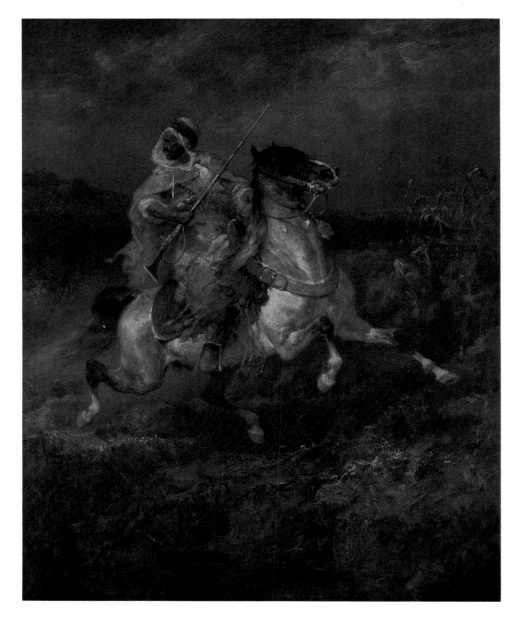

CHRISTIAN ADOLF SCHREYER *Arab Warrior* Catalogue number 145

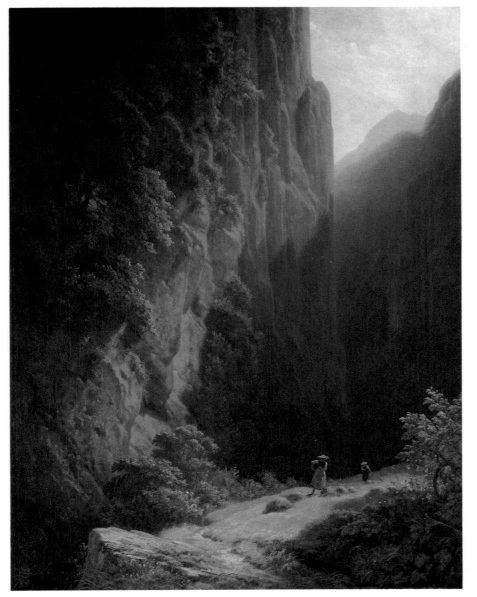

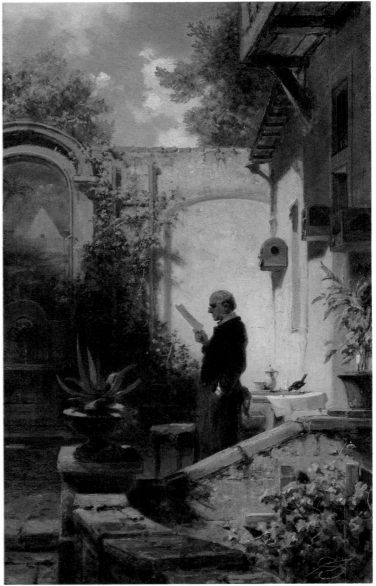

Carl Spitzweg *Women Mowing in the Mountains* Catalogue number 156

Carl Spitzweg *The Morning Reading* Catalogue number 157

37

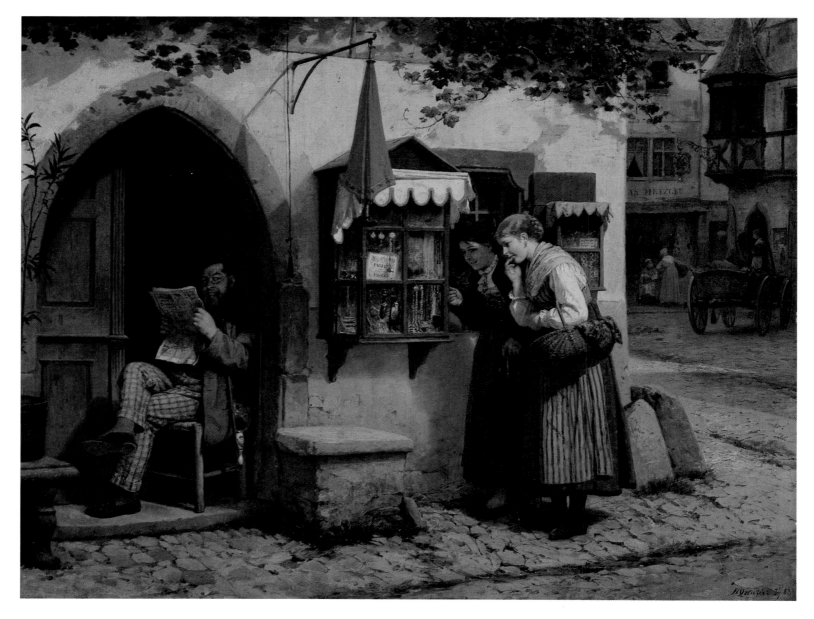

Louis Benjamin Vautier the Elder *At the Shop Window* Catalogue number 170

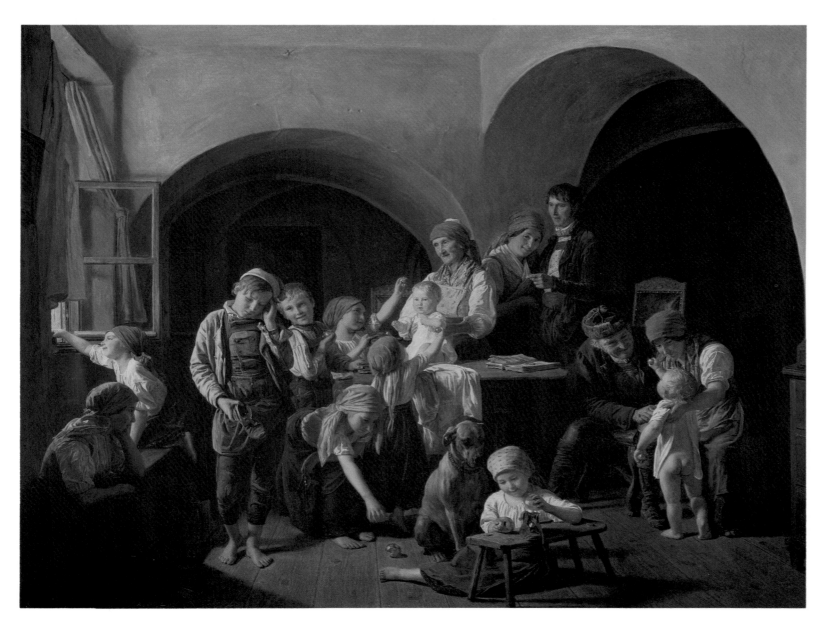

Ferdinand Georg Waldmüller *St. Nicholas Day* Catalogue number 177

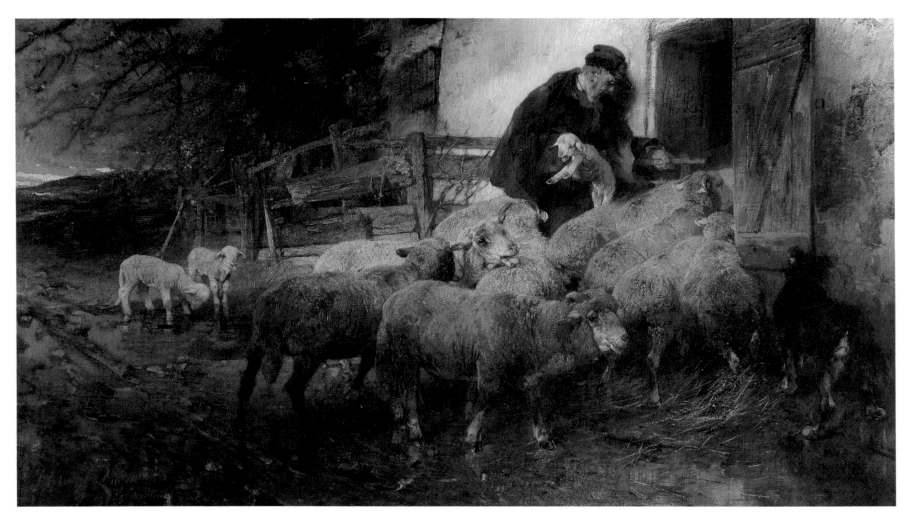

JOHANN HEINRICH VON ZÜGEL *The Shepherd's Return* Catalogue number 186

Catalogue Raisonné:
The Artists
and Their Works

Notes on the Use
of the Catalogue

THE ARTISTS

The artists' names are arranged alphabetically.

The designation "represented at" refers only to major museums at selected locations.

Bibliographical entries are selective and are arranged chronologically according to date of publication.

THE PAINTINGS

The paintings are arranged numerically and consecutively. To the extent determinable, several paintings by one artist are listed chronologically.

The sizes of paintings are shown in inches, height by width, followed by centimeters in parentheses.

Unless noted as gifts by other donors, the paintings belong to the René von Schleinitz Collection.

"MAC cat. no." refers to the Milwaukee Art Center registration catalogue.

References are ordered chronologically.

Numbers in boldface (1) refer to illustrations in this catalogue.

Abbreviations

b.:	born
d.:	died
L.R.:	Lower Right
L.L.:	Lower Left
L.C.:	Lower Center
U.R.:	Upper Right
U.L.:	Upper Left

ACHENBACH, ANDREAS

b. September 29, 1815, Kassel, Hessen
d. April 1, 1910, Düsseldorf
represented at nearly all important museums in
 Germany

Andreas Achenbach, together with Carl Friedrich Lessing (see entry in Catalogue) and Johann Wilhelm Schirmer, form the illustrious triad of Düsseldorf landscape painters in the nineteenth century. As with the other two, he also belongs among the great landscape artists of all time. The son of a merchant, Achenbach began studying drawing at the Düsseldorf Academy at the age of twelve. Schadow's and Schirmer's instructions proving fruitless for him, the young Achenbach resolved to try his luck as an independent painter, a decision that was to be followed by almost instant success. Of his academic instructors he gained most from Carl Friedrich Lessing, but, above all, he felt a strong kinship with the seventeenth-century Dutch Masters.

After first relocating in Munich (1835), Achenbach moved to Frankfurt am Main in the company of his close friend Alfred Rethel. Constantly rising in fame, Achenbach set out on a number of study trips that took him, in the 1830s and forties, through Holland, Denmark, Norway (1835 and 1839), Sweden, Southern Germany, Austria, and Italy, where he spent two years. In 1846 Achenbach settled in Düsseldorf to a prolific and highly influential career as painter, although he instructed only a very few students himself. One of them was the German-American landscapist Albert Bierstadt. His most famous pupil was his younger brother, Oswald

Achenbach (1827–1905), whose reputation today stands close to that of Achenbach himself.

Achenbach's huge oeuvre includes a substantial body of drawings, etchings, and lithographs. It is characterized by a great variety of subjects and a constant development of technical means that range from his early miniaturist precision to an ever broader, more daring, and richly impastoed delivery. Most significantly, Achenbach pioneered in an important development in the middle decades of the nineteenth century, namely the rejection of Romanticism in favor of realistic treatment of subject matter. He was a consummate master of every aspect of realistic landscape painting and his interests in nature ranged from the windswept coasts of Norway to the balmy reaches of the Southern Campagna and Sicily. Among his special gifts was his unrivaled ability to portray with compelling truth human life and toil in nature. But, above all, his genius was at its most gripping when he painted the storm-tossed seas of Northern Europe.

All German landscape and marine painters in the nineteenth century and beyond came, to a greater or lesser extent, under his powerful influence. Henry Ottley recapitulates:

> To sum up: the tendency of Achenbach's genius is realistic in the highest and best sense of the word. He explores nature in her most secret traits, in order to seize upon what is charac-

teristic in essence, form and color. In his manipulation, as regards the quality and texture of various materials, he is eminently successful, discriminating all to the exact point of requirement, yet without the slightest tendency to elaborate the trifling; the general effect prevailing over all minuteness and elegance of detail, being that of a bold and free handling. (Quoted from C. E. Clement and L. Hutton, *Artists of the Nineteenth Century and Their Works*, Boston, 1884 [facsimile ed., St. Louis, 1969], Vol. I, p. 3.)

BIBLIOGRAPHY
H. Deiters, ANDREAS ACHENBACH, Düsseldorf, 1885. L. Pietsch, CONTEMPORARY GERMAN ART: AT THE CENTENARY FESTIVAL OF THE ROYAL ACADEMY OF ARTS, Berlin, Vol. II, London, 1888, pp. 74 ff. F. Schaarschmidt, ZUR GESCHICHTE DER DÜSSELDORFER KUNST, Düsseldorf, 1902, pp. 207 ff. DIE DEUTSCHE JAHRHUNDERTAUSSTELLUNG BERLIN 1906, Munich, 1906, pp. 2 ff. C. Gurlitt, DIE DEUTSCHE KUNST SEIT 1800, Berlin, 1924, pp. 276 ff. R. Hamann, DIE DEUTSCHE MALEREI VOM 18. BIS ZUM BEGINN DES 20. JAHRHUNDERTS, Leipzig and Berlin, 1925, p. 197. O. Fischer, GESCHICHTE DER DEUTSCHEN MALEREI, Munich, 1956, p. 412. W. Hutt, DIE DÜSSELDORFER MALERSCHULE, 1819–1869, Leipzig, 1964, F. Novotny, PAINTING AND SCULPTURE IN EUROPE, 1780–1880, Baltimore, 1970, pp. 134, 168. J. D. Farmer, GERMAN MASTER DRAWINGS OF THE NINETEENTH CENTURY, Cambridge, Mass., 1972.

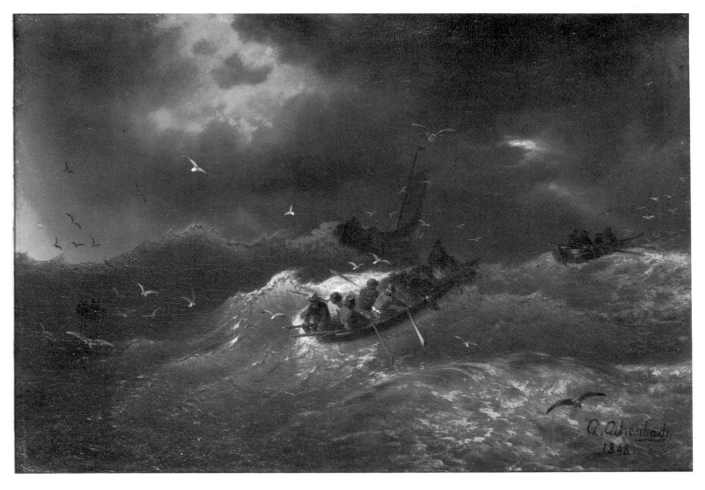

1
Fishing Boats in a Heavy Sea
1848

signed and dated L.R.: A. Achenbach / 1848
oil on canvas, 10¼ × 14¼ (26 × 36.2)
MAC cat. no. M 1962.101

Although done in Achenbach's early miniaturist style, this painting conveys with great intensity the terror of the high seas and the struggle of the men who depend on them for their livelihood. Free of trifling matter and mincing description, the painting is redolent with the highly romantic symbolism of the "storm-tossed boat," which suggests nature's sublime impartiality and the vicissitudes of life itself. While the diagonally placed boats evoke a sense of turbulent imbalance and surging movement, the white-capped, blue-green swells of the ocean combine with the purplish gray of the sky to create an awesome menace threatening to engulf the fishermen. Achenbach's formative and impassioned Romanticism here contrasts with the mature and calm Realism of the next exhibit.

REFERENCE
Probably belongs to corpus nos. 75, 76, 77, F. von Boetticher, MALERWERKE DES NEUNZEHNTEN JAHRHUNDERTS, Vol. I, Dresden, 1891, p. 4. S. Wichmann, PAINTINGS FROM THE VON SCHLEINITZ COLLECTION (Catalogue), Milwaukee Art Center, 1968, No. 1.

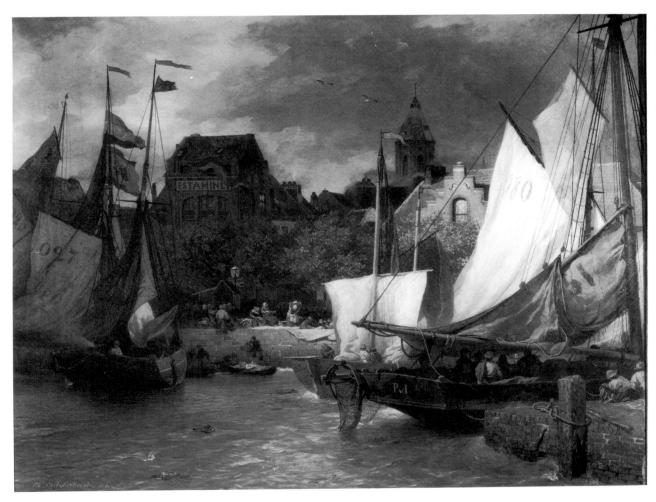

2
Fish Market at Ostend
1886

> signed and dated L.L.: A. Achenbach 86
> oil on canvas, 31¾ × 39⅝ (80.6 × 100.6)
> donor: Miss Elizabeth A. Plankington (gift of
> 1896–1907)
> MAC cat. no. Layton 154

While many times larger than *Fishing Boats in a Heavy Sea* (**1**), *Fish Market at Ostend* seems to lack the former painting's heartfelt vigor or Romantic abandon to an idea. A coolly realistic portrayal of a harbor scene in Belgium, it has a more grainy surface, a more static balance, greater spatial depth, and a stress on formal rather than sentimental values. The more complex palette, ranging from the white of the large sail, various sienas, ochres, and umbers to the gray blues of the sea, the pale blue flecks in the sky, and orange-red pennants, ultimately fails to achieve a unified chord. While the calm objectivity of the mature artist produced here a flawless and even bold recreation of a marine motif, it also failed to imbue this canvas with the kind of psychological excitement communicated by the previous work.

PROVENANCE
Layton Art Collection; gift of Miss Elizabeth A. Plankington between 1896–1907

ADAM, JULIUS, THE YOUNGER

b. May 18, 1852, Munich
d. September 23, 1913, Munich
represented mostly in private collections

Julius Adam was the youngest member of a large family of artists who, in the first half of the nineteenth century, had produced eight excellent specialists in battle, animal, genre, and landscape painting. By far the most illustrious representative of that prolific clan was its founder, Julius's grandfather Albrecht. After training in the lithography and photography shop of his father, Julius (the Elder), Adam spent six years doing photography work in Rio de Janeiro, Brazil. After his return to Munich (1872), he eventually entered upon a six-year study period in the renowned studio of Wilhelm Diez (see entry in Catalogue). During this time he did mostly figural, historical, and literature-inspired canvases that excel in expressive drama and superb milieu description and that earned him repeated awards. However, after leaving the academy (1882), he specialized in animal painting, specifically of house cats.

For Adam, who lived in a century that teemed with specialists and that witnessed an unprecedented passion for specialization in all picture categories, it was no mean accomplishment to have won acclaim as the greatest painter of *Felis domestica* to have come out of Germany.

BIBLIOGRAPHY
Kunstchronik, Old Series (1886–89), Vol. XXIV, p. 75. F. von Boetticher, MALERWERKE DES NEUNZEHNTEN JAHRHUNDERTS, Vol. I, Dresden, 1891, p. 18. KUNST FÜR ALLE, 1903, p. 338. H. Uhde-Bernays, DIE MÜNCHNER MALEREI IM NEUNZEHNTEN JAHRHUNDERT, Vol. II, Munich, 1927, p. 114.

3
Kittens at Play
signed L.R.: Jul. Adam
verso: L.R.: Meinem Lieben Freunde / Ad. Eberle / v. Jul. Adam
oil on canvas, 13⅝ × 11¹/₁₆ (34.6 × 28.1)
MAC cat. no. M 1972.123

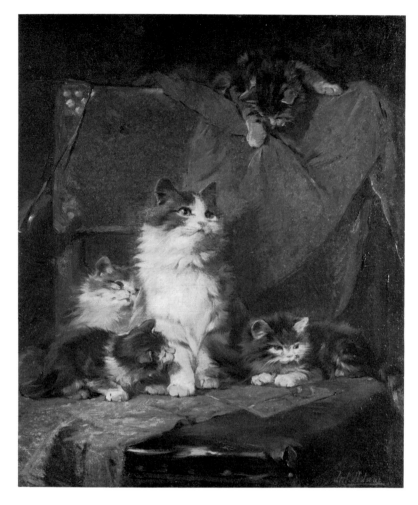

A black-and-white mother cat with identically colored kittens is placed against a warm-toned, raw umber drapery and burnt umber background. Very painterly execution; the fluffy texture of silky fur is superbly rendered. A gratifyingly unself-conscious, fresh, and direct painting of a subject that can all too easily lapse into maudlin anthropomorphism when handled by one endowed with less talent than Adam.

PROVENANCE
Galerie Schöninger, Munich.

REFERENCE
S. Wichmann, PAINTINGS FROM THE VON SCHLEINITZ COLLECTION (Catalogue), Milwaukee Art Center, 1968, No. 2, illus. 10.

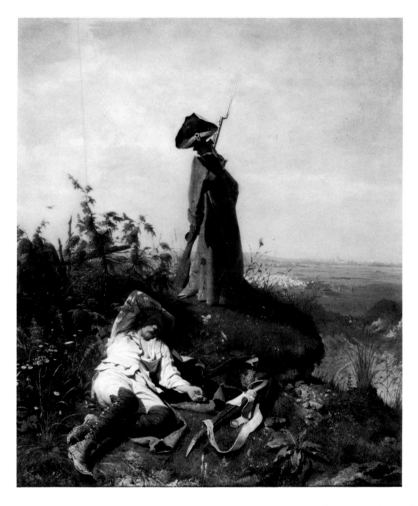

b. May 24, 1834, Munich
d. December 12, 1911, Munich
represented at Breslau and in private collections

After early studies under Joseph Anton Rhomberg and the history painter Hermann Anschütz at the Munich Academy, Baumgartner's talents for a coloristic and painterly style were first brought to the fore by Karl von Piloty's instruction. Baumgartner's penchant for the humoresque and his jovial treatment of light subjects (e.g., folk tales, legends, the exploits of clerical mashers and itinerant mendicant friars, Bavarian folk customs, etc.) brought sensationally high prices for his works and they made him a worthy forerunner of Eduard Grützner (see entry in Catalogue). As with Julius Adam (see entry in Catalogue), so also with Baumgartner: most of his later productions—works that, despite their occasional strength of characterization and technical panache, show signs of a progressive creative lassitude—found their way into private collections in the United States.

BIBLIOGRAPHY
KUNSTCHRONIK, Old Series (1886–89), Vol. XXIV, p. 249. F. Pecht, GESCHICHTE DER MÜNCHNER KUNST DES 19. JAHRHUNDERTS, Munich, 1888, p. 251. F. von Boetticher, MALERWERKE DES NEUNZEHNTEN JAHRHUNDERTS, Vol. I, Dresden, 1891, p. 52.

4
The Trusty Sentinel (Der wachsame Vorposten)
1861
 signed and dated L.R.: München 1861 / Pet.
 Baumgartner
 oil on canvas, 35⅝ × 28³/₁₆ (90.6 × 71.7)
 MAC cat. no. M 1971.77

This superb early canvas by Baumgartner is distinguished by a stable triangular disposition of the foreground motif, a deep aerial perspective, and an atmosphere drenched in the brilliantly sharp sunlight of a midday in summer. Incisive modeling, delicate details—especially of the various, lovingly rendered grasses and flowers—a simple but very effective "story"—the scarecrow substitutes for the real sentinel—and a terse characterization of the sleeping guard further distinguish this work. The dominant earth greens and sky blues are highlighted by the soldier's white uniform and brilliant red coat lining.

REFERENCE
U. Thieme and F. Becker, ALLGEMEINES LEXIKON DER BILDENDEN KÜNSTLER VON DER ANTIKE BIS ZUR GEGENWART (hereafter cited as Thieme-Becker, KÜNSTLERLEXIKON), Leipzig, 1907–50, Vol. III, cites "Der wachsame Vorposten" (1861), p. 85.

BECKER, CARL (LUDWIG FRIEDRICH)

b. December 12, 1820, Berlin
d. December 20, 1900, Berlin
represented at Berlin, Cologne, Munich, Vienna;
private collections

Carl Becker gave a significant impulse to Berlin art by offering it a painterly Neo-Baroque style as a stimulating alternative to the Nazarene-inspired Neo-Renaissance manner of that school, on the one hand, and its often mincing veduta style, on the other. After studies at the Berlin Academy, he continued his training in fresco technique in Munich under Heinrich Maria Hess. After brief sojourns in Paris, Rome (where he became cofounder of the *Kunstverein*), and Venice (where he felt drawn to the art of Titian), he settled in Berlin to execute historical and mythological easel paintings with life-sized figures as well as monumental frescoes at the New Berlin Museum under the guidance of Peter von Cornelius.

Around 1855 Becker struck out in a new direction, namely a richly coloristic, Venetian-influenced illusionism. He executed this with great technical virtuosity and applied it to historical genre. His subjects revolve around Shakespearean, Goethean, German Renaissance, Rococo, and especially Venetian Cinquecento themes. He exploited these for their maximum effectiveness in terms of elegance of dress, ornateness of appointments, and depth of glowing color.

Becker's best paintings combine incisive characterizations with brilliant surface textures. He was one of the most accomplished, if frequently superficial, painters of decorative costume pieces in the nineteenth century. From 1882 onwards he served in the capacity of President of the Academy of the Arts in Berlin. Contemporary opinions about him varied sharply. Here are two examples:

> Carl Becker, who for a time successfully followed the lead of the Venetians, has strayed far away from them. Instead of gaining in clearness and depth, he has lost himself in a superficial, decorative mannerism that is not very far removed from carpet decoration. *Zeitschrift für bildende Kunst*, 1876.

Among the German genre painters of the day, Carl Becker takes a distinguished and distinct position. He excites popular approbation most unexpectedly, and by his last works silences the voices of the critics and disarms his opponents. Ludwig Pietsch, *Illustrierte Zeitung*, 1861.

(Both quotations from C. F. Clement and L. Hutton, *Artists of the Nineteenth Century and Their Works*, Boston, 1884 [facsimile ed., St. Louis, 1969], p. 46.

BIBLIOGRAPHY
F. von Boetticher, MALERWERKE DES NEUNZEHNTEN JAHRHUNDERTS, Vol. I, Dresden, 1891, pp. 60–62. C. Gurlitt, DIE DEUTSCHE KUNST DES 19. JAHRHUNDERTS, Berlin, 1907, p. 329. R. Hamann, DIE DEUTSCHE MALEREI VOM 18. BIS ZUM BEGINN DES 20. JAHRHUNDERTS, Leipzig and Berlin, 1925, pp. 283, 293, 345.

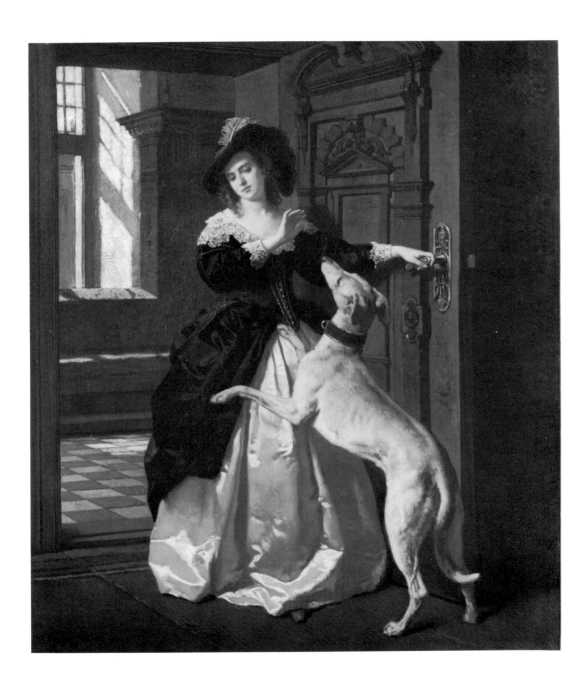

5
Lady with Greyhound
1858
> signed and dated L.L.: C. Becker 1858
> oil on canvas, 29¾ × 25½ (75.7 × 64.9)
> MAC cat. no. M 1971.76

The style of *Lady with Greyhound* is more deeply indebted to Dutch Baroque sources of influence than to Becker's later inspiration, Seicento Venetian illusionism. Specifically, the figure here is a descendant of Gerard Terborch's fastidious ladies, and the interior is a successor to Pieter de Hooch's choice apartments.

The young lady's black silk dress, silvery white taffeta skirt, her blushing morbidezza, and the velvety, sand colored hound's coat combine with the glowing raw sienas of the background into a refined harmony and strikingly decorative ensemble of colors. The vividly rendered textures never interfere here with the amply swaying figural movement, nor does the exquisite detailing, especially of the lady's face, clash with the generously simple setting. The depth of the interior space and an incisive handling of natural light further contribute to the unity of this brilliant early work by Becker.

REFERENCE
MIRRORS OF 19TH CENTURY TASTE: ACADEMIC PAINTING;
Exhibition Handlist, 1974, No. 3.

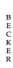

BEST, HANS

b. August 25, 1874, Mannheim
d. March 4, 1942, Munich
represented at Leipzig and in private collections

Hans Best was a pupil of Karl Raupp at the Munich Academy and the School of Wilhelm von Diez (see entry in Catalogue). The recipient of numerous high awards for artistic excellence, including the Gold Medal at the prestigious *Glaspalast Ausstellung* (Munich, 1913), Best undertook study trips to Italy, Paris, and Belgium. As a sculptor, he did mostly animal pieces. His varied painted oeuvre includes peasant genre, peasant "character types," portraits, nudes, landscapes, and animal paintings that often excel in well-observed rapid movement of figures and skillfully presented anecdotage.

Even more than Diez, Best leaned toward Impressionism. I fully agree with Siegfried Wichmann when he asserts, in speaking of Best, that the Impressionist technique is "not altogether suitable to the detailed requirements of miniature painting." (See Siegfried Wichmann, *Paintings from the von Schleinitz Collection*, Milwaukee Art Center, 1968.) Best was a minor figure in art but among the last painters who genuinely belonged to the "traditional" School of Munich.

BIBLIOGRAPHY
Thieme-Becker, Künstlerlexikon, Leipzig, 1907–50, Vol. III, p. 198. G. J. Wolf, Hans Best, Munich, 1928. Kunstrundschau, No. 50, 1942, p. 34.

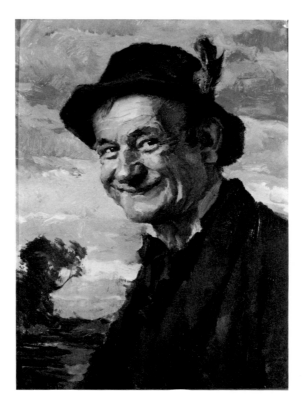

6
Character Head
signed L.L.: Hans Best
oil on wood panel, 12¾ × 9½ (32.4 × 24.1)
MAC cat. no. M 1962.95

See description under entry **8**.

REFERENCE
S. Wichmann, Paintings from the von Schleinitz Collection (Catalogue), Milwaukee Art Center, 1968, No. 3.

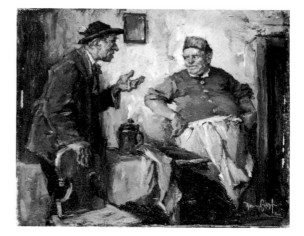

7
The Innkeeper (Der Gastwirt)
signed L.R.: Hans Best
oil on wood panel, 4¹/₁₆ × 4¹⁵/₁₆ (10.3 × 12.5)
MAC cat. no. M 1972.110

See description under entry **8**.

PROVENANCE
Scratched on reverse of panel: "Andenken von meinem lieben Freunde, Dickerle Karl Eyner, Weihnachten 40."

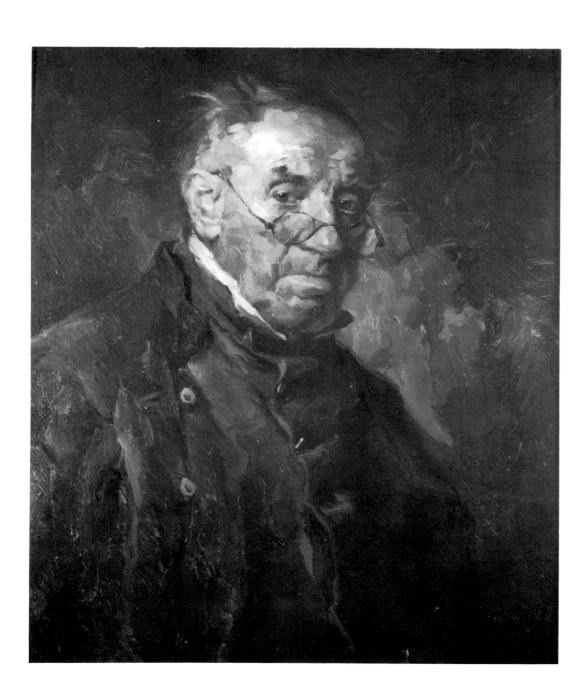

8
The Village Schoolteacher (Der Dorfschulmeister)
signed L.R.: Hans Best
oil on heavy artist's cardboard, 23⅝ × 19⅝ (60 × 49.9)
MAC cat. no. M 1970.116

Broken brushwork, heavy impasto, "wet on wet" palette knifing of pigments and an uneventful coloration, one that vitiates hues through the admixture of lamp black, characterize the rushed *alla prima* style of these three exhibits by Best. Only *The Village Schoolteacher* (**8**) goes beyond mere surface bravura to model, circumspectly and in depth, form with color. It appears that a large picture format (as in **8**) was required so that the artist's broadly gestural brush stroke could develop to its full expressive potential.

BÖHM, PÁL (PAUL)

b. December 28, 1839, Nagyvárad (Grosswardein),
 Hungary
d. March 29, 1905, Munich
represented at Budapest, Cologne, Manchester;
 private collections in England, Germany, the
 United States

In his early years Paul Böhm sustained himself by
painting advertising signs and theater decorations.
Thereafter, he taught himself how to paint by
studying the Old Masters at museums in Budapest
and at the Belvedere in Vienna. He soon returned to
Hungary and set out on extensive study trips
through Siebenbürgen and the Banat where he be-
came fascinated by the color and visual excitement
of the country folk, fishermen, and itinerant gyp-
sies. Afterwards, he earned a living doing portraits
and altarpieces in Arad, Romania. These works are
regarded as being of an exceptionally fine quality. In
1871 he obtained a scholarship from the Hungarian
government to study art at Munich. He remained in
that city until his death.

In his style Böhm was influenced, above all, by his
friend, the Munich-trained Hungarian landscapist
and professor at the Budapest Academy, Géza von
Mészöly. Böhm's subjects, even during the
thirty-five years he spent in Munich, derive almost
exclusively from those Balkan ethnic and rural
backwaters of Southeastern Europe, people and
places he knew so well. It was, above all, this pic-
turesque "foreign" subject matter, lending his
lively, realistic style a pronounced "romantic"
flavor, that gained him many appreciative private
collectors and that represents his unique contribu-
tion to traditional genre painting, on the one hand,
and, on the other, to the School of Munich, of which
he must be counted a member.

BIBLIOGRAPHY
V. Olgyai, "Böhm Pál," in Müvészet, 1905, pp. 182–86. F.
von Boetticher, Malerwerke des Neunzehnten Jahr-
hunderts, Vol. I, Dresden, 1891, pp. 113, 114.

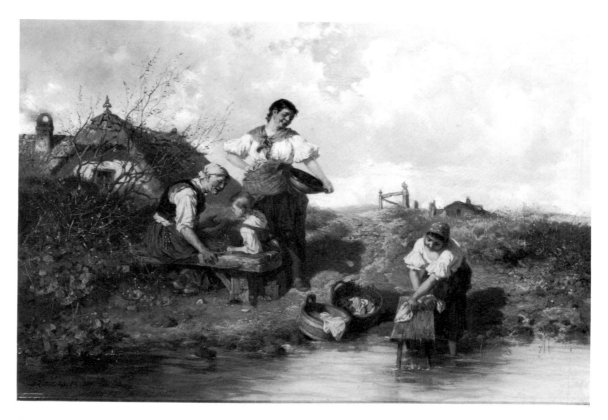

9
Washday
c. 1892
 signed L.L.: Frst. Böhm Pál, München
 oil on wood panel, 9½ × 13¾ (24.1 × 34.9)
 MAC cat. no. M 1962.55

A lively and fresh panel whose enamel finish and
"old master" touch is reminiscent of Diez, Bürkel, or
Waldmüller (see entries in Catalogue). Sparkling
colors (especially of the central woman's brightly
white blouse, blue kerchief, and brilliant red outer
skirt), the uniformly distributed, warm sunlight,
and a joyful, breezy, out-of-doors quality, all belie
the fact that the work was completed in the studio.

REFERENCE
S. Wichmann, Paintings from the von Schleinitz Col-
lection (Catalogue), Milwaukee Art Center, 1968, No. 4.
Mirrors of 19th Century Taste: Academic Painting;
Exhibition Handlist, Milwaukee Art Center, 1974, No. 7.

BOKELMANN, CHRISTIAN LUDWIG (LOUIS)

b. April 2, 1844, St. Jürgen, near Bremen
d. May 14, 1894, Charlottenburg
represented at Berlin, Dresden, Krefeld

"One of the strongest and most original of the pupils of Wilhelm Sohn (a celebrated genre painter and influential teacher at the Düsseldorf Academy) and, in general, one of the most outstanding German genre painters was Christian Ludwig Bokelmann" (Schaarschmidt, p. 277). In addition to painting genre, Bokelmann was an eminent portraitist who often masterfully combined fine characterizations with harmoniously balanced moods and colors. Bokelmann began with small, humorous but largely literary or anecdotal genre pictures. But he soon gave up painting in the sweet tones of the Old Masters by changing over to a blackish brown-toned studio phase, largely inspired by Munkácsy (see entry in Catalogue), which, by the mid-eighties, gave way to his late style of daring and energetic open-air illumination based on nature studies in Friesland.

In terms of subject matter, Bokelmann was one of the true Moderns, rejecting Italian, literary, or pleasant fantasy themes for concrete motifs based on often unsettling occurrences in the real life of his fellow countrymen. His art often accurately reflects the social effects of the major forces that shaped the 1870s in Germany, the decade which began with the so-called *Gründerjahre*: prosperity, entrepreneurship, the financial collapse of 1873, accelerated industrialization, increase in emigration until 1885, and the unrest of the proletariat. Bokelmann's mature paintings are characterized, above all, by two outstanding qualities: the painterly conception of his compositions and his brilliant characterization.

Because the "aesthetic atmosphere" in Düsseldorf was not favorable toward Bokelmann's often uncomfortably serious, not to say disquieting, "social realist" themes, and because the critics of that city felt disgust for his gruff handling of the brush, which is especially evident in his portraits, Bokelmann at first had a very hard time making his way as an artist. Nevertheless, after a period of bitterness and isolation in Düsseldorf, there followed an appointment to the Karlsruhe Academy. Upon receiving the Great Gold Medal from the Berlin Academy (1879)—the capital city was more receptive to newer forms of realism—he obtained a professorship at the Berlin Akademische Hochschule in 1893. Ironically and tragically, one year later, just as his fame was beginning to spread, he fell to his death from a ladder that he had mounted in order to hang up a laurel wreath bestowed upon him by his grateful students.

BIBLIOGRAPHY
L. Pietsch, CONTEMPORARY GERMAN ART: AT THE CENTENARY FESTIVAL OF THE ROYAL ACADEMY OF ARTS, BERLIN, Vol. II, London, 1888, p. 12. F. von Boetticher, MALERWERKE DES NEUNZEHNTEN JAHRHUNDERTS, Vol. I, Dresden, 1891, p. 115, and "Nachtrag," p. 967. F. Schaarschmidt, ZUR GESCHICHTE DER DÜSSELDORFER KUNST, Düsseldorf, 1902, p. 277. C. Gurlitt, DIE DEUTSCHE KUNST SEIT 1800, Berlin, 1924, pp. 261, 336. ALBUM DER DRESDNER GALERIE: GEMÄLDE DES XIX. JAHRHUNDERTS UND DER GEGENWART, Leipzig, n.d., p. 9.

10

The Broken Bank (Zusammenbruch einer Volksbank)
1877

signed and dated L.R.: Bokelmann f. 1877
oil on canvas, 38⅝ × 52 (98.1 × 132.1)
donor: Frederick Layton (gift of 1888)
MAC cat. no. L 1888.24

A major early canvas by Bokelmann dealing with a significant and disturbing subject in the spirit of "social realism." The late 1860s and earliest years of the 1870s witnessed in Germany a business boom accompanied by corrupt financial practices. The worldwide economic crisis of 1873 brought to a close the *Gründerjahre* in Germany, a period that saw the founding of many new industries and financial institutions as well as an unprecedented amount of speculation. Consequently, numerous banks throughout Germany collapsed. The scene shown in this painting—a run on a bank—therefore depicts an occurence that was only all too frequent in the period of the *Gründungsschwindel*.

The composition is very strong, although the color scheme is restrained and consists largely of blacks, grays, and off-whites. Conversely, the paisley patterns of the three women's shawls in tones of red, rose, and blue do provide a startlingly abstract contrast to that essay in monochromaticism. While the throng of figures describes a forceful movement across the canvas and into depth, nevertheless, owing to the parallel recession of the main group, a classic balance is maintained. Although many dozens of attitudes and characters are portrayed, the composition is totally unified. This is due to the fact that Bokelmann strikes a harmonious balance between the particular and the typical or general. Moreover, the two men (at right front) also stabilize the composition while the overturned ash basket, in addition to providing a powerful *repoussoir* anchor, forcefully but unobtrusively symbolizes material ambition foredoomed. A painterly canvas of compelling expressive strength, magisterially simple staging, and solid formal and coloristic beauty.

PROVENANCE
S. A. Avery, New York. Collection George Whitney, Philadelphia. (Apparently purchased by Layton from Whitney Estate sale, Chickering Hall, New York, N.Y., Dec. 16–18, 1885; no. 225 in cat.)

REFERENCE
Universal Exhibition, Paris, 1878, F. von Boetticher, MALERWERKE DES NEUNZEHNTEN JAHRHUNDERTS, Vol. I, Dresden, 1891, p. 115, No. 8: "VOLKSBANK KURZ VOR AUSBRUCH DES FALLIMENTS. E: S. A. Avery, New York. Abb. 'Illustr. Z.' 79 and 'Meisterw.', 1. Bd. – Berl. ak. KA. 77: Par. WA. 78." Note: different title in Boetticher has same meaning. F. Schaarschmidt, ZUR GESCHICHTE DER DÜSSELDORFER KUNST, Düsseldorf, 1902, p. 277: "DER ZUSAMMENBRUCH EINER VOLKSBANK illustriert einen Vorgang, wie er nach der Zeit des Gründungsschwindels nur zu häufig war." Thieme-Becker, KÜNSTLERLEXIKON, Leipzig, 1907–50, Vol. IV, p. 237; note: ZUSAMMENBRUCH EINER VOLKSBANK subsumed here under heading of "ältere Arbeiten." MIRRORS OF 19TH CENTURY TASTE: ACADEMIC PAINTING; Exhibition Handlist, Milwaukee Art Center, 1974, No. 8.

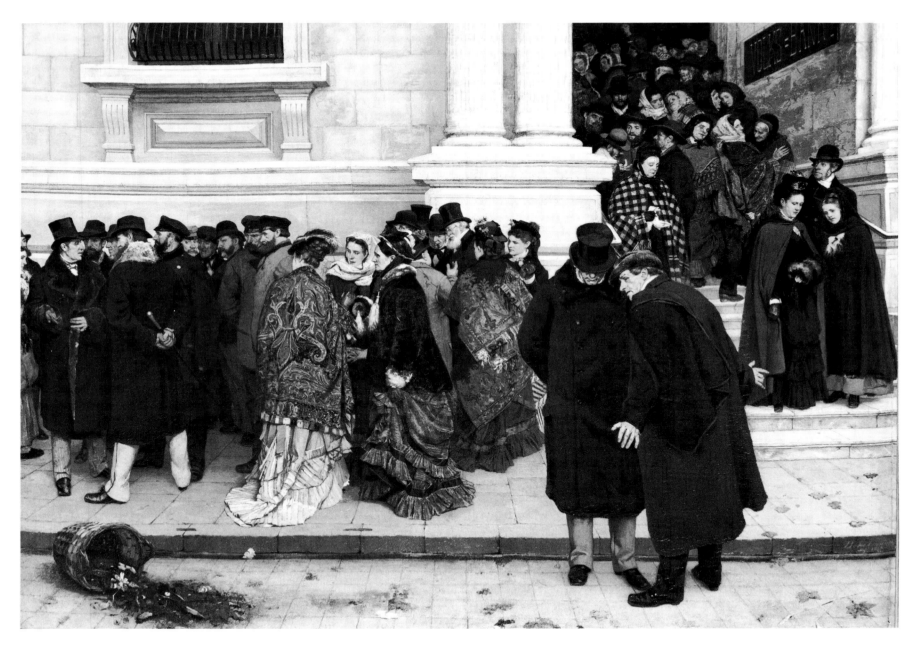

BOSCH, ERNST
b. March 23, 1834, Krefeld
d. March 22, 1917, Düsseldorf
represented at Bremen, Hanover

Ernst Bosch was a portraitist and painter of genre subjects in Düsseldorf. He received his training from Carl Sohn, Theodor Hildebrandt, and Wilhelm von Schadow at the Düsseldorf Academy. He exhibited frequently in the *Kunstverein* shows at Bremen, Cologne, Dresden, and the Berlin Academy. He did genre pictures that often feature landscapes, the world of animals, the hunt, and humorous and soulful subjects suggestive of *Biedermeier Gemütlichkeit*.

Bosch was especially partial to subjects taken from German fairy tales and legends (e.g., *Rotkäppchen, Aschenbrödel, Genovefa*) in paintings that reverberate with strains of the late Romanticism of a Ludwig Richter or Moritz von Schwind. They are charming, idyllic, idealizing, suggestive, and mysterious. Bosch was also very active as illustrator (e.g., Goethe's *Werthers Leiden*), engraver, and lithographer. In his later years Bosch devoted himself almost exclusively to portraiture, notably the female portrait.

BIBLIOGRAPHY
F. von Boetticher, MALERWERKE DES NEUNZEHNTEN JAHRHUNDERTS, Vol. I, Dresden, 1891, p. 120. L. Pietsch, CONTEMPORARY GERMAN ART: AT THE CENTENARY FESTIVAL OF THE ROYAL ACADEMY OF ARTS, BERLIN, Vol. II, London, 1888, pp. 64–66. F. Schaarschmidt, ZUR GESCHICHTE DER DÜSSELDORFER KUNST, Düsseldorf, 1902, pp. 244, 265.

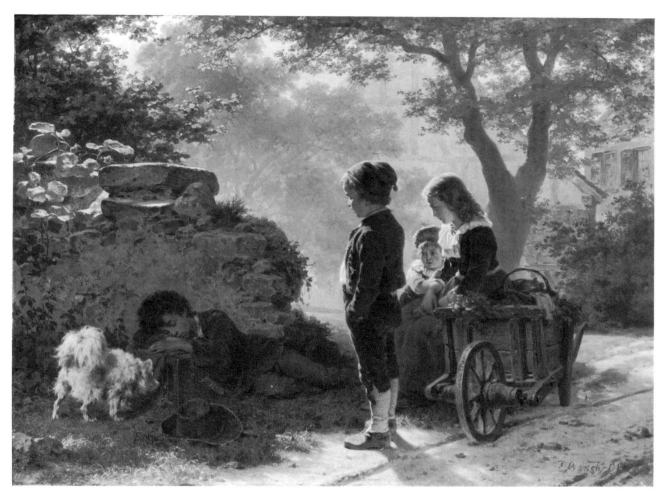

11
Far from Home (Fern der Heimat)
1865
 signed L.R.: E. Bosch
 oil on canvas, 19⅜ × 25¾ (49.2 × 65.4)
 MAC cat. no. M 1962.102

Of the inscription cited in Boetticher ("E. Bosch. Ddf., 65") only "E. Bosch, D" are decipherable now. It is conceivable but not probable that *Far from Home*

is a later (or earlier) variant of No. 5 in Boetticher. Technically, the painting is toned to an overall golden green while the figures are done in an extremely close enamel finish. A fairy tale mood pervades the scene, as three German peasant children discover a strange boy, a runaway (from Savoy; see Boetticher, Vol. I, p. 120) sleeping in their sylvan playground

REFERENCE
F. von Boetticher, Malerwerke des Neunzehnten Jahrhunderts, Vol. I, Dresden, 1891, p. 120. No. 5: "Fern der Heimat. Drei Bauernkinder betrachten einen an der Mauer schlafenden Savoyardenknaben. Bez. E. Bosch. Ddf. 65. Gest. von F. Dinger. roy. qu. fol. Kölner K.V.-Bl.1868."
Mirrors of 19th Century Taste: Academic Painting; Exhibition Handlist, Milwaukee Art Center, 1974, No. 10.

BRAITH, ANTON

b. September 2, 1836, Biberach, Württemberg
d. January 3, 1905, Biberach, Württemberg
represented at Berlin, Biberach, Cologne, Hamburg,
Munich, Stuttgart, Wiesbaden

Like Friedrich Voltz and Heinrich Zügel (see entries in Catalogue for each), Braith, a farm animal painter who was the son of a day laborer, began drawing as a child, appropriately enough, while helping out as a cow herder. In his early youth Braith studied under Johann Baptist Pflug at Biberach before entering the art school at Stuttgart. The most important influence, however, one that "liberated" his technique and sense of color, came when he relocated permanently in Munich in 1860 and enrolled in Karl von Piloty's class. He then specialized in motifs of house animals and landscapes. Braith traveled widely in the 1860s and visited London, North Germany, Switzerland, and Italy. On a trip to France in 1867 he became lastingly influenced by the Barbizonist Constant Troyon.

Braith's style evolved through several stages. His early phase reflected the influence of Pflug's dry and detailed miniaturist-like manner. His second period fell under the influence of Piloty's generous brushwork and coloristic illusionism. Troyon's example, lastly, led him to experiment with the effects of luminism, which resulted for him in his preferred melancholy atmospheric moods. In the late sixties, Braith found his own style, one that was only intermittently interrupted (in the mid-nineties) by renewed, albeit indecisive, experimentation with an impressionistically lightened palette. Although Braith exerted no influence on the course of modern art and technically did not advance as far as had Zügel, for example, he nevertheless ranks today among the important painters of the animal genre in the nineteenth century.

Braith and his friend, the equally significant animal painter Christian Friedrich Mali, owned a large house in Munich that served often enough as a place of refuge and temporary studio for fellow artists from the region of Württemberg. The two friends also founded an art gallery in Bozen, Southern Tyrol. The city museum of Biberach, which inherited both artists' estates, today possesses a large share of Braith's oeuvre, including his sketch books.

In attempting to categorize several quite similar painters (who are all in the Catalogue), Uhde-Bernays comments:

Anton Braith can be regarded as the full-fledged heir of Friedrich Voltz. Braith is more powerful and dynamic than Voltz and he painted his animal scenes with the softer atmospheric handling of the French without giving up his studio-like restraints. Compared to Voltz's unerring surety, Braith was freer but more vacillating in his output. Otto Gebler's pictures of dogs became more popular than his paintings. (p. 78)

BIBLIOGRAPHY

F. Pecht, Geschichte der Münchner Kunst des 19. Jahrhunderts, Munich, 1888, p. 266. L. Pietsch, Contemporary German Art: At the Centenary Festival of the Royal Academy of Arts, Berlin Vol. II, London, 1888, pp. 56–58. Adolf Fischer, "Braiths Leben," Strassburger Post, Vol. I, No. 12, 1905. Die Deutsche Jahrhundert ausstellung Berlin 1906, Munich, 1906, p. 56. R. Hamann, Die deutsche Malerei vom 18. bis zum Beginn des 20. Jahrhunderts, Leipzig and Berlin, 1925, p. 337. H. Uhde-Bernays, Die Münchener Malerei im Neunzehnten Jahrhunderts, Vol. II, Munich, 1927, p. 78.

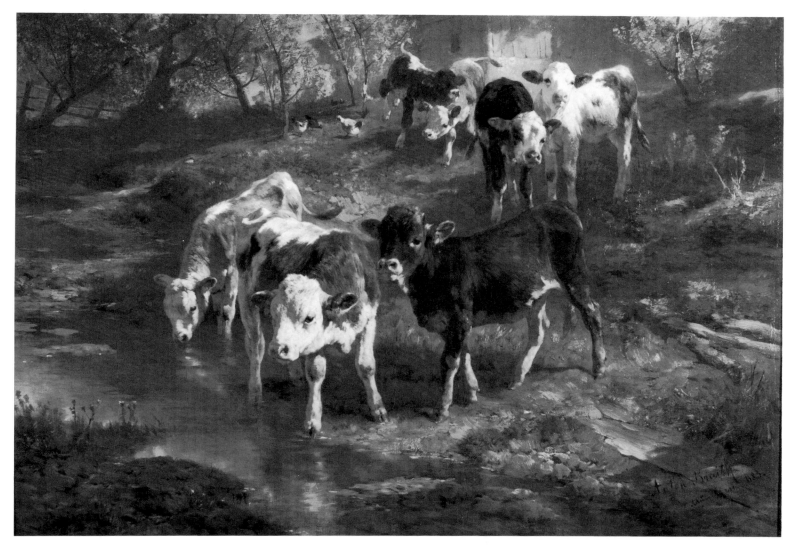

See description under entry **13**.

12
Heifers at Play
1883
 signed and dated L.R.: Anton Braith / München;
 1883.
 oil on canvas, 26¼ × 35¹¹/₁₆ (66.7 × 90.7)
 MAC cat. no. M 1972.120

REFERENCE
S. Wichmann, PAINTINGS FROM THE VON SCHLEINITZ COL-
LECTION (Catalogue), Milwaukee Art Center, 1968, No. 5,
illus. 7. MIRRORS OF 19TH CENTURY TASTE: ACADEMIC
PAINTING; Exhibition Handlist, Milwaukee Art Center,
1974, No. 14

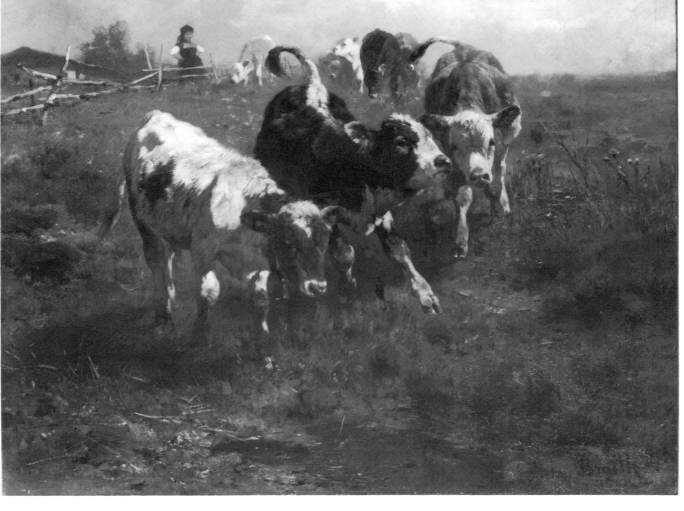

13
Frolicking Heifers
1885 (probable)
 signed and dated L.R.: Anton Braith München
 1885 (?)
 oil on canvas, 16⅜ × 20⅜ (41.6 × 51.8)
 MAC cat. no. M 1962.32

Heifers at Play and *Frolicking Heifers* (**12** and **13**) are very similar in style and feature these identical qualities: high station point of the observer, high horizon line, solid light-dark modeling, authentic outdoor lighting, superb animal anatomy and movement, as well as the same siena and umber and black-and-white spotted heifers against grounds of terre verte. Both paintings belong to Braith's mature and accomplished period.

PROVENANCE
Wimmer & Co., Gallery of Fine Arts, Munich.

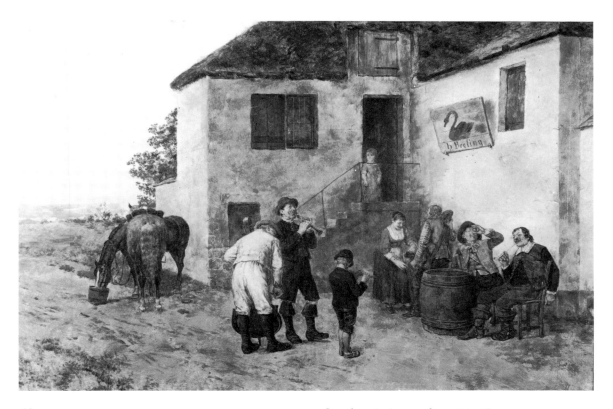

14
At the Inn
 signed U.R. (as part of sign on the wall of the inn):
 H. Breling
 oil on wood panel, 11¼ × 17⅞ (28.7 × 45.5)
 MAC cat. no. M 1972.19

See description under entry **15**.

BRELING, HEINRICH
 b. December 14, 1849, Burgdorf, Hanover
 d. June 3, 1918, Munich
 represented at Schloss Linderhof and in private
 collections

The genre painter and engraver Heinrich Breling was a pupil of Wilhelm Diez (see entry in Catalogue) and, much as his teacher, preferred to depict scenes from the life of the lansquenets and vagabonds of the period of the Thirty Years' War. His realistic style, also like Diez's, was minutely articulated and highly detailed. A famous painting of his, *The Defense of the Cemetery of Beaune-la-Rolande* (1896), depicting an incident from the Franco-Prussian War of 1870, is characterized by more drama and dynamic movement than is usually the case with his work.

The public knows Breling's work, though it may not always associate his name with it, from photographs and sightseeing tours of the Castle Linderhof (Upper Bavaria) of King Louis II of Bavaria. It was there that Breling decorated the stage of the famous Grotto of Venus in the garden of the Schloss with paintings that are quite different from his usual work. Done in a frothy Rococo manner and featuring Tannhäuser in the company of Venus, her handmaidens, and putti, Breling's scenic concept, an integral part of a real grotto, subterranean waterfall, and a lake that is complete with cockleshell gondola and multicolored electric lighting effects, was a worthy backdrop for Wagner's opera. It was performed in that fantastic setting for the private enjoyment of an eccentric king. (See W. Blunt, *The Dream King*, Harmondsworth, England, 1973, pp. 135, 146 ff.)

BIBLIOGRAPHY
F. Pecht, GESCHICHTE DER MÜNCHNER KUNST DES 19. JAHRHUNDERTS, Munich, 1888, p. 368. F. von Boetticher, MALERWERKE DES NEUNZEHNTEN JAHRHUNDERTS, Vol. I, Dresden, 1891, pp. 133, 134. KATALOG DER AUSSTELLUNG VON WERKEN DER DIEZ-SCHULE, Galerie Heinemann, Munich, 1907.

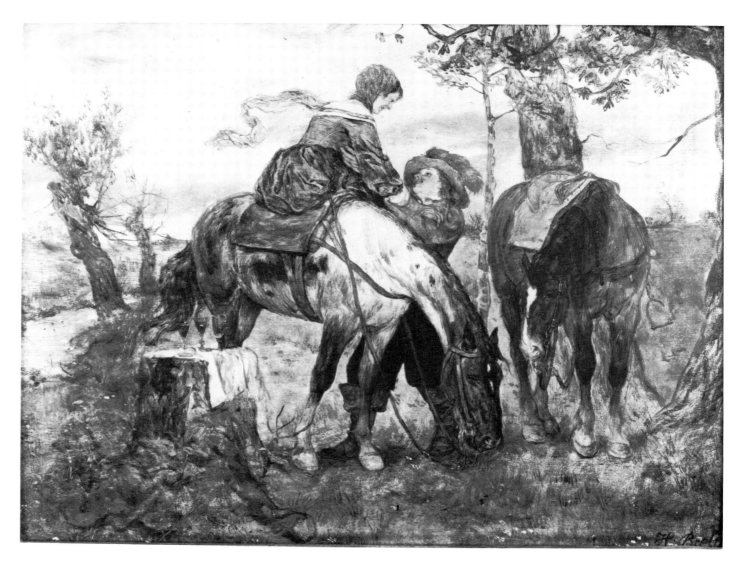

15
The Tryst (Das Stelldichein)
 signed L.R.: H. Breling
 oil on wood panel, 6 × 8 (15.2 × 20.3)
 MAC cat. no. M 1962.67

62 Although less sketchy than *At the Inn* (**14**), *The Tryst*

(**15**), too, convinces less as a painting than as a somewhat anemic colored drawing. Other characteristics of these two painted Romantic ballads include: thin, short brush strokes, very blond, lean, transparent colors on white gesso grounds, vigorous drawing, tepid overall effects.

REFERENCE
S. Wichmann, Paintings from the von Schleinitz Collection (Catalogue), Milwaukee Art Center, 68, No. 6.

BÜRKEL, HEINRICH

b. May 29 (?), 1802, Pirmasens, Rheinpfalz
d. June 6, 1869, Munich
represented at most museums in Germany and many throughout the world

The genre, animal, and landscape painter Heinrich Bürkel was destined by his father, a farmer and innkeeper, to become a businessman. It was only after great difficulty that the twenty-two-year-old Bürkel was allowed to follow his artistic inclinations, journey to Munich, and take up studies in art. With the possible exception of some instruction from Peter von Hess (see Catalogue), Bürkel was self-taught in art. He copied the Old Dutch Masters at Schloss Schleissheim, notably his beloved Wouvermann, Ruysdael, Brouwer, and Ostade. Through their searching and humorous eyes he experienced the country folk and rustic scenery of Upper Bavaria and the Tyrol.

Having soon established himself as a sought-after genre painter, Bürkel traveled to Italy (in 1827 and repeatedly thereafter), where he stayed in Rome and Naples. After his return, he settled in Munich and continued to paint, in small, lively, and charmingly engaging pictures, the well-known Bürkel subjects: stagecoaches, river ferries, haywagons, hostelries, village fairs, travelers, brigands, beggars, highwaymen, bear hunters, farmers, and itinerant friars. And always there are the animals: rearing horses, stampeding cattle, obstinate donkeys, yelping dogs. And again there are always landscapes from the Alpine region, the Campagna, or Sicily, landscapes of all seasons, containing smithies with charcoal kilns glowing softly against pastel cushions of snow, or watermills, or pouring rain in a remote mountain village, the misty twilight vapors rising over the horizon.

Bürkel was influenced by a great many different artists during his formative years, and they affected his earlier stylistic phases—Wouvermann, the cool tonal approach; Wilhelm Kobell, clear structuring of light; the Nazarenes, chromatic buildup; Franz Dreber, the veiled, chalky gray scaling of values; Adam Klein and Friedrich Gauermann, the blue tonal arrangement (for Gauermann, see entry in Catalogue). By the early 1840s Bürkel had evolved a style of his own which was based on his own choice of subjects and his observation of nature.

> Bürkel, popular not because of his painterly qualities, but more because of his gift for narrative, the suggestion of the story and the sometimes strikingly affective anecdote, is the master of the open-air genre picture. In this his work is similar to the late work of Waldmüller. But because this anecdotal and genre-like ingredient was not an end in itself and not the only value for him, and because these elements were always subordinated by him to a beautiful vision of nature and to the painterly total effect, his paintings are very attractive and fresh. The truly artistic begins for him beyond the genre. (Waldmann, p. 18)

Ever since the 1906 Berlin Centennial Exhibition of German art, scholarship in art history has regarded Bürkel as the last important link in the evolution of the Old Munich School. In terms of landscape painting, Bürkel continued the tradition founded by such painters as Ferdinand Kobell and Max Josef Wagenbauer on the one hand, and, on the other, he ushered in the succeeding movement of *Stimmungslandschaft* (mood landscape). Like his friends and acquaintances Carl Spitzweg, Eduard Schleich the Elder (see entries in Catalogue), and Adolf Lier, Bürkel stood outside the academic tradition. Today's critical art history tends to reverse the previous trend of looking askance at these popular painters by crediting them instead with a steadily growing significance in the evolution of art history. Moreover, the recent increase in the attention paid by scholars to Bürkel and similar popular artists seems to be, judging from the prevailing tenor of recent writings, just the beginning of a major critical reassessment.

Although he was accustomed to painting five or six works at the same time and often repeated his subjects, Bürkel's extraordinarily large oeuvre (close to one thousand paintings; see Luigi von Buerkel, pp. 127–157) is characterized by the highest standards of quality throughout. The dating of his paintings, an ongoing challenge to scholarship today, presents a real problem because Bürkel did not date his works after 1848 and because many of his paintings are unsigned. A steady flow of Bürkel paintings moved to the United States after 1839 (see *Katalog Pfalzgalerie Kaiserslautern*, p. 28).

BIBLIOGRAPHY
E. Waldmann, DIE KUNST DES REALISMUS UND DES IMPRESSIONISMUS IM 19. JAHRHUNDERT, Berlin, 1921, p. 18. R. Oldenbourg, DIE MÜNCHNER MALEREI IM NEUNZEHNTEN JAHRHUNDERT, Vol. I, Munich, 1922, pp. 130–33. P. F. Schmidt, BIEDERMEIER MALEREI, Munich, 1923, pp. 137 ff., 215 ff., and passim. G. Buchheit, HEINRICH BÜRKEL, EIN PFÄLZER LANDSCHAFTS- UND GENREMALER, Kaiserslautern, 1929. H. Karlinger, MÜNCHEN UND DIE KUNST DES 19. JAHRHUNDERTS, Munich, 1933 (2d ed., 1966), pp. 39–42, and passim. L. von Buerkel, Heinrich Bürkel, EIN MALERLEBEN DER BIEDERMEIERZEIT, Munich, 1940. S. Wichmann, CARL SPITZWEG UND SEIN FREUNDESKREIS; Exhibition Catalogue, Haus der Kunst, Munich, Oct. 1967–Jan. 1968, p. 81. KATALOG PFALZGALERIE KAISERSLAUTERN, Kaiserslautern, 1969. F. Novotny, PAINTING AND SCULPTURE IN EUROPE, 1780–1880, Baltimore, 1970, p. 78.

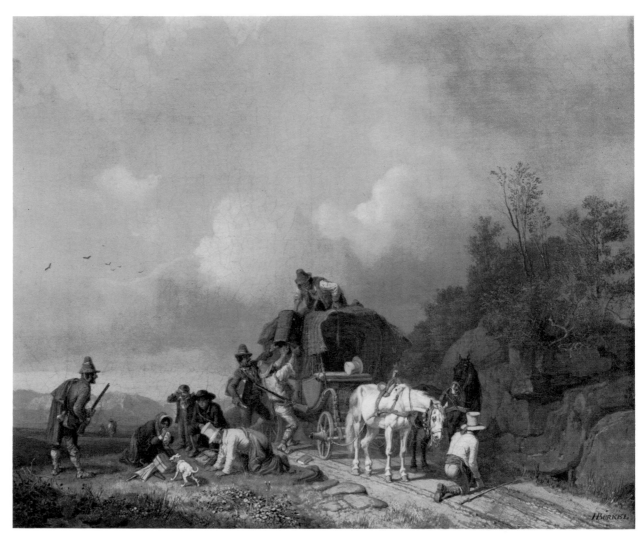

See description under entry **17**.

16
The Holdup (Strassenräuber)
1850
 signed L.R.: HBürkel
 oil on canvas, 15½ × 18¼ (39.4 × 46.4)
 MAC cat. no. M 1962.77

64 Color plate page 25

REFERENCE
Painting seems to belong to cycle around nos. 543, 547, 551, 552, 553, in L. von Buerkel (pp. 146, 147) or is a variant of one of these. If this assumption is correct, the dating of the painting must be moved up to 1853. S. Wichmann, PAINT-INGS FROM THE VON SCHLEINITZ COLLECTION (Catalogue), Milwaukee Art Center, 1968, No. 7, illus. 1. Strobl, "Die Sammlung von Schleinitz," KUNST IM VOLK, Nos. 3/4, 1968/69, pp. 80–87, illus. p. 85.

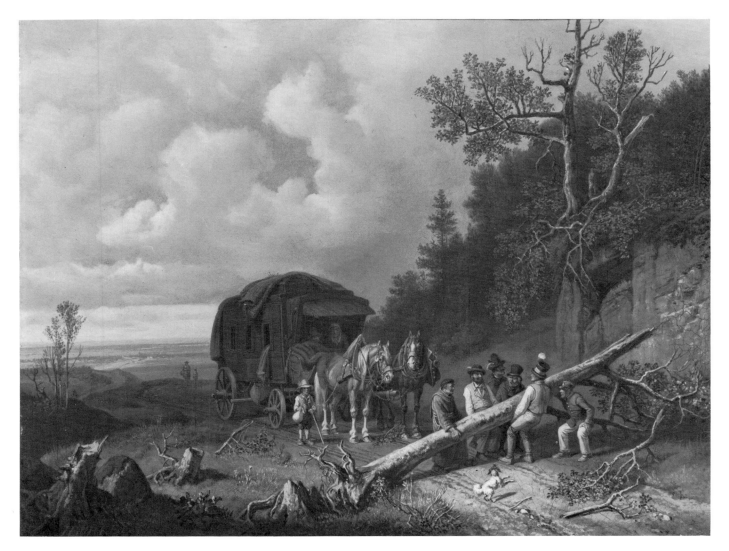

17
Removing the Fallen Tree (or The Accident)
signed L.L.:HBürkel
oil on canvas, 14⅜ × 18⅛ (36.5 × 46)
MAC cat. no. M 1970.114

The low horizon, right "stage wing" construction, small and highly mobile figures, and highlighting of the earth and terre verte passages with tiny red articles of clothing are shared by both of these superb "classic" Bürkels. In both, the exciting narration is subordinated to an overall painterly conception of which the tall, marvelous, atmospherically rendered skies are the pictorially unifying factors. These are brilliant canvases by one of the greatest German masters of country genre.

PROVENANCE
Henry Wimmer, Gallery of Fine Arts, Munich. Melvin Mallon, Appraiser and Antique Dealer, Milwaukee, 1969. Eric Siemens, Milwaukee.

DEFREGGER, FRANZ VON

b. April 30, 1835, Dölsach, Tyrol
d. January 2, 1931, Munich
represented at nearly all German and Austrian
 museums, also Copenhagen, New York, Prague,
 Zurich; private collections in Germany and the
 United States

The decisive part of Franz Defregger's oeuvre is made up of a pictorial category that he himself invented, namely historical genre or "genre history," centering on the Austrian occupation of Bavaria in 1704–5 and the Tyrolean Peasant Wars of Liberation of 1809–10. The critical question concerning his art, therefore, is necessarily one that examines the "authenticity of feeling" or "purity of conviction" inherent in those productions. Twentieth-century literature on the arts (unlike its nineteenth-century counterpart, which worshiped Defregger), to the extent that it takes a critical position one way or another at all, offers very little encouragement for a positive evaluation of Defregger today. As recently as 1933, in addressing the issue, Karlinger wrote:

> However, what is being shown to us by Defregger is not Tyrolean *Volkstum* [nationality] but rather sentimentality; the same sentimentality that Ganghofer [German writer of popular novels in the "peasant genre"] later used to such good advantage. The spirit of the Piloty studio is again proven true here, the spirit attending feelings of historical eeriness. Defregger merely furnishes that feeling with a nourishing ground by choosing an obvious range of subjects: the Tyrolean uprising, the *Mordweihnacht* ["The Christmas Massacre"; the betrayal and destruction of a rebellion mounted by Bavarian peasants against the Austrian occupation of Munich in 1705]. Besides that, he used the upright Alpine folk complete with the bragging Herr Forrester, the jovial young priest, the guys and gals from the ranks of the people. (pp. 53, 54)

Although for the most part his book is fair and evenhanded, Uhde-Bernays is even less forgiving and even more critical in the "case of Defregger." Two more concomitant biases surface in critical literature: one pertains to Defregger's visit to Paris which (unlike Leibl's Parisian sojourn, for example) does not seem to have had any effect whatever on his style, such as moving it in the direction of Courbet's avant garde, for instance, a circumstance considered by those critics to be "unfortunate." The other "unhappy development" concerns Defregger's earliest work, done in a straightforward and "artless" realistic manner that seemed to show the "promise" of evolving toward a Leiblian form of "painterly realism" before it was "arrested" by Defregger's experiences in Piloty's studio.

Proceeding from an unbiased personal position and the only views that seem to us historically apposite in this matter, namely those of nineteenth-century critics, it seems clear to us that all three of these "major criticisms" are inappropriate and false. We counter them by asserting that Franz Defregger was the greatest nineteenth-century Austrian (and German) painter of native peasant history, that he plumbed *Volkstum* deeper than anyone, that he fully satisfied his contemporary compatriots' craving for "folk-history," and that he was among the half-dozen greatest artists that Austria produced in the nineteenth century.

The son of a well-to-do farmer, Defregger inherited the estate after his father's death in 1858. He soon sold the farm, seriously considering emigration to South America. Nothing came of that, however, and Defregger fell back on his earliest talents, those for woodcarving and drawing. After some studies at Innsbruck (with the sculptor Stolz) he attempted to enter Piloty's studio in Munich. Piloty suggested that he study under Professor Dyk instead. Defregger followed his advice and, prior to his trip to Paris (1863–64), he also attended the class of Anschütz at the academy. Only after his return from France was he able to find a place in Piloty's overcrowded studio, and he remained with the master for five years until 1870. He then settled permanently in Munich and embarked on a career that was as spectacular in terms of his critical fortunes as it was financially rewarding for him.

Defregger's was a friendly and open personality and it was filled with a warm sentimentality on behalf of his native Tyrolean countryside, its people, customs, and history. His paintings—peasant genre and peasant history (but also portraits and religious works)—are often characterized by humor, charm, and a narrative simplicity that contrasts pleasantly with the often heavy pathos of Piloty's painted melodramas. They are, furthermore, distinguished by well-observed figural movement, convincing characterizations, and authentic milieu descriptions as well as the occasional idealization of poses and compositions with a classicizing bias. As professor at the Munich Academy over several decades (1878–1910) he trained many younger painters and generated ranks of followers.

BIBLIOGRAPHY
L. Pietsch, CONTEMPORARY GERMAN ART: AT THE CENTENARY FESTIVAL OF THE ROYAL ACADEMY OF ARTS, BERLIN, London, 1888 Vol. I, pp. 2 ff., Vol. II, pp. 49 ff. F. Pecht, GESCHICHTE DER MÜNCHNER KUNST DES 19. JAHRHUNDERTS, Munich, 1888. F. H. Meissner, FRANZ VON DEFREGGER, Vol. VI in Das Künstlerbuch, Berlin, 1900. A. Rosenberg, DEFREGGER, Leipzig, 1900. H. Uhde-Bernays, DIE MÜNCHNER MALEREI IM NEUNZEHNTEN JAHRHUNDERT, Vol. II, Munich, 1927, pp. 192 ff. and passim. H. Karlinger, MÜNCHEN UND DIE KUNST DES 19. JAHRHUNDERTS, Munich, 1933 (2d ed., 1966), passim. H. Hammer, FRANZ VON DEFREGGER, Innsbruck, 1940. F. Novotny, PAINTING AND SCULPTURE IN EUROPE, 1780–1880, Baltimore, 1970, pp. 169, 174.

18
The Story Teller
1870
 signed and dated L.R.: F. Defregger 1870
 oil on canvas, 16 × 19½ (40.4 × 49.5)
 MAC cat. no. M 1962.38

This "incidental" canvas by Defregger is excellent in the attitudes and characterizations of the figures as well as in its "atmospheric" conception of an interior space. Grays and umbers predominate in a color scheme that is highlighted by the muted reds of the woman's kerchief and the central boy's vest. Drawing and form as colored planes are beautifully balanced here. Domestic tranquillity, the strength to be gained from "home and hearth," and a tradition rooted in "folk wisdom" are the subject of several paintings by Defregger and countless others by very many German painters throughout the nineteenth century.

REFERENCE
F. von Boetticher, MALERWERKE DES NEUNZEHNTEN JAHRHUNDERTS, Vol. I, Dresden, 1891, p. 209, No. 10: "Die Märchenerzählerin. Drei Knaben einer alten Frau zuhörend, die ihnen aus einem Buche Geschichten mitteilt. Holzschn. von Th. Knesing.-Lepke's Berl. KA. 72." DIE WELTKUNST, Vol. XV, Nov. 1956, p. 17, illus. S. Wichmann, PAINTINGS FROM THE VON SCHLEINITZ COLLECTION (Catalogue), Milwaukee Art Center, 1968, No. 9, illus. 25. Strobl, "Die Sammlung von Schleinitz," KUNST IM VOLK, Nos. 3/4, 1968/69 pp. 80–87, illus. p. 83. MIRRORS OF 19TH CENTURY TASTE: ACADEMIC PAINTING; Exhibition Handlist, Milwaukee Art Center, 1974, No. 26.

19
The Prize Horse (Das Preispferd)
1873
 signed and dated L.L.: Defregger / 1873
 oil on canvas, 39½ × 51½ (100.3 × 130.8)
 MAC cat. no. M 1972.112
Color plate page 26

The Prize Horse belongs to the few paintings for which Defregger chose motifs from Bavarian folk life in which he became interested after founding his own household . . . and settling in a village near Munich. It was there, presumably, that he observed a scene such as that represented in this painting (Rosenberg, p. 25).

On the advice of his doctors to seek a warmer climate (he suffered from rheumatism), Defregger and his young wife relocated in Bozen. Here he found suitable and sunny quarters in the Villa Moser. On the terrace of this country house he could, even in winter, spend many hours in the out-of-doors, and he eagerly continued to paint: it was here that the *Prize Horse* came into being, as well as the *Itinerant Singer*, both of which he sent along to the Vienna World Exhibition of 1873 (Hammer, p. 21)

The Prize Horse is a major canvas by Defregger and

one that was decisive in establishing his European fame overnight. The subject is set in an Upper Bavarian village where the beribboned stallion is trotted before a critical and admiring audience after having won first prize at the Munich *Oktoberfest*. Although still somewhat indebted to Piloty's histrionic staging of forces, the "drama" here appears subdued and the assembly totally integrated in the *mise en scène* of a village. Defregger skilfully combines a static, frieze-like grouping of figures with a dynamic and deeply receding space. The color scheme is monochrome and patterned in a profuse variety of off-whites, grays, and earth tones.

PROVENANCE
Purchased at Parke-Bernet Los Angeles Auction 2/28/72 "from the collection of Victor Emmanuel von Metternich." Illustrated in Parke-Bernet's book "Art at Auction," 1971–72, p. 93 (lower).

REFERENCE
F. von Boetticher, MALERWERKE DES NEUNZEHNTEN JAHRHUNDERTS, Vol. I, Dresden, 1891, p. 209, No. 15: "Das Preispferd. BEZ: Defregger 1873. In Wiener Besitz.-Wien WA. 73." A. Rosenberg, DEFFREGGER, Leipzig, 1900, p. 25. H. Hammer, FRANZ VON DEFREGGER, Innsbruck, 1940, pp. 21, 58, text and illus.

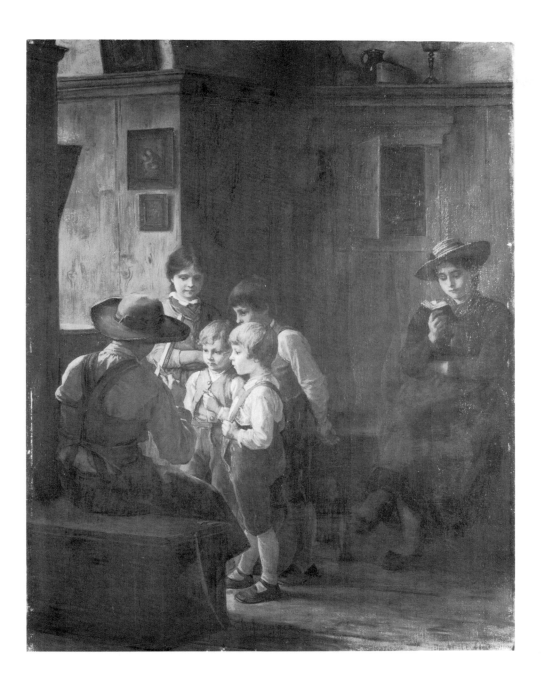

20
Sunday Afternoon
probably 1874
 signed L.C.: Defregger
 oil on canvas, 24⅞ × 19½ (63.1 × 49.5)
 donor: Miss Elizabeth A. Plankington (gift of
 1888–90)
 MAC cat. no. Layton 93

A routine canvas by Defregger, the painting is distinguished by the harmonious resolution of the contrasting, sun-brightened children's figures, on the one hand, and the dusky space of the interior, on the other. Earth and gray colors are delicately offset by a few accents of muted reds appearing in the clothing.

PROVENANCE
Gregor Hölzl, Munich.

REFERENCE
Probably No. 22 in F. von Boetticher, MALERWERKE DES NEUNZEHNTEN JAHRHUNDERTS, Vol. I, Dresden, 1891, p. 209: "Sonntags-Nachmittag, Wien. JA. 74." MIRRORS OF 19TH CENTURY TASTE: ACADEMIC PAINTING; Exhibition Handlist Milwaukee Art Center, 1974, No. 25.

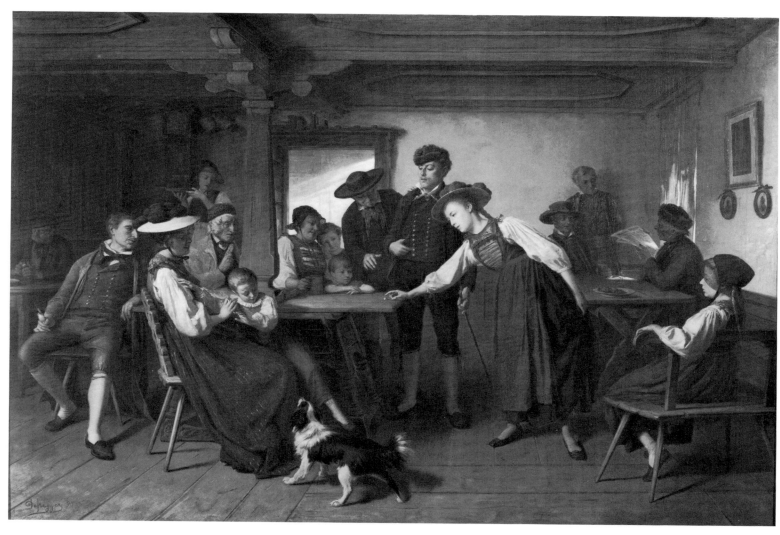

21

The Friendly Game
1895

 signed and dated L.L.: Defregger 95
 oil on canvas, 34½ × 49¾ (87.6 × 126.4)
 MAC cat. no. M 1962.78

This rather late Defregger, while ambitious in scale, seems to suffer somewhat from a discursive composition, mincing detail, and an unresolved mixture of monochrome painterly and polychrome enameled passages. Its strongest aspects lie in the unifying conception of light and an engaging narrative.

REFERENCE
S. Wichmann, PAINTINGS FROM THE VON SCHLEINITZ COLLECTION (Catalogue), Milwaukee Art Center, 1968, No. 8 (incorrectly dated there 1890).

DIEZ, WILHELM VON

b. January 17, 1839, Bayreuth
d. February 25, 1907, Munich
represented at Dresden, Hamburg, Leipzig, Munich;
private collections

Except for a fourteen-day stint at the studio of Karl von Piloty, Wilhelm von Diez was a self-taught artist. Endowed with a great native talent for drawing and a penchant for depicting all manner of rough peasant customs and ribald low life, which he observed on his "slumming" junkets in the suburbs of Munich, Diez soon established a fine reputation as illustrator for such popular journals as *Fliegende Blätter* and *Münchner Bilderbogen* as well as for numerous books. While keeping busy with these projects, he also found the time to study the Little Dutch Masters at the Pinakothek, especially Brouwer, Wouvermann, and Teniers. Although their styles largely determined the eclecticism of his earliest paintings, he quickly found his way to a personal style of his own. Vigorous drawing, subtle tones, and, above all, a sophisticated colorism helped assure his small-scale paintings a widening market and for him a position of great influence in the School of Munich.

Next to Piloty's, Diez's studio attracted the largest number of pupils. The list of Diez's followers reads like a roster of German realist and impressionist painters. It was especially in his capacity as a mediator between the traditional realism of the Old Munich School as well as Piloty's naturalistic history painting, on the one hand, and a Leibl-related objective realism and Impressionism, on the other, that art history today measures the significance of Diez.

Diez possessed the sure instinct of recognizing the good and the bad in the doctrines of history painting. He proceeded to develop only the good while concentrating on the painterly conception. This characteristic enabled Diez to become the most brilliant teacher that the Munich School has ever enjoyed. As with all great teachers, he did not himself reach those goals toward which he guided his pupils with such a sure hand. His own principles regarding realism were often subject to a preference for deeply glowing color contrasts and an irresistible bent for spinning those narrative yarns that are the highest virtue of the illustrator. This last quality, however, encumbers his art—a form of decorative objectivism—only with a slight burden. He is an artist of outstanding merits. (H. Uhde-Bernays, *Die Münchner Malerei im neunzehnten Jahrhundert*, Munich, 1922, p. 107)

Often compared to Adolf Menzel, the Berlin master of Realism by whom he was undoubtedly influenced in his style, Diez furnished German art with its finest historical and literary genre. Kuhn considers Diez to be one of the "most German and most original talents of his times" (p. 1327). His foremost contribution to German art history was to have liberated and renewed genre painting by substituting for the older (Munich) convention of slavish adherence to a descriptive and anecdotal narrative a new form of painterly exposition, and to have done so with enough nuance of color and light as to have clearly anticipated and shown the way to the later Impressionism of a good number of his many pupils.

Although his paintings are an integral part of the German "cultural renaissance" of the post-Franco-Prussian War era (1871 and after), in the universality of their appeal, they are actually much more akin to the robust charm of a Hans Sachs or the ribald humor of a Grimmelshausen (sixteenth-century and seventeenth-century German writers of farces and rogues' novels, respectively), for example, than to the strident Frederician or Wilhelmian brand of patriotism that somewhat unpleasantly characterized the decades of the 1870s and eighties in Germany.

Sometimes drastic in its picaresque episodes and rough convival wit, Diez's special genre from the Thirty Years' War, the eighteenth century, and the Napoleonic campaigns abounds with masterfully conceived characters: brash lansquenets, scurvy brigands, cunning peasants, and outlandish adventurers of every description. In addition, Diez's large oeuvre includes excellent animal studies, especially horses, and landscapes, portraits, and a few religious works.

BIBLIOGRAPHY
C. E. Clement and L. Hutton, ARTISTS OF THE NINETEENTH CENTURY AND THEIR WORKS, Boston, 1884 (facsimile ed., St. Louis, 1969), Vol. I, p. 208. F. von Boetticher, MALER-WERKE DES NEUNZEHNTEN JAHRHUNDERTS, Vol. I, Dresden, 1891, pp. 228 ff. A. Kuhn, GESCHICHTE DER MALEREI, Vol. II, in Vol. III of ALLGEMEINE KUNSTGESCHICHTE, Cologne and New York, 1909, p. 1327. E. Waldmann, DIE KUNST DES REALISMUS UND DES IMPRESSIONISMUS IM 19. JAHRHUNDERT, Berlin, 1927, pp. 55 ff. H. E. von Berlepsch, "Wilhelm Diez," ZEITSCHRIFT FÜR BILDENDE KUNST, Vol. XXII, n.d., pp. 293–303. F. Novotny, PAINTING AND SCULPTURE IN EUROPE, 1780–1880, Baltimore, 1970, p. 174.

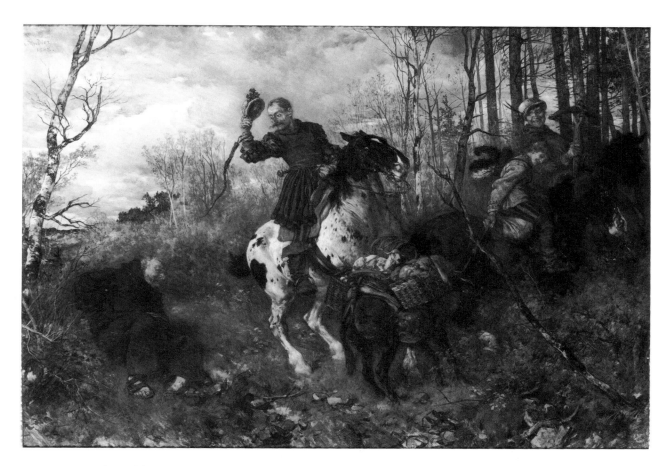

22
Highwaymen (Beraubt)
1888
 signed and dated U.L.: Wilh. Diez / 1888
 oil on wood panel, 19½ × 27¼ (49.5 × 69.2)
 MAC cat. no. M 1962.103
Color plate page 27

A very strong painting by Diez, bringing all his powers of crisp drawing, painterly gifts, and his penchant for picaresque situations brilliantly to the fore. Robbed of all his worldly possessions—a donkey laden with wine, victuals, and a live lamb—a corpulent elderly friar writhes on the ground as grinning and mocking cutthroats ride off into the thicket. The palette features an immense variety of incredibly subtle shades of green and gray, the dominant tones of this canvas. The painting, moreover, harmoniously conveys a lively anecdote with the most painterly means, the most pleasing aspect of which is the rich nuances of light and dark gradations that enliven this master canvas throughout. Although Diez's technique here is dazzling and brilliant, it does not interfere with but rather enhances the total pictorial effect and the story as well.

PROVENANCE
Purchased from Stuttgarter Kunstkabinett Auction, October 30, 1956, No. 54 in Catalogue, illustrated, plate no. 19.

REFERENCE
KUNST FÜR ALLE, Vol. IV, 1888–89, pp. 5 ff., 124 ff., illus. F. von Boetticher, MALERWERKE DES NEUNZEHNTEN JAHRHUNDERTS, Vol. I, Dresden, 1891, p. 222, No. 54: "Beraubt. Ein Strauchritter mit zwei Gesellen hat einem alten Kapuziner seinen mit Lämmern, Eiern und Wein beladenen Esel weggenommen." S. Wichmann, PAINTINGS FROM THE VON SCHLEINITZ COLLECTION (Catalogue), Milwaukee Art Center, 1968, No. 10, illus. 19.

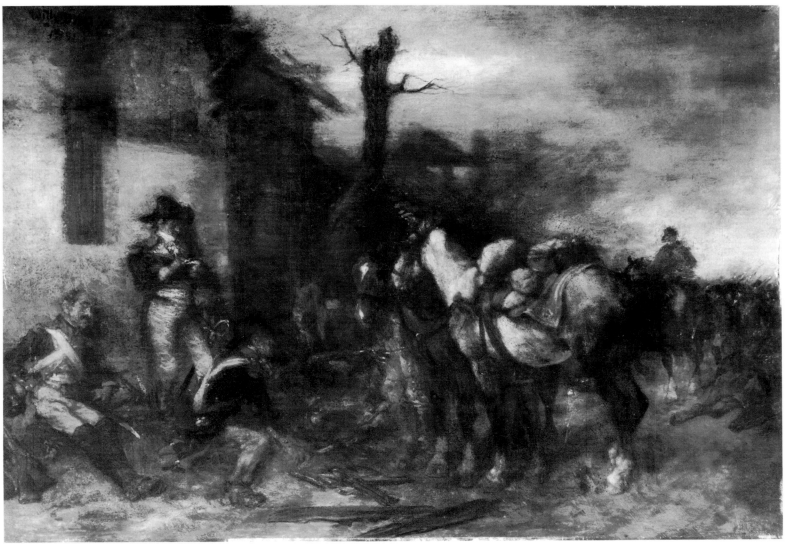

23
Soldiers at Rest
1891
 signed and dated U.L.: Wilh. Diez / 1891
 oil on wood panel, 9¼ × 13 (23.5 × 33)
 MAC cat. no. M 1962.79

Very illusionistic in its technique, *Soldiers at Rest* (**23**) veils all forms in rich chiaroscuro. All forms are "open" and the color very "fluid." But it is not nearly as resolute in drawing as *Highwaymen* (**22**). The composition seems "accidental," as if caught at a glance. This quality, in addition to the loose handling of forms, imparts an impressionistic feeling here. Palette: grays, burnt umbers, vitiated carmines throughout.

24

Cavalier with Horse
 signed L.L.: Wilh. v. Diez
 oil on wood panel, 6³/₁₆ × 4³/₁₆ (15.7 × 10.6)
 MAC cat. no. M 1972.122

A quite "incidental" little "oil sketch," very Baroque in design, flamboyant in execution; decorative usage of carmine in drapery on right.

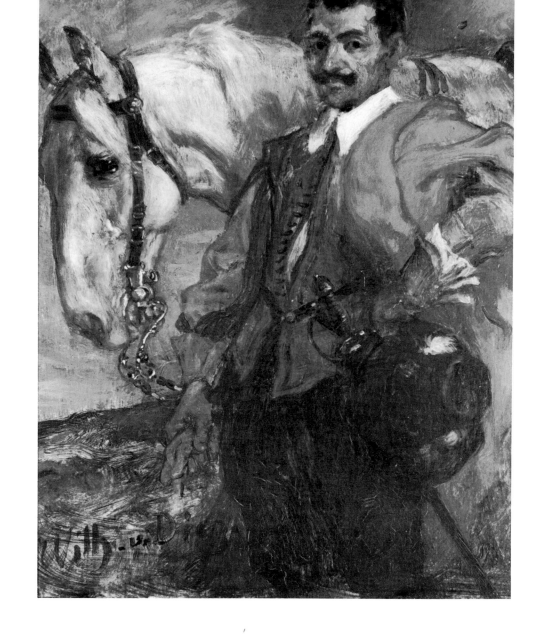

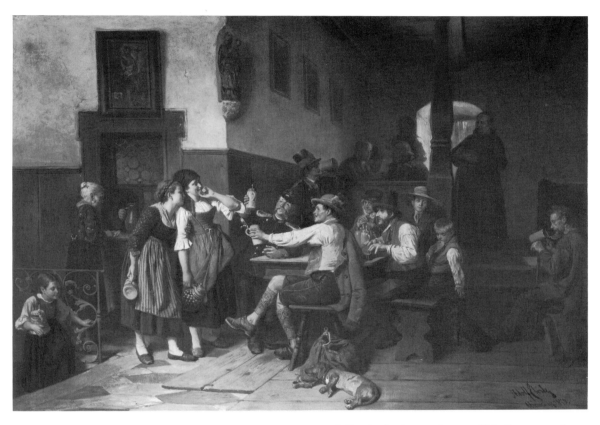

25
Munich Tavern
1870
 signed and dated L.R.: Adolf Eberle München / 1870
 oil on canvas, 33 × 45 (83.8 × 114.3)
 MAC cat. no. M 1962.109

An important, early Eberle done long before he succumbed to his more facile late manner. A composition well rounded in terms of lighting and atmosphere, it also epitomizes Eberle's "decorative staging" and "jaunty colorism" in the service of light and jolly tavern scenes. Eberle seemed to have had a

partiality for letting each one of his figures perform some kind of "natural task" in order to convey a feeling of "real life." This tactic, while effective at first glance, tends, on closer inspection, to disintegrate his compositions into their component parts. (The same is true of works by such as Riefstahl or Kaltenmoser, for example; see entries in Catalogue.) Only a few artists (e.g., Defregger, Waldmüller, Knaus; see entries in Catalogue) were able to maintain an overall compositional tension in large genre canvases containing a huge variety of figures performing a multitude of individual actions.

EBERLE, ADOLF
 b. January 11, 1843, Munich
 d. January 24, 1914, Munich
 represented at Bautzen, Hamburg, Karlsruhe,
 Munich

Adolf Eberle today stands in the shadow of his more highly regarded father Robert, a landscape and animal painter from whom he received his first lessons in art. His earliest independent works also suggest a debt to the robust style of Peter Baumgartner (see entry in Catalogue). Training in Karl von Piloty's studio resulted in other early works reflecting that master's jaunty colorism, decorative staging, and even his subject matter (e.g., *Feldschule in Wallensteins Lager*, 1867). Bucolic idylls, jolly tavern scenes, humorous animal paintings, charming childrens' pictures, and light genre from the worlds of the hunt as well as of popular customs and manners thereafter became the mainstays in Eberle's naively entertaining repertory.

It is difficult to refrain from chuckling (perhaps a bit derisively), especially when one views Eberle's sentimental and anthropomorphized dogs—the hunter's dachshund was his special forte—with which he habitually favored the exhibitions at the Glaspalast in Munich and for which he just as habitually received warm accolades of praise from the artistic officialdom, because of their "human qualities." If there is an ordained time and place for everything in the general scheme of things, the time and place for an Eberle "dog-genre" revival seem to lie in the as yet indeterminable future.

BIBLIOGRAPHY
F. Pecht, GESCHICHTE DER MÜNCHNER KUNST DES 19. JAHRHUNDERTS, Munich, 1888, p. 251. F. von Boetticher, MALERWERKE DES NEUNZEHNTEN JAHRHUNDERTS, Vol. I, Dresden, 1891, pp. 247–48, and in "Nachträge," p. 970. R. Oldenbourg, DIE MÜNCHNER MALEREI IM NEUNZEHNTEN JAHRHUNDERT, Vol. I, Munich, 1922, pp. 166–69. H. Uhde-Bernays, DIE MÜNCHNER MALEREI IM NEUNZEHNTEN JAHRHUNDERT, Vol. II, Munich, 1927, pp. 202, 203.

FRIEDLÄNDER, FRIEDRICH, RITTER VON MALHEIM

b. January 1, 1825, Kohljanowitz, Bohemia
d. June 13, 1901, Vienna
represented at Austrian museums and in private
collections

Friedrich Friedländer is known to all connoisseurs of nineteenth-century genre painting as an uncommonly fine eclectic stylist whose original contribution was a novel subject matter, namely the life and characters of contemporary war veterans and military invalids, a theme he took up and developed in a rich sequence of variations following the Prusso-Austrian war of 1866. These later canvases of his are marked by painstaking attention to the most miniscule detail and a moralizing earnestness that goes beyond the usual in popular genre.

Friedländer's early work was formed by the influences he received at Waldmüller's (see entry in Catalogue) studio in Vienna, though it shows no trace of that master's concern for light and atmosphere. Subsequently, it was stimulated by a study trip to Italy (1850), a stay at Düsseldorf (1852), a trip to Paris (1854), and, most significantly, by the influence, after the 1870s, of two famous Düsseldorf painters: Ludwig Knaus and Benjamin Vautier (see entries in Catalogue).

Among the most forthright founders of the Vienna *Künstlergenossenschaft* (artists' association), on whose behalf he earned a distinguished record of service, Friedländer lived permanently in Vienna from the year 1856 onward. An honored member of the academy there, he received the patent of nobility from the Emperor and the title "von Malheim" in 1889. Friedländer's oeuvre, ranging from history painting, his earliest endeavor, to folksy and domestic situation genre, *Sittenbilder* (paintings of morals and manners, a subspecies of *Genremalerei*), charming costume peasant scenes, and portraiture, culminates in his valued paintings of war veterans.

BIBLIOGRAPHY
F. von Boetticher, MALERWERKE DES NEUNZEHNTEN JAHRHUNDERTS, Vol. I, Dresden, 1891, pp. 326–28, and in "Nachträge," p. 972. A. Kuhn, GESCHICHTE DER MALEREI, Vol. II, in Vol. III of ALLGEMEINE KUNSTGESCHICHTE, Cologne and New York, 1909, pp. 1330–31. Thieme-Becker, KÜNSTLERLEXIKON, Leipzig, 1907-50, Vol. XII, p. 458. R. Darmstaedter, KÜNSTLERLEXIKON, Bern and Munich, 1961, p. 165. B. Grimschitz, ÖSTERREICHISCHE MALER VOM BIEDERMEIER ZUR MODERNE, Vienna, 1963. R. Feuchtmüller, KUNST IN ÖSTERREICH, Vol. II, Vienna, 1973, p. 213.

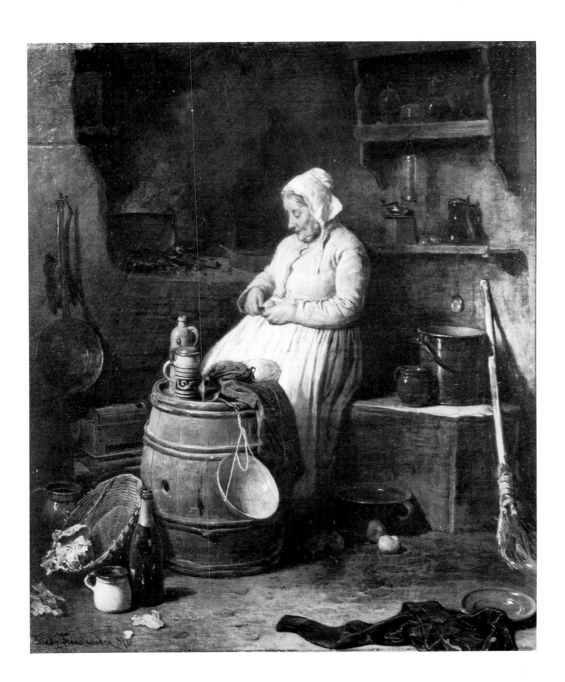

26

The Potato Peeler (Kücheninterieur mit einer alten Frau als Staffage)
1876

> signed and dated L.L.: Friedr. Friedländer 876
> oil on wood panel, 17⅝ × 10¾ (44.8 × 27.3)
> MAC cat. no. M 1972.9

This composition by Friedländer gives the impression of a large still-life ensemble to which has been added a figure. Because all objects shown are rendered with the same degree of intensity, the composition lacks focus. A rich variety of earth colors forms the palette here.

REFERENCE
F. von Boetticher, MALERWERKE DES 19. JAHRHUNDERTS, Vol. I, Dresden, 1891, p. 327, No. 32, lists "Kücheninterieur mit einer alten Frau als Staffage. Bez. 1876. Holz. h. 0,255, br. 0,42 - Wien. hist. KA. 77." The remarkable closeness (except size) of this work to M 1972.9 suggests the possibility of two versions. S. Wichmann, PAINTINGS FROM THE VON SCHLEINITZ COLLECTION (Catalogue), Milwaukee Art Center, 1968, No. 12.

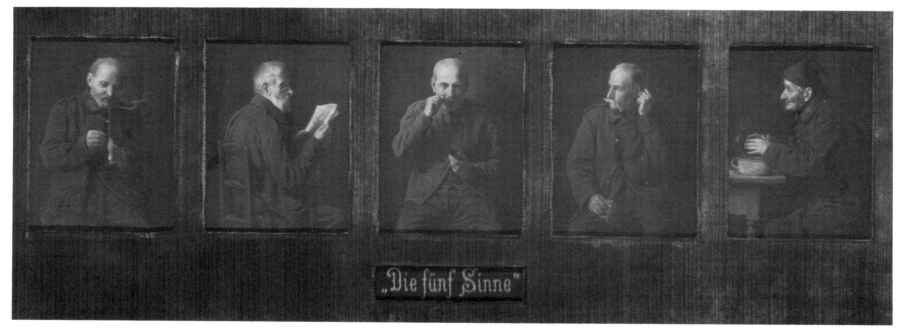

„Die fünf Sinne"

27
The Five Senses (Die fünf Sinne)
c. 1885 or 1886
 each panel signed Fried. Friedländer: U.R. of panels
 1, 3, 4; U.L. of panels 2, 5;
 oil on wood panel; all five panels framed together
 horizontally, each panel 6 × 4½ (each panel 15.2
 × 11.4)
 MAC cat. no. M 1962.42

This portrait grouping of Austrian military invalids, Friedländer's specialty, may once have been owned by the emperor of Austria. The flesh tones of faces and hands form an eloquent and visually stimulating pattern against the subtly modeled powder grays of the uniforms and dark umbers of the backgrounds. From left to right: taste, sight, smell, hearing, touch.

REFERENCE
F. von Boetticher, MALERWERKE DES 19. JAHRHUNDERTS, Vol. I, Dresden, 1891, p. 327, No. 58: "Die fünf Sinne. Gruppe von fünf österr. Invaliden. E: Kaiser v. Oesterreich." THE AMERICAN-GERMAN REVIEW, Oct. 1951, p. 21, illus. S. Wichmann, PAINTINGS FROM THE VON SCHLEINITZ COLLECTION (Catalogue), Milwaukee Art Center, 1968, No. 11.

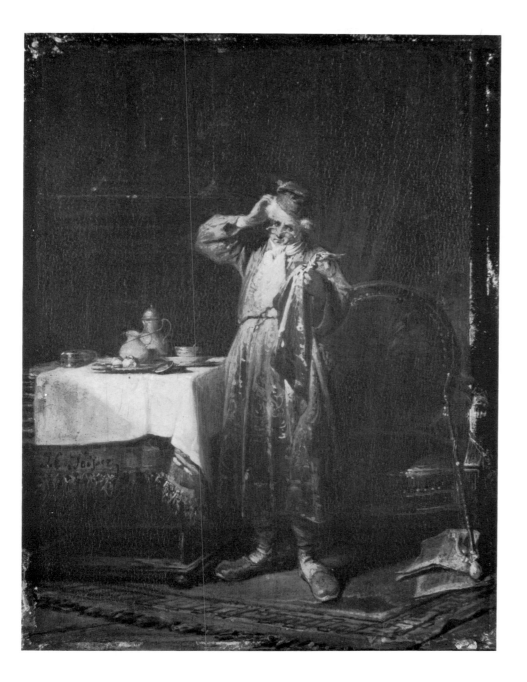

GAISSER, JAKOB EMANUEL

b. November 21, 1825, Augsburg
d. January 21, 1899, Munich
represented at Mainz and museums in East Germany

Jakob Emanuel Gaisser received his earliest training from his father, a highly regarded drawing teacher in Augsburg, and from Johann Geyer in his home town. Thereafter, he studied at the Munich Academy under Clemens Zimmermann, the classicist Friedrich Gärtner, and the great Nazarene painter Julius Schnorr von Carolsfeld. Active in Munich all his life, Gaisser developed a special and very popular picture category, namely a type of humorous "Rococo genre" that often features parlor games, amorous plays, and jovial or pious characters, but also ribald and satirically treated themes of gamblers and drinkers. His fine miniatures are highly regarded by connoisseurs for their strong characterizations, vibrant color, description of choice period costumes and accouterments, their irony and deft tongue-in-cheek quality. He was the father of Max Gaisser (see following Catalogue entry).

BIBLIOGRAPHY
H. A. Müller, Biographisches Künstlerlexikon der Gegenwart, Leipzig, 1884. F. von Boetticher, Malerwerke des 19. Jahrhunderts, Vol. I, Dresden, 1891, p. 351.

28
The Faulty Memory

signed L.L.: J. E. Gaisser
oil on wood panel, $7^{15}/_{16} \times 5^7/_8$ (20.2 × 14.9)
MAC cat. no. M 1962.44

Formally it is a very well focused, painterly little composition; thematically, it is affectionately humorous. The umber background is foiled by the patterned viridian morning coat and sparkling white table cloth on which rests an exquisite little still life with steins.

REFERENCE
S. Wichmann, Paintings from the von Schleinitz Collection (Catalogue), Milwaukee Art Center, 1968, No. 13.

GAISSER, MAX

b. June 22, 1857, Augsburg
d. 1922, Munich
represented at museums throughout Germany and at
Brooklyn and Chicago

A direct line of stylistic evolution can be traced from
Diez (see entry in Catalogue) through his pupil
Ludwig Löfftz (who, in his later years, rivaled Diez's
popularity as a teacher) to the many younger Löfftz
disciples. This line can be shown to have been the
mainstream of popular naturalistic painting of the
School of Munich. One of many pupils of Löfftz,
Max Gaisser, the son of Jakob Emanuel Gaisser (see
previous Catalogue entry), specialized in techni-
cally highly precise and polished miniatures. He
especially favored scences from Holland and Bel-
gium, where he had traveled and done extensive
studies of indigenous art.

Imbued with a sense of fictional literariness,
Gaisser's street, interior, architectural, and beach
scenes suggest a strong talent for narrative genre.
Stylistic inflections of Terborch, deHooch, and
E. deWit seem to surface in Gaisser's paintings.
They are, furthermore, characterized by a concen-
tration on precise optical, light, and atmospheric
effects as well as minute detail. Like his father, Max
Gaisser was very popular with collectors in his day
and regularly exhibited at shows in Munich and
Berlin.

BIBLIOGRAPHY
KUNSTCHRONIK, Old Series (1886–89), Vol. XXIII, p. 115;
Vol. XXIV, p. 75. F. von Boetticher, MALERWERKE DES
NEUNZEHNTEN JAHRHUNDERTS, Vol. I, Dresden, 1891, p.
351, and "Nachtrag," p. 973. Thieme-Becker, KÜNSTLER-
LEXIKON, Leipzig, 1907–50, Vol. XIII. H. Uhde-Bernays,
DIE MÜNCHNER MALEREI IM NEUNZEHNTEN JAHRHUNDERT,
Vol. II, Munich, 1927, p. 210.

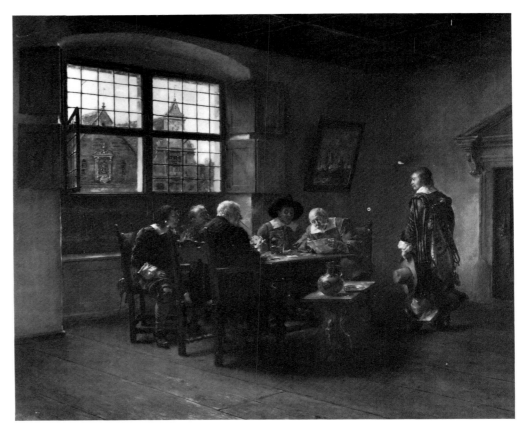

29
*Interrupted Card Game (Die unterbrochene Karten-
partie)*
1885–88
 signed U.R.: M. Gaisser
 oil on wood panel, 19 × 23 (48.3 × 58.4)
 MAC cat. no. M 1962.70

The reader's red tunic is the sole color accent in a
monochromatic sea of smoothly enameled warm
and cool grays, blacks, and vitiated morbidezza
tones. Superb light effects, uniformly well observed,
unite the composition. An apparently simple but
psychologically fully exploited story: a messenger of
the militia interrupts a gaming circle of gentlemen;
they react to the interruption collectively and indi-
vidually. The influence of the Little Dutch Masters is
obviously present here, even to the point of imita-
tion, as it is in *The Scholar* (**31**) and *Dutch Interior*
(**32**).

REFERENCE
F. von Boetticher, MALERWERKE DES NEUNZEHNTEN JAHR-
HUNDERTS, Vol. I, Dresden, 1891, p. 351, No. 2: "Die
unterbrochene Kartenpartie. Herren beim Kartenspiel,
denen eine Ordonnanz ein Schreiben bringt. Dresd.
ak. K. A. 88." S. Wichmann, PAINTINGS FROM THE VON
SCHLEINITZ COLLECTION (Catalogue), Milwaukee Art Cen-
ter, 1968, No. 14 (titled here falsely "THE CONFERENCE").

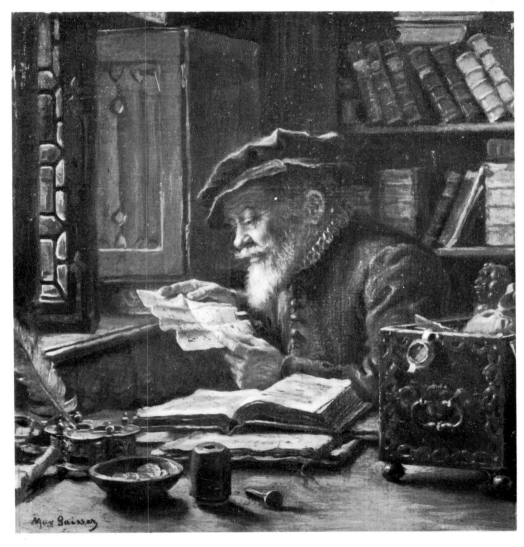

30
The Scholar
 signed L.L.: Max Gaisser
 oil on wood panel, 6⁷/₁₆ × 5¹⁵/₁₆ (16.4 × 15.2)
 MAC cat. no. M 1971.71
Palette similar to **31** and **32**.

PROVENANCE
A partially cut-off Winsor and Newton label glued to back
indicates that this painting was executed on a fragment of a
larger prepared panel or that it has been cut down from a
larger composition.

REFERENCE
Selections from the von Schleinitz Collection; Ex-
hibition Catalogue, Paine Art Center, Oshkosh, Wiscon-
sin, Feb. 1–20, 1972. Mirrors of 19th Century Taste:
Academic Painting; Exhibition Handlist, Milwaukee Art
Center, 1974, No. 31.

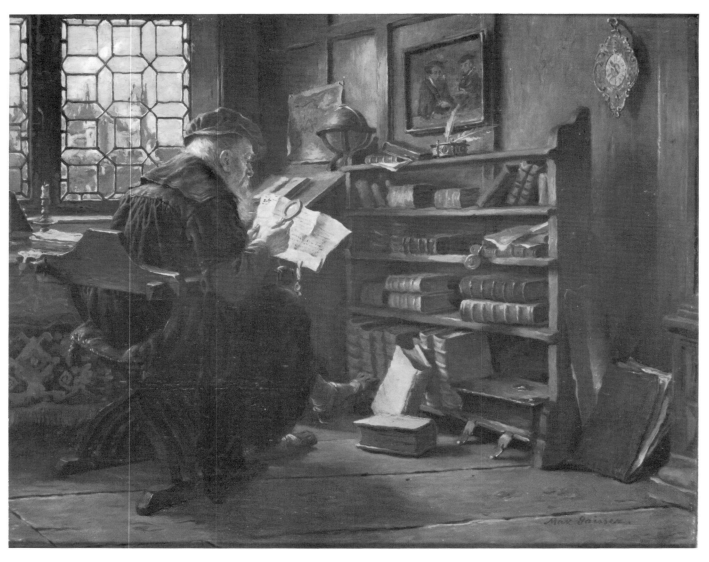

31

The Scholar

signed L.R.: Max Gaisser
oil on wood panel, 8¹³/₁₆ × 10¾ (22.4 × 27.3)
MAC cat. no. M 1962.58

82

The interior space is aglow with sunlight. As was often his practice, limited carmine accents (scholar's cap, Oriental rug) enliven his brownish and black palette.

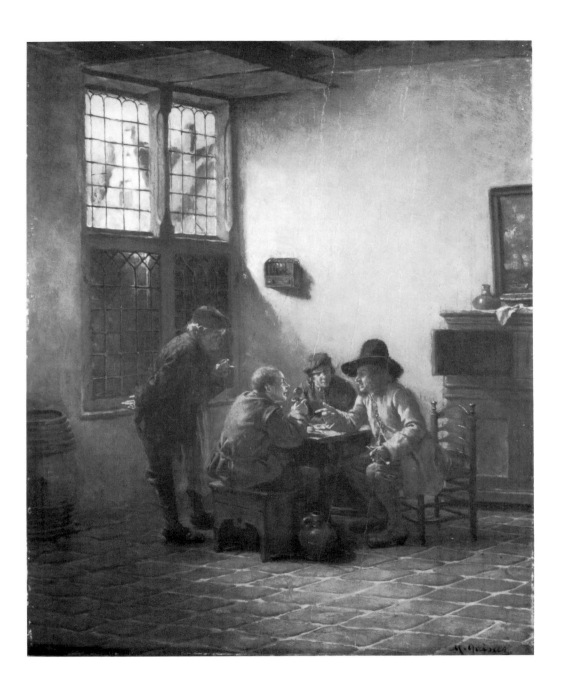

32
Dutch Interior
 signed L.R.: M. Gaisser
 oil on wood panel, 10¼ × 8 (26 × 20.3)
 MAC cat. no. M 1962.132

The palette is very similar to that of *Interrupted Card Game* (**29**) and *The Scholar* (**31**). Again, Gaisser proves here to be a very accomplished master at painting objects in light and dark, and at portraying the spontaneous psychological interactions of his *dramatis personae*. Gaisser seems to stand closer in spirit to the Old Dutch Masters than any other of the moderns.

PROVENANCE
Adolf Weinmüller, Munich, Auction No. 87, Catalogue No. 95, Oct. 2–3, 1963, No. 977 in cat., illustrated, plate No. 85.

REFERENCE
SELECTIONS FROM THE VON SCHLEINITZ COLLECTION; Exhibition, Paine Art Center, Oshkosh, Wisconsin, Feb. 1–20, 1972.

GAUERMANN, FRIEDRICH

b. September 20, 1807, Miesenbach, near
Wiener-Neustadt, Lower Austria
d. July 7, 1862, Vienna
represented at Berlin, Innsbruck, Leipzig, Posen,
Prague, Vienna, Zürich

In speaking of the artists of the Viennese School of landscape painting during the placid decades of the *Vormärz* period, P. F. Schmidt summarizes, somewhat laconically:

> Friedrich Gauermann, a magnificent and theatrical version of Bürkel [see Catalogue] was the greatest among them. His landscapes with tempests, thunderstorms, and excited animals must surely have warmed up the passions of the townsfolk in their secure niches behind their stoves; all these paintings could not be considered out of context of the constantly active Dutch masters of the seventeenth century. Likewise, the Viennese landscapists carried the type of cultivated idyll practiced in the eighteenth century deeply into their present times. (*Biedermeier Malerei*, p. 56)

Recent years have witnessed a lively burgeoning of interest in Gauermann and shown sure signs of an upward critical revaluation of his art. Feuchtmüller's views on the matter, therefore, balance and update Schmidt's criticism.

> We must not see in Gauermann's genre paintings and animal fighting scenes reproductions of reality but rather creations of an artistic fantasy. Only when we have recognized their poetic and unreal character can we understand the justifiably high esteem in which they were held by *Biedermeier* society. These paintings have beautifully preserved for us the atmosphere of those times. On the one hand, they were able to represent banal materiality; on the other, they are fantastic 'ideal pictures' that are intimately connected with reality through a multitude of living relationships. This recognition is by it-

self very interesting. But that recognition cannot only result from an analysis of content or consideration of cultural history. Rather, it represents a real artistic problem. That it is such is proven by Gauermann's ingenious studies and sketches. (*Friedrich Gauermann*, p. 65)

Gauermann was a self-taught artist whose cursory apprenticeship at the Vienna Academy (1822) proved inconsequential for him. He studied nature on his many walking trips through the regions of the Tyrol, the Salzkammergut, and the Steiermark, and was drawn to the collections of seventeenth century Dutch and Flemish animal and landscape paintings at the galleries in Vienna, Dresden, and Munich, where he sketched after, among others, Wouvermann, Everdingen, Ruisdael, and Rubens. He wished to portray in his art living aspects of nature in totally integrated, organic patterns rather than follow in the footsteps of his artist father (Jakob Gauermann, 1773–1843) who painted traditional veduta with figural staffage. The original mood landscapes that resulted from this attitude excel in virtuoso effects of atmosphere, illumination, and integral figural movement. They are, moreover, pioneering achievements in the evolution of Viennese naturalism in landscape painting.

The most common themes of the over one thousand paintings by Gauermann include grazing cattle or deer, bears, fighting wolves, wild boars in wooded alpine settings; the hunt, travel scenes with overland coaches and their colorful retinue of passengers; superbly depicted teams of draft animals; village smithies and watering places, as well as occasional picaresque stagings of brigands and rogues. The freshness of vision and spontaneity of execu-

tion of his more than five hundred drawings and oil sketches done after nature forcefully challenge most of the negative critical evaluations of Gauerman's oeuvre written in the past.

In the 1830s Gauermann was enormously popular with the art-buying public in Vienna and throughout Europe. His canvases and panels then fetched record prices on European art markets. But in the 1840s, after he adapted a Munich variant of mood painting after the manner of his friends Rottmann, Bürkel (see entry in Catalogue), and Morgenstern, his paintings assumed a sweetly sentimental flavor that vitiates, in the opinion of some modern critics (e.g., A. Matáček) the quality of his later works. By 1848, the year of political upheavals and social revolutions, Gauermann's contemporary reputation had fallen suddenly and sharply. He did retain, however, a faithful if small following among patrons and collectors to the end of his life.

BIBLIOGRAPHY
C. E. Clement and L. Hutton, ARTISTS OF THE NINETEENTH CENTURY AND THEIR WORKS, Boston, 1884 (facsimile ed., St. Louis, 1969), Vol. I, pp. 283, 284. P. F. Schmidt, BIEDERMEIER MALEREI, Munich, 1923, pp. 56, 220. E. Krauland, "Das Werk Friedrich Gauermanns unter besonderer Berücksichtigung seiner Studien and Skizzen," Ph.D. dissertation, Vienna, 1952. S. Freiberg, AUSSTELLUNG DER BIBLIOTHEK DER AKADEMIE DER BILDENDEN KÜNSTE: DAS OSTERREICHISCHE ALPENLAND, FRIEDRICH GAUERMANNS HANDZEICHNUNGEN, ÖLSKIZZEN UND AUTOGRAPHEN, Vienna, 1954. R. Feuchtmüller, FRIEDRICH GAUERMANN, Vienna, 1962. K. Kaiser, DER FRÜHE REALISMUS IN DEUTSCHLAND, 1800–1850, Nürnberg, 1967. F. Novotny, PAINTING AND SCULPTURE IN EUROPE, 1780–1880, Baltimore, 1970, pp. 76, 113.

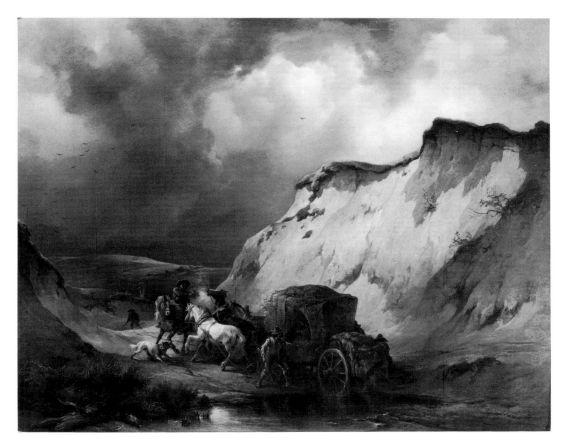

33
The Holdup (Räuberüberfall im Hohlweg)
October, 1847
 signed L.R.: F. Gauermann
 oil on wood panel, 16¹¹/₁₆ × 20⅜ (42.5 × 51.8)
 MAC cat. no. M 1971.72
Color plate page 28

A splendid and fully accomplished Gauermann that excels, in its ferocity of drama and ominous mood, anything done by Bürkel, the artist to whom Gauermann stood closest in spirit. "Brigand genre" of this kind filled the same psychological need in nineteenth-century German-speaking lands as the "Wild West" story does for us today: the thrill of danger and daring exploits safely enjoyed in the comforts of a soft easy chair. Earth and sand tones dominate the lower tier of the painting. Soft, billowy gray clouds fill the tall sky. Only the vest of the centrally placed figure sparkles with a ruby accent in this composition that, in a veritable *tour de force*, contrasts one massive area of "warm" monotones (all the earth passages) with that of the entirely "cool" sky. Yet the overall effect is one of a painting whose action, time, place, atmosphere, and color are totally integrated into a single expressive, light-filled mold.

PROVENANCE
Herr Leistler bought the painting from artist (see F. Gauermann, Einnahmebuch Gauermanns [manuscript p. 118], published by C. von Lützow in Zeitschrift für Bildende Kunst, 1883–84). Dr. A. Wodickk, No. 23, (ink on back of panel).

REFERENCE
R. Feuchtmüler, Friedrich Gauermann, Vienna, 1962, p. 190: "Ein Hohlweg; Räuber überfallen einen Reisewagen; herbstliche Luft, regnerisch; im Vordergrunde ein Sumpf, worin ein alter Baumstamm liegt und der Schädel eines Pferdes—Breite 1 Schuh, 7 Zoll, Höhe 1 Schuh, 4 Zoll.— Auf Holz." Selections from the von Schleinitz Collection; Exhibition, Paine Art Center, Oshkosh, Wisconsin, Feb. 1–20, 1972.

GEBLER, FRIEDRICH OTTO

b. September 18, 1838, Dresden
d. February, 1917, Munich
represented at many museums in Germany and at
Philadelphia

Like such artists as Voltz, Braith, Adam, Jutz (for
these see entries in Catalogue) and Mali, Gebler
specialized in animal paintings. Within that cate-
gory he again specialized in the depiction of sheep,
"rendering the unconscious humour of their man-
ners in masterly fashion" (Clement, p. 287). In this
modest pursuit he established a reputation that had
few equals.

After studies in Dresden (1854) Gebler entered the
studio of Karl von Piloty in 1858. He adapted that
teacher's coloristic still life treatment of subject
matter (but not, of course, his historical direction) to
his own ends. Gebler's paintings excel in very fine
chiaroscuro and they are not seldom enlivened by a
charming sense of humor. The large body of draw-
ings that he produced is justifiably famous for its
excellence. Gebler, who lived in Munich, was very
popular in his day and his paintings are scattered
throughout public collections in Germany.

BIBLIOGRAPHY
Catalogues of Exhibitions at the Academies of Dresden,
Berlin, and Munich in the years from 1855–1914. C. E.
Clement and L. Hutton, ARTISTS OF THE NINETEENTH CEN-
TURY AND THEIR WORKS, Boston, 1884 (facsimile ed., St.
Louis, 1969), Vol. I, pp. 287, 288. F. von Boetticher,
MALERWERKE DES NEUNZEHNTEN JAHRHUNDERTS, Vol. 1,
Dresden, 1891, p. 362. Thieme-Becker, KÜNSTLERLEXIKON,
Leipzig, 1907–50, Vol. XIII, p. 316. H. Uhde-Bernays, DIE
MÜNCHENER MALEREI IM NEUNZEHNTEN JAHRHUNDERT,
Vol. II, Munich, 1927, p. 78.

G
E
B
L
E
R

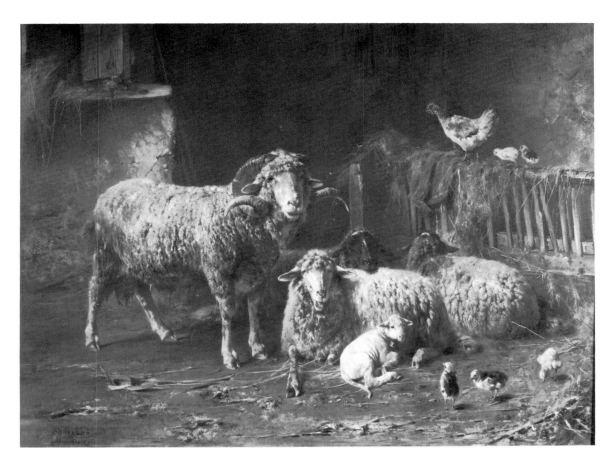

34
Sheep in Barn
 signed L.L.: Otto Gebler / München
 oil on canvas, 29⅞ × 39¾ (76 × 101.1)
 MAC cat. no. M 1972.11

This "sheep family" by Gebler is a technically flaw-
less *tour de force* in monochromatic composition.
The browns, golds, olive greens, and off-whites and
grays are extremely varied in the nuances of their
chromas and are woven into a rich and warm,
roughly textured painterly fleece.

REFERENCE
S. Wichmann, PAINTINGS FROM THE VON SCHLEINITZ COL-
LECTION (Catalogue), Milwaukee Art Center, 1968, No. 15,
illus. 21.

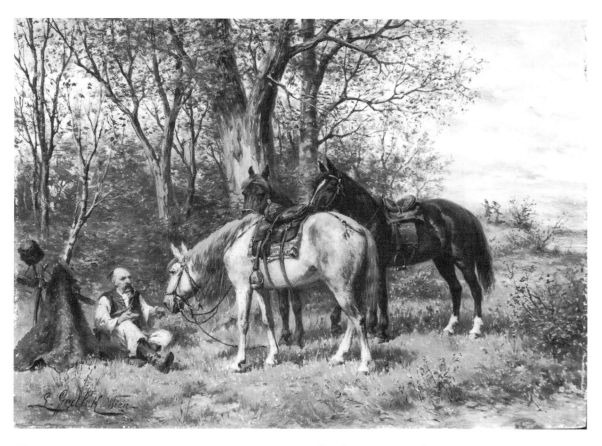

35
Horses and Soldiers
 signed L.L.: L. Gedlek Wien
 oil on wood panel, 6⅝ × 8¼ (16.8 × 21)
 MAC cat. no. M 1962.45

See description under entry **36**.

GEDLEK, LUDWIG
 b. June 30, 1847, Cracow
 d. unknown
 represented at Chemnitz (Karl-Marx-Stadt),
 Stockholm

After studies at the art school of Cracow and under Eduard Peithner Ritter von Lichtenfels (a follower of Carl Friedrich Lessing; see entry in Catalogue) in Vienna, Ludwig Gedlek was active in the Austrian capital, specializing in paintings of horses and hunting scenes.

BIBLIOGRAPHY
L. Eisenberg, Das Geistige Wien, Vol. I, Vienna, 1893. F. von Boetticher, Malerwerke des Neunzehnten Jahrhunderts, Vol. I, Dresden, 1891, p. 362. Thieme-Becker, Künstlerlexikon, Leipzig, 1907–50, Vol. XIII, p. 319.

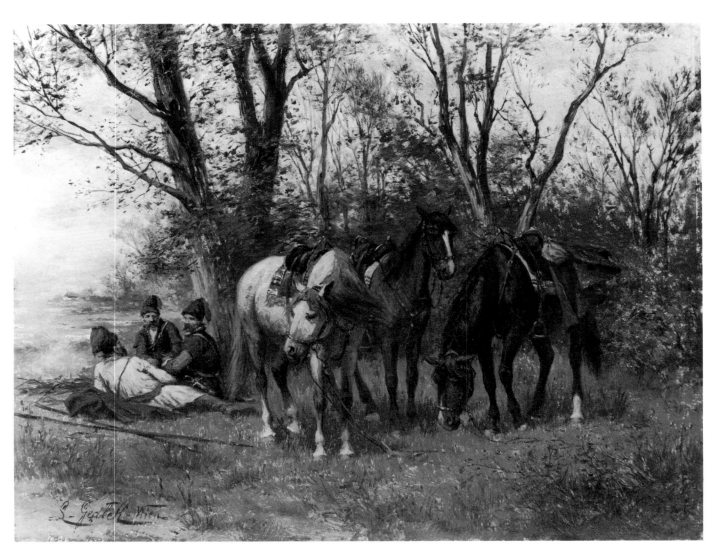

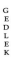

36
Horses and Soldiers
 signed L.L.: L. Gedlek Wien
 oil on wood panel, 6⅛ × 8¼ (15.6 × 21)
 MAC cat. no. M 1962.46

88

Both *Horses and Soldiers* (**35** and **36**) are high-keyed gesso panels and both use blond colors and feature a silvery sheen as a result of probable admixture of lead, especially in the very masterfully rendered tree and shrubbery passages. While the horses in these two near-miniatures are very well observed in their movement and anatomy, the figures seem somewhat wooden. Both are well united in terms of light, shade, tone, and atmosphere.

GRÜTZNER, EDUARD

b. May 26, 1846, Grosskarlowitz bei Neisse, District Oppeln, Silesia
d. April 3, 1925, Munich
represented at Cologne, Frankfurt, Leipzig, Mainz, Mannheim, Munich, Würzburg, and many other locations in Germany; Chicago, Philadelphia

The story of Grützner's life can, at least in part, be compared with that of the fictional artist-hero whose ascent from humble beginnings to "fame and fortune" is familiar fare to all readers of novels. By skilfully punctuating their yarn with sundry crises, adversities, and misfortunes, most authors in this genre try to make the point, if only for the sake of a "good story," that ultimate success can only be gained by their hero if he overcomes life's "awesome hurdles" through a "titanic struggle." But real life, once more, proves stranger, if not necessarily more gripping, than fiction: Grützner's spectacular success story was as undramatic as it was meteoric, for it was seemingly effortless. As it actually occurred, his career would make poor copy for a novel.

It is true that, as a young boy, Grützner helped his parents, dirt-poor farmers with seven children, to make ends meet by tending the flock in the fields. But because of his unusual talent for drawing he soon became in turn the protégé of the local village priest and of a relative of the family, the architect Hirschberg in Munich. Grützner went to that artistic capital in 1864 to study art. He did not heed the violent objections of his father who, as might be expected, equated the artistic calling with vagabondage. Upon his arrival in the city, Grützner repaired straight to Karl von Piloty, who liked what he saw in the young man's portfolio yet counseled him "to start from scratch and keep in touch with him." The next three years saw Grützner study in the academic preparatory classes of Hermann Dyk, the plaster cast copying studios of Hiltensperger and Krähhuber, and the painting class of Anschütz, whose *Korrekturen* (corrections) all young artists dreaded for their pedantry and despised for their late Cornelian austerity. Then, in 1867, Grützner was allowed to enter Piloty's advanced *Atelier*. There

he received the fruitful encouragement for which the master was worshipped and that had made his studio the most successful art class in Europe. (The sheer number of Piloty's students is startling. So is the fact that so very many of them became famous artists. But what is truly amazing is the fabulous variety of talents and the striking diversity of stylistic directions that he was able to foster.)

Feeling uncomfortable with Piloty's historical subjects, grand compositions, and dramatic staging of forces, but strongly influenced by his sensual textures, warm tonalities—the famed "Munich tone"—vibrant colorism, and effective chiaroscuro, Grützner struck out with an original subject, one that was to become both the basis for his subsequent worldly success as well as a fateful, limiting factor for his development as an artist: the subject of monks in the lighter moments of their lives. Piloty praised his *Im Klosterkeller* (*In the Monastery Cellar*) of 1869, Grützner's first "monastic *cum* vinous" production, as a "fine job" and wished him "good luck." And there was virtually no end to the good luck that was to come his way. *Im Klosterkeller* was the first and also the last painting for which Grützner had to seek (and very quickly find) a buyer. From that time onward to the end of his life buyers pursued *him*, guaranteeing for the artist a lifestyle comparable only to that of a wealthy prince. He became one of the most resplendent of the *Malerfürsten* of Munich.

Grützner's enormously large oeuvre—reliable total figures have yet to be compiled—is characterized by these qualities: incisive drawing, warm tones, sparkling colorism, fluid chiaroscuro, natural figure movement, simple "organic" stagings, and a psychologically intensified and universally comprehensible anecdotage. Significantly, the total effects of his paintings do not result from a cumulative inventory by the viewer of their wealth of detail—a common occurrence with naturalistic painters—but rather from a harmonious interplay of lightened and darkened passages, natural movement, oratorical gestures and characterizations, stagings, color, and drawing. In short, they are fully integrated in their content and form and they impress the spectator as wholly unified aesthetic experiences.

The bulk of Grützner's production falls into four broad subject categories: the pictures of monks, motifs from the theatrical stage (these two are the most plentiful and feature the largest number of often routinely executed variations on a theme), miscellaneous compositions of peasant, hunter, and tavern scenes, and, finally, portraits and still lifes. As to the first, the models (repeatedly used by Grützner) were provided by the Franciscan, Benedictine, and Augustinian friars and monasteries of Munich, the *Pfaffenwinkel* (a region dotted with cloisters southwest of the city), and especially *Kloster* Andechs there, as well as by convents in the Tyrol. Grützner, who was a Roman Catholic, in no way wished to offend pious sensibilities or censure monastic life by constantly depicting his friars imbibing wine or beer. On the contrary. None of his paintings qualifies as satire or shows the ugly side effects of alcohol. Instead, they portray sympathetically and humorously, with a sly hint of irony, the leisurely hours of monks in their "off duty" pursuit of the two carnal pleasures allowed them: eating and drinking. These he interprets as integral aspects of an orderly cultural life and he intersperses them with other witty depictions, as of monastic industries (e.g., brewing, wine making, etc.), housekeeping chores, kitchen genre, and especially

scenes in cloister libraries. Going even beyond his mentor Piloty in this respect, Grützner shows us all accouterments, and particularly the architectural settings, with the close fidelity of a naturalistic still life painter. He does so without even once skipping a beat of his unifying twin rhythms: those of form and narration.

Grützner's canvases of theatrical subjects were, if anything, in even greater demand than his monk genre. Already in his student years he was interested in Shakespearean subjects, and he received his first commission for such a painting from a Mr. Giles, an art fancier from London. It was a scene from *Henry IV*, namely the *Rekrutenmusterung Falstaffs* (*Falstaff Mustering Recruits*, first version, 1869). With the rotund, roguish, but amiable type of Falstaff, Grützner struck not only his finest characterization but also the one most sought after by collectors. Consequently, he created a whole gallery of serio-comic dramas, often featuring Falstaff as the central hero. "The figures from Shakespeare had always fascinated Grützner. He seemed to have memorized his dramas as if in a series of colorful and indelible pictures. He was better at it than historians of literature or the theater people, as many who had conversed with him soon found out to their amazement" (Ostini, p. 72).

Grützner was a habitué of the Munich theater, and he personally knew many principal directors and the great actors of the Munich stage. Falstaff, one of his most lively characterizations, can be traced back to at least two different models: a friend of his from his student years (his exact identity is lost) and "Pappa Kindermann," a popular Munich actor of Grützner's times. As with many of his characters, he is an amalgam of reality, invention, and caricaturistic license. Conversely, Grützner also frequently peopled his paintings with portrait likenesses of his friends, who appear in various costumes and roles.

Considering Grützner's penchant for portrait-like characterizations in his genre and his ceaseless patience in the minute description of all manner of accessory details, it is surprising to find relatively few actual portraits or still life paintings among his works. Those he did complete, especially in the latter category—he preferred flower arrangements—count as important nineteenth-century masterpieces. Of his innumerable portrait sketches and drawings, that of Carl Spitzweg (see entry in Catalogue) at his easel, an artist by whom he was fleetingly influenced in his early years, is the most memorable.

BIBLIOGRAPHY
L. Pietsch, CONTEMPORARY GERMAN ART: AT THE CENTENARY FESTIVAL OF THE ROYAL ACADEMY OF ARTS, BERLIN, Vol. II, London, 1888, pp. 70–71. F. Pecht, KUNST FÜR ALLE, Vol. V, 1890, pp. 177 ff. F. von Ostini, GRÜTZNER, Leipzig, 1902. R. Braungart, EDUARD GRÜTZNER, Munich, 1916. H. Karlinger, MÜNCHEN UND DIE KUNST DES 19. JAHRHUNDERTS, Munich, 1933 (2d ed., 1966), pp. 20, 21, 54, 60. R. von Schleinitz, "Grützner, Portrayer of Merry Art," THE AMERICAN-GERMAN REVIEW, Dec.-Jan. 1956–57, pp. 23–26.

The gallery of Grützners at the Milwaukee Art Center contains fifteen exhibits. These span the years from 1869 to 1908, the most productive four decades of his career. Moreover, except for *Falstaff Mustering Recruits* (**37**), the exhibits clearly demonstrate that Grützner's style, technique, and subject matter scarcely changed over all those many years. Conversely, not a single one of these paintings shows the slightest trace of journeyman-like, hurried, or unaffectionate execution. Grützner favored a warmly glowing palette and he was a master at bringing into play a vast register of umbers, sienas, and values of black and white; on occasion, he would heighten these with accents of carmine. His morbidezza is extraordinarily subtle and beautifully keyed to the dominant golden chromas. To achieve his deep patinas, he utilized the full range of techniques, including stippling, scumbling, scratching, and a variety of brush stroke lengths. Grützner's rich "tonal painting" typifies, in the realm of genre, the very best that the naturalistic phase of the late Munich School was capable of producing.

37
Falstaff Mustering Recruits
1869
> signed L.L.: Eduard Grützner
> oil on canvas, 30⅛ × 47⅛ (76.5 × 119.7)
> MAC cat. no. M 1971.69
Color plate page 29

When [the young] Grützner still had his studio at the academy, a certain Mr. Giles, an art lover from London, visited the institute. He saw the works of the young Silesian and wished to purchase a painting from him. The artist suggested "Falstaff mustering Recruits," from Shakespeare's *Henry IV, Part II*, and the Englishman agreed. Merrily, Grützner set to work on the project right away and produced, still in the year 1869, this picture that is so extraordinarily interesting for his development as an artist. (Ostini, p. 20)

This very early and important canvas by Grützner still stands foursquare under the influence of the Piloty school of "painted histrionics." The polychromatic palette also belongs to the young artist: it is rather high-keyed and features carmines, alizarine crimsons, slate blues, and mint and bottle greens. But the facial types, "recruited" from Grützner's many friends, anticipate his mature style. In later years, Grützner was to repeat, at least twice and in altered versions, the subject of Falstaff mustering recruits (e.g., Falstaff Cartoons, Breslau/Wroclaw).

REFERENCE
F. von Boetticher, MALERWERKE DES NEUNZEHNTEN JAHRHUNDERTS, Vol. I, Dresden, 1891, pp. 423 ff., No. 4. S. Wichmann, PAINTINGS FROM THE VON SCHLEINITZ COLLECTION (Catalogue), Milwaukee Art Center, 1968, No. 19. MIRRORS OF 19TH CENTURY TASTE: ACADEMIC PAINTING; Exhibition Handlist, Milwaukee Art Center, 1974, No. 36.

PROVENANCE
The painting was commissioned and purchased in 1869 by Mr. Giles of London, then sold by him to a party in Munich, and from there found its way to the United States (see Ostini, p. 20).

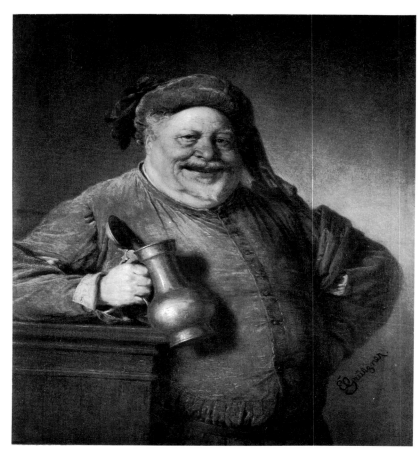

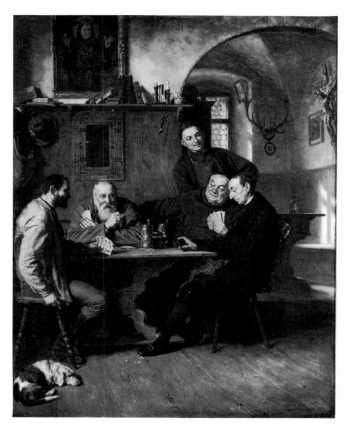

39
The Card Players
1883

 signed and dated L.R.: Eduard Grützner. 1883.
 oil on wood panel, 34¼ × 27¼ (87 × 69.2)
 MAC cat. no. M 1967.67

See description under Bibliography following essay
on Grützner.

PROVENANCE
Formerly belonged to Henrici's Restaurant, Chicago.

REFERENCE
S. Wichmann, PAINTINGS FROM THE VON SCHLEINITZ COL-
LECTION (Catalogue), Milwaukee Art Center, 1968, No. 16.

38
Falstaff
c. 1870–75 (?)
 signed L.R.: E. Grützner
 oil on wood panel, 15⅞ × 14⅜ (40.3 × 36.5)
 MAC cat. no. M 1962.71

See description under Bibliography following essay
on Grützner.

REFERENCE
R. von Schleinitz, "Grützner, Portrayer of Merry Art," THE
AMERICAN-GERMAN REVIEW, Dec.-Jan. 1956–57, p. 26
illus.

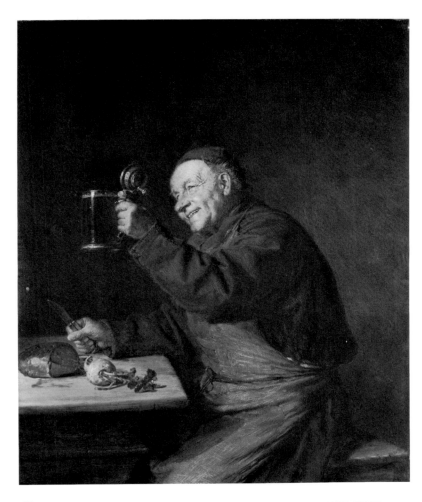

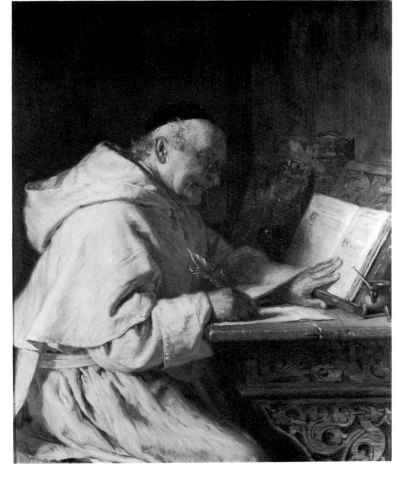

40
Prosit
1884
 signed and dated L.L.: Ed. Grützner. 84.
 oil on wood panel, 14 × 11½ (36.6 × 29.2)
 MAC cat. no. M 1962.89

See description under Bibliography following essay
on Grützner.

REFERENCE
"Malerei deutscher Meister des 19. Jahrhunderts in Mil-
waukee," DIE WELTKUNST, Vol. XV, Nov. 1956, p. 17, illus.
R. von Schleinitz, "Grützner, Portrayer of Merry Art," THE
AMERICAN-GERMAN REVIEW, Dec.-Jan. 1956–57, illus. p.
23. S. Wichmann, PAINTINGS FROM THE VON SCHLEINITZ
COLLECTION (Catalogue), Milwaukee Art Center, 1968, No.
20. T. Atkinson, "German Genre Paintings from the von
Schleinitz Collection," ANTIQUES, Nov. 1969, pp. 712 ff.,
illus. MIRRORS OF 19TH CENTURY TASTE: ACADEMIC PAINT-
ING; Exhibition Handlist, Milwaukee Art Center, 1974,
No. 35.

41
Monk at Desk
1886
 signed and dated U.L.: Ed. Grützner. 86
 oil on wood panel, 12 × 9¹¹⁄₁₆ (30.5 × 24.6)

See description under Bibliography following essay
on Grützner.

REFERENCE
THE AMERICAN-GERMAN REVIEW, Oct. 1951, p. 2.

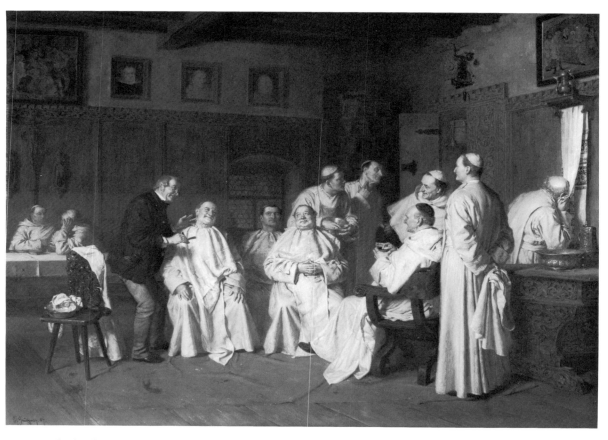

42
Shaving Day at the Monastery (Rasiertag im Kloster)
1887

 signed and dated L.L.: Ed. Grützner 87
 oil on canvas, 34⅜ × 45¾ (87.3 × 116.2)
 MAC cat. no. M 1972.118
Color plate page 30

In *Shaving Day at the Monastery* we can observe how masterfully Grützner was able to deal with the great art of arranging a larger number of persons in a limited space and to make them appear as if in movement and at ease. It is, above all, in the natural and free manner with

which all these figures relate to each other that we must seek, first and foremost, the secret of the viable and true effect of Grützner's paintings. . . . and as regards drawing, he had hardly been surpassed by any of the Old Masters, and certainly by none of the moderns. (Braungart, p. 24)

Of special note in this major painting by Grützner is the marvelously decorative color arrangement: a profusion of creamy and grayish off-whites punctuated with black accents is set against a foreground and background of orange-tinted sienas. (The two monks in conversation on the extreme left, while suggesting greater spatial depth, also seem to

"fall out" of context as something of a compositional afterthought.)

REFERENCE
F. von Boetticher, MALERWERKE DES NEUNZEHNTEN JAHRHUNDERTS, Vol. I, Dresden, 1891, p. 425, No. 58: "Rasiertag im Kloster. Elf im Refectorium versammelte Mönche sollen vom Dorfbarbier rasiert werden. Abb. "Kunst f. Alle" V.—Münch. KV., anfangs 87." F. von Ostini, GRÜTZNER, Leipzig, 1902, p. 36, Plate 30. R. Braungart, EDUARD GRÜTZNER, Munich, 1916, illus. 32. WISCONSIN COLLECTS; Exhibition Catalogue, Milwaukee Art Center, 1964, No. 74. S. Wichmann, PAINTINGS FROM THE VON SCHLEINITZ COLLECTION (Catalogue), Milwaukee Art Center, 1968, No. 21.

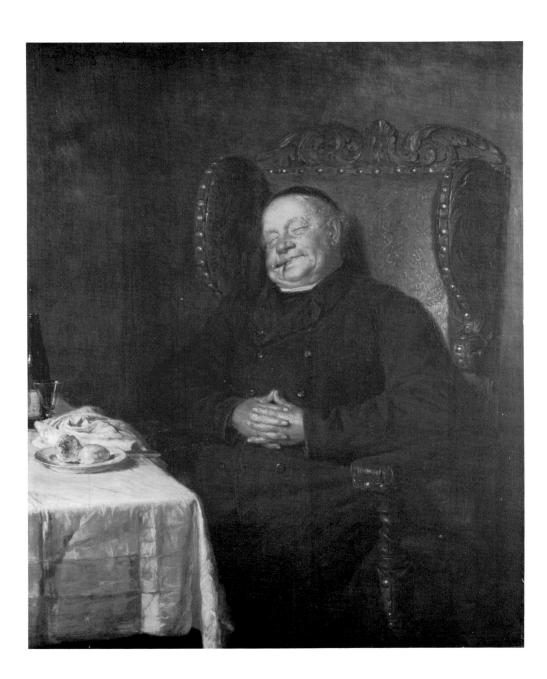

43
"Siesta" or *"Midday Nap" (Mittagsschläfchen)*
1888
 signed and dated U.L.: Ed. Grützner 88
 oil on wood panel, 15 × 11¾ (38.1 × 29.9)
 MAC cat. no. M 1962.59

See description under Bibliography following essay
on Grützner.

REFERENCE
F. von Boetticher, MALERWERKE DES 19. JAHRHUNDERTS,
Vol. I, Dresden, 1891, p. 425, No. 63: "Mittagsschläf-
chen.-Münch. Jub. A. 88." R. von Schleinitz, "Grützner,
Portrayer of Merry Art", THE AMERICAN-GERMAN REVIEW,
Dec.-Jan. 1956–57, p. 24, illus.

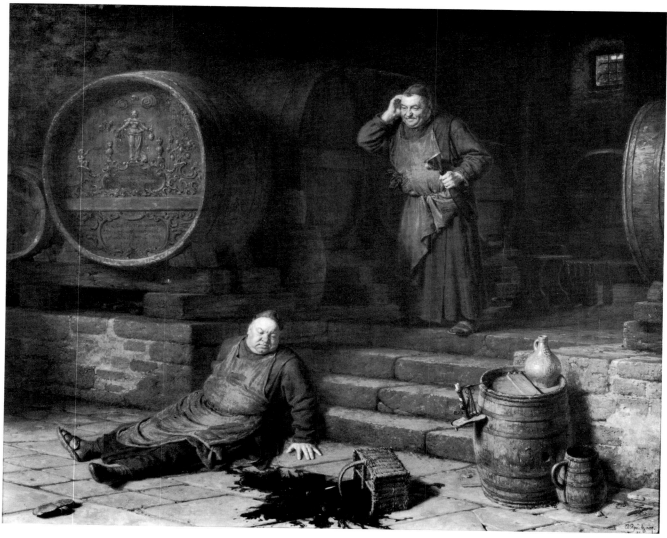

44
The Catastrophe (Der verunglückte Bruder Keller-meister)
1892

 signed and dated L. R.: Ed. Grützner / 92
 oil on canvas, 27½ × 34 (69.9 × 86.4)
 MAC cat. no. M 1962.92

See description under Bibliography following essay
on Grützner.

REFERENCE
F. von Ostini, GRÜTZNER, Leipzig, 1902, p. 21, No. 16.
R. Braungart, EDUARD GRÜTZNER, Munich, 1916, illus. 36.

R. von Schleinitz, "Grützner, Portrayer of Merry Art," THE
AMERICAN-GERMAN REVIEW, Dec.–Jan. 1956–57, p. 25,
illus. S. Wichmann, PAINTINGS FROM THE VON SCHLEINITZ
COLLECTION (Catalogue), Milwaukee Art Center, 1968,
No. 18.

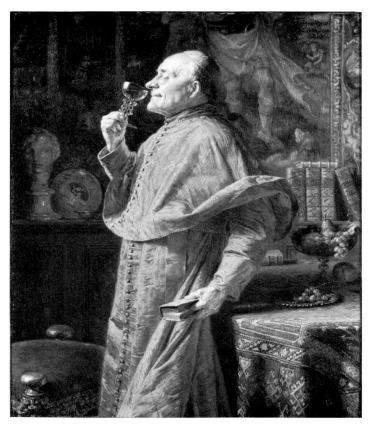

45
Still Life of Poppies (Roter Mohn)
1893
 signed and dated L.R.: Ed. Grützner. Aug. / 93
 on reverse: [undecipherable] / Grützner
 oil on canvas, 15¼ × 11⅞ (38.9 × 30.3)
 MAC cat. no. M 1972.12

See description under Bibliography following essay
on Grützner.

PROVENANCE
Formerly Collection Dr. A. E. Lampe, Munich; purchased
by René von Schleinitz from Adolf Weinmüller Auction 91,
Catalogue 99, Sept. 30–Oct. 1964, No. 1885, illustrated,
plate no. 135, titled "Red Poppies." Inscription listed as
Aug. 93.

46
The Cardinal
1895
 signed and dated U.R.: Ed. Grützner / 1895
 oil on canvas, 18 × 14¾ (45.7 × 37.5)
 MAC cat. no. M 1962.122

See description under Bibliography following essay
on Grützner.

REFERENCE
S. Wichmann, Paintings from the von Schleinitz Col-
lection (Catalogue), Milwaukee Art Center, 1968, No. 17,
illus. 33. Mirrors of 19th Century Taste: Academic
Painting; Exhibition Handlist, Milwaukee Art Center,
1974, No. 37.

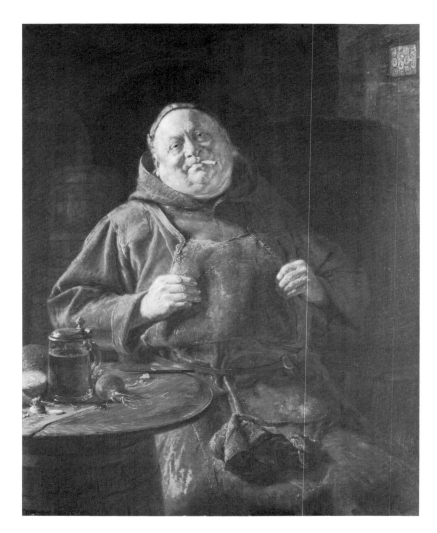

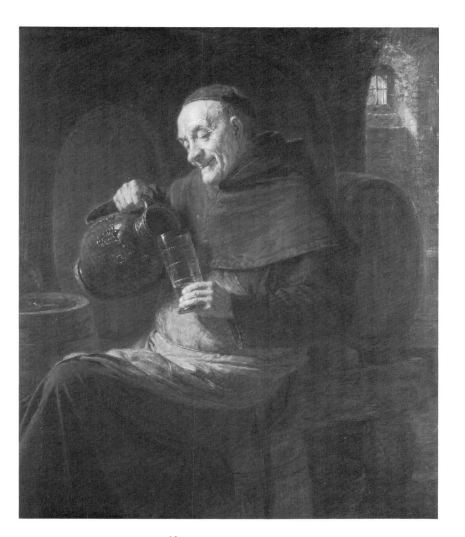

47
Monk Smoking Cigar
1897
 signed and dated L.L.: E. Grützner. 97.
 oil on canvas, 18½ × 15⅛ (47 × 38.4)
 MAC cat. no. M 1962.113

See description under Bibliography following essay
on Grützner.

PROVENANCE
H. S. Neumann, Munich.

48
Monk Pouring Wine
1898
 signed and dated L.R.: E. Grützner 98
 oil on canvas, 16¹¹⁄₁₆ × 14¼ (42.5 × 36.3)
 MAC cat. no. M 1972.16

See description under Bibliography following essay
on Grützner.

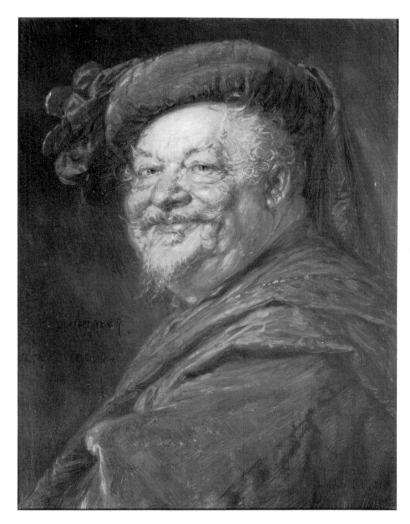

49
Falstaff
1900
 signed and dated on left: E. Grützner / 22.1.1900
 oil on wood panel, 7⁹/₁₆ × 5¹³/₁₆ (19.2 × 14.8)
 MAC cat. no. M 1962.133

See description under Bibliography following essay
on Grützner.

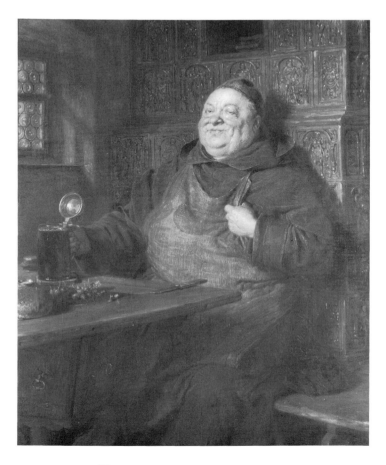

50
After the Meal (Nach der Mahlzeit)
1901
 signed and dated L.R.: Ed. Grützner / 1901
 oil on canvas, 19 × 15¾ (48.3 × 40)
 MAC cat. no. M 1962.131

See description under Bibliography following essay
on Grützner.

PROVENANCE
Purchased from Math. Lempertz Kunstversteigerungs-
haus, Cologne, Auction Catalogue 456, Nov. 11–14, 1959,
No. 227 in cat., illustrated, plate no. 24.

51
Wine Sampling in the Cloister Cellar (Weinprobe im
Klosterkeller)
1908
 signed and dated L.L.: E. Grützner / 1908
 oil on canvas, 20¹/₁₆ × 24 (51 × 61)
 MAC cat. no. M 1962.87

See description under Bibliography following essay
on Grützner.

REFERENCE
Variant of F. von Boetticher, MALERWERKE DES NEUN-
ZEHNTEN JAHRHUNDERTS, Vol. I, Dresden, 1891, p. 424, No.

40: "Weinprobe im Klosterkeller. Gest. von F.
Fraenbel.—Münch. int. KA. 83." R. von Schleinitz,
"Grützner, Portrayer of Merry Art," THE AMERICAN-
GERMAN REVIEW, Dec.–Jan. 1956–57, p. 26, illus.

HARTMANN, LUDWIG

b. October 28, 1835, Munich
d. October 20, 1902, Munich
represented at Chemnitz, Hamburg, Munich;
Philadelphia

A clear and consequent line of stylistic development can be traced in Munich animal painting from Wagenbauer, in the early part of the nineteenth century, via Bürkel (see entry in Catalogue) and Voltz (see entry in Catalogue) to its culmination in the pleinairism and Impressionism of Zügel (see entry in Catalogue) in the final decades of the century. A great many of the animal painters were self-taught. And so it was with Ludwig Hartmann. His brief academic studies, despite praise for his fine drawings, culminated in his dismissal "for lack of talent." Undaunted, he continued to study the Dutch Masters on his own and, consequently, felt the influence of other Munich specialists, especially that of J. A. Klein and Eduard Schleich the Elder (see entry in Catalogue), for example. Hartmann staked out for himself a narrow special subcategory in the field, namely an original treatment of working and draft horses and their woebegone lot. Painstaking study of detail, superb drawing, lively color sketches, several excellent etchings, and somewhat dry finished paintings characterize and make up his oeuvre.

It is not very easy to relate to Johann Friedrich Voltz [see entry in Catalogue] and his profound art, an art that is simultaneously filled with coloristic brilliance and human sympathy, an inner idyllic mood as well as clear dramatic movement, the two other Munich animal painters of importance. Among these, mention must be made, first of all, of Ludwig Hartmann, who, at least as a painter of horses, excelled above the average. The other was Chr. Mali. What is true about the difference between Schleich [see entry in Catalogue] and Voltz is similarly true for Voltz and Hartmann. Hartmann is an excellent *Kleinmaler* [miniaturist] whose horses, especially when they are surrounded by a genre-like staffage—a staffage that Hartmann had often added for him by such of his friends as Anton Seitz [see entry in Catalogue]—and even when they are viewed in their decoratively adjusted stage lighting, appear somewhat dwarfish. His scenes of villages, horse markets, etc. are perhaps best characterized if we place them in Schleich's wider sphere of influence without discerning in them a particularly noticable milestone of progressive development. (Uhde-Bernays, pp. 76, 77)

BIBLIOGRAPHY

F. von Boetticher, MALERWERKE DES NEUNZEHNTEN JAHRHUNDERTS, Vol. I, Dresden, 1891, p. 464. G. Hartmann, LUDWIG HARTMANN, EIN KÜNSTLERLEBEN, Munich, 1921. H. Uhde-Bernays, DIE MÜNCHENER MALEREI IM NEUNZEHNTEN JAHRHUNDERT, Vol. II, Munich, 1927, pp. 76, 77.

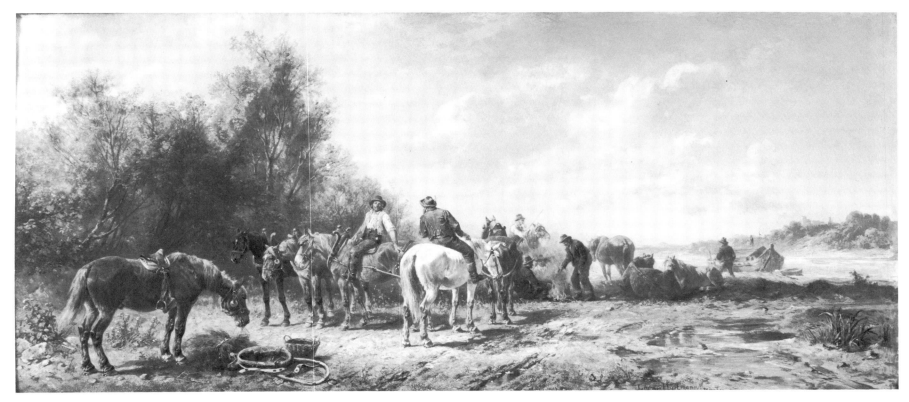

52
Tow Horses on the Inn River (Schiffszug auf dem Inn)
probably 1874
 signed L.R.: Ludwig Hartmann, München
 oil on wood panel, 13½ × 29⅝ (34.3 × 75.3)
 MAC cat. no. M 1969.57

102 This painting well represents Hartmann's luminist

treatment of his preferred subject matter: tired and worn-out horses. It is midday, and the scene is bathed in sunlight. The pony was celebrated by the "Romantiques" as a dashing symbol of indomitable nature. But nineteenth-century equine iconography here undergoes a profound change: the pitiable horse as nature enslaved and flayed.

REFERENCE
Possibly F. von Boetticher, MALERWERKE DES NEUN-ZEHNTEN JAHRHUNDERTS, Vol. I, Dresden, 1891, p. 464, No. 9: "Schiffszug auf dem Inn.—Münch. KV., Ende 74. Ein Bild 'Schiffsschlepper am Inn': Bremer KA. 80."

HESS, PETER VON

b. July 27, 1792, Düsseldorf
d. April 4, 1871, Munich
represented at Berlin, Darmstadt, Dresden, Kiel,
Mannheim, Munich

Peter von Hess was one of two outstanding members of an important artists' family named Hess. (The other was his brother Heinrich Maria.) He was the co-founder (with Albrecht Adam) of the new school of genre painting in Munich. Moreover, he subjected the species of battle painting to further stylistic advances above and beyond Wilhelm von Kobell, the major eighteenth-century German exponent of that genre. Lastly, and perhaps most significantly for art history, he acted as the catalyst and influential rallying point for all anti-academic artistic forces; he thus prepared the way for the Munich School of naturalism to flourish in the future.

Hess received his earliest training from his father, the engraver and academy professor Carl Ernst Christoph Hess. At the age of ten he already had executed excellent little etchings of animals. He entered the Munich Academy at the age of sixteen but left it soon afterward to pursue a naturalistic direction on his own. The seventeenth-century Dutch genre painters, on the one hand, and Adam, Dorner, and Wagenbauer, on the other, may have provided useful early stimuli for his art. But he ultimately developed his style on his own, on the basis of personal observations of life around him. These caused him to experience with freshness of vision and to depict with exciting vigor the habits and customs of the peasants in the Bavarian Alps and Italy. He did so without ever resorting to the later (and somewhat cloying) Munich practice of exploiting his subjects for didactic, sentimental, or humorous effects.

Spontaneous composition, precise description of detail, natural movement of figures, organic integration of staffage and landscape, and, above all, a crisply articulated and calmly unifying overall pictorial structure characterize his style. However, in utilizing a cool, polychromatic palette and local colors, he did not advance beyond the conventions of his period and toward the warm and painterly technique present in the mood landscapes of the succeeding generation of artists.

It was, above all, in the category of battle painting that Hess achieved an international reputation of the first rank. He earned that distinction by presenting truthfully and movingly innumerable scenes from the varied European military campaigns, as well as scenes of plunder, mischief, and minor skirmishes from their peripheries, to an eager audience that yearned for information about contemporary events and "history in the making." His services were so much in demand from a number of princes that he was constantly occupied with large-scale commissions for them. This circumstance explains why there are relatively few easel paintings by Hess.

Hess accompanied Count von Wrede on the 1813–15 French campaign and recorded his activities in battle. In 1833, on request from King Louis I of Bavaria, he joined Louis's son Otto on his journey to Athens and Nauplion, where he immortalized the ceremonies attending Otto's accession to the throne of Greece. Painting scenes from the Greek Wars of Liberation further enlarged his martial oeuvre and deepened the experiences of his nine-month-long Hellenic sojourn. In 1839 Tsar Nicholas I invited him to St. Petersburg to produce a series of paintings depicting highlights of the 1812 campaign. After visiting most of the battle sites, he worked for the next fifteen years on the completion of eight paintings on the major engagements of that war. Occasional work on genre and landscape paintings punctuated his declining years of activity.

Hess's renowned ability to marshal enormous crowds and countless portrait likenesses in sovereignly unified compositions hardly had a match in all of Europe; his only equal was the French horse and battle painter Horace Vernet; he surpassed Adam. In speaking of his Greek commissions, Oldenbourg comments: "Despite a tremendous display of the sharpest particulars in portraiture, costuming, genre, and landscape, Hess never succumbed to detail. Rather, he was always concerned with the wider scope of his artistic mission. He does not articulate his masses according to any formula but according to the natural motivation of the action at hand" (p. 120).

BIBLIOGRAPHY
C. E. Clement and L. Hutton, ARTISTS OF THE NINETEENTH CENTURY AND THEIR WORKS, Boston, 1884 (facsimile ed., St. Louis, 1969), Vol. I, p. 351. H. Reidelbach, KÖNIG LUDWIG I. VON BAYERN UND DIE KUNST, Munich, 1888. F. Pecht, DEUTSCHE KÜNSTLER DES 19. JAHRHUNDERTS, Vol. IV, Munich, 1895. ZEITSCHRIFT FÜR BILDENDE KUNST, New Series, Vol. XXVII, 1916, pp. 17–18. R. Oldenbourg, DIE MÜNCHENER MALEREI IM NEUNZEHNTEN JAHRHUNDERT, Vol. I, Munich, 1922, pp. 116 ff., and passim. P. F. Schmidt, BIEDERMEIER MALEREI, Munich, 1923, pp. 138, 222, and passim. C. Gurlitt, DIE DEUTSCHE KUNST SEIT 1800, Berlin, 1924, pp. 121, 123. H. Karlinger, MÜNCHEN UND DIE KUNST DES 19. JAHRHUNDERTS, Munich, 1933 (2d ed., 1966), pp. 16–18, 26–28, 67, 71. H. Beenken, DAS NEUNZEHNTEN JAHRHUNDERT IN DER DEUTSCHEN KUNST, Munich, 1944, pp. 184 ff., 285. K. Kaiser, DER FRÜHE REALISMUS IN DEUTSCHLAND, 1800–1850, Nürnberg, 1967, pp. 182, 183, and passim. T. Atkinson, "German Genre Paintings from the von Schleinitz Collection," ANTIQUES, Nov. 1969, p. 716. F. Novotny, PAINTING AND SCULPTURE IN EUROPE, 1978–1880, Baltimore, 1970, p. 78.

53
Plundering Cossacks
1826

> signed and dated L.R.: P. Hess 1826
> oil on wood panel, 15½ × 13½ (39.4 × 34.3)
> MAC cat. no. M 1962.138

Color plate page 31

This priceless early easel painting by Hess is distinguished by brisk and lively local colors (browns, black, greens, sands), a lucid sky, vigorous movement of figures, solid light and dark construction of volumes, and an engaging story from the life of the soldiers, his special thematic forte.

REFERENCE
S. Wichmann, PAINTINGS FROM THE VON SCHLEINITZ COLLECTION (Catalogue), Milwaukee Art Center, 1968, No. 22. K. Strobl, "Die Sammlung von Schleinitz," KUNST IM VOLK, Nos. 3/4, 1968–69, pp. 80–87, illus. p. 86. T. Atkinson, "German Genre Paintings from the von Schleinitz Collection," ANTIQUES, Nov. 1969, pp. 712 ff. illus. MIRRORS OF 19TH CENTURY TASTE: ACADEMIC PAINTING; Exhibition Handlist, Milwaukee Art Center, 1974, No. 40.

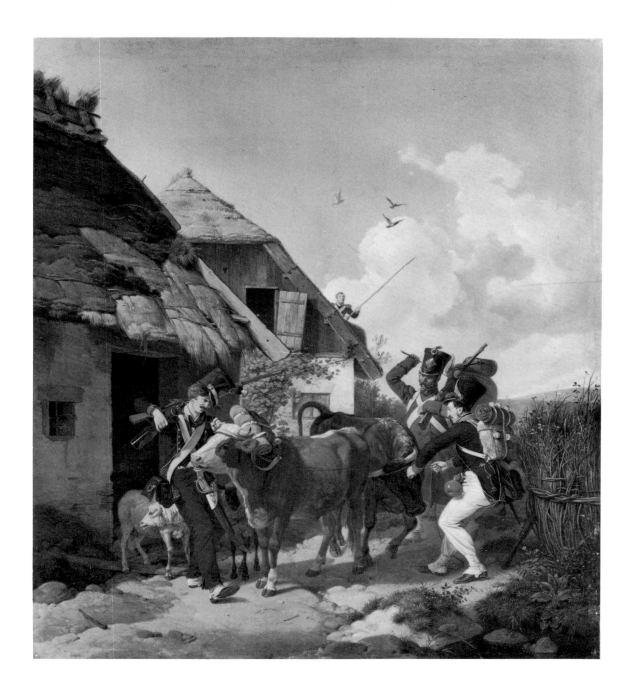

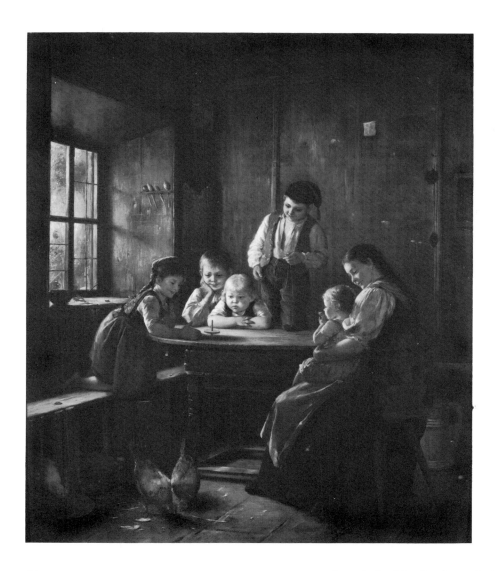

HEYN, AUGUST

b. August 10, 1837, Sophienau, duchy of
Saxe-Meiningen, Saxony
d. unknown
represented in private collections

The genre and portrait painter August Heyn received his artistic training first under Raupp and then under Defregger (see entry in Catalogue) at the Munich Academy. He was active in Munich and made study trips in Hesse, South Germany, the Tyrol, and Italy. His subjects, which derive mostly from the world of children and the peasantry, are often interpreted by him in a gently moralistic, humorous, or sentimental fashion. As often as not, all three of these qualities coincide in one picture. The titles of his works evoke his mild genre of domesticity, customs, and mores: e.g., *The Village Gossip, The Spinning Room, Love's Sorrows, Give Us This Day Our Daily Bread*, etc. His style, close to that of Defregger, to whose school he belonged, received high praises during his lifetime for its careful drawing technique and thoroughly detailed treatment of subject matter. He exhibited regularly in Munich exhibitions after 1864.

BIBLIOGRAPHY
KUNST FÜR ALLE, Vol. II, 1887. F. von Boetticher, MALER-WERKE DES NEUNZEHNTEN JAHRHUNDERTS, Vol. I, Dresden, 1891, p. 529. DAS GEISTIGE DEUTSCHLAND, Vol. I, 1898. KATALOG DER GLASPALAST-AUSSTELLUNG, Munich, 1894, p. 53; 1895, p. 16; 1897, p. 74; 1898, p. 108; 1899, p. 107; 1906. Thieme-Becker, KÜNSTLERLEXIKON, Leipzig, 1907–50, Vol. XVII, p. 36.

54
Spinning the Top
signed L.R.: Aug. Heyn / München
oil on canvas, 37⅝ × 31⅝ (95.6 × 80.3)
MAC cat. no. M 1970.117

A typically sentimentalized depiction of a scene characterized by the domestic tranquility preferred by Hess, as a minor follower of Defregger (see entry in Catalogue) and done in blacks, off-whites, and crimsons against a tobacco-colored ground.

PROVENANCE
Purchased by René von Schleinitz from Chicago Art Galleries Auction, Nov. 16–18, 1969, No. 85 in catalogue; illustrated. Formerly owned by Balaban and Katz Management Corporation.

REFERENCE
SELECTIONS FROM THE VON SCHLEINITZ COLLECTION; Exhibition, Paine Art Center, Oshkosh, Wisconsin, Feb. 1–20, 1972, illus. on cover.

HIRT, HEINRICH
b. unknown
d. unknown
represented in private collections

Heinrich Hirt was a German genre painter who was active in Munich in the 1870s and eighties. At that time he was represented in numerous German exhibitions.

BIBLIOGRAPHY
GARTENLAUBE, 1883. F. von Boetticher, MALERWERKE DES NEUNZEHNTEN JAHRHUNDERTS, Vol. I, Dresden, 1891, p. 543. Thieme-Becker, KÜNSTLERLEXIKON, Vol. XVII, Leipzig, 1907–50, p. 144.

55
Children with Kitten
signed L.R.: Heinrich Hirt / München
oil on canvas, 29¼ × 22⅞ (74.3 × 58.1)
MAC cat. no. M1972.114

Quite similar in mood and subject to Heyn (see previous Catalogue entry). Although the expressions of all four children are nearly identical and their rendering rather mechanical, the lighting technique is effective in establishing, however statically or photograph-like, the three-dimensional quality of the figural volumes. Several unrelated colors (in the clothing and pillow) appear against straw, sand, and umber background tones.

PROVENANCE
Orr's Gallery, San Diego, California.

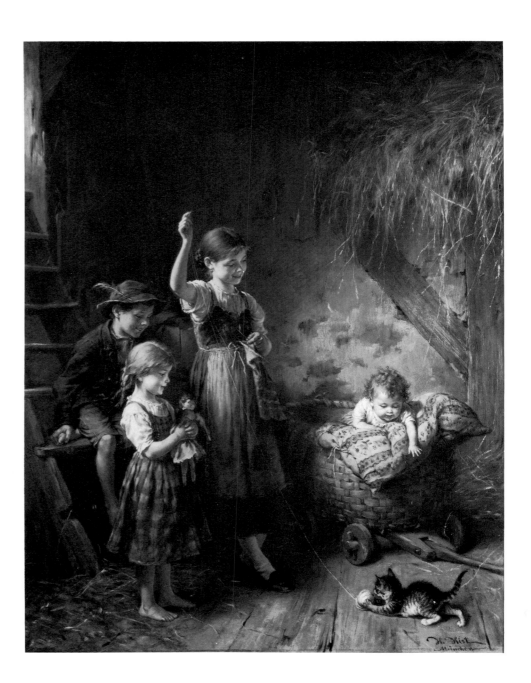

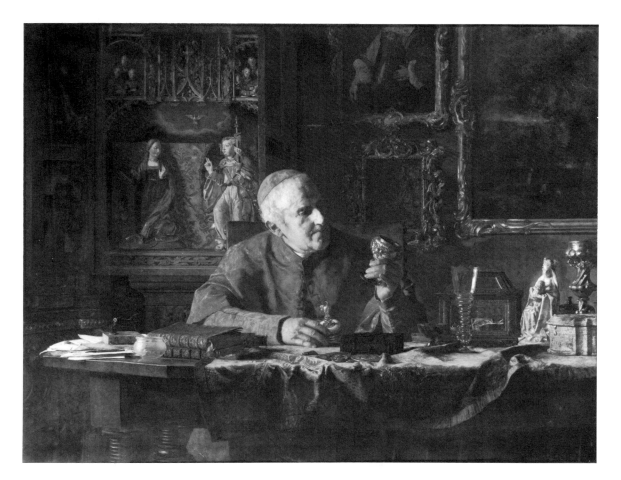

HOLMBERG, AUGUST JOHANN
b. August 1, 1851, Munich
d. October 7, 1911, Munich
represented at Berlin, Breslau, Leipzig, Munich,
 Philadelphia; private collections in England and
 the United States

August Johann Holmberg who, in the last decade of
his life, combined a successful career as painter with
that of museum curator (he was director of the Neue
Pinakothek in Munich after 1900) was trained at the
Munich Academy as well as under Wilhelm Diez
(see entry in Catalogue), whose follower he became.
Holmberg, who was a prominent artist after 1873,
produced a painterly, very colorful, and piously
sentimental genre centered on depictions of clerics
and monks as well as occasional Rococo costume
pieces. He was also a sought-after still life painter
and portraitist of the aristocracy.

BIBLIOGRAPHY
F. Pecht, GESCHICHTE DER MÜNCHNER KUNST DES 19. JAHR-
HUNDERTS, Munich, 1888, p. 266. F. von Boetticher,
MALERWERKE DES NEUNZEHNTEN JAHRHUNDERTS, Vol. I,
Dresden, 1891, pp. 565, 566. Thieme-Becker, KÜNSTLER-
LEXIKON, Leipzig, 1907–50, Vol. XVII, p. 391. H. Uhde-Ber-
nays, DIE MÜNCHNER MALEREI IM NEUNZEHNTEN JAHR-
HUNDERT, Vol. II, Munich, 1927, p. 114, 205, 208. H. Kar-
linger, MÜNCHEN UND DIE KUNST DES 19. JAHRHUNDERTS,
Munich, 1933 (2d ed., 1966), pp. 60, 75, 311.

56
The Latest Acquisition
possibly 1891
 signed L.R.: A. Holmberg
 oil on canvas, 44⅜ × 56⅝ (112.7 × 143.8)
 donor: Frederick Layton
 MAC cat. no. L 138

Holmberg, who was himself an ardent collector of
art, obviously relished depicting the various *objets
d'art* crowding the cleric's chamber. The saturated
cardinal red of the old man's robe provides a
ravishing foil for the muted "Old Master" browns,
lavish "Rembrandtian" golds, and muted moss
greens forming his surroundings. But it is, above
all, the marvelous pinks, caput mortuums, and
cream tones of the flesh parts, delivered in a very
painterly manner, that contrast most decoratively
with the darkling harmony of the other colors. Ulti-
mately, however, it is perhaps the strikingly true
characterization of the priest's intensely absorbed
facial expression that captivates the observer most
durably of all in this, one of the finest canvases by
Holmberg.

PROVENANCE
Layton Art Collection donated 1890–96.

REFERENCE
Possibly related to No. 37 (or to work[s] around it) in F. von
Boetticher, MALERWERKE DES NEUNZEHNTEN JAHRHUN-
DERTS, Vol. I, Dresden, 1891, p. 566.

JUNCKER, JUSTUS

b. July 24, 1703, Mainz
d. June 6, 1767, Frankfurt am Main
represented at Darmstadt, Dessau, Göttingen,
Grasse, Kassel, Mainz, Stuttgart

In recollecting his youth, Goethe referred often and affectionately to Justus Juncker, one of several painters who worked for his father, a major patron of the arts in eighteenth-century Frankfurt. He praised Juncker for his flower and fruit paintings, still lifes and his "clearly executed and quietly active figures done in the technique of the Dutch" (*Dichtung und Wahrheit*, p. 26). In discussing the then-practiced *Tapetenstil* (i.e., decorative "wallpaper-style," in which, not uncommonly, several artists would collaborate on one painting with their respective specialities, e.g., landscape, figures, animal staffage, etc.), Goethe observed that "Juncker, who was accustomed to the imitation of the most detailed Dutchmen, was least able to submit to the *Tapetenstil*; however, he would, for good payment, accommodate himself to decorating some sections with flowers and fruit" (ibid., p. 79).

Most charming of all is Goethe's reminiscence of an incident when, as a boy, he helped Juncker in executing an especially delicate flower panel commissioned by his father, by bringing the artist various flowers, butterflies, and beetles—it happened to be spring at the time—that he managed to get hold of. Juncker obliged him by including these offerings one by one in his creation. One day, the young Goethe brought him a mouse that he had caught and to humor the boy, Juncker also incorporated that lowly rodent into his composition by showing it nibbling on a sheaf of wheat placed at the foot of the vase. "I was, therefore, very surprised," Goethe continues, "when, shortly before the work was supposed to be delivered, the good man ceremoniously allowed that he no longer liked the picture. Although it had turned out fine in its details, it was, on the whole, not well composed because it had been created bit by bit, and because he had neglected at the beginning to sketch in a general plan for light, shadows, and colors according to which the individual flowers should have been put in order" (ibid., pp. 136 ff.). Goethe tells us further that afterward Juncker painted a substitute for that unfortunate collaborative effort with the young poet, and that, in the process, the latter had learned a good lesson in art.

Juncker, who arrived in Frankfurt as a boy, received there his earliest, albeit unfruitful, training in art from Johann Heinrich Schlegel. He then studied the Dutch Masters, especially Thomas Wyck, in the collection of Baron von Haeckel. His earliest independent works feature alchemists and scholars in their laboratories and studies. Subsequently, he entered upon a new phase of still life, flower, and fruit painting based on such Dutchmen as Jan Davidsz de Heem and van Huysum, for example. After a brief stint in London, he settled permanently in Frankfurt, where he belonged to the artists' circle around Goethe's father. Later on, he was kept busy with commissions for Count von Thoranc and his palatial residences in Provence. Eventually, Juncker discarded most of his overt, Dutch-influenced traits and, in so doing, also changed the nature of his genre from the former "exotic" to his later philistine and proto-*Biedermeier* accent on the comforts and convivial pleasures of the Frankfurt domestic scene. One of the most noteworthy stylistic qualities of Juncker's oeuvre is his fluid chiaroscuro.

BIBLIOGRAPHY
H. S. Hüsgen, Nachrichten von Frankfurter Künstlern und Kunstsachen, 1780. J. W. von Goethe, "Aus meinem Leben, Dichtung und Wahrheit" (1811–), in Goethes Werke, Hamburg, 1949–, especially Vol. XXI, pp. 26, 79, 136 ff. P. F. Gwinner, Kunst und Künstler in Frankfurt a. M. 1862. R. Bangel, J. G. Trautmann und seine Zeitgenossen, Vol. CLXXIII in Studien zur deutschen Kunstgeschichte, Strassburg, 1918. P. F. Schmidt, Deutsche Landschaftsmalerei von 1750–1830, Munich, 1922. R. Hamann, Die deutsche Malerei vom 18. bis zum Beginn des 20. Jahrhunderts, Leipzig and Berlin, 1925, pp. 31 ff.

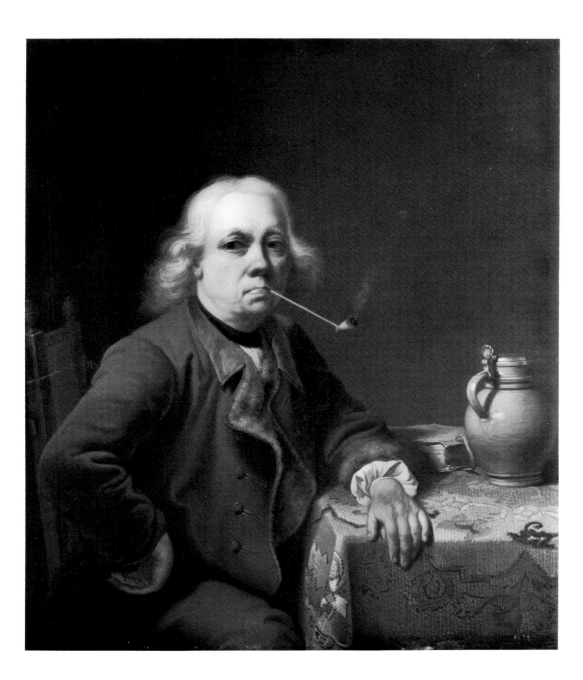

57
The Smoker
signed L.L.: J. Juncker fecit
oil on wood panel; 12 × 10⅜ (30.5 × 26.4)
MAC cat. no. M 1962.39
Color plate page 31

A humble but solid and direct portrayal of a citizen whose "honesty and virtue" are brought to the fore by means of classic compositional devices: near facial frontality, closeness of the subject to the observer, parallel placement of the table to the picture plane, a neutral and barren background, and sparseness of accouterments. The sitter's serious and straightforward demeanor and his intimate rapport with the viewer, in conjunction with the dimunitive detailing, costume, and scale of the painting, make this a "definitive" example of *Zopfstil* painting. In this respect, it easily stands on the level of a Graff or Chodowiecki. While the textures of fur, ceramic, and Persian rug are delightful in the precision of their effects, the chiaroscuro modeling is very fluid and the finish of the finest enamelled *Schmelz*. The flesh tones are peach-tinted, the rug light crimson, the rest mostly shades of gray. In addition to being a very fine work of art, this painting is also a priceless testimonial to the spiritual and moral values that prevailed in the period of eighteenth-century German "citizens' Rococo."

PROVENANCE
Amalien Stiftung, Germany.

J
U
N
C
K
E
R

109

JUTZ, CARL, THE ELDER

b. September 22, 1838, Windschlag, near Offenburg,
Baden
d. August 31, 1916, Pfaffendorf, near Coblenz,
Rheinland-Pfalz
represented at Breslau, Düsseldorf, Karlsruhe,
Königsberg, Leipzig, Mannheim; Philadelphia

Carl Jutz, whose formidable talent would easily have enabled him to become one of the great animal painters of all time, succumbed in his later years to dazzling pyrotechnics and surface glitter in works that are as minutely detailed as they are, on the whole, uneventful artistically. Despite or perhaps because of his (it would seem self-imposed) limitations in terms of subject matter, Jutz established a reputation that was second to none in his area of specialization, namely paintings of domestic poultry and wild fowl.

Trained in Munich and Düsseldorf, mostly autodidactically on the basis of studies after nature, Jutz was also influenced by the superb bird painter Gustav Süs of Düsseldorf. In the 1860s he began to produce small and intimate landscapes and paintings of fowl. The latter are especially startling in the magnificent glow of their colors and the powerful action of moving animals, as well as in their broad and fluid brushwork. But unlike Süs's life-sized works, Jutz's sprawling aviaries contain small and much more preciously rendered feathered beasts that "in their lively coloration and original conception are almost reminiscent of Japanese and Chinese bird pictures" (Schaarschmidt, p. 239). Perhaps most forcefully, we are reminded of the seventeenth-century Dutch Orpheus and Paradise pictures in the tradition of, for example, Jan Bruegel the Elder, Coninxloo, or Savery, whose jewel-like precision no doubt inspired Jutz.

The opalescent rainbow hues of majestic plumage in shifting patterns of light, the anthropomorphized animals acting out serio-comic dramas and droll anecdotes, and the lush landscapes that harbor them fuse to beautifully unified, iridescent gobelins in Jutz's best works. Later on, he no longer developed stylistically and his ever more elaborate avian productions became increasingly shallow pastiches of surface textural details often lacking a significant sense of artistic order. Jutz was extremely productive and he exhibited regularly from 1865 onward at Dresden, Munich, Berlin, and Düsseldorf.

BIBLIOGRAPHY
L. Pietsch, DEUTSCHE KUNST UND KÜNSTLER IN WORT UND BILD, Berlin, n.d., p. 31; L. Pietsch, CONTEMPORARY GERMAN ART: AT THE CENTENARY FESTIVAL OF THE ROYAL ACADEMY OF ARTS, BERLIN, Vol. II, London, 1888, pp. 66–67. F. Schaarschmidt, ZUR GESCHICHTE DER DÜSSELDORFER KUNST, Düsseldorf, 1902, pp. 239, 244. W. Cohen, 100 JAHRE RHEINISCHER MALEREI, in Kunstbücher deutscher Landschaften, Bonn, 1924, p. 22. R. Hamann, DIE DEUTSCHE MALEREI VOM 18. BIS ZUM BEGINN DES 20. JAHRHUNDERTS, Leipzig and Berlin, 1925, p. 335.

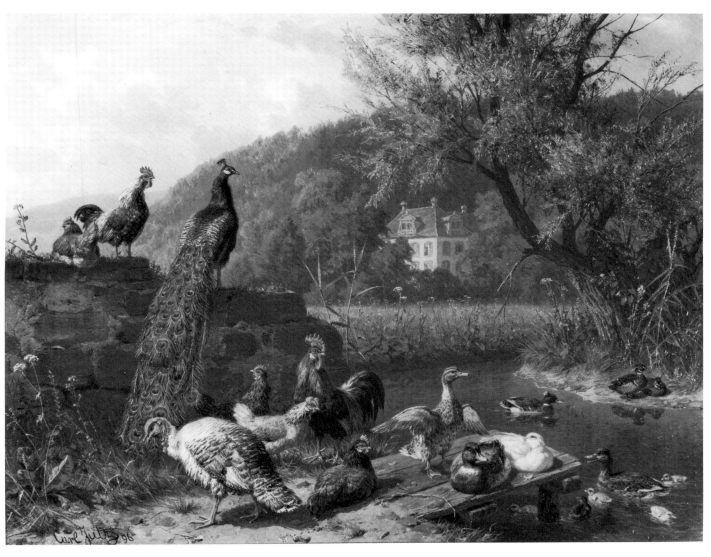

58
A Gathering of Fowl
1896
 signed and dated L.L.: Carl Jutz 96
 oil on canvas, 14¾ × 18½ (37.5 × 47)
 MAC cat. no. M 1962.116

A Gathering of Fowl (**58**) and *Ducks at Pond* (**59**) are two luscious little feasts for the eye. While both are green tinted, **58** is particularly aglow with luxuriant colors: iridescent verdigris, hooker greens, ultramarines, carmines, and ochres.

REFERENCE
S. Wichmann, Paintings from the von Schleinitz Collection (Catalogue), Milwaukee Art Center, 1968, No. 23. Mirrors of 19th Century Taste: Academic Painting; Exhibition Handlist, Milwaukee Art Center, 1974, No. 43.

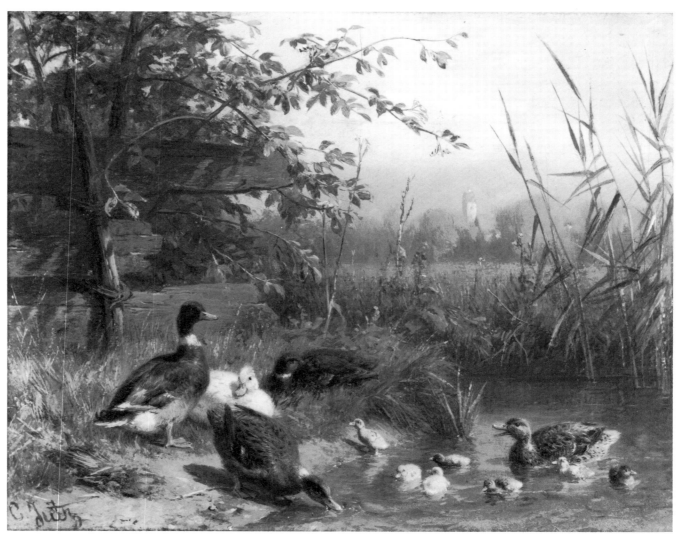

59
Ducks at Pond (Der Geflügelhof)

J
U
T
Z

 signed L.L.: C. Jutz
 oil on wood panel, 4¼ × 5⅛ (10.8 × 13)
 MAC cat. no. M 1972.106

PROVENANCE
Peikin-Mueller, Inc., Art Dealers, New York. Purchased
from Math. Lempertz Kunstversteigerungshaus, Cologne,
Auction Catalogue 448, Nov. 21–24, 1957, No. 302 in cat.,
illus., plate No. 36—titled "DER GEFLÜGELHOF".

See description under entry 58.

KALTENMOSER, KASPAR

b. December 25, 1806, Horb am Neckar, Württemberg
d. March 8, 1867, Munich
represented at Hamburg, Munich; private collections

After completing his training in lithography and a three-year stint at the lithography studio of Riemroth at Schweinfurt (1827–30), Kaspar Kaltenmoser entered the Munich Academy, where he remained for a period of six months (1830), copying after plastercasts under the tutelage of Heinrich Maria Hess. He did not, however, advance to the painting class prior to leaving school, in order to pursue, on his own, studies after nature. He liked to travel a lot and went on frequent sojourns to southwestern and southern Germany and to Austria, as well as Italy. In order to sustain such a lifestyle, he had, once again, to earn a living drawing on stone in the lithography shop of Bodmer in Munich. By 1833 Kaltenmoser had established his reputation as a genre painter and could forthwith devote himself fully to painting.

Various domestic genre, especially a type featuring peasants at minor toils and at play in their cozy huts, soon became Kaltenmoser's thematic mainstay. The later 1840s and early 1850s saw him reach the peak of his creativity. Contemporary criticism of his art took note of a curious stylistic discrepancy in his work, namely that which lies between his jovial naturalism and a Dutch-like naiveté, on the one hand, and his penchant for idealization and "beautification" of some elements in his compositions, on the other. Uhde-Bernays singles out his drawings for special praise. Kaltenmoser's style leaned toward volumatic modeling, strong contours, and crisp drawing, and he preferred distinctly polychrome schemes to a chiaroscuro treatment of light and shade. Kaltenmoser exhibited in very many important German art centers during his lifetime, most notably with the Münchner Kunstverein.

BIBLIOGRAPHY
A. Raczynski, GESCHICHTE DER MODERNEN KUNST, Berlin, 1836–41, vol. II. pp. 401–2. DEUTSCHES KUNSTBLATT, 1855, pp. 143, 356; 1856, p. 444; 1857, p. 135. ZEITSCHRIFT FÜR BILDENDE KUNST, Vol. II, 1867, p. 103. F. von Boetticher, MALERWERKE DES NEUNZEHNTEN JAHRHUNDERTS, Vol. I, Dresden, 1891, pp. 637–38. R. Oldenbourg, DIE MÜNCHENER MALEREI IM NEUNZEHNTEN JAHRHUNDERT, Vol. I, Munich, 1922, p. 144.

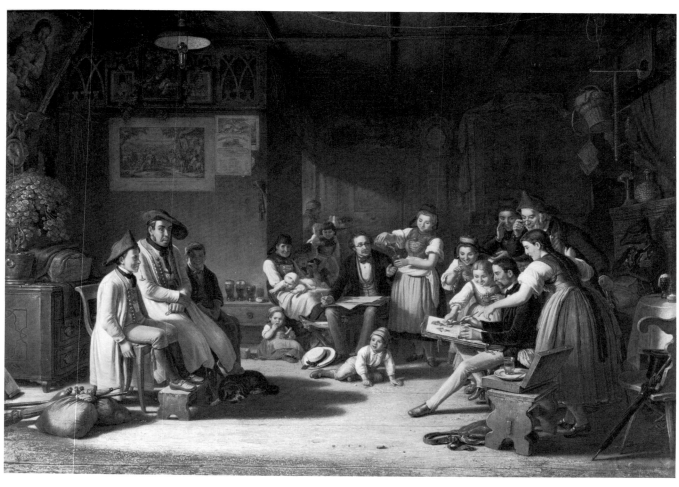

60
The Artists' Visit
possibly 1860
 signed L.R.: C. Kaltenmoser/munchen; date difficult
 to decipher
 oil on canvas, 30¼ × 40½ (77 × 103)
 MAC cat. no. M 1971.75

Two itinerant artists amaze and delight, and are in
turn regaled by, naïvely grateful countryfolk in a
setting of a rich farmer's *gute Stube*. A combination

of idealized components (e.g., woman, right fore-
ground) and tightest naturalism (e.g., three sitters
on left) in conjunction with myriad details and a
checkered polychromaticism lends a note of the
"neo-primitive" to this major canvas by Kalten-
moser. But his splendid knack for anecdotal narra-
tion and uniform handling of light as well as his
persistent, curiously idiosyncratic sense of form
provides this painting with unity and, moreover,

with a memorable feeling of wilful inevitability,
integrity, rightness.

PROVENANCE
Orr's Gallery, San Diego, California; or Maxwell Galleries,
San Francisco, California.

REFERENCE
Spectacle of Realism; Exhibition Catalogue, Mint
Museum of Art, Charlotte, North Carolina, 4/15–5/17,
1970, No. 30, date listed as 1860.

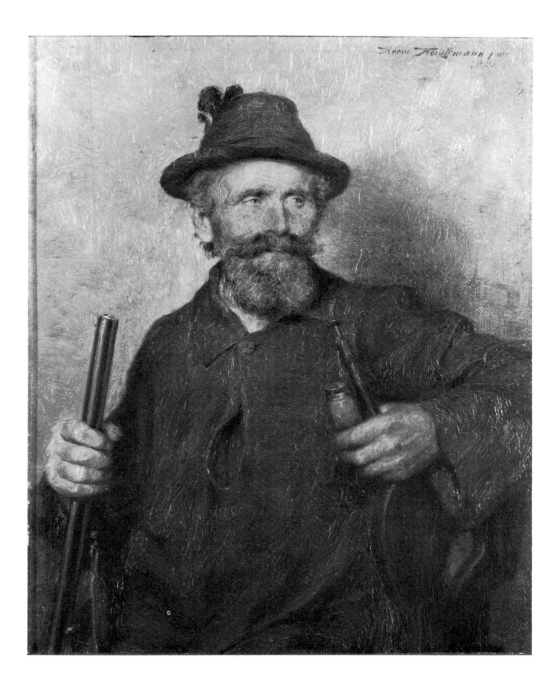

KAUFFMANN, HERMANN, THE YOUNGER

b. February 27, 1873, Munich
d. unknown
represented in private collections

Hermann Kauffmann the Younger was the grandson of Hermann Kauffmann the Elder, the famous Hamburg *Biedermeier* master of landscapes and genre, and the son of Hugo Wilhelm Kauffmann (see following Catalogue entry). He received his training at the Munich *Gewerbeschule* (technical school) and through private lessons in art from Paul Nauen in the same city. He undertook a study trip to Italy in the mid-1800s and, thereafter, lived first in Hamburg and later on in Munich. Kauffmann gained his reputation as a portraitist, ranging from miniature to life-sized figures. In addition, he did a good number of genre pieces from the Upper Bavarian folk scene as well as boudoir subjects. From 1899 onward, Kauffmann showed periodically at the Munich Glaspalast, whose exhibitions were coveted by most artists as a means to fame.

BIBLIOGRAPHY
Thieme-Becker, KÜNSTLERLEXIKON, Leipzig, 1907–50, Vol. XX, p. 8. W. Dressler, KUNSTHANDBUCH, Vol. II, Dresden, 1909.

61
The Hunter
probably 1920
 signed and dated U.R.: Herm. Kauffmann, jun. / 1920
 [date hard to decipher; may be 1890]
 oil on wood panel, 8⅛ × 6⅜ (20.7 × 16.2)
 MAC cat. no. M 1962.130

Grayed, olive green coat and hat, light gray background, impastoed, mottled matière: competent but "thin" and uneventful in all major respects.

KAUFFMANN, HUGO WILHELM

b. August 7, 1844, Hamburg
d. December 30, 1915, Prien am Chiemsee, Bavaria
represented at Bremen, Frankfurt, Hamburg,
Munich, Stuttgart; Melbourne, Prague

Hugo Wilhelm Kauffmann was the son of Hermann Kauffmann the Elder, the famous Hamburg *Biedermeier* master of landscape and genre, and the father of Hermann Kauffmann the Younger (see previous Catalogue entry). He received his first art training from the brothers Gensler in Hamburg. (Günther, Jakob and Martin Gensler were important representatives of *Biedermeier* portrait, landscape, and genre painting.) From 1861 to 1863 he studied under Jakob Becker (a genre painter trained at the Düsseldorf Academy) and Edward Steinle at the Städelsches Kunstinstitut in Frankfurt am Main. Thereafter, Kauffmann lived in Cronberg im Taunus, for half a year (1867) in Düsseldorf, and then, for a year and a half, in Paris until the outbreak of the Franco-Prussian War caused him to leave. After 1871 he resided in Munich and in his villa in Prien, on the Chiemsee, southeast of the city.

Kauffmann's position in the popular School of Munich, while noteworthy, did not reach the level of eminence that his father attained by leading the North German School in Hamburg. While in Munich, he developed a style that is, at least in part, based on such Dutch models as A. van Ostade and A. Brouwer, and characterized by small formats, a brownish palette, warm overall tonalities, and a very fine perception of chiaroscuro lighting. A late Hamburg *Biedermeier* devotion to detail, a penchant for straightforward drama and relatively large

figures in line with the bias of the Düsseldorf academics, as well as the glowing, suffused radiance of the modern Munich School: these reflect the influences he received and they summarize his style. His subjects are Bavarian peasants and small-town folk, usually posed in the interiors of inns or rural dwellings. His paintings are redolent with humor as well as with a kind of sentimentality that is the special province of North German tourists experiencing their Bavarian backwoods vacation haunts: a curious mixture of admiration and disdain, enthusiasm and amusement. This element of bemused fascination blends most effectively with Kauffmann's masterful use of agile lines to describe movement and space in his several large drawing cycles, such as *Biedermänner und Konsorten*, or *Spiessbürger und Vagabunden*. These echo in the dimension of art the contents of such literary satirical journals as the perennial Munich *Fliegende Blätter* (founded in 1844) and, incidentally, also vied for the same audience. Kauffmann's oeuvre is extraordinarily large.

The inconstant critical fortunes of the whole popular Munich School of genre painting can be traced on the basis of those experienced by Kauffmann. These changing values enter prominently into view when we observe that in 1888 Pecht's discussion of Wilhelm Leibl is sandwiched in between that of Mathias Schmid (a minor Aus-

trian genre painter and disciple of Piloty; see description of **113**), on the one hand, and Hugo Kauffmann, on the other! Uhde-Bernays's scale (1927) already tips dramatically in favor of the non-literary and non-anecdotal "pure" Realism of Leibl while still, on the whole, attempting to maintain a "balanced perspective." But Karlinger's judgment (1933), the belated product of a 1920s "new criticism" mentality, seems to "seal the fate" of Kauffmann. Having thus reached its nadir but at no time losing its place of affection in the hearts of the people, the popular Munich School can go nowhere but up in critical esteem. And that is precisely the direction toward which virtually all prominent signs seem to be pointing at the present time.

BIBLIOGRAPHY

F. Pecht, Geschichte der Münchner Kunst des 19. Jahrhunderts, Munich, 1888, p. 345. F. von Boetticher, Malerwerke des Neunzehnten Jahrhunderts, Vol. I, Dresden, 1891, pp. 652–54. H. Weizsäcker and A. Dessoff, Kunst und Künstler in Frankfurt a. M., Vol. II, Frankfurt a. M., 1909, p. 71. H. Uhde-Bernays, Die Münchner Malerei im Neunzehnten Jahrhundert, Vol. II, Munich, 1927, p. 202. H. Karlinger, München und die Kunst des 19. Jahrhunderts, Munich, 1933, p. 47. Die Weltkunst, Vol. XV, Nov. 1956, p. 17, illus. R. Darmstaedter, Künstlerlexikon, Bern and Munich, 1961, p. 240. T. Atkinson, "German Genre Paintings From the von Schleinitz Collection," Antiques, Nov. 1969, p. 716, illus.

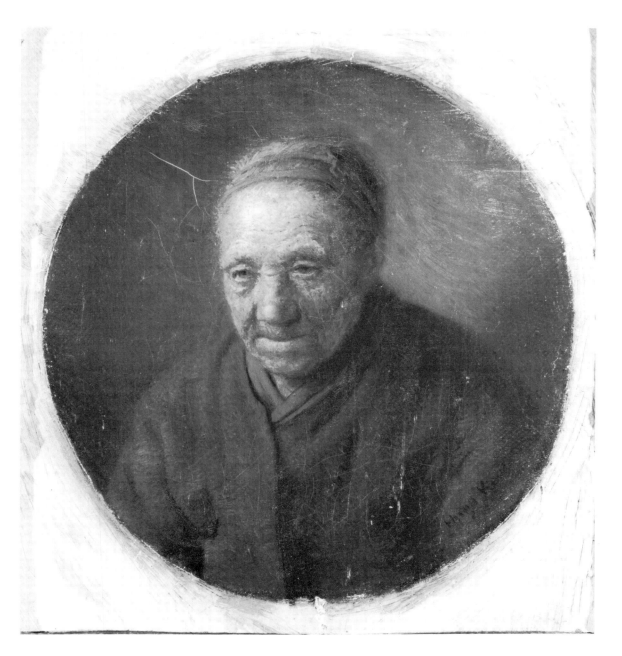

62
Character Head of a Woman
1864

> signed and dated L.R.: Hugo Kauffmann 64
> oil on canvas, 7⅛ × 6½ (18.1 × 16.5)
> MAC cat. no. M 1962.134

The gallery of works by Kauffmann at the Milwaukee Art Center comprises seventeen paintings, mostly panels, and spans five decades (1864–1910), or the whole creative lifetime of the artist. Since Kauffmann did not vary in the constantly high quality of craftsmanship and the affection he held for his chosen subject matter, all of these exhibits are characterized by uniform excellence. With the exception of this quite early work, they are all "vintage" Kauffmanns, some being more, some less ambitious in terms of the size and the numbers of figures depicted.

All the general stylistic criteria cited in the essay on Kauffmann preceding this entry hold true of these exhibits. Beyond that, mention should be made of some of the following technical and stylistic preferences of Kauffmann: scumbling with graying washes, especially of umbers, sienas, and terre vertes, in order to neutralize their effects and to achieve various textural illusions; painterly application of pigments; a non-structured or dynamic brush stroke (one that follows or describes forms in contour fashion); lively, moving matières; very frugal usage of bright colors; sparingly applied accents of scumbled lakes, ultramarines; overall tones resembling the warm, muted shades of coffee, tobacco, moss.

63

The Old Tramp

1872

 signed and dated L.L.: Hugo Kauffmann 72
 oil on wood panel, 8½ × 6 (21.6 × 15.2)
 MAC cat. no. M 1972.125

118 See description under entry **62**.

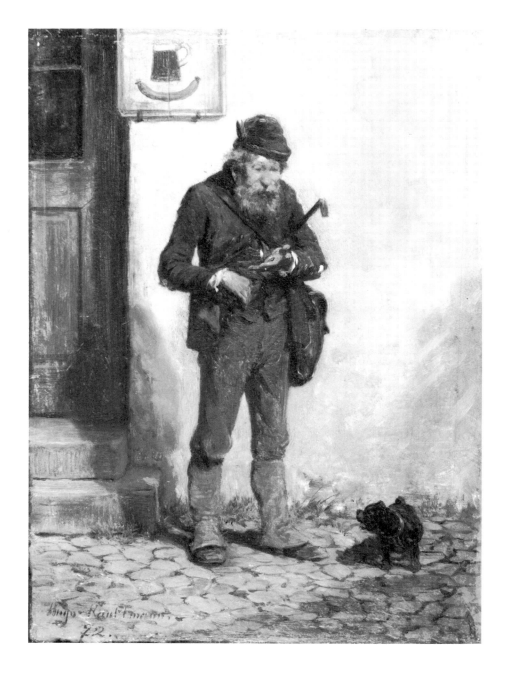

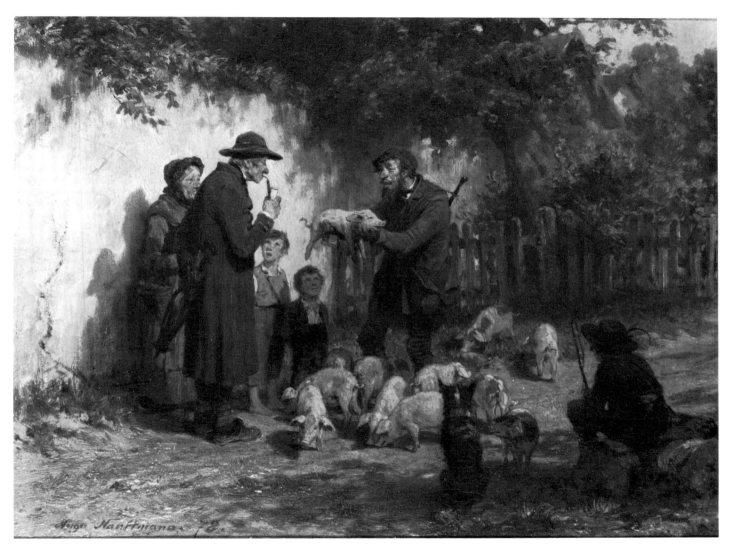

64
Making a Sale
1878
 signed and dated L.L.: Hugo Kauffmann 78
 oil on wood panel, 7⅞ × 10⅛ (20 × 25.7)
 donor: Frederick Layton (gift of 1916)
 MAC cat. no. L.1916.6

See description under entry **62**.

65
Man with a Tassel Cap
1879
 signed and dated L.L.: Hugo Kauffmann 79
 oil on wood panel, 12¼ × 9¾ (31.1 × 24.8)
 MAC cat. no. M 1962.96

See description under entry **62**.

REFERENCE
S. Wichmann, Paintings from the von Schleinitz Collection, (Catalogue) Milwaukee Art Center, 1968, No. 26, illus. 30. T. Atkinson, "German Genre Paintings from the von Schleinitz Collection," Antiques, pp. 712 ff., Nov. 1969, p. 716, illus.

H.
W.
K
A
U
F
F
M
A
N
N

120

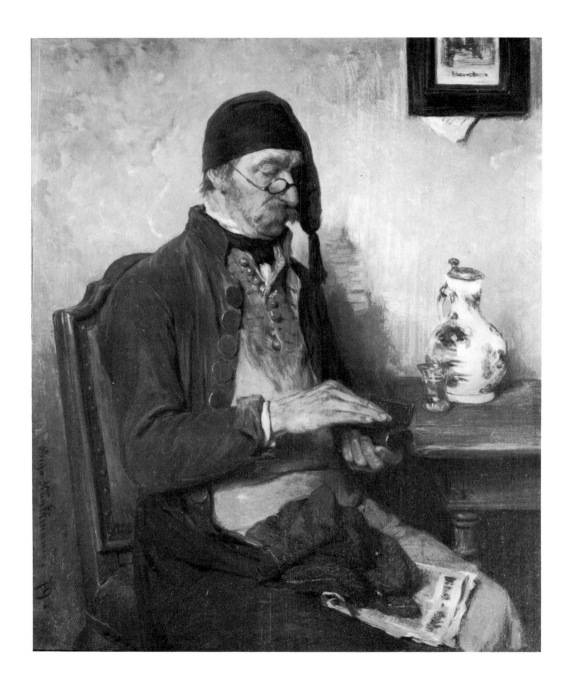

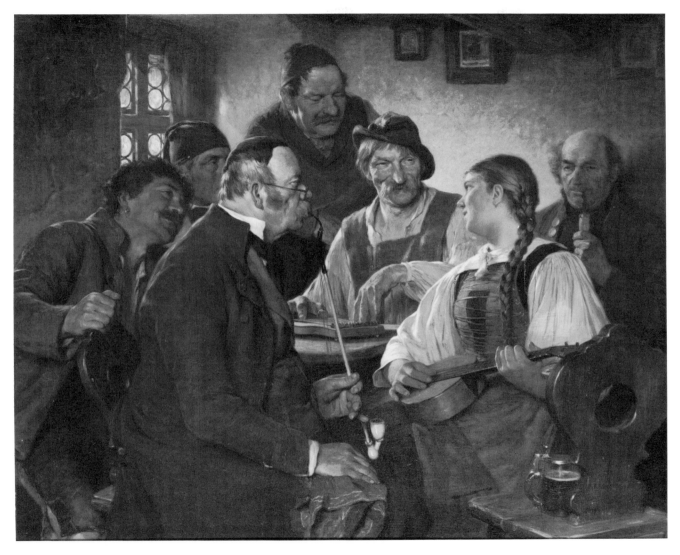

66
The Zither Player
1879
 signed and dated L.R.: Hugo Kauffmann 79
 oil on wood panel, 14⅝ × 18 (37.2 × 45.7)
 donor: Frederick Layton
 MAC cat. no. L.126

See description under entry **62.**

PROVENANCE
Gift of Frederick Layton, sometime between 1890–96.
Adolph Kohn, Art Dealers, New York, label no. 1400.

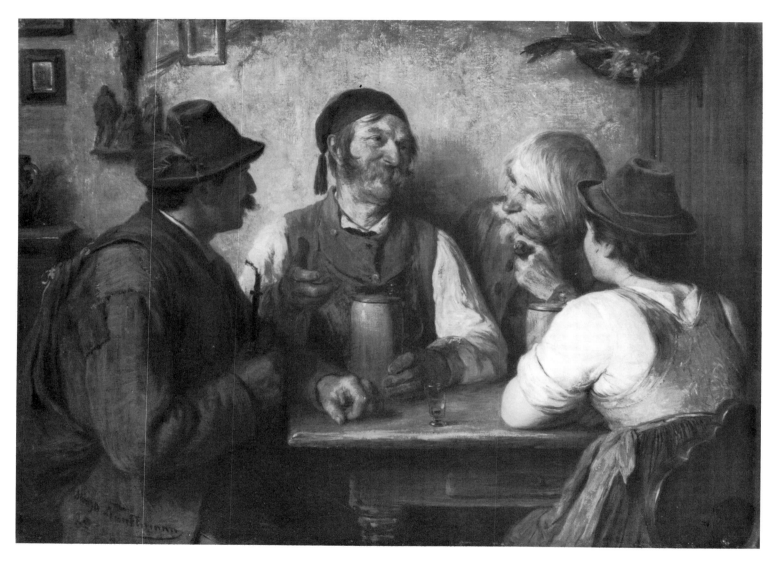

67
Company at the Table (Tischgesellschaft)
1880
 signed and dated L.L.: Hugo Kauffmann/80.
 oil on wood panel, 9 × 12³⁄₁₆ (22.9 × 31)
122 MAC cat. no. M 1962.69

See description under entry **62**.

REFERENCE
DIE WELTKUNST, Vol. XV, Nov. 1956, p. 17, illus.

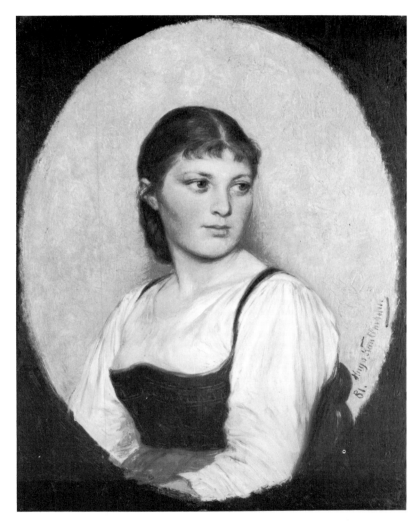

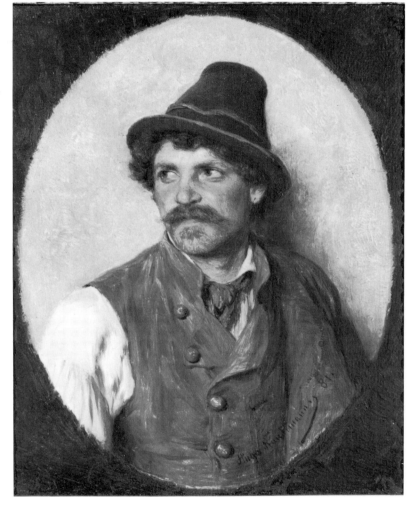

68
Portrait of a Peasant Woman
 (Pendant of Cat. No. 69)
1881
 signed and dated on right edge: Hugo Kauffmann/81.
 oil on wood panel, 7⅛ × 5½ (18.1 × 14)
 MAC cat. no. M 1962.65

See description under entry **62**.

PROVENANCE
Peikin-Mueller, Inc., Art Dealers, New York.

REFERENCE
THE AMERICAN-GERMAN REVIEW, Oct. 1951, illus. on cover.

69
Portrait of a Peasant Man
 (Pendant of Cat. No. 68)
1881
 signed and dated L.R.: Hugo Kauffmann / 81
 oil on wood panel, 6¹¹⁄₁₆ × 5⁹⁄₁₆ (17 × 14.1)
 MAC cat. no. M 1962.66

See description under entry **62**.

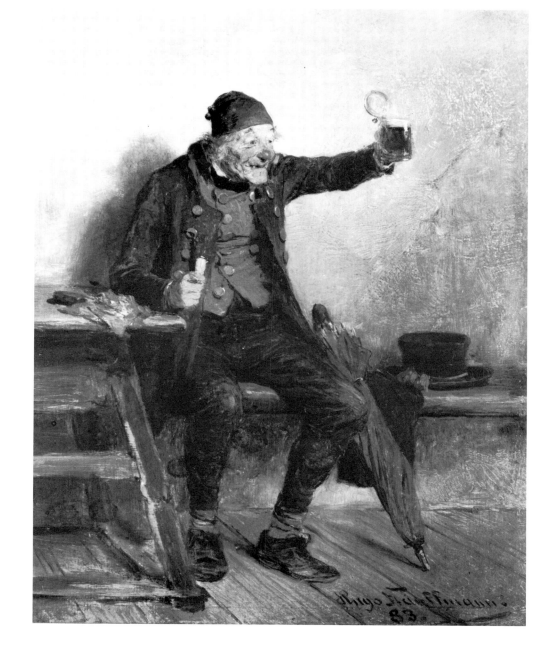

70
Peasant with Tankard of Beer (Bauer beim Bier)
1883
 signed and dated L.R.: Hugo Kauffmann/83
 oil on wood panel, 5¹³⁄₁₆ × 4⁹⁄₁₆ (14.8 × 11.6)
 MAC cat. no. M 1962.82

124 See description under entry **62**.

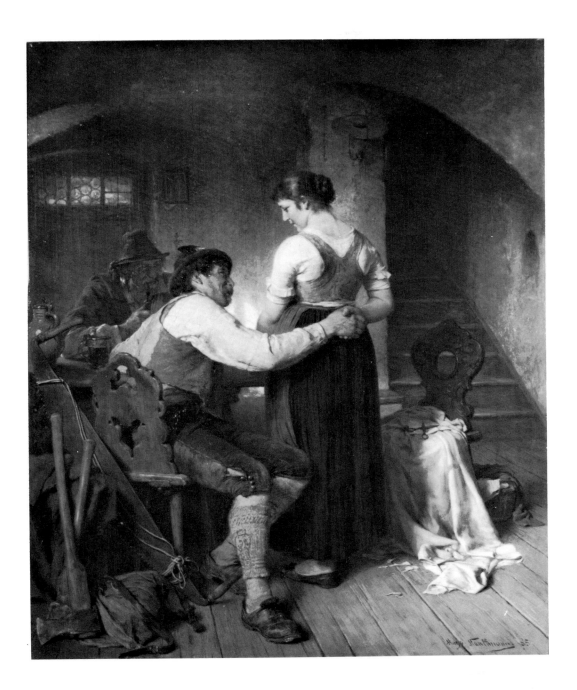

71
The Old Suitor (Der alte Verehrer)
1885
　　signed and dated L.R.: Hugo Kauffmann 85
　　oil on wood panel, 26 × 21¹⁄₁₆ (66.1 × 53.6)
　　MAC cat. no. M 1971.74
See description under entry **62**.

REFERENCE
SELECTIONS FROM THE VON SCHLEINITZ COLLECTION; Exhibition, Paine Art Center, Oshkosh, Wisconsin, Feb. 1–20, 1972. MIRRORS OF 19TH CENTURY TASTE: ACADEMIC PAINTING; Exhibition Handlist, Milwaukee Art Center, 1974, No. 45.

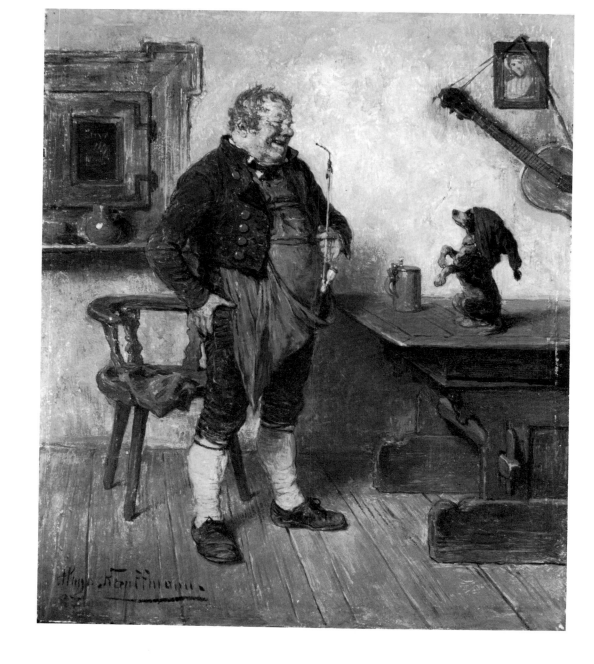

72
The Learned Dachshund (Der gelehrte Dackel)
1887
signed and dated L.L.: Hugo Kauffmann/87
oil on wood panel, 5⅞ × 4¾ (14.9 × 12.1)
MAC cat. no. M 1962.129

126 See description under entry **62**.

73
Conversation in the Tavern
1893
 signed and dated L.R.: Hugo Kauffmann/93
 oil on wood panel, 14 × 18 (35.7 × 46.8)
 MAC cat. no. M 1972.17

See description under entry **62**.

REFERENCE
S. Wichmann, PAINTINGS FROM THE VON SCHLEINITZ COL-
LECTION (Catalogue), Milwaukee Art Center, 1968, No. 24.

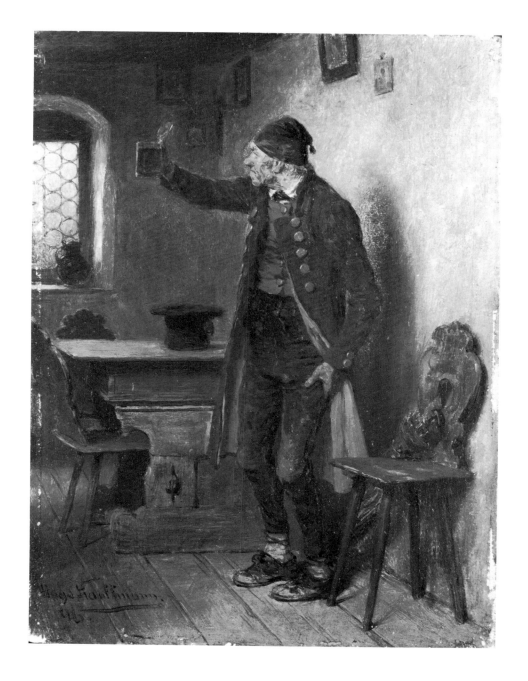

74
The Toast
1896
 signed and dated L.L.: Hugo Kauffmann/96
 oil on wood panel, 6⅛ × 4⅝ (15.6 × 11.8)
 MAC cat. no. M 1962.61

128 See description under entry **62**.

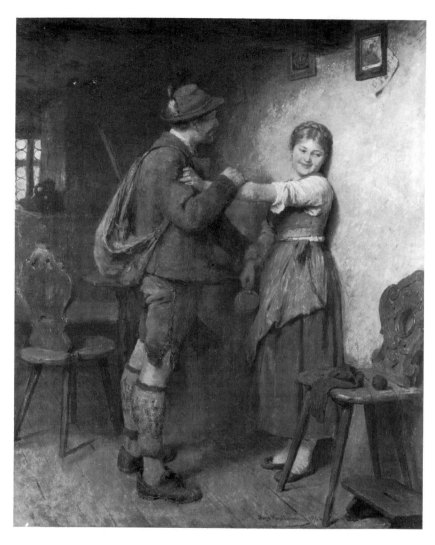

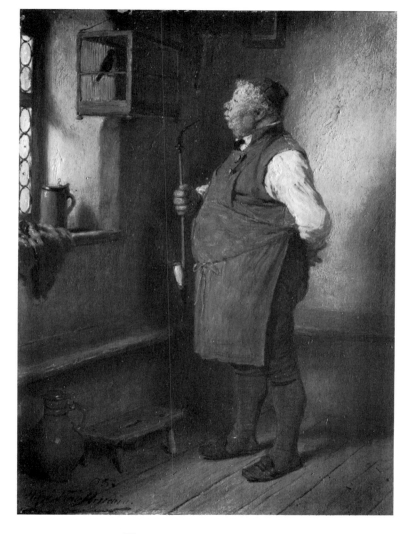

75
Flirting (Hunter and Peasant Girl)
1902
 signed and dated L.R.: Hugo Kauffmann 1902
 oil on wood panel, 18¼ × 14¾ (46.4 × 37.5)
 MAC cat. no. M 1972.127

See description under entry **62**.

PROVENANCE
Purchased at Adolf Weinmüller Auction No. 87, Catalogue
No. 95, Oct. 2–3, 1963, No. 1003, in Catalogue, illustrated,
plate No. 89.

REFERENCE
S. Wichmann, PAINTINGS FROM THE VON SCHLEINITZ COL-
LECTION (Catalogue), Milwaukee Art Center, 1968, No. 25.

76
Innkeeper
1905
 signed and dated L.L.: 05 / Hugo Kauffmann
 oil on wood panel, 5¾ × 4¼ (14.6 × 10.8)
 MAC cat. no. M 1962.40

See description under entry **62**.

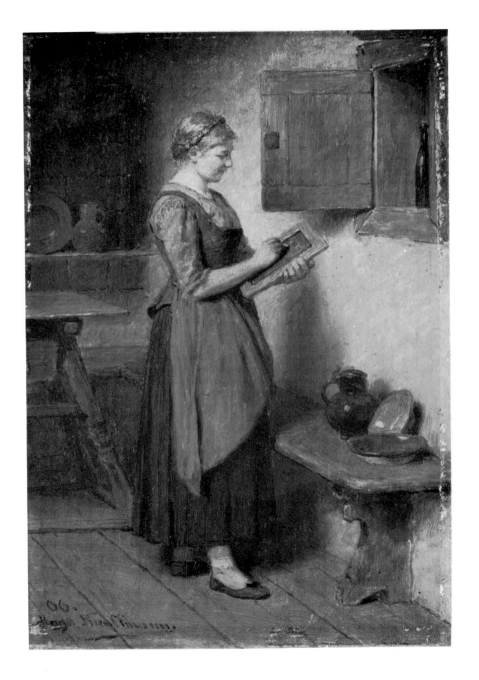

77
The Waitress
1906
 signed and dated L.L.: 06 / Hugo Kauffmann
 oil on wood panel, 5 × 3⅜ (12.7 × 8.6)
 MAC cat. no. M 1962.41

130 See description under entry **62**.

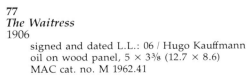

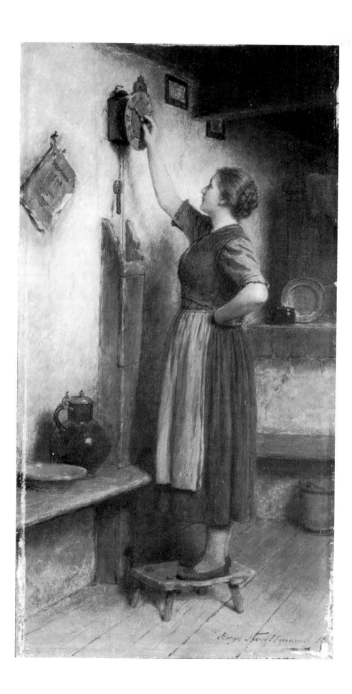

78
Girl at Wall Clock
1910
 signed and dated L.R.: Hugo Kauffmann 10
 oil on wood panel, 10¼ × 5 (26 × 12.7)
 MAC cat. no. M 1962.51

See description under entry **62**.

REFERENCE
MIRRORS OF 19TH CENTURY TASTE: ACADEMIC PAINTING;
Exhibition Handlist, Milwaukee Art Center, 1974, No. 44.

H.
W.
KAUFFMANN

KAULBACH, FRIEDRICH AUGUST VON

b. June 2, 1850, Munich
d. July 26, 1920, Ohlstadt, near Murnau, Bavaria
represented at Frankfurt, Munich, Nürnberg; New York

In the 1870s and eighties the art capital Munich went through a Renaissance revival in architecture and ornamentation that was virtually unparalleled in nineteenth-century history. In painting it also recalled that bygone epoch while simultaneously glorifying German nationhood with the most conspicuously ostentatious Venetian and Baroque pomp that has ever been amassed on canvas. That sumptuously decorative *Prunkstil*, sometimes disparaged as the "Patina- or Persian Rug-Style," is often also identified by the names of those who played out its splendid variations: Lenbach (see entry in Catalogue), Makart, or Kaulbach, for example.

Friedrich August von Kaulbach was the son of the successful portraitist Friedrich Kaulbach and the grandnephew of the illustrious Wilhelm Kaulbach. His style was based entirely on the eclectic method. First, he was influenced by his father, from whom he received training after attending for several years the art academy in Nürnberg. Subsequently, his style incorporated elements of Rembrandt, Rubens, Van Dyck, the Venetian painters (for example, Titian), Piloty (whose successor as director of the Munich Academy he became in 1886), Diez (see entry in Catalogue), and Makart. Among Kaulbach's strongest stylistic attributes are his sovereign panache in self-confident drawing, his elegance of figural representation, and his striking brio for finding the optimally decorative properties of color.

Kaulbach's early work comprises genre and paintings of single figures that were influenced by his experiences of medieval art in Nürnberg and German Renaissance art as well as seventeenth-century Flemish and Dutch painting. The times called for sentimental subjects in art and Kaulbach supplied that need with a gush of increasingly saccharine fantasies. But it was, above all, in portraiture that Kaulbach established a virtually unrivaled reputation as the chronicler of values held by the high society of Wilhelmian Germany; portraits of the fashionable young ladies of the aristocracy and of the worlds of finance and the theater became Kaulbach's repertorial mainstay. What we would today experience as the "simulated" psychological depth that is frequently in evidence in his svelte but passively posed ladies can be traced to the influence of Gabriel Max (a Piloty-trained Austrian who became famous for his dreamily melancholy woman types) and, through Max, back to the painted love poetry of the English Pre-Raphaelites and the ecstatic visions of brooding *femmes fatales* of a Dante Gabriel Rossetti, for example.

The master *per se* of chiaroscuro and coloration, of healthy sweetness and light-filled fleshtones, Kaulbach utilized excellently all contrasts in the treatment of jewelry, flowers, and all manner of costume in order to increase the softness of flesh. Without doubt, he is now not only the most popular but also the most genuine representative of the cult of woman whom we possess in Germany and who is equally removed from a treacly idealization as he is full of variety and the enchanting freshness of nature. (F. Pecht, *Kunst und Leben*, Stuttgart, 1878, Vol. I, pp. 7, 8)

This view by a renowned art historian and contemporary of Kaulbach stands in enlightening contrast to the critical opinions of later generations of writers who dismissed Kaulbach's refined aesthetics of elegance as "superficial," "sweet," "theatrical," "frigid." The time seems at hand for looking again and possibly revaluating.

BIBLIOGRAPHY
C. E. Clement and L. Hutton, ARTISTS OF THE NINETEENTH CENTURY AND THEIR WORKS, Boston, 1884 (facsimile ed., St. Louis, 1969), Vol. II, pp. 20–21. L. Pietsch, CONTEMPORARY GERMAN ART: AT THE CENTENARY FESTIVAL OF THE ROYAL ACADEMY OF ARTS, BERLIN, Vol. I, London, 1888, pp. 13 ff. F. Pecht, GESCHICHTE DER MÜNCHENER KUNST DES 19. JAHRHUNDERTS, Munich, 1888. A. Rosenberg, FRIEDRICH AUGUST VON KAULBACH, in Velhagen u. Klasing Künstlermonographien, Leipzig, 1900 (2d ed., 1910). A. Kuhn, GESCHICHTE DER MALEREI, Vol. II, in Vol. III of ALLGEMEINE KUNSTGESCHICHTE, Cologne and New York, 1909, p. 1322. H. Karlinger, MÜNCHEN UND DIE KUNST DES 19. JAHRHUNDERTS, Munich, 1933 (2d ed., 1966), pp. 47, 56.

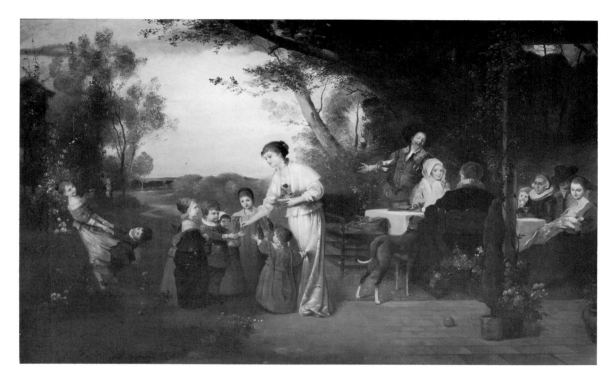

79
A May Day (Ein Maientag)
1879
 signed and dated L.L.: Fritz Aug. Kaulbach/1879
 oil on canvas, 37¹¹/₁₆ × 58⅞ (95.7 × 148.9)
 MAC cat. no. M 1972.119

Ein Maientag was Kaulbach's earliest major gambit to attract attention to himself and perhaps the best known of all his historical costume pieces. He managed to surprise his contemporaries. But, as Rosenberg points out, the new direction he had attempted to give to history painting was short-lived:

 Ein Maientag was the most resplendent and most characteristic monument of an epoch in German painting of the nineteenth century that held the promise of an indefinitely long duration and that ended so soon after a dream of glory and magnificence. But when we look closer at the faces of the young woman and girls as well as those of the children, we feel, nevertheless, the independence of the modern painter, an independence that resulted from years of study of the people around him. And equally independent is the treatment of the landscape which definitely betrays a modern feeling for nature and that, with its light and joyous tone, does not remind us of the special manner of any old master. (pp. 27, 28)

The painting has several faults. For example, its composition falls into two distinct parts, the contrived and technically flawed "Flemish grouping" on the right, and the much more successfully rendered lady with seven children on the left. In the former, Kaulbach followed models from Netherlandish painting, while for the latter he used either life models or photographs or both. Moreover, the shrubbery and architecture segment (upper right) is not determinable as to form. Conversely, the more distant landscape passage on the left is a quite credible effort in luminism.

In the Böcklinian sense, the painting qualifies as an early symbolist statement: contrasting scenic strata foil each other semi-abstractly in allusion (here) to the continuity, over the ages, of art, life, and love. But it is, above all, in the likenesses on the left, and particularly that of the lady and child at center, that Kaulbach anticipated, in this uneven early effort, his eventual calling as celebrated society portraitist. Color: placed against a leafy green overall ground appear hues of red, violet, purple; most pleasing of all is the decorative effect of the brilliant carmine dress of the child and the radiant white silks of his mother on whose skirt folds he tugs.

PROVENANCE
Dresdener Galerie, Dresden, Germany. Kunsthandlung Wimmer and Co., Munich.

REFERENCE
F. Von Boetticher, Malerwerke des Neunzehnten Jahrhunderts, Vol. I, Dresden, 1891, p. 656, No. 10: "Ein Maitag. Familienfest im Freien, Tracht des 17. Jahrh. Bez: Fritz Aug. Kaulbach 1879. E: Gal. Dresden, 1879 von d. Kunsth. Wimmer & Co. in München erworben. Abb. 'Illustr. Z.' 83 u. 'Meisterw.' VI; Pecht's Gesch. d. Münch. K. im 19. Jahrh." In "abweichender Composition 'Ein Maitag', Oelskizze zum Bilde der Dresd. Gal., rad. von W. Hecht und von W. Unger. qu. fol. - Wiener JA. 79; Münch. int. KA. 79." A. Rosenberg, Friedrich August von Kaulbach, in Velhagen u. Klasing Künstlermonographien, Leipzig, 1900 (2d ed., 1910), pp. 27 ff., illus. facing p. 6.

KELLER, FRIEDRICH VON

b. February 18, 1840, Neckarweihingen, near
Ludwigsburg, Baden-Württemberg
d. August 26, 1914, Gmünd (Abtgemünd), Austria
represented at Hamburg, Stuttgart, Ulm; Bucharest

The seventy-four years of Friedrich von Keller's life were marked by a childhood of dire poverty as the son of destitute peasants and a mature age distinguished by his success as painter, a professorship at the Stuttgart Academy, the luster of medals, and the patent of nobility bestowed upon him by a grateful government. He had to struggle very hard in his youth in order to be able to enroll (1867) at the Stuttgart Academy. In 1871 he transferred to the Munich Academy, where he was influenced, above all, by Karl von Piloty in his coloristic history paintings and Wilhelm von Lindenschmit the Younger in his atmospheric conception of chiaroscuro spaces. Eduard Schleich the Elder (see entry in Catalogue) influenced him in his pursuit of landscape painting. Franz von Stuck and Hans Thoma counted among his close friends in Munich.

Keller's subjects and style underwent several changes, the most significant of which were the following: he concentrated first on peasant genre; then he was attracted to compositions with themes from history; then landscapes, whose impressionism was unusually advanced for the times in which they were conceived; thereafter, he did workers, especially stonebreakers and cutters, and other heavy laborers (an interest of Keller's that paralleled but was not influenced by either Courbet or Millet); then, following an Italian journey in the early 1880s, he produced religious works under the influence of the Venetian Renaissance; lastly, he again returned to his favorite subject, namely workers, whom he often depicted with heroic ponderations of stress. These paintings make up that portion of his oeuvre by which he is best remembered today. Stylistically, Keller fluctuated between a cool, academic approach and an all-out impressionism of delivery and, by contrast again, a mincing description of detail. On the whole, however, his development was one of transition from narrative to pure painting.

BIBLIOGRAPHY

F. von Boetticher, MALERWERKE DES NEUNZEHNTEN JAHR-HUNDERTS, Vol. I, Dresden, 1891, p. 671. J. Baum, DIE STUTTGARTER KUNST DER GEGENWART, Stuttgart, 1913, pp. 40–45. KATALOG DER GEÄLDESAMMLUNG STUTTGART, Stuttgart, 1921. KATALOG DER KUNSTHALLE HAMBURG (Neuere Meister), Hamburg, 1922.

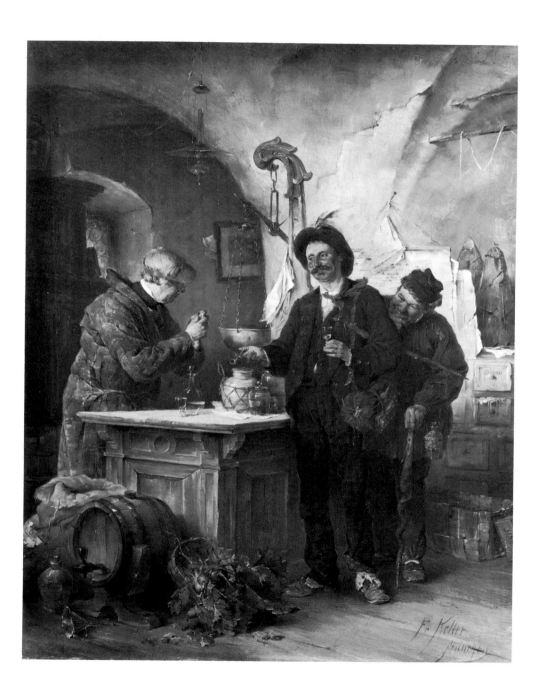

80
Vagabonds Drinking
c. 1880
>signed L.R.: Fr. Keller / München
>oil on canvas, 25¾ × 20¼ (65.4 × 51.4)
>MAC cat. no. M 1962.97

A cluttered, discursive, very detailed composition in muted shades of earth and black. Although its characterization, however self-conscious, stands out, this cannot be regarded as a strong painting.

REFERENCE
S. Wichmann, PAINTINGS FROM THE VON SCHLEINITZ COLLECTION (Catalogue), Milwaukee Art Center, 1968, No. 27.

KERN, HERMANN (also signed ARMIN)

b. 1839, Liptóujvár, Hungary
d. January 1912, Maria-Engersdorf, near Vienna
represented at Budapest, Vienna; private collections

Hermann Kern studied first in Pest under Tivadar (Theodor) Boemm, then with Karl Rahl in Vienna; thereafter, in Düsseldorf, and, after 1870, with the Hungarian-born follower of Karl von Piloty, Alexander Wagner, at the Munich Academy. These experiences introduced Kern to the most advanced aspects of academic narrative painting of his time, and to the avant-garde techniques of both the German and (indirectly, through Rahl, who had studied at Paris and lectured on its art) the French School. This background prepared Kern for a career as coveted portraitist and sought-after genre painter in Vienna, where he settled permanently in the early 1880s.

Although his name has now all but slipped into forgotten history, Kern was very successful in his day, and Emperor Francis Joseph I and Archduke Ludwig Viktor counted among his illustrious patrons. Kern's work surpasses the ordinary because of his penchant for taking on the challenge of demonstrating art theory in his paintings.

BIBLIOGRAPHY

L. Eisenberg, DAS GEISTIGE WIEN, Vol. I, 1893. Thieme-Becker, KÜNSTLERLEXIKON, Leipzig, 1907–50, Vol. XX, p. 179. Auction Catalogue: DOROTHEUM, Vienna, September, 1918. Auction Catalogue: ERNST MUSEUM, Vol. IV, Budapest, 1925.

K
E
R
N

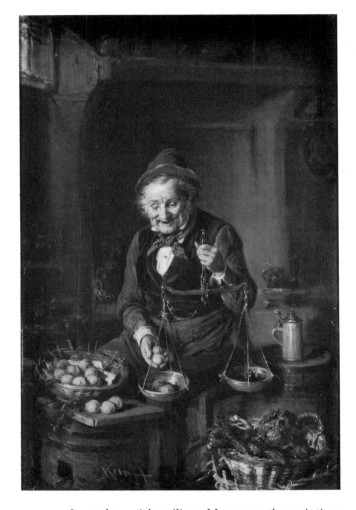

81
The Fruit Peddler
c. 1880 (?)
 signed L.L.: Kern H.
 oil on wood panel, 18⁹/₁₆ × 12¼ (47.2 × 31.2)
 MAC cat. no. M 1972.13

A coloristically very interesting little painting: warm (prominently orange and gold fruit and paler flesh) tones are beautifully integrated into a cool charcoal grayish milieu. Moreover, the painting succeeds in contrasting a very crisply conceived but painterly foreground still life motif with a deep, atmospherically treated chiaroscuro space. The painting possesses artistic tension as well as truth to life.

REFERENCE

S. Wichmann, PAINTINGS FROM THE VON SCHLEINITZ COLLECTION (Catalogue), Milwaukee Art Center, 1968, No. 28.

KNAUS, LUDWIG

b. October 5, 1829, Wiesbaden
d. December 7, 1910, Berlin
represented at Berlin, Darmstadt, Dortmund,
 Dresden, Frankfurt, Hamburg, Cologne,
 Munich, Stuttgart, Vienna; Chicago, Cincinnati,
 Leningrad, Minneapolis, Montpelier, New York,
 Paris, St. Louis, Washington

Ludwig Knaus, Member of the Academies of Berlin, Vienna, Munich, Amsterdam, Antwerp, and Christiana. Officer of the Legion of Honor, Knight of the Order of Merit. Various medals at Paris, Berlin, Weimar, etc. (Clement and Hutton, p. 24)

This great master, one of the most justly famed of the modern German school, was pre-eminently successful not only in the general grouping and technique of his subject, but in the individuality of every member of the groups in his scenes from home life. His works give us a glimpse of the very inner life of the households to which we are admitted and we share the hopes and fears, the joys and sorrows underlying the current daily routine. (Pietsch, *Contemporary German Art*, p. 47)

Ludwig Knaus was without a doubt the greatest genre painter who has ever lived. His paintings combine more great virtues than the works of anyone else. In drawing, in technique, in the ease of representation, in composition, in the expression of feeling—in these he had no rivals. (Andrews, p. 7)

Knaus offered the public enjoyment in the same convenient and cheap manner as the film directors do nowadays: to serve spiritual greatness in small doses to the mentally small is in both cases the basic intention. (Beenken, p. 373)

[Düsseldorf art] required a new power, an original talent, and that was found in Ludwig Knaus. His stay in Düsseldorf belongs to the most glorious epochs of post-Schadowian art

precisely because Knaus and his whole personality formed not only the antithesis of the Schadow School but also the opposite of genre painting up to that time. (Schaarschmidt, p. 148)

In Knaus the fountain of invention flowed with a never diminishing abundance and freshness and each new work which he sent to our exhibitions appeared to the spectator as the best and the most beautiful, as superior to all that had preceded. What he showed us in his paintings were genuine people from the western and southwestern regions of the nation in their most sharply drawn racial characterizations and peculiarities and in the rich variety of distinctive personalities. (Pietsch, *Knaus*, pp. 33, 34)

There is in Knaus a gap between truth and art. . . . He is tainted by his times. Education condescending to the subject; benevolence palliating our social gap instead of reminding us of our duty to care; smiling at the awkwardness of the uneducated: many of us have later learned to hate these over-refinements because they only serve us truth covered with a tasty sauce. (Gurlitt, p. 259)

If we enumerate the most famous and best known artists of this period, we must, nevertheless, include Ludwig Knaus. If the question is 'who was the most popular,' then he must be ranked among the very first. Today's art criticism values him less highly; posterity will once again judge him more justly. (Kuhn, p. 1332)

Ludwig Knaus, the son of an impecunious Swabian lens grinder, received his artistic training from Otto Reinhard Jacobi and at the Düsseldorf Academy under Carl Ferdinand Sohn (1845–48). His great love for genre painting led to several significant events in his life: to the close study of seventeenth-century Dutch art (especially A. van Ostade and A. Brouwer), to the charter membership of the *Künstlerverein "Malkasten"* (an influential association of artists who were primarily interested in landscape painting and popular subjects from everyday life and whose basic attitudes were anti-academic), and to the eventual split with the director of the Düsseldorf Academy, Wilhelm von Schadow, over artistic aims. (Incidentally, the latter also disallowed the young Knaus a fee waiver for the use of models on grounds that "such favors were only granted talented students.")

Encouraged by the example set by certain genre painters of the older Düsseldorf generation, Knaus set out on his own to study peasant life in the small village of Willingshausen on the Schwalm River (Hesse). Having once discovered this remote place, Knaus was to return there for periods of study and artistic regeneration throughout his life as well as to draw other, younger painters to the artists' colony that he established there and made famous. His first large paintings of consequence—peasant genre all—were immediately hailed by contemporary critics (e.g., Pietsch) as outstanding artistic events comparable to the work of the celebrated Adolf von Menzel. Having gained a solid reputation back home, Knaus set out for Paris in order to hone his talent on the example of French art "for a few weeks." But the spectacular critical and financial successes that his German peasant genre met with

there caused him to stay on for eight years. During these years Knaus received numerous medals of highest award at the Paris Salon, including the First Gold Medal. (Later, he also received the Grand Gold Medal there.) During this period he made repeated trips to London and Belgium and a journey to Italy.

At the height of his international fame Knaus returned to Wiesbaden and then settled down to an active career in Berlin (1861–66). After this, from 1867 to 1874, came his happy Düsseldorf years. During this time his friendship with Vautier and the Achenbachs (for both see Catalogue) deepened, as did his influence on younger artists. Knaus's final period ensued when he accepted the appointment as head of a newly instituted master studio in painting at the Berlin Academy in 1874. Although he resigned that time-consuming position in 1882, Knaus remained in Berlin for the rest of his life. Knaus was an inveterate traveler, and he often went on study trips to Willingshausen, the countryside of the Black Forest region, Switzerland, and Austria, as well as on innumerable sojourns to various artistic capitals of Europe.

In his student years Knaus already had introduced a new style to genre painting in Düsseldorf which was characterized by a softly tonal palette and a loose brush technique that contrasted with the then prevailing polychromaticism and mirror-smooth, enamel-like finishes. At the height of his

creative powers, Knaus had virtually no equal in these stylistic qualities: tonally unified compositions, a warm, golden overall lighting, a refreshingly contrasting coloristic sparkle, sharply incisive drawing, the nuances of painterly differentiation, acuity of psychological characterization. In those years Knaus never resorted to distorting his subject matter with sentimentality. His keen eye for reality, brilliant humor, profound psychological insights, and dazzling technique contributed to raising genre painting to a level of artistic quality never achieved anywhere before.

Although he was very productive to the end of his years, his last period (which coincided with his second Berlin period) witnessed a slackening of creativity. Specifically, he no longer invented new characters or fresh pictorial models but constantly drew on an already established repertoire of stock types and situations. Worse, he became ever more concerned with the manipulation of his subjects for sentimental effect. Setting aside a few exceptions, the result was scores of quite self-consciously posed and maudlinly staged productions, whose often embarrassing lack of sincerity stands in sharp contrast to Knaus's earlier, compellingly true naturalism. In an obvious attempt at catching up with avant-garde developments that had overtaken him, he also changed his palette for the worse by adopting a tonal scale of grays which he used with an all

too obviously facile ease. But his drawings, untouched by these changes, retained to the end the same astounding clarity of line and resolute freshness of vision for which they were justly hailed throughout his career and afterwards.

BIBLIOGRAPHY
J. Ruskin, NOTES ON SOME PRINCIPAL PICTURES EXHIBITED IN THE ROYAL ACADEMY, 1855–59, London, 1855–59. L. Jourdan, LES PEINTRES FRANÇAIS, SALON DE 1859, Paris, 1859. C. E. Clement and L. Hutton, ARTISTS OF THE NINETEENTH CENTURY AND THEIR WORKS, Boston, 1884 (facsimile ed., St. Louis, 1969), Vol. II, pp. 25, 26. L. Pietsch, CONTEMPORARY GERMAN ART: AT THE CENTENARY FESTIVAL OF THE ROYAL ACADEMY OF ARTS, BERLIN, Vol. II, London, 1888, pp. 47, 48. L. Pietsch, KNAUS, Leipzig, 1901. F. Schaarschmidt, ZUR GESCHICHTE DER DÜSSELDORFER KUNST, Düsseldorf, 1902, pp. 247 ff. A. Kuhn, GESCHICHTE DER MALEREI, Vol. II, in Vol. III of ALLGEMEINE KUNSTGESCHICHTE, Cologne & New York, 1909, pp. 1332 ff. E. T. Andrews, LUDWIG KNAUS, Leipzig, 1915. W. Zils, LUDWIG KNAUS, No. 36 in DIE KUNST DEM VOLKE, Munich, 1919. C. Gurlitt, DIE DEUTSCHE KUNST SEIT 1800, Berlin, 1924, pp. 257–59. E. Waldmann, DIE KUNST DES REALISMUS UND DES IMPRESSIONISMUS IM 19. JAHRHUNDERT, Berlin, 1927, pp. 18–19, and passim. J. Harms, LUDWIG KNAUS, 1829–1910, Vol. II, Nassauische Lebensbilder, Wiesbaden, 1943, pp. 244–56. H. Beenken, DAS NEUNZEHNTE JAHRHUNDERT IN DER DEUTSCHEN KUNST, Munich, 1944, pp. 372 ff. F. Novotny, PAINTING AND SCULPTURE IN EUROPE, 1780–1880, Baltimore, 1970, pp. 168 ff., 173 ff., and passim.

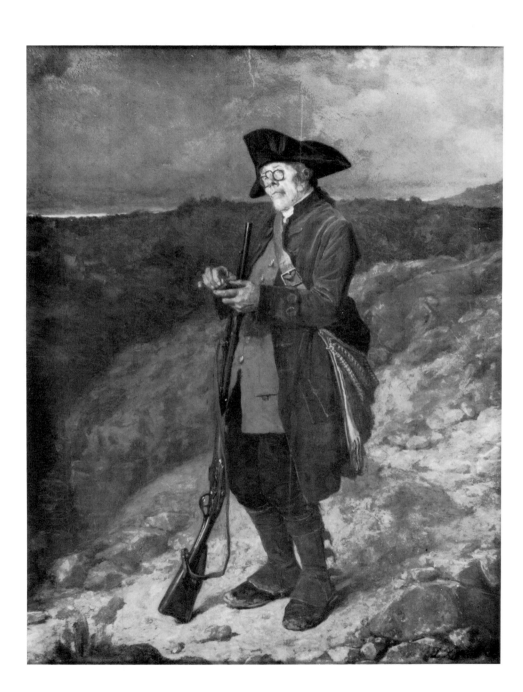

82
*The Amateur Hunter (The Sunday Hunter[?]) (Der
Sonntagsjäger [?])*
1859
 signed and dated L.R.: L. Knaus/1859
 oil on wood panel, 12 × 9⅛ (30.6 × 23.3)
 MAC cat. no. M 1972.10

A striking early Knaus of a querulous old geezer in
brown jacket and brilliant red vest against a tonal
backdrop of earths and grays.

83

Peaceful Life's End
1872 (possibly 1878)
 signed and dated L.R.: L. Knaus/1872 [possibly 1878]
 oil on canvas, 35½ × 28½ (90.2 × 72.4)
 MAC cat. no. M 1962.135

A very painterly, large, occasionally heavily impas-
toed canvas contrasting close naturalism (sitters)
with a sketchy background. The fact that the sitters
were completed in the studio and the rest of the
painting largely in the out-of-doors threatens to
disintegrate the composition but ultimately does
not. The obvious symbolism of the two couples,
one, seated on a bench in the shadow, peaceably
awaiting life's end, the other gaily strutting in the
bright sun with their small child in tow, allegorizing
the "fall" and "summer" of life is underscored by a
comparable juxtaposition of cool greens and
purplish-tinted morbidezza, on the one hand, and
blazing yellow greens and golden whites (upper
left) on the other.

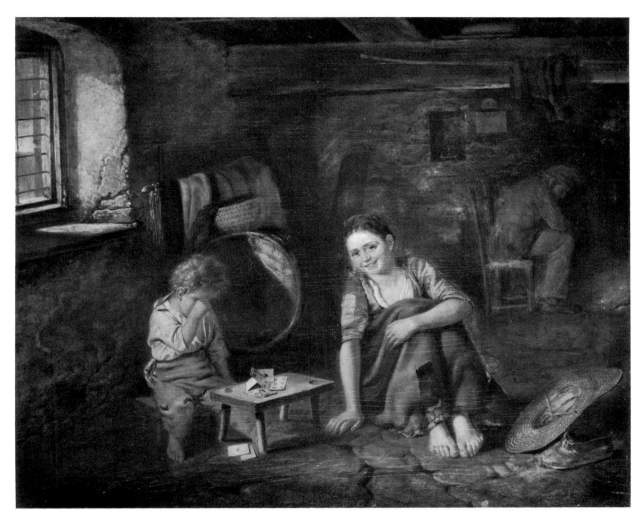

84
An Interior in the Black Forest
probably 1874
 signed (on reverse) U.R.: Ludw. Knaus
 oil on wood panel, 14⅜ × 16⅝ (36.5 × 42.2)
 MAC cat. no. M 1962.85

Of **84**, **86** (a rare nude by Knaus), **87**, **88**, and **89**, *An Interior in the Black Forest* stands out as an especially

fresh, direct, and painterly work and *Children with the Shopkeeper* (**87**) for the superb child figures. Although all are fine Knauses, none of them represents a major effort on his part.

REFERENCE
Possibly F. von Boetticher, MALERWERKE DES NEUN-ZEHNTEN JAHRHUNDERTS, Vol. I, Dresden, 1891, p. 708, No.

72: "Das Innere einer schwarzw. Bauernstube mit einem alten Landmann, der am Kamin eingeschlafen. In seiner Umgebung spielende Kinder. Anfang 74 im Ddf. Atelier des Künstlers." SELECTIONS FROM THE VON SCHLEINITZ COLLECTION; Exhibition Paine Art Center, Oshkosh, Wisconsin, Feb. 1–20, 1972. MIRRORS OF 19TH CENTURY TASTE: ACADEMIC PAINTING; Exhibition Handlist, Milwaukee Art Center, 1974, No. 46.

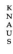

85

Dance under the Linden Tree (Tanz unter der alten Linde-Ländliches Fest-Hessische Kirmess-Hessischer Bauerntanz)
1881
> signed and dated L.R.: L. Knaus/1881
> oil on canvas, 40 × 57 (101.6 × 144.8)
> MAC cat. no. M 1962.31
Color plate page 32

That Knaus was also able to rise vigorously to new challenges during his declining years is convincingly demonstrated to us by his *Dance under the Linden Tree*. It contains over one hundred figures and, for some of the reasons stated by Ludwig Pietsch, among others, it is one of the most important works of his second Berlin period.

One feels as though one had met once before some of the figures among the dancing pairs, the debating peasants, the playing children. But in the abundance of the extraordinarily well invented and observed motifs of these groups virtually all is new and original. Everything here seems to be modeled on real life and its quickest movement is captured at a glance. Robust mirth, naively bashful joy, comical peasant awkwardness, and a delightful childlike charm are most truly reflected by the dancing figures. Everywhere, even outside of the circle of dancers, we see delectable and characteristic episodes. Unlike the similar version of the painting [Pietsch probably refers to *Hessischer Bauerntanz unter den Linden* of 1849, Knaus's first large canvas and earliest triumph] this painting is more the product of fantasy and less a description of reality with the definite local color of the former. It is also more wildly lusty and frolicsome. There is something of the temper and bacchic madness that animates the daring peasant pictures of Rubens roaring through the dancing and jubilating wenches and lads in this painting by Knaus. (Pietsch, *Knaus*, pp. 74 ff.)

A sense of flawless unity of color and tone, light and dark, movement and characterization, depth and atmosphere pervades this masterful canvas of Willingshausen countryfolk in their traditional native Hessian garb. One of Knaus's finest, the painting is aglow with myriad warm and sunlit hues of green; accents of reds and whites enliven the composition throughout.

REFERENCE
F. von Boetticher, MALERWERKE DES NEUNZEHNTEN JAHRHUNDERTS, Vol. I, Dresden, 1891, p. 709, No. 89: "Hessische Kirmess. Unter einer alten Linde die Dorfmusikanten; rings herum die tanzenden Burschen und Mädchen. In der Nähe sitzen die Alten. Gegen 100 Figuren. 1881 vollendet. Gegenstand und Grösse des vor 30 Jahren gemalten 'Tanzes unter der Linde,' doch wesentlich verändert. -Schulte's Berl. Salon, April 89." L. Pietsch, KNAUS, Leipzig, 1901, pp. 74 ff., illus. plate No. 51. L. Scheewe, "Ludwig Knaus," in Thieme-Becker, KÜNSTLERLEXIKON, Leipzig, 1907–50, Vol. XX, p. 572. "Malerei deutscher Meister des 19. Jahrhunderts in Milwaukee," DIE WELTKUNST, Vol. XV, Nov., 1956, p. 17, illus. plate L.L. S. Wichmann, PAINTINGS FROM THE VON SCHLEINITZ COLLECTION (Catalogue), Milwaukee Art Center, 1968, No. 30, illus. 5.

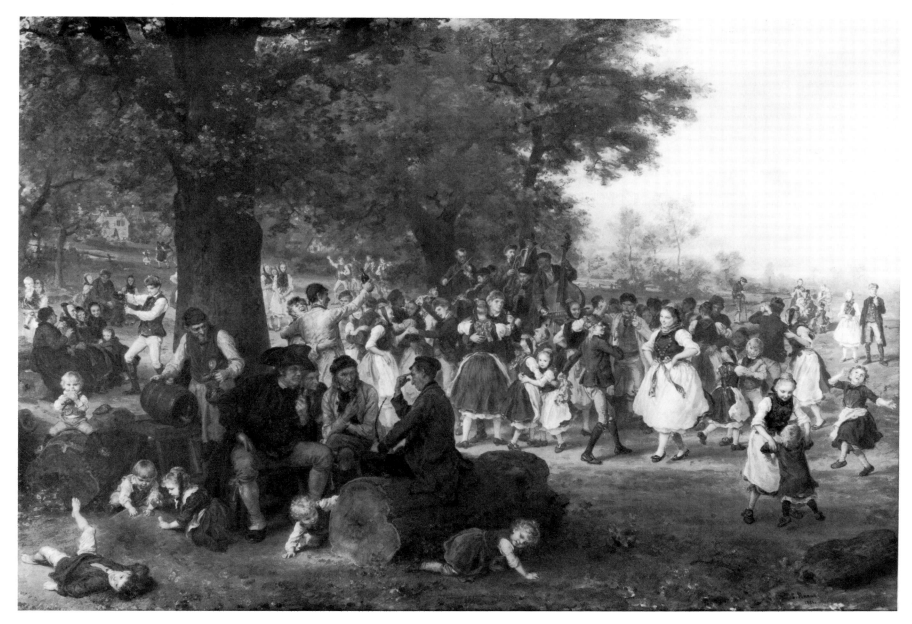

86
Nude ("Reflection")
1882
signed and dated L.R. (on rock): L. Knaus/1882
oil on wood panel, 17 5/8 × 23 9/16 (44.8 × 59.9)
MAC cat. no. M 1962.86

See description under entry **84**.

PROVENANCE
Frederick Mueller, Fine Paintings, Miami Beach, Florida.
Biegelow and Jordan, Boston, Massachusetts.

REFERENCE
MIRRORS OF 19TH CENTURY TASTE: ACADEMIC PAINTING;
Exhibition Handlist, Milwaukee Art Center, 1974, No. 48.

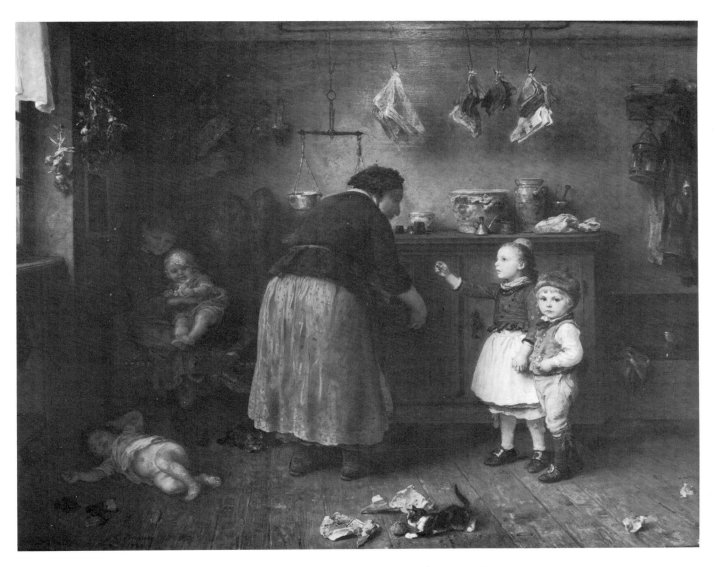

87
Children with the Shopkeeper
1883
 signed and dated L.L.: L. Knaus/1883
 oil on wood panel, 25 × 29¹⁵/₁₆ (63.6 × 76.1)
 MAC cat. no. M 1972.20

See description under entry **84**.

88
Portrait of a Child
1885

 signed and dated L.L.: L. Knaus 85.
 oil on wood panel, 10³/₈ × 9¹¹/₁₆ (26.4 × 24.6)
 MAC cat. no. M 1972.105

See description under entry **84**.

REFERENCE
MIRRORS OF 19TH CENTURY TASTE: ACADEMIC PAINTING;
Exhibition Handlist, Milwaukee Art Center, 1974, No. 47.

K
N
A
U
S

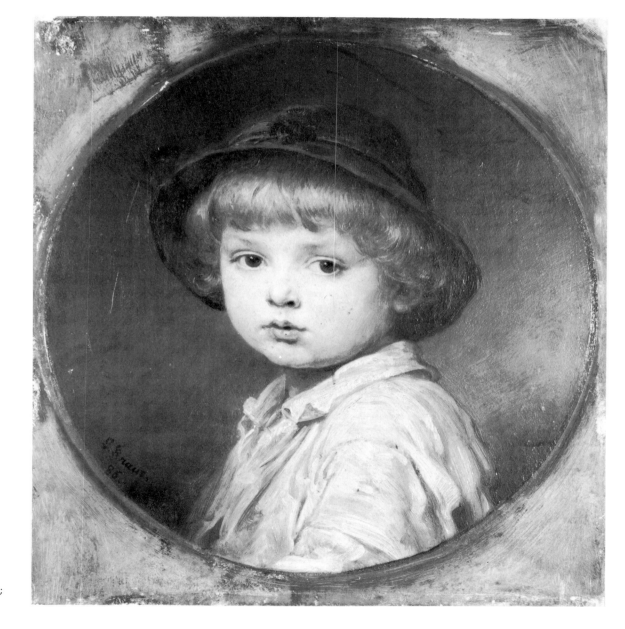

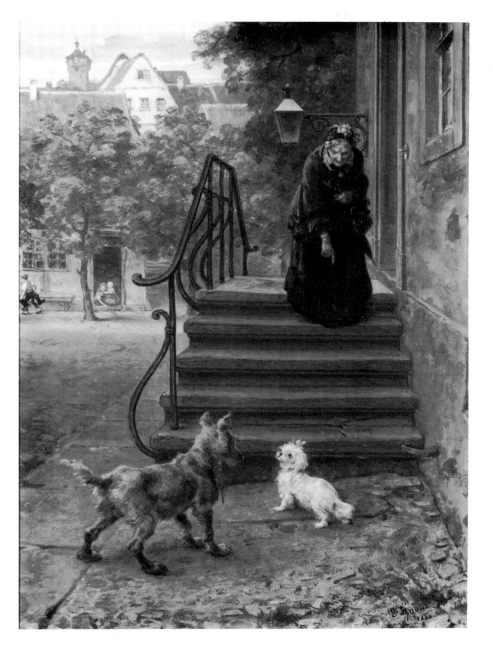

89
The Aristocrat
1888
 signed and dated L.R.: Ludwig Knaus/1888
 oil on wood panel, 19 × 13½ (48.3 × 34.3)
 MAC cat. no. M 1962.47

See description under entry **84**.

REFERENCE
S. Wichmann, PAINTINGS FROM THE VON SCHLEINITZ COL-
LECTION (Catalogue), Milwaukee Art Center, 1968, No. 29.

KÖHLER, GUSTAV

b. July 20, 1859, Dortmund
d. unknown
represented in private collections

Gustav Köhler was a painter and illustrator who trained under minor artists at the academies of Düsseldorf (1881–83) and Munich (1884–85). He did genre, portraiture, and miniature "character heads." The latter have been especially eagerly sought by collectors because of their precisionism. He exhibited regularly at the Munich *Glaspalast* and later occasionally also at Berlin and Düsseldorf. In addition, he executed humorous drawings for various illustrated journals and books.

BIBLIOGRAPHY
DAS GEISTIGE DEUTSCHLAND, Vol. I, 1898, Selbstbiographie. Thieme-Becker, KÜNSTLERLEXIKON, Leipzig, 1907–50, Vol. XXI, p. 120.

90
The Poacher (Der Wilderer)
 signed U.R.: Gustav Köhler/Mchn.
 oil on wood panel, 9¼ × 7 (23.5 × 17.8)
 MAC cat. no. M 1962.52

A very competent miniature in the style of Kronberger (see entry in Catalogue) done in olives (hat, jacket), yellows (scarf) and browns (vest, background) to a degree of precision and exactitude not even a photographic camera would be capable of achieving. The model used in this painting is the same as that appearing in **100–104**.

REFERENCE
SELECTIONS FROM THE VON SCHLEINITZ COLLECTION; Exhibition, Paine Art Center, Oshkosh, Wisconsin, Feb. 1–20, 1972.

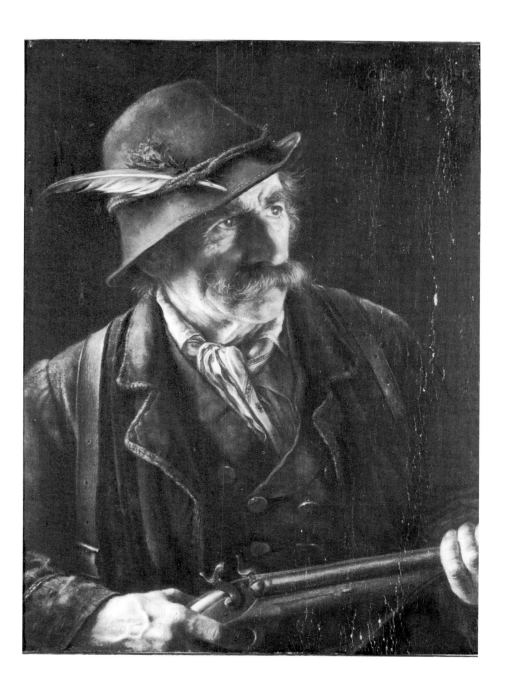

KOEHLER, ROBERT

b. November 27, 1850, Hamburg
d. April 24, 1917, Milwaukee, Wisconsin
represented at Milwaukee, Minneapolis,
Philadelphia; private collections

Robert Koehler was brought to Milwaukee, Wisconsin, at the age of four. He remained there until 1871, apprenticing in lithography and studying painting under Henry Vianden and Henry Roese. He then worked as a lithographer in Pittsburgh and New York while studying at the evening class of the National Academy of Design. At age twenty-three he relocated in Germany and took painting lessons from Löfftz and Defregger (see entry in Catalogue) at the Munich Academy. In 1883 and 1888 he directed the American section of the annual Munich Exhibition. He also showed his works together with German artists in that city and in Berlin. In addition, he sent his paintings to exhibitions in New York, Paris (1889, "honorable mention" for *Der Streik*, mistakenly listed as at the Public Library Gallery, Milwaukee, by Thieme-Becker, *Künstlerlexikon*; instead it was at the Minneapolis School of Art, from which Lee Baxandall purchased the painting in 1970) and Minneapolis (1919, "honor fund"). His city scenes with figures earned him a fine reputation everywhere.

Koehler lived in Minnesota after 1893, where he was director of the School of Fine Arts in Minneapolis as well as the president of one and member of several other state art and artists' associations. Koehler painted genre, portraits, and landscapes.

In his recent *Ästhetik des Widerstands* (aesthetics of resistance) Peter Weiss, one of Germany's leading literary historians and social critics, has prominently featured Robert Koehler as a major nineteenth-century spokesman of exploited factory workers in their struggle against capitalist overlords. Weiss's plea on behalf of the workers' oppressed lot, which, according to his lengthy interpretation of the painting, is so movingly evident in *The Strike* (1886; he first saw it as a child in a journal illustration), is subjective and impassioned but not free of some factual errors. It seems that the artist did not "die in poverty in Minneapolis." With his infectious sympathy for the subject Weiss also magnifies Koehler's importance by equating him with Adolph Menzel. More significantly, Weiss's thesis that Koehler as painter was a forthright champion of social causes is supported by his many working-class subjects, although many other of his paintings display innocuous, middle-class genre events. Even so, when measured against most of their fellow genre painters in Wilhelmian Germany, or in the United States for that matter, Koehler in Munich and Bokelmann in Düsseldorf (see entry in Catalogue) seem to have been exceptional in the degree of social consciousness and engagement in the subject of class antagonisms disclosed by their work. They paid for their convictions with the loss of support from middle-class patronage. In pursuing his socialist interests in art, Weiss has brought to attention in Germany one of her near-forgotten emigrant painters and reminded America to be more mindful of our own neglected heritage in art. Lee Baxandall, a specialist in comparative literature and, as is Weiss, in Marxist criticism of art, seems to be addressing the issue for the American audience; his planned book on Koehler (see N. Bernstein's article, which is an interview with Baxandall) may yet lead to national recognition of the artist.

BIBLIOGRAPHY

F. von Boetticher, MALERWERKE DES NEUNZEHNTEN JAHRHUNDERTS, Vol. I, Dresden, 1891, p. 726. R. Muther, GESCHICHTE DER MALEREI IM 19. JAHRHUNDERT, 1893–, Vol. III. Thieme-Becker, KÜNSTLERLEXIKON, Leipzig, 1907–50, Vol. XXI, p. 125. WHO'S WHO IN AMERICA, Vol. VIII, 1914–15, p. 1344. M. Fielding, DICTIONARY OF AMERICAN PAINTERS, SCULPTORS AND ENGRAVERS, Greens Farms, Connecticut, enl. ed., 1974, p. 204. P. Weiss, ÄSTHETIK DES WIDERSTANDS, Frankfurt a. M., 1975, especially pp. 357 ff. N. Bernstein, "A Historian's Quest for a Forgotten Artist," MILWAUKEE JOURNAL, May 16, 1975.

91
In the Park (The First Guests)
1887
 signed and dated L.L.: Robt Koehler 87
 oil on canvas 28³/₁₆ × 24⁷/₁₆ (71.6 × 59.5)
 donor: Frederick C. Winkler
 MAC cat. no. M 1921.4

An early spring day, probably in the Englischer
Garten in Munich, where friends gather for
Frühschoppen (brunch and beer). Lee Baxandall
suggested that the man on the left may be the
American painter Frank Duveneck. The tracery of
black branches against a milky, blue-gray sky forms
a visually strong pattern. Only the red stripes of the
woman's blouse and slight touches of blue at the
very top of the sky relieve the basic gray tonality of
this painting, done in the style of a luminous
Freilichtnaturalismus (plein-air naturalism).

REFERENCE
Charlotte Whitcomb, "Koehler," BRUSH AND PENCIL, 1901,
p. 151. Exhibited, Wisconsin State Fair, 1928. Porter Butts,
ART IN WISCONSIN, Madison, 1936, p. 182, illus. 33, p. 193.

K
O
E
H
L
E
R

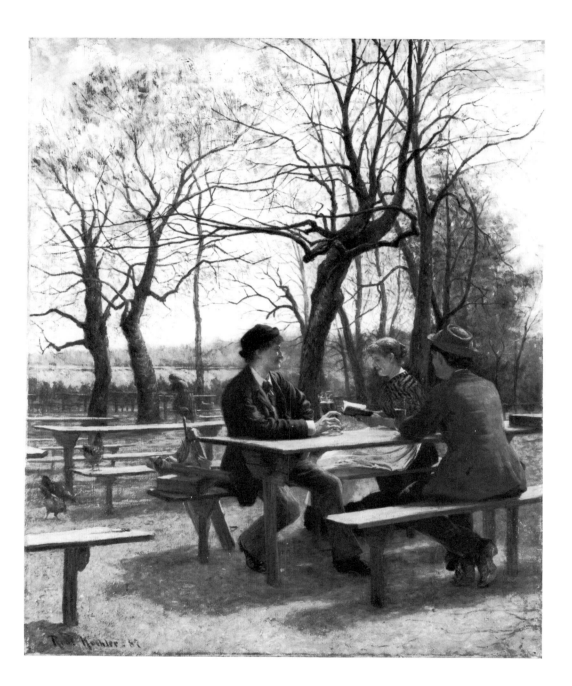

KOWALSKI-WIERUSZ (or WIERUSZ-KOWALSKI), ALFRED VON

b. October 11, 1849, Suwalki, near Warsaw
d. February 16, 1915, Munich
represented at Dresden, Munich, Wiesbaden;
Boston, Brooklyn

Alfred von Kowalski-Wierusz, like Julius or Adalbert Kossak, for example, painted in the rich Polish tradition of peasant genre and, like his fellow Pole, Anton Kozakjewicz, or the Hungarian Pál Böhm (see entry in Catalogue), for instance, was part of a large contingent of foreign-born artists who lived in Munich and belonged to that school. His, and their, contribution to the school was to have deepened and expanded the indigenous Bavarian repertory of subject matter with "strange" peoples and customs. In the days before mass travel and communication, these "outlandish" accents lent a special note of interest to their work which was treasured by the art-loving public for its educational and entertainment values.

Kowalski-Wierusz received his training at Warsaw, Dresden, Prague, as well as, finally, at Munich, where he lived permanently from 1876 onward and where, in 1890, he became an honorary member of the Academy. His mostly small-scale paintings were done in a rapid and lively style, often featuring a black and white range. This latter quality of his paintings was technically especially well suited for their reproduction in numerous popular journals, such as *Moderne Kunst*, *Gartenlaube*, *Daheim*, *Universum*, etc. Kowalski-Wierusz favored depicting Russian ponies, roving wolf packs, traveling peasants, and often the hunt, set in the forlorn and gloomy snow-covered landscapes of Galicia and Russo-Poland. This ethnographic specialization as-

sured him of a wide audience among all those who hungered for a "romantic adventure" in art. Although the artist often signed his canvases Wierusz-Kowalski, the form Kowalski-Wierusz is the generally accepted one in art history.

BIBLIOGRAPHY
F. von Boetticher, MALERWERKE DES NEUNZEHNTEN JAHRHUNDERTS, Vol. I, Dresden, 1891, pp. 751 ff. F. Pecht, GESCHICHTE DER MÜNCHNER KUNST DES 19. JAHRHUNDERTS, Munich, 1888. H. Piatkowski, POLSKIE MALARSTWO, Warsaw, 1895, p. 152. LE MUSÉE NATIONAL POLONAIS DE RAPPERSWIL (Catalogue), Cracow, 1909, pp. 34, 48.

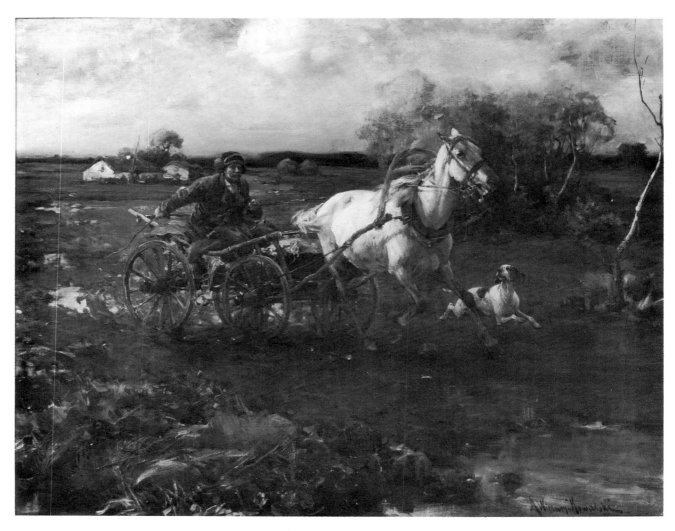

92
The Landowner
 signed L.R.: A. Wierusz-Kowalski
 oil on canvas, 17½ × 22 (44.5 × 55.9)
 MAC cat. no. 1962.50

The surge of the actual movement shown combines with a compelling, sketchy, and "impressionistic" technique to produce an irresistible feeling of clattering, pounding, whooshing speed. The red blanket corner (behind driver) is the only "color patch" in an otherwise predominantly green, monochromatic, superb work of Kowalski-Wierusz.

REFERENCE
S. Wichmann, PAINTINGS FROM THE VON SCHLEINITZ COLLECTION (Catalogue), Milwaukee Art Center, 1968, No. 31, illus. 18. T. Atkinson, "German Genre Paintings from the von Schleinitz Collection," ANTIQUES, Nov. 1969, pp. 712 ff., illus. MIRRORS OF 19TH CENTURY TASTE: ACADEMIC PAINTING; Exhibition Handlist, Milwaukee Art Center, 1974, No. 50.

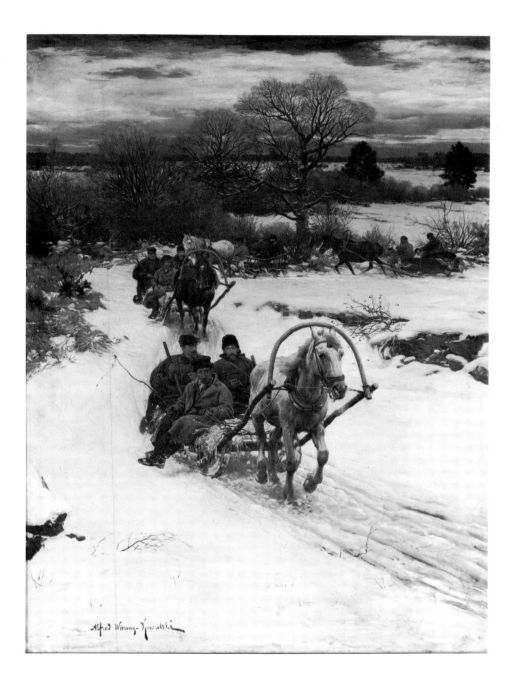

93
Winter in Russia
(before 1885)
 signed L.L.: Alfred Wierusz-Kowalski
 oil on canvas, 40¼ × 30⁵⁄₁₆ (102.2 × 77)
 donor: Frederick Layton
 MAC cat. no. L. 1888.15

Hunters and serfs riding on horse-drawn sledges in
a snow-covered field.

PROVENANCE
Purchased by Layton from George I. Seney sale, 3/31–
4/2, 1885, No. 96 in Catalogue. Sale held in Chickering
Hall, New York, under the management of the American
Art Association.

KRONBERGER, CARL

b. March 7, 1841, Freistadt, Upper Austria
d. October 27, 1921, Munich
represented at Leipzig, Munich; Prague; private
collections

In comparing Eduard Grützner (see entry in Catalogue) to his lesser contemporary genre painters, Uhde-Bernays dispenses with Carl Kronberger in less than three lines: "Much more superficial [than Grützner], Carl Kronberger treated in small formats and with a calculated accent on the 'original Munich flavor' episodes from the earthly existence of the Philistines" (p. 206). Had the author based his valuation on the popularity that Kronberger himself enjoyed during his lifetime with his sharply lighted, photographically detailed, and often humorously staged little "slices of life" or miniaturist "character heads"—a popularity that has not waned among collectors to this day—he might well have devoted more space to him.

After learning the architectural decorator's trade in Linz, Austria, Kronberger went to Munich and studied under Dyk, Anschütz, and Hiltensperger at the Academy, although all authorities seem to agree that his art was ultimately self-taught. In 1859 he settled permanently in Munich, where he exhibited regularly from 1866 to 1919. He was able to widen his audience immeasurably through constant exposure in such popular journals as *Daheim* and *Gartenlaube*. (According to Siegfried Wichmann, he was also busy executing commissions for dioramas and panoramas, which were then among the most prevalent forms of visual entertainment and education, and for which he had already prepared during his earliest training.)

BIBLIOGRAPHY
F. Pecht, GESCHICHTE DER MÜNCHNER KUNST DES 19. JAHRHUNDERTS, Munich, 1888. F. von Boetticher, MALERWERKE DES NEUNZEHNTEN JAHRHUNDERTS, Vol. I, Dresden, 1891, pp. 771, 772. Exhibition Catalogues: Munich Glaspalast, 1894, 1895, 1897–1901, 1904, 1906–09, 1911, 1913, 1914, 1916, 1919; Berlin, Grosse K.A., 1893–95, 1897–99, 1910; Vienna Künstlerhaus, 1893. H. Uhde-Bernays, DIE MÜNCHNER MALEREI IM NEUNZEHNTEN JAHRHUNDERT, Vol. II, Munich, 1927, p. 206.

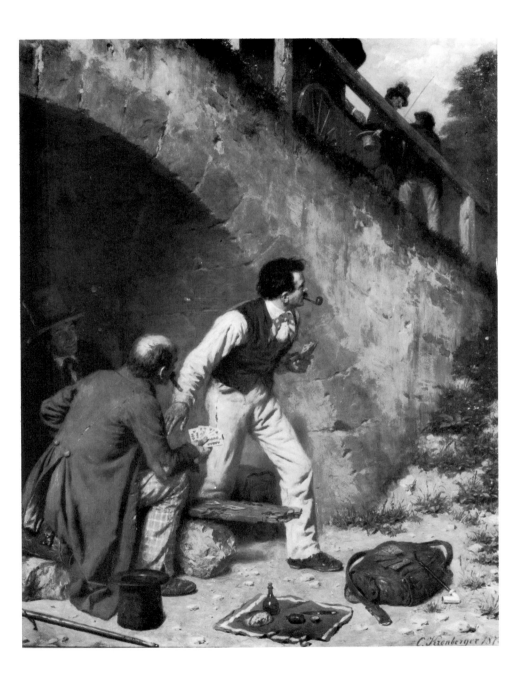

94
Surprised (Beim Kartenspiel Überrascht)
1875
> signed and dated L.R.: C. Kronberger 1875
> oil on wood panel, 14⁵⁄₁₆ × 11½ (36.4 × 29.2)
> MAC cat. no. M 1971.73

To order the following fifteen paintings (**94–108**) by Kronberger in chronological sequence is more or less pointless, because his style hardly changed at all over the years and because he usually did not date his works. I found it desirable, therefore, to arrange the following exhibits according to subject or motivic groupings. Thus, **94, 95, 96,** and **97** represent a very plain, humorous, narrative genre in which, however obliquely, certain traits of Spitzweg (see entry in Catalogue) surface. Exhibits **98** and **99** are two extraordinarily tight pendant miniatures, even when judged by Kronberger's own unusually exacting standards of naturalism.

There follows a distinct grouping of "character heads" (**100, 101, 102, 103, 104**) for which the same white-mustachioed elderly model was used. Finally, there is a collection of various "left profiles" (**105, 106, 107, 108**). Of these, **105, 106,** and **107** belong to the same model; **106** and **107** are very close variants of the same composition, and **108** is a different one. Totally self-explanatory, none of these paintings wavers in one basic respect: excellent craftsmanship. Except for **94–97,** which are tonal, atmospheric, and even rich in the nuances of sands, grays, and greens, especially in the backgrounds, all others are done in deep earth, moss colors, and look-alike morbidezza on plain, very dark umber, almost black, or black backgrounds.

PROVENANCE
Adolf Weinmüller Auction 132, Catalogue 140, Dec. 2–3 1970, No. 1807 in catalogue, illustrated, plate No. 76.

REFERENCE
Thieme-Becker, Künstlerlexikon, Leipzig, 1907–50, Vol. XXI, p. 574: "Beim Kartenspiel (Abb. im Kat. d. Münchener Glaspal.-Ausst. 1908)."

155

95
The Pickpocket
1887 (see below, under Reference)
 signed L.L.: C. Kronberger
 oil on wood panel, 14 × 11¾ (35.6 × 29.9)
 MAC cat. no. M 1962.33

See description under entry **94**.

REFERENCE
S. Wichmann, PAINTINGS FROM THE VON SCHLEINITZ COL-
LECTION (Catalogue), Milwaukee Art Center, 1968, No. 34,
illus. 23 On the basis of his research, Wichmann assigns
the date 1887 to this painting.

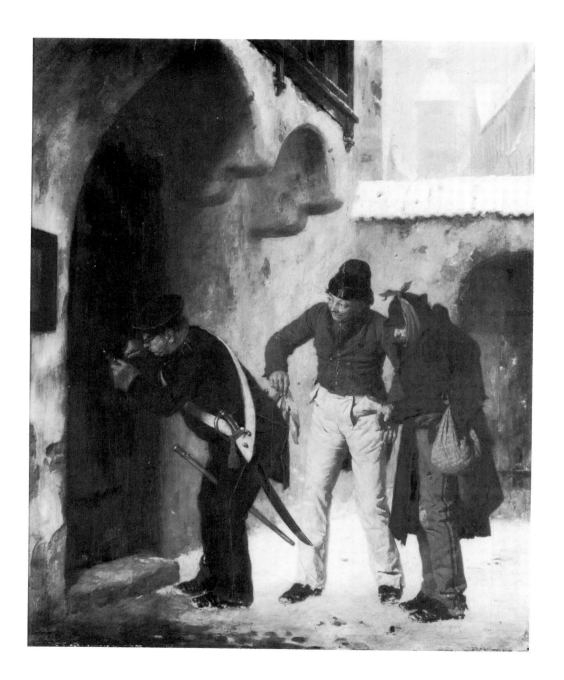

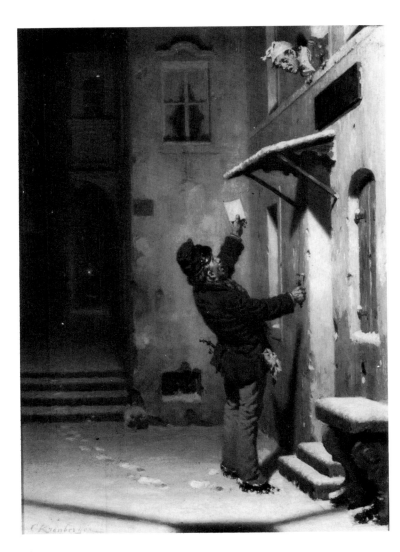

96
The Postman (Der Briefträger)
 signed L.L.: C. Kronberger
 oil on wood panel, 7¹/₁₆ × 5 (17.9 × 12.7)
 MAC cat. no. M 1962.128

See description under entry **94**.

97
So Near and Yet so Far
 signed L.L.: C. Kronberger
 oil on wood panel, 6³/₈ × 4⁵/₈ (16.2 × 11.8)
 MAC cat. no. M 1962.34

See description under entry **94**.

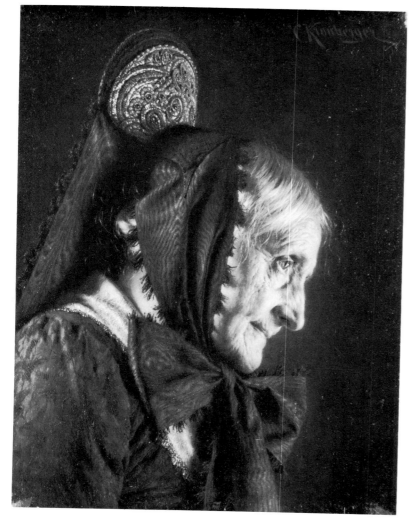

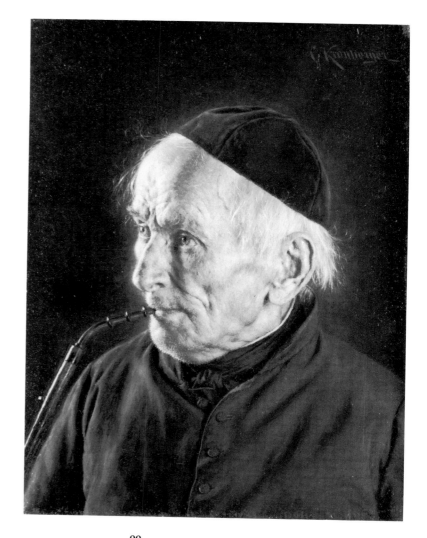

98
Peasant Woman (pendant of Cat. No. 99)
c. 1884
 signed U.R.: C. Kronberger
 oil on wood panel, 7¼ × 5½ (18.4 × 14)
 MAC cat. no. M 1962.74

See description under entry **94**.

REFERENCE
S. Wichmann, PAINTINGS FROM THE VON SCHLEINITZ COL-
LECTION (Catalogue), Milwaukee Art Center, 1968, No. 33.
MIRRORS OF 19TH CENTURY TASTE: ACADEMIC PAINTING;
Exhibition Handlist, Milwaukee Art Center, 1974, No. 51.

99
Peasant Man (pendant of Cat. No. 98)
c. 1884
 signed U.R.: C. Kronberger
 oil on wood panel, 7⁷⁄₁₆ × 5⅝ (18.9 × 14.3)
 MAC cat. no. M 1962.75

See description under entry **94**.

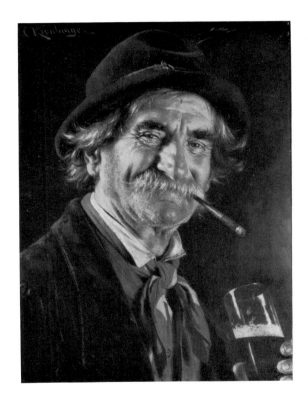

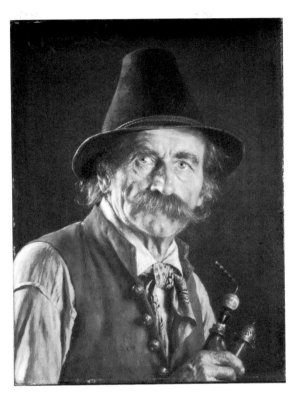

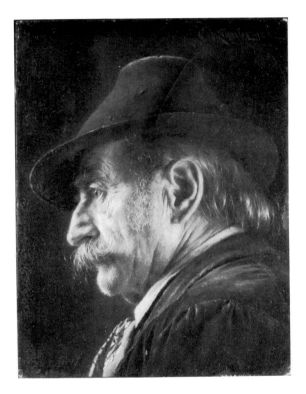

100
Peasant Man
c. 1894
 signed U.L.: C. Kronberger
 oil on wood panel, 7¼ × 5½ (18.4 × 14)
 MAC cat. no. M 1962.35

See description under entry **94**.

REFERENCE
S. Wichmann, PAINTINGS FROM THE VON SCHLEINITZ COL-
LECTION (Catalogue), Milwaukee Art Center, 1968, No. 32,
illus. 28. T. Atkinson, "German Genre Paintings from the
von Schleinitz Collection," ANTIQUES, Nov. 1969, pp. 712
ff., illus. p. 716.

101
The Pipe Smoker
c. 1894
 signed U.L.: C. Kronberger
 oil on wood panel, 7¼ × 5¼ (18.4 × 13.3)
 MAC cat. no. M 1962.121

See description under entry **94**.

REFERENCE
WISCONSIN COLLECTS; Exhibition Catalogue, Milwaukee
Art Center, 1964, No. 36, titled "Man in Red Vest."
S. Wichmann, PAINTINGS FROM THE VON SCHLEINITZ COL-
LECTION (Catalogue), Milwaukee Art Center, 1968, No. 35.

102
Character Head
 signed U.R.: C. Kronberger
 oil on wood panel, 4⅝ × 3¾ (11.8 × 9.5)
 MAC cat. no. M 1962.93

See description under entry **94**.

REFERENCE
SELECTIONS FROM THE VON SCHLEINITZ COLLECTION; Ex-
hibition, Paine Art Center, Oshkosh, Wisconsin, Feb.
1–20, 1972.

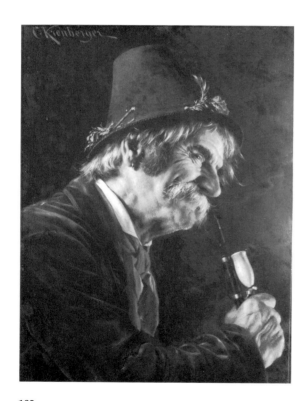

103
Character Head with Pipe
 signed U.L.: C. Kronberger
 oil on wood panel, 6⅞ × 5 (17.5 × 12.7)
 MAC cat. no. M 1962.107

160 See description under entry **94**.

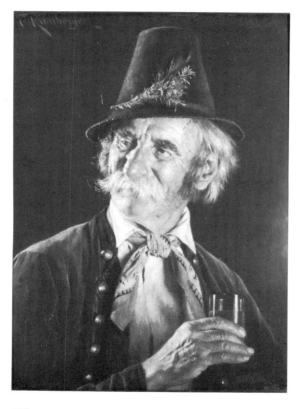

104
Man Drinking Beer
 signed U.L.: C. Kronberger
 oil on wood panel, 6⅞ × 4¹⁵⁄₁₆ (17.5 × 12.5)
 MAC cat. no. M 1962.83

See description under entry **94**.

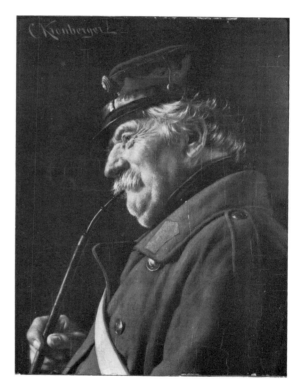

105
Old Soldier with Pipe
 signed U.L.: C. Kronberger
 oil on wood panel, 6¾ × 4¾ (17.2 × 12.1)
 MAC cat. no. M 1962.114

See description under **94**.

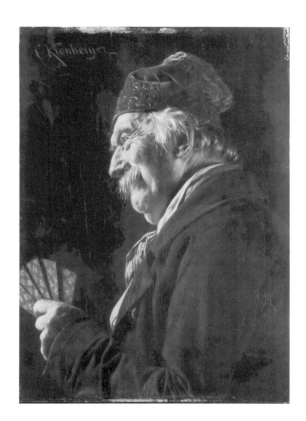

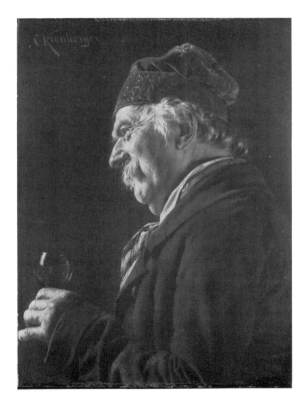

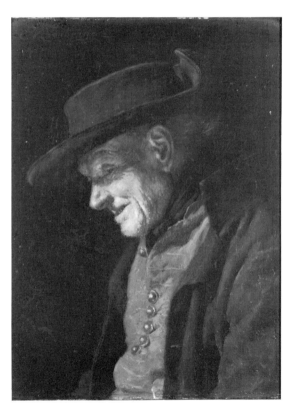

106
The Usual Game
 signed U.L.: C. Kronberger
 oil on wood panel, 6⅞ × 4⅞ (17.5 × 12.4)
 MAC cat. no. M 1962.119

See description under entry **94**.

107
Anticipation
 signed U.L.: C. Kronberger
 oil on wood panel, 6⅞ × 4⅞ (17.5 × 12.4)
 MAC cat. no. M 1962. 118

See description under entry **94**.

108
Character Head of a Peasant
 signed U.L.: C. Kronberger
 oil on wood panel, 6⁵⁄₁₆ × 4⅝ (16 × 11)
 MAC cat. no. M 1962.91

See description under entry **94**.

LEIBL, WILHELM MARIA HUBERTUS

b. October 23, 1844, Cologne
d. December 4, 1900, Würzburg
represented at Berlin, Cologne, Frankfurt, Hamburg,
 Karlsruhe, Leipzig, Munich, Stuttgart, Vienna,
 Winterthur

Wilhelm Leibl was trained at the Munich Academy under Ramberg and Piloty. In 1869 he went to Paris but returned to his homeland during the Franco-Prussian War. Thereafter, he lived in Munich and Southern Bavaria. He painted peasant genre in the style of Realism. Although he is today universally regarded as among the greatest painters of the nineteenth century and of all time, his unadorned objective realism found many detractors in his own day.

It is instructive to contrast Leibl's undisputed fame of today with a view expressed in the later nineteenth century:

> Leibl reveals in painting the rough-featured, roughly clad *Bauerein*, or peasants of the Bavarian hamlets, and the results are sometimes quite marvelous. He can also give you, if he chooses, the delicate beauty of a lady's hand with a truth to nature that throws enthusiastic young artists into raptures. But he does not often so choose, and this leads us reluctantly to say that the essential coarseness of his character prevents him from being as great an artist as his abilities might otherwise have made him. The greatest artists generally combine with strength a certain refinement, apparent in their works, if not in their manners. Beauty in the ordinary sense of the term has no attraction to Leibl. Even amidst the homely uncouthness of German peasantry handsome men and comely maidens are to be found. He seems to go out of his way to give us the most repulsive specimens of both sexes that he can find. (Benjamin's *Contemporary Art in Europe*; quoted from C. E. Clement and L. Hutton, *Artists of the Nineteenth Century and Their Works*, Boston, 1884 [facsimile ed., St. Louis, 1969], Vol. II, pp. 53 ff.)

Leibl attracted many followers, and the large Leibl Circle included, among others, the following important painters: Thoma, Sperl, Alt, Hirth du Frênes, Albert von Keller, Schider, Trübner, Haider, Eysen, Schuch.

BIBLIOGRAPHY
W. L. Gronau, WILHELM LEIBL, Bielefeld, Leipzig, 1901, J. Mayr, WILHELM LEIBL, SEIN LEBEN UND SEIN SCHAFFEN, Berlin, 1907, (4th ed., Munich, 1935). E. Waldmann, WILHELM LEIBL, EINE DARSTELLUNG SEINER KUNST; GESAMTVERZEICHNIS SEINER GEMÄLDE, Berlin, 1914. G. J. Wolf, LEIBL UND SEIN KREIS, Munich, 1923. E. Waldmann, DIE KUNST DES REALISMUS UND DES IMPRESSIONISMUS IM 19. JAHRHUNDERT, Berlin, 1927, pp. 51–57, 61–63, 297–307, and passim. E. Waldmann, WILHELM LEIBL ALS ZEICHNER, Munich, 1943. O. Fischer, GESCHICHTE DER DEUTSCHEN MALEREI, Munich, 1956, pp. 434 ff. A. Langner, WILHELM LIEBL, Leipzig, 1961. R. Zeitler, DIE KUNST DES 19. JAHRHUNDERTS, Berlin, 1966, pp. 121 ff., and passim. J. Canady, MAINSTREAMS OF MODERN ART, New York, 1966, p. 306. F. Novotny, PAINTING AND SCULPTURE IN EUROPE, 1780–1880, Baltimore, 1970, pp. 163 ff., and passim. E. Diem, E. Ruhmer, and others, WILHELM LEIBL UND SEIN KREIS (Catalogue), Munich, 1974.

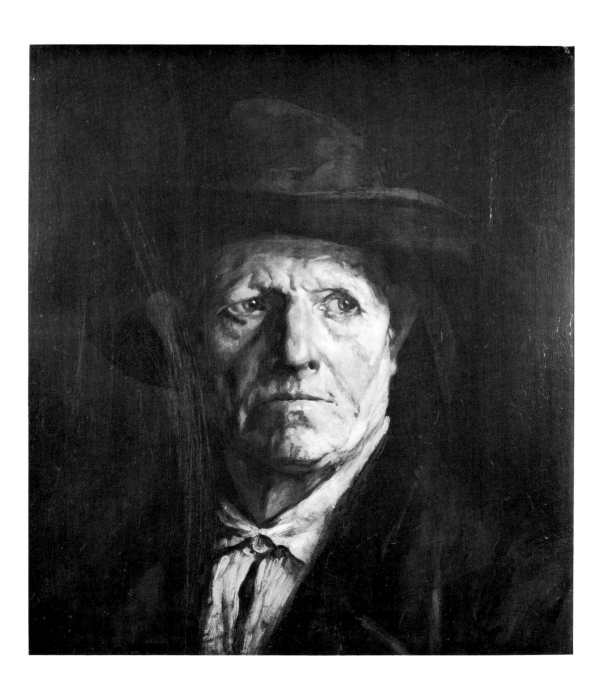

109
(attributed to Leibl or Leibl Circle)
Portrait of a Peasant
possibly early 1870s
 signed L.L.: W. Leibl
 oil on wood panel, 19⅞ × 17¼ (50.5 × 43.8)
 MAC cat. no. M 1954.7

Eberhard Ruhmer, a well-known Leibl scholar, expressed this opinion in a letter to the author (7/27/76):

> . . . the expression is too overtly pathetic for Leibl. To be sure, the "handwriting" of the Leibl Circle is evidenced, especially in the manner the hat and the shirt are painted. However, with all respect, more likely it is that of Trübner, who also used these exceedingly lively flesh tones. Nevertheless, I must hesitate to attribute the painting to Trübner. . . .

Wilhelm Trübner (1851–1917), from Heidelberg, who studied under Canon and Diez (for the latter, see entry in Catalogue) and eventually became a fellow professor of Hans Thoma at the Karlsruhe Academy, was one of the most distinguished members of the extensive Leibl Circle. He developed a pronounced tendency toward Impressionism in his later years. His oeuvre is divided into three distinct periods: the "Leibl period," a transitional phase of mythological and narrative paintings, and, finally, an impressionistic *Freilichtmalerei* (open-air painting), of which he became a leading exponent in the 1890s. If we speculate on a Trübner attribution here, then the painting definitely belongs to his Leibl period and could be dated in the early 1870s.

163

LENBACH, FRANZ SERAPH VON

b. December 13, 1836, Schrobenhausen, Upper
 Bavaria
d. May 6, 1904, Munich
 represented at major museums throughout Germany
 and the world; larger collections at Munich and
 Schrobenhausen

Perhaps no other artist of the Gilded Age triggered a more violent controversy in the literature on the arts than Franz von Lenbach. Celebrated as one of the greatest geniuses and *Malerfürsten* in his own lifetime, Lenbach was vilified by critics of the generation that followed as the antithesis of "all good art." Until quite recently, he played the role of the arch-enemy of progress in a critical scenario that had the white knights of modernism battling him and his minions, the salon painters and their henchmen: critics, dealers, bourgeois patrons. At stake was nothing less than the "survival of art" as a "vital force in Western culture." Accordingly, it was Lenbach who, more than anyone else, had "sealed the fate" of the Munich School.

The basic argument, still staunchly defended by Karlinger (1933), for example, was that the cult of genius and the machinations of art dealers had combined to form a sinister force in Munich (and in other art capitals) which fully explains the nature of popular salon art as a form of patinaed trash. But Zeitler (1966) cautions us against such a "bull in the china shop" approach to art history:

> The cult of genius as much as merchandising in the open market place belonged to the outer life's necessities of nineteenth century art and they determined worldly success or failure. But the inner creative evolution and the structure of the works of art of that century themselves were not determined by that process. We can draw preciously few inferences from the cult of artists and their commercial fame with a bearing on the "meaning" and "content" of art. (p. 25)

Lenbach, the son of a stonemason, was destined for a life in his father's craft. But around 1850, after his father had died and while he was attending the polytechnical school in Augsburg, he took up dabbling in art. Following some instruction from the sculptor Anselm Sikkinger in Munich and the animal painter Johann Baptist Hofner in Schrobenhausen, located about sixty km north of Munich, Lenbach was occupied with occasional artistic "odd jobs," such as painting votive pictures, as well as with copying after, among others, Jacob Jordaens. In 1857 he studied in Munich with Albert Gräfle and Karl von Piloty, whom he accompanied on a trip to Rome in the following year. Having distinguished himself early on with a remarkably realistic style that excelled in brilliant color and an effective treatment of light, and armed with recommendations from Piloty, he obtained a teaching post at the Weimar Academy in 1860. But only two years later he quit that job in order to return to Munich. There he soon came to the attention of the great art patron Count von Schack, who supported or commissioned, among many others, Moritz von Schwind, Arnold Böcklin, Hans von Marées, and Anselm Feuerbach, and who collected Spitzweg paintings (see entry in Catalogue).

On commission from Count von Schack he went to Rome (he shared a studio there with his friend Arnold Böcklin), where he executed many copies after the Old Masters. Lenbach was soon able to apply to portraiture the lessons he learned through his constant and deep absorption in the Renaissance painters. His world fame as the unchallenged "prince of portrait painters" from about 1867 onward was as spectacular in its extent as it was invulnerable during his lifetime. His position of social eminence now also assured—he counted Count von Bismarck, the subject of over eighty of his paintings, among his personal friends—Lenbach built for himself a lavish Neo-Renaissance palace in Munich (now the Städtische Galerie im Lenbachhaus) that had few rivals for splendor or as a glittering meeting place for high society. It ranks today among the finest monuments to the opulent taste in residential culture of the Wilhelmian period. (The Gardner Museum in Boston, also built as a residence, comes to mind as a comparable edifice.)

Lenbach's earliest style (up to about 1860; in re-cent decades considered his finest) was characterized by sharp realism (not unlike that of Leibl, with whom he was often compared in those years), brilliant lighting contrasts, a joyous polychromatic palette, and an impastoed *alla prima* application. Virtually all of his genre paintings fall into that early period. The next seventeen years witnessed a succession of different Old Masters as models for his ensuing eclectic styles: Jordaens, Rembrandt, Rubens, Titian, and Velazquez, as well as many others. Thereafter, Lenbach evolved his own personal style in portraiture, a style that is distinguished by a concentration on the spiritually fascinating features of the face, while peripheral aspects are treated with an antithetical disdain for detail and an "old-masterly" flair for chiaroscuro and decorative glazes. It is only in his late portraits of women—the 1890s saw him become an increasingly facile and modish society painter—that a slackening resulting in an overall patinaed decorativeness, can be noted in his paintings. Lenbach was a ceaseless experimenter in painting techniques and he favored a variety of mixed media over conventional means. His immensely large oeuvre is estimated at over four thousand paintings.

BIBLIOGRAPHY
A. F. von Schack, Meine Gemäldesammlung, Munich, 1881. A. Rosenberg, Lenbach, Bielefeld-Leipzig, 1898. F. Hanfstaengel, Bildnisse, 3 Mappen Photogravuren, Munich, 1900–1904. F. von Lenbach, Gespräche und Erinnerungen, mitgeteilt von W. Wyl, Stuttgart, 1904. F. von Ostini, Franz von Lenbach, Schönheit-Ideale, Munich, 1904. G. Pauli, "Lenbach," Kunst und Künstler, Vol. II, Berlin, 1904. J. Meier-Graefe, Entwicklungsgeschichte der Modernen Kunst, Munich, 1914 (new ed., 1966), Vol. I, pp. 312 ff. H. Karlinger, München und die Kunst des 19. Jahrhunderts, Munich, 1933 (2d ed., 1966), pp. 47–49, 54–57, and passim. A. Rümann, "Franz von Lenbach, 1836–1904," Zwei Vorträge, Munich, 1955. E. Hanfstaengl, Meisterwerke der Kunst in der Städtischen Galerie im Lenbachhaus München, Munich, 1965. R. Zeitler, Die Kunst des 19. Jahrhunderts, Berlin, 1966. F. Novotny, Painting and Sculpture in Europe, 1780–1880, Baltimore, 1970, pp. 162 ff. S. Wichmann, Franz von Lenbach und seine Zeit, Cologne, 1973.

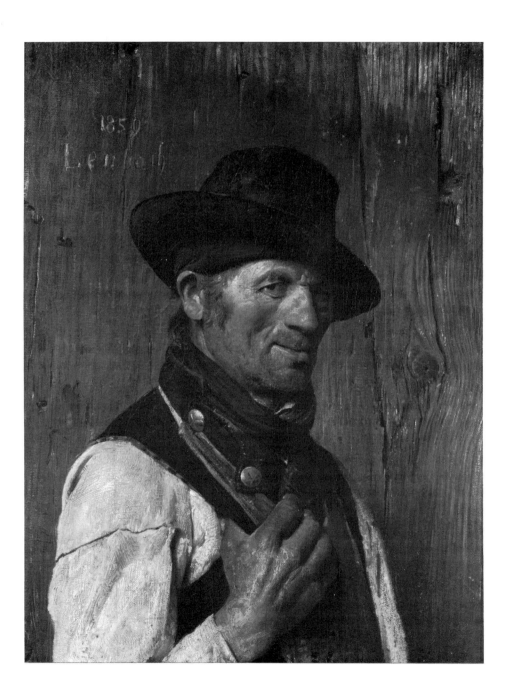

110
Portrait of a Man (Bavarian Peasant)
1859

> signed and dated U.L.: Lenbach [in the trompe l'oeil
> wood carving] 1859
> oil on canvas, 27½ × 19⅞ (69.9 × 50.5)
> MAC cat. no. M 1972.116

Portrait of a Man (Bavarian Peasant) is a very valuable early work by Lenbach, because it superbly exemplifies the accomplished phase of his early period of unalloyed Realism. Art historians in the first half of the twentieth century have honored him for his original contribution to the new style of Realism in its early phase, of which this exhibit is a prime specimen, while criticizing him for his later eclectic styles. This work is, therefore, in addition to being an excellent painting in its own right, also representative of an important stylistic milestone in the morphology of art. A slight deficiency in the anatomy and the rendering of the hand does not significantly mar the overall effect of this brilliantly effective portrait. The painting has recently been cleaned, with excellent results. Formerly yellowed passages (e.g., shirt, background) now appear in their original crisp and cool tones. The colors are bright and incisive. The carnation varies from umber and burnt orange to carmine and peach tints. The remaining parts move through gradations of white gray (sleeves), medium gray (background), and black gray (hat, scarf, vest).

Siegfried Wichmann, a noted authority on Lenbach, advanced the following view on this painting (letter to author, 8/17/76): " . . . ist ein anerkanntes und gut signiertes Bild und stimmt mit der Malweise um 1859 genau überein." (This painting "is a recognized and well-signed painting and corresponds exactly with [Lenbach's] painting style of around 1859.")

PROVENANCE
Paul Dietrich Collection, San Francisco.

REFERENCE
Mirrors of 19th Century Taste: Academic Painting; Exhibition Handlist, Milwaukee Art Center, 1974, No. 55.

111
Bavarian Peasant Girl
1860

 signed and dated L.R.: Lenbach fec. / 1860
 oil on canvas, 36 × 28⅛ (91.4 × 71.4)
 MAC cat. no. M 1969.58
Color plate page 33

A perfect masterpiece by Lenbach and a large and outstanding paean to the art of portraiture in the nineteenth century, *Bavarian Peasant Girl* (like the previous exhibit) falls into what nearly all modern writers consider to have been the most original and productive period in the painter's life: his early Realism. In the opinion of Siegfried Wichmann (see quotation following **110**) this painting is also a "recognized and well-signed portrait by Lenbach." The clarity and directness of the artist's formulation equal and even excel anything that Leibl (see entry in Catalogue) had ever done. Of special note here are the masterfully precise, yet sovereignly structured costume and the beautiful balance between the flawless details of the facial features, on the one hand, and the exquisite, spherically abstract, larger volumes of cheeks, cranium, and neck. It is interesting to recognize here that Realism carried to its logical conclusion, as in this painting, not only imparts to the subject an overwhelming feeling of physical presence, but also lends the composition a lasting sense of classical balance, simplicity, and monumentality. The cream-tinted flesh tones and the golden blond hair, which is highlighted with orange red, stand out brilliantly against the neutral black background. A white to gray blouse, brown bodice and apron (the latter is striated with dark blue and magenta), and an alizarine-crimson, burnt-siena, orange dress complete this strikingly simple but exceedingly beautiful color chord.

PROVENANCE
Estate of Paul Dietrich, Sr., San Francisco.

REFERENCE
Exhibited, A. Havermeyer, 197 W. 14th St., New York (see labels painting verso). MIRRORS OF NINETEENTH-CENTURY TASTE: ACADEMIC PAINTING; Exhibition Handlist, Milwaukee Art Center, 1974, No. 54.

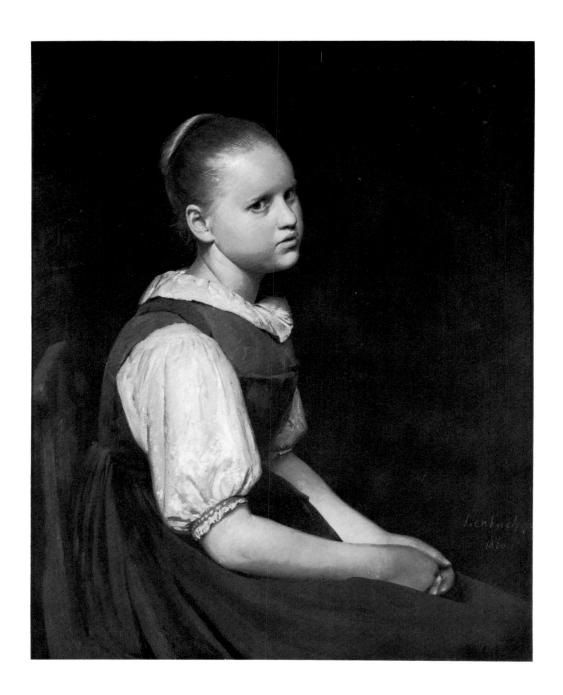

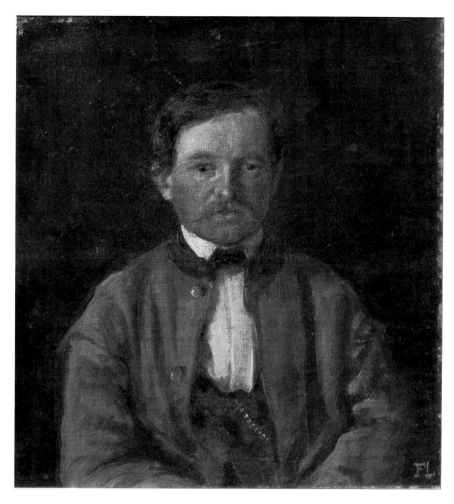

112
(attributed to Lenbach)
Portrait of a Man
c. 1855

 signed L.R.: F. L. [plus undecipherable mark]
 oil on canvas, mounted on board 7⅛ × 6¼ (18.1 ×
 15.9)
 MAC cat. no. M 1972.21

The authenticity of *Portrait of a Man* (**112**) can neither be emphatically affirmed nor denied. If Lenbach's authorship is assumed, it would be a quite early, sketchy, or tentative effort on his part. The resolute brush stroke, on the other hand, especially in the coat passages, anticipates the vigor of the mature master. In addition to this characteristic, these qualities add further substance to a positive evaluation: the peach to burnt-orange flesh tones, olive grays (coat), and blackish background strongly suggest the earliest style and preferred colors of Lenbach just prior to his decisive breakthrough to his accomplished realistic style in the late 1850s, as exemplified in **110** and **111**; the disarmingly simple frontal composition strongly hints at the unsophisticated manner of the young painter; finally, there is the unmistakable likeness so strongly reminiscent of other early self-portraits by Lenbach.

Siegfried Wichmann (see entry following **110**) is of the opinion that among the early portraits at the Lenbach Museum at Schrobenhausen, the artist's home town, there are several versions that seem to him to be related to this painting. (" . . . müsste ich die frühen Portraits in Schrobenhausen vergleichen. Es gibt dort einige Fassungen, die Ihrem Bild verwandt erscheinen" Letter from Wichmann to author, 8/17/1976.)

PROVENANCE
Andrew H. Alexander

REFERENCE
A statement of authenticity in German appears on verso: "Das umstehende Gemälde, darstellend einen Mann in mittleren Jahren, mit gesunden Gesichtsausdruck, braunem Haar, blondem Schnurrbart, weissem Hemd, schwarzer Krawatte, Jadgjoppe, Brustbild, Oel auf Leinwand auf Pappe aufgezogen 18 cm hoch, 16 cm breit, stammt, wie mir mitgeteilt wird, aus verwandtschaftlichen Besitze Professor Franz von Lenbach's und wird als eine Jugendarbeit Lenbach's bezeichnet. Ich kenne sehr viele Jugendarbeiten Franz von Lenbach's und bin der Ueberzeugung, dass es sich auch hier um eine der bekannten und geschätzten Jugendarbeiten Lenbach's handelt. Das Bild ist F.L. gezeichnet und zwar in der für die Jugendarbeiten typischen Weise. München, den 21. Januar, 1930. Adolf Alt [signature difficult to decipher, could also be Adolf Ultz], Gerichtlich vereidigter Sachverständiger." ("The painting on the reverse, representing a man in his middle years, with a healthy facial expression, brown hair, blonde mustache, white shirt, black necktie, hunting jacket, quarter length portrait, oil on canvas mounted on cardboard, 18 cm high, 16 cm wide, originates, as I am being informed, from the family ownership of Professor Franz von Lenbach and is being designated as a youthful work of Lenbach. I know very many youthful works by Franz von Lenbach and I am convinced that we are also dealing here with one of the well known and appreciated early works by Lenbach. The picture is signed F. L. in the manner that is typical for the work from his youth. Munich, January 21, 1930. Adolf Alt [Ultz?], Expert sworn by the Court.")

113
(attributed to Lenbach)
Portrait of a Girl
c. 1855
 signed L.R.: F. Lenbach [or F. L.]
 oil on wood panel, 5½ × 4¼ (14 × 10.8)
 MAC cat. no. M 1962.104

Although Siegfried Wichmann accepted Lenbach's authorship of **113** in his *Paintings from the von Schleinitz Collection* of 1968, he seems to have reversed his opinion now (see his letter to author, 8/17/76): "Bei dem Köpfchen . . . bin ich sehr skeptisch. Ich glaube eher an den Defregger-Kreis oder Matthias Schmidt." ("With regard to this little head, I am very skeptical. I believe [it] rather [belongs] to the Defregger Circle [see entry in Catalogue] or Matthias Schmidt.") (Matthias Schmidt [Mathias Schmid] was a minor Austrian genre painter and disciple of Piloty.) The carnation, olive-gray background, the brush stroke, the tone of the underpainting, the lean shadows revealing the canvas grain, the general economy of means, and the straightforward placement of the profile head in the middle of the canvas: all these qualities stand very close to the direct manner exemplified by *Portrait of a Man* (**112**). As with **112**, **113** is a very likely attribution falling into Lenbach's years of study, preparation, and experimentation that led up to his first period of Realism. The subject here is almost certainly identical with the young girl in *Bavarian Peasant Girl* (**111**).

PROVENANCE
See label in verso: Stuttgarter Kunstkabinett, R. N. Ketterer, Stuttgart, No. 180.

REFERENCE
S. Wichmann, Paintings from the von Schleinitz Collection (Catalogue), Milwaukee Art Center, 1968, No. 36.

L
E
N
B
A
C
H

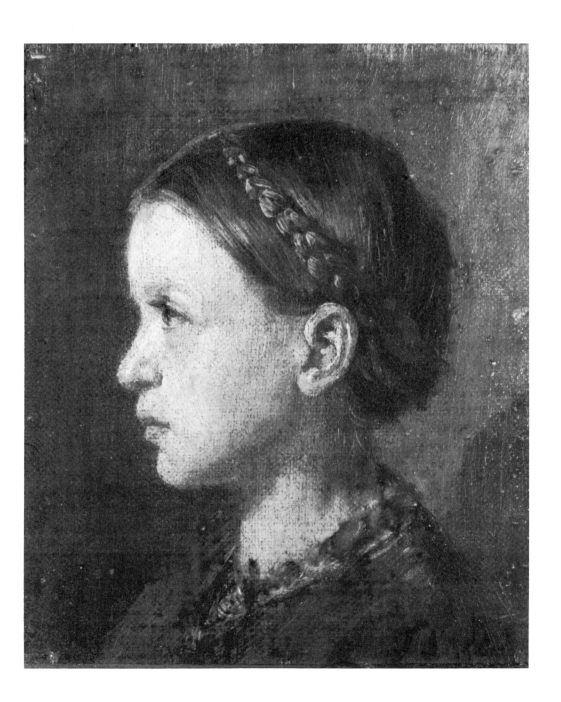

LESSING, CARL FRIEDRICH

b. February 15, 1808, Breslau, Silesia
d. June 5, 1880, Karlsruhe
represented at most important museums in Germany;
 Basel, Boston, Cincinnati, London, Milan, New
 York, Philadelphia, Vienna

Within the School of Schadow as well as within the whole field of Düsseldorf painting, Carl Friedrich Lessing was the strongest and most unique phenomenon. The simplest explanation for his artistic peculiarity, a peculiarity that knew how to preserve its character under the crushing weight of Schadow's influence, as well as in the midst of a whole variety of spiritual and aesthetic currents, is lodged in the personal will of the man. Among his colleagues, Lessing was not only the strongest but also the most versatile, and he was the first to conceive and create history painting in its purest form, a form that was free of the then virtually unavoidable admixture of sentimental and romantic ingredients. (Schaarschmidt, pp. 107, 108)

After some studies at the Berlin School of Architecture (1822) and brilliant early successes with landscape painting, Lessing met Wilhelm von Schadow and followed his invitation to Düsseldorf. There, he continued to paint naturalistic landscapes that echo romantic and literary themes. But as a result of Schadow's influence, Lessing also soon began work on very ambitious and large-scale history paintings. In the course of executing these commissions he evolved an original approach to the treatment of heroic personages from history and literature that was to be adopted as the standard by the entire field of Düsseldorf "heroic genre." He became the leading exponent of the coloristically

heightened Düsseldorf School of painting and he influenced an entire generation of German artists.

Among Lessing's subsequent original contributions to history painting was the new genre of religio-political art. His numerous treatments of subjects from the lives of Huss and Luther are filled with pathos and they stirred storms of controversy and excitement among his contemporaries throughout Germany. (One immediate personal result for him was the loss of Schadow's friendship who, as a converted Catholic, felt offended by Lessing's giant painted "theological broadsides.") In 1858 he accepted the position of director of the Karlsruhe Gallery. There, he continued to exert a liberal influence on German art that was far stronger in its impact than might be expected of one coming from that artistic province.

In addition to his paintings featuring historic and romantic literary subjects, Lessing left behind a very large body of landscape paintings. As with the former, so also with these works: contemporary criticism valued them very highly.

A painter as vigorous, truth-seeking and naturalistic as Lessing, might reasonably be supposed to find delight in Nature's way. Lessing, indeed, has been deemed by some persons greater as the painter of landscape than history. . . . All the landscapes I have seen by Lessing have been accentuated with predetermined purpose. The fixed and the forcible intent manifest in the artist's historic composi-

tions speaks out scarcely less decisively and intelligently in his protraiture of inanimate nature, which, thus, becomes, as it were, vocal under his touch. (J. Beavington Atkinson, *Art Journal*, September, 1865; quoted from Clement and Hutton, Vol. II, p. 63)

That critical perception has in recent years been enforced even more in favor of Lessing's landscapes: "He represented native German nature in richly moving and tonally beautiful mood landscapes that not seldom evince a sense of true emotion and real greatness" (Fischer, p. 472). As mentioned in the Introduction to this catalogue, Lessing founded in 1827, together with Johann Wilhelm Schirmer, his one-time pupil, later friend, and eventual grand master of the German ideal landscape tradition, the Association for Landscape Composition in Düsseldorf. This organization became one of the chief rallying points for the "anti-academics" as well as an important driving force for the emancipation of landscape painters as serious artists and the freeing of their specialty as a respectable calling in art.

As landscapist Lessing began in the ultra-romantic modes of a Blechen, Schinkel, Carus, or even Friedrich. The aging and increasingly classically oriented Goethe "thought that he still had to perceive in paintings such as those by C. F. Lessing [e.g., his early *Klosterhof*, Cologne] the admonition of death as the end, as the destruction of life. But he himself believed in the motto *'stirb und werde'* ['die and become']; for him the idea of passing was one of

making possible the continuation of life in eternal being" (Beenken, p. 239). By about 1832 Lessing forsook his outright "moribund," romantic stagings in favor of an intensely detailed Realism that strikingly fulfilled his new demands both for objective truth to the motif as such, as well as for the expression of subjective feelings about it. But as to the latter, he still favored haunting and melancholy moods in scenic prospects observed on his study trips to the regions of Silesia, the Eifel, and the Harz. Many of these paintings also contain a variety of anecdotal staffage. Lessing left behind a very large oeuvre, which to date has not been exhaustively catalogued.

BIBLIOGRAPHY
C. E. Clement and L. Hutton, ARTISTS OF THE NINETEENTH CENTURY AND THEIR WORKS, Boston, 1884 (facsimile ed., St. Louis, 1969), Vol. II, pp. 62, 63. F. Schaarschmidt, ZUR GESCHICHTE DER DÜSSELDORFER KUNST, Düsseldorf, 1902, pp. 107 ff. AUSSTELLUNG DEUTSCHER KUNST AUS DER ZEIT 1775–1875 IN DER KÖNIGLICHEN NATIONALGALERIE, Berlin, 1906, p. 336. P. F. Schmidt, BIEDERMEIER MALEREI, Munich, 1923, pp. 95 ff., 142 ff., 202 ff. and passim. H. Beenken, DAS NEUNZEHNTE JAHRHUNDERT IN DER DEUTSCHEN KUNST, Munich, 1944, pp. 286 ff. O. Fischer, GESCHICHTE DER DEUTSCHEN MALEREI, Munich, 1956, p. 11, and passim. K. Kaiser, DER FRÜHE REALISMUS IN DEUTSCHLAND, 1800–1850, Nürnberg, 1967, p. 191. DRAWINGS BY CARL FRIEDRICH LESSING (Catalogue), Cincinnati Art Museum, Ohio, 1972.

114
Castle Eltz
c. 1855
 signed L.R.: C. F. L.
 oil on canvas, 15¾ × 16¼ (40 × 41.3)
 MAC cat. no. M 1962.94

Very scenically located off the River Mosel, Schloss Eltz near Cochem (Rheinland/Koblenz) dates back in its oldest parts to the mid-twelfth century (1157) and incorporates Romanesque forms. Subsequent additions through the sixteenth century have contributed to making Eltz one of the most "fantastic" of all of Germany's "dream castles." While Lessing's choice of subject matter is indebted to his romantic past, his interpretation is realistic in terms of composition, outdoor lighting, coloration, and the details of architecture and landscape. Resolute in his design, the artist here articulated depth in terms of a simple sequence of staggered planes, the foremost of which is umber, the next, enveloping the castle, prominent siena, ocher, and green; behind it looms an umber mountain skyline behind whose jagged indentation on the right comes into sight the last, delicately mauve-colored plane. Tiny staffage can be seen on the bridge. Having divested his vision and palette of Romantic fantasy, but not his subject of its fascination, the artist lets us partake directly of the ages' unalloyed mystery.

REFERENCE
S. Wichmann, PAINTINGS FROM THE VON SCHLEINITZ COLLECTION (Catalogue), Milwaukee Art Center, 1968, No. 37. TO LOOK ON NATURE: EUROPEAN AND AMERICAN LANDSCAPE 1800–1874; Exhibition Catalogue, Dept. of Art, Brown University, Rhode Island School of Design, 1972. MIRRORS OF 19TH CENTURY TASTE: ACADEMIC PAINTING; Exhibition Handlist, Milwaukee Art Center, 1974, No. 57.

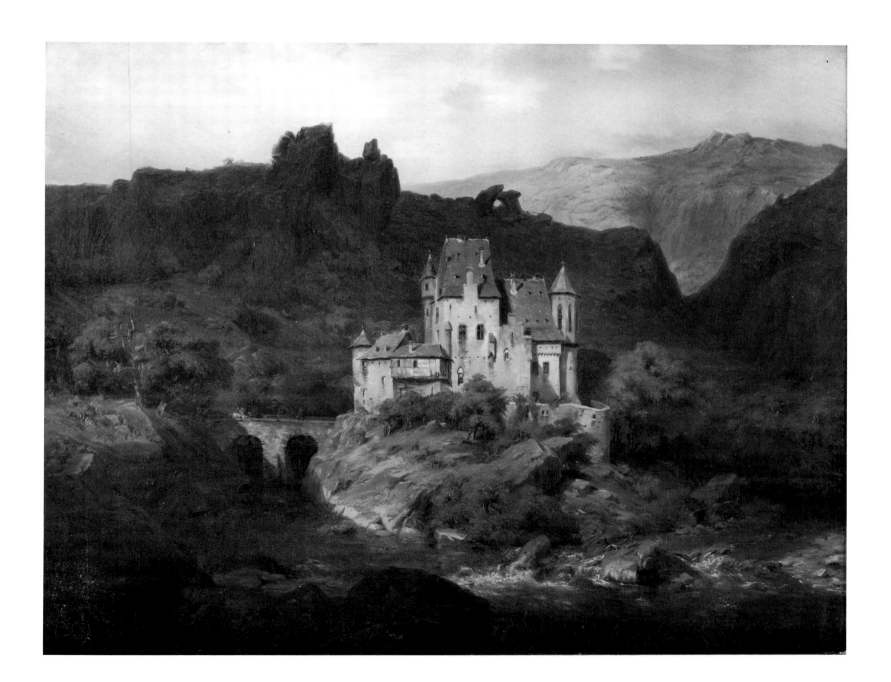

LINDLAR, JOHANN WILHELM

b. December 9, 1816, Bergisch-Gladbach, near
 Cologne
d. April 4, 1896, Düsseldorf
represented at Hanover, Besançon; private collections

Johann Wilhelm Lindlar was a landscape painter
who received his training at the Düsseldorf
Academy from the excellent landscapist Wilhelm
Schirmer. Through Schirmer he also became heir to
Carl Friedrich Lessing's (see previous Catalogue
entry) landscape tradition. An independent artist
after 1851, Lindlar based all his paintings (mostly
scenes from Switzerland, the Tyrol, northern Italy,
and southern France) on very precise studies after
nature. These studies provided him with a realistic
scaffold which he elaborated with "invented" ele-
ments, including staffage. Lindlar was a member of
the Amsterdam Academy and he received medals at
exhibitions in Besançon, Metz, and Paris.

BIBLIOGRAPHY
Gazette des Beaux Arts, Vol. VIII, 1860, pp. 112, 349; Vol.
XI, p. 383. A. Rosenberg, Düsseldorfer Malerschule,
Düsseldorf, 1889, p. 67. F. von Boetticher, Malerwerke
des Neunzehnten Jahrhunderts, Vol. I, Dresden, 1891,
pp. 881, 882. Thieme-Becker, Künstlerlexikon, Leipzig,
1907–50, Vol. XXIII, p. 247.

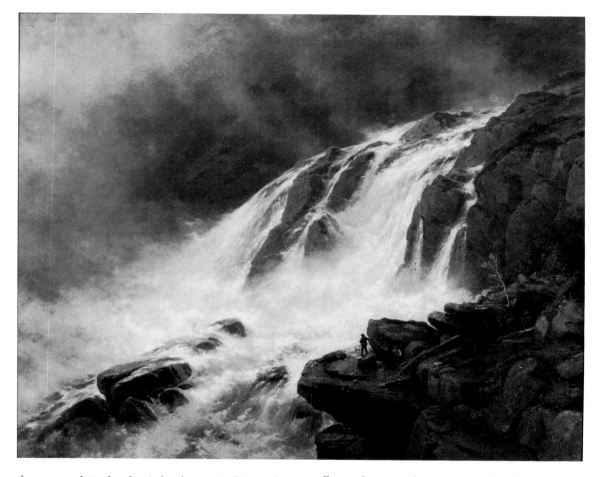

115

Waterfall (in Norway?)
 signed L.R.: J. W. Lindlar
 oil on canvas, 50 × 63 (127 × 160)
 donors: Marie K. Ingersoll and George L. Kuehn
 MAC cat. no. M 1962.1159

Aspiring to be the product of a sudden, accidental
encounter with a sublime prospect of nature, the
painting does not, at first glance, yield its secrets of
staging for calculated effect. Lindlar's style does not
seem classic—i.e., structured, idealistic (through
Schirmer he also became "heir," however reluctantly

or far removed, to the classic landscape tradition of
the great Joseph Anton Koch); nor does it strike us as
Romantic—i.e., subjective and intimate—in the
tradition of a Friedrich or Blechen, for example. Yet,
it utilizes elements of both schools and mixes them
in the new crucible of naturalism. As to the first, we
measure the impressive physical scale of the paint-
ing, the quasi-"tectonic" quality of the rock forma-
tions; as to the second, we cannot help but be awed
by the primeval wilderness and promptly identify
with our counterfeit self, the tiny *Rückenfigur* peer-
ing into the chasm who, together with the other

staffage, also provides us with a handy reference
point for scale; as to the third, we lose ourselves in
the myriad naturalistic details of faithfully rendered
surfaces, textures, colors. This hybrid of styles is
known as academic painting.

Academic landscape painting succeeds to the de-
gree that this stratagem of blending styles succeeds
in capturing the audience's imagination, in causing
them to believe in the "truth" of what they perceive
and partake of the aesthetic treat offered. Judged by
these criteria, *Waterfall* is very successful, moving,
true, and edifying.

LÖWITH, WILHELM

b. May 21, 1861, Drossau, Bohemia
d. October 26, 1932, Munich
represented at Frankfurt, Munich, Nürnberg;
Cincinnati, Prague

After studies at the Vienna Academy (1876–80) under Griepenkerl and Eisenmenger, and at the Munich Academy (1880–82) under the popular teacher and history painter from Karl von Piloty's circle, Wilhelm Lindenschmit, Wilhelm Löwith settled permanently in Munich. He painted small-scale peasant genre set mostly in the period of the Thirty Years' War and drawing room genre staged in the period of the Rococo. Uhde-Bernays points out a similarity between Löwith and Franz Simm (see entry in Catalogue), while Siegfried Wichmann pauses to suggest a stylistic closeness with Heinrich Breling (see entry in Catalogue). In addition to these apparent relationships, I also direct the reader's attention to perhaps the most obvious stylistic kin of Löwith, namely Ernest Meissonier. Perhaps most significantly, Löwith based his exquisitely refined, enameled *Atelierstil* on the seventeenth-century Dutch masters of genre painting.

BIBLIOGRAPHY
KUNST FÜR ALLE, Vol. III, 1888; Vols. VII; XII; XVII. ZEITSCHRIFT FÜR BILDENDE KUNST, Vol. XXIII, 1888, p. 329, illus. F. von Boetticher, MALERWERKE DES 19. JAHRHUNDERTS, Vol. I, Dresden, 1891, p. 900. Thieme-Becker, KÜNSTLERLEXIKON, Leipzig, 1907–50, Vol. XXIII, pp. 328, 329. H. Uhde-Bernays, DIE MÜNCHNER MALEREI IM NEUNZEHNTEN JAHRHUNDERT, Munich, 1927, p. 206.

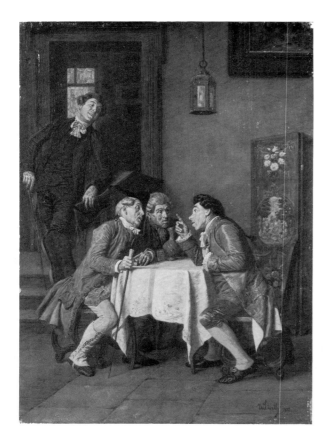

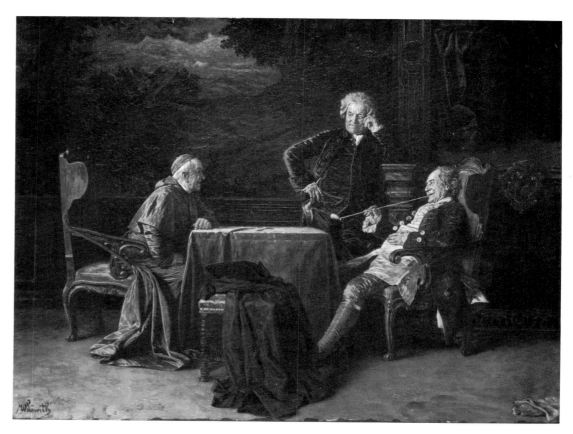

116
Four Gentlemen
1892
> signed and dated L.R.: W. Löwith 1892
> oil on wood panel, 6⁷/₁₆ × 4⁵/₈ (16.4 × 11.9)
> MAC cat. no. M 1972.18

These four exhibits (**116–119**) by Löwith are extremely tight in technique and delivery, uneventful in composition, passable in narration, entertaining in characterization, and appealing in the rendering of textures. His strongest side seems to have been an adaptable sense of color that unites a variety of hues (salmon pinks, mint greens, lakes, blues, magenta, indigo) into pleasing little bonbonnières.

117
The Conference
> signed L.L.: W. Löwith
> oil on wood panel, 9⁷/₈ × 13 (25.1 × 33)
> MAC cat. no. M 1972.128

See description under entry **116**.

REFERENCE
S. Wichmann, Paintings from the von Schleinitz Collection, Milwaukee Art Center, 1968, No. 38. Mirrors of 19th Century Taste: Academic Painting; Exhibition, Milwaukee Art Center, 1974, No. 58 on list.

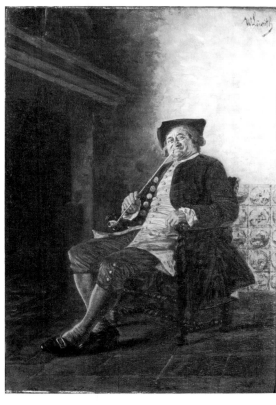

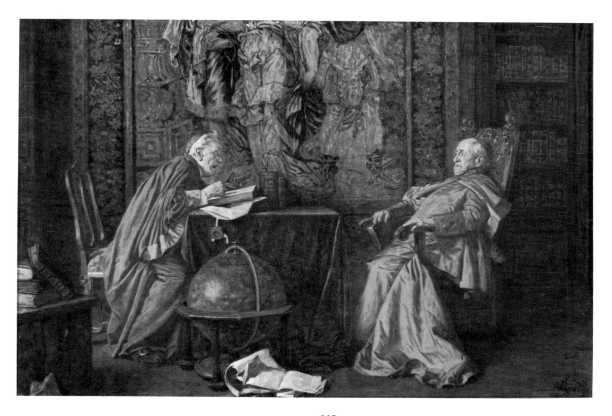

118
Man Smoking Pipe
 signed U.R.: W. Löwith
 oil on wood panel, 6⅞ × 4¾ (17.5 × 12.1)
 MAC cat. no. M 1962.137

See description under entry **116**.

REFERENCE
SELECTIONS FROM THE VON SCHLEINITZ COLLECTION; Exhibition, Paine Art Center, Oshkosh, Wisconsin, Feb. 1–20, 1972.

119
Cardinals in Dispute
 signed L.R.: W. Löwith
 oil on wood panel, 9⁹⁄₁₆ × 14¼ (24.3 × 36.2)
 MAC cat. no. M 1972.124

See description under entry **116**.

MEYER, JOHANN GEORG (called MEYER VON BREMEN)

b. October 28, 1813, Bremen
d. December 4, 1886, Berlin
represented at Berlin, Bremen, Hanover; Amsterdam, Brooklyn, Cincinnati, New York, Pittsburgh

Johann Meyer, son of a poor baker, was of Lower Saxon and Frisian family background. His early talent for drawing eventually won out over his youthful devout zeal for becoming a missionary. With a little money he had saved by his modest efforts as portraitist and some financial aid from family friends, Meyer set out, in 1833, for Düsseldorf and studies at the art academy there. At that time the academy had reached the zenith of the Late Romantic movement and its director, Wilhelm von Schadow, stood at the height of his power and influence. Meyer first entered the introductory class of Joseph Wintergerst, the Nazarene, where he drew copies after plaster casts of antique statuary. Intermediate and life drawing lessons from Carl Sohn and advanced instruction in composition followed in sequence.

After a study trip to the Low Countries in 1835, Meyer launched his career as a painter of religious subjects, in which he was under the influence of Schadow and the Nazarenes. Although he did receive academic encomiums for these works, he was unable to find buyers for them and he soon gave up that whole direction in disgust. After 1835 he again returned to portraiture but also, more significantly, to studies after nature in the countryside of Hesse. Simultaneously, he subjected the Dutch masters (Brouwer, Teniers, de Hooch, Terborch, Ostade, Steen, Vermeer, et al.) to systematic study. By 1840 he had completed his transition to genre painting.

The decade of the 1840s witnessed the rapid growth of Meyer's reputation as a genre painter. His special treatment of the mother and child and children motifs assured him of quick success. Although he also tried his hand at several large-scale, multifigural narrative genre paintings, they are flawed by various deficiencies. But in his preferred small-scale, lyrical "mood genre" of quiet domestic life, he had no equal. The signature "Meyer von Bremen" soon became synonymous with children genre *per se*; it justified his popular nickname *Kindermeyer*. Meyer's first genre painting, *Mother and Child* (1838), fetched 19 thalers at an exhibition in Amsterdam; his last picture, *The Little Darling* (1886), shown at an exhibition in Berlin, brought 25,000 Reichsmarks. This phenomenal growth in the market value of his art during the artist's lifetime suggests much about the constant quality of his output. But it also speaks volumes about the aesthetic value structure of half a century in the history of art.

After relocating in Berlin in 1852, Meyer began concentrating totally on small-scale children pictures. These he executed with an increasingly tuneful chiaroscuro. He often used his own children as models—he was a devoted family man—and his art stayed fresh and vigorous to the end. More and more of his paintings were bought by Americans and in the last ten years of his life virtually all of them found their way to the United States.

The contrast between Meyer's popularity in the United States and waning esteem in Germany becomes readily apparent when we compare later nineteenth-century writings about art. Clement and Hutton asserted in 1884 that "the pictures of this artist are so well known, and their place is so well established, that nothing need be said of them" (p. 113). Was it the same great popularity (and what he perceived as a lack of other recommendations) that caused Schaarschmidt in 1902 to omit Meyer's name from his critical history of the Düsseldorf school? Although it happened against the strenuous objections of many academics, Meyer's art received something of a belated kind of official sanction at home when he was appointed professor at the Berlin Academy. But it can be summarily stated that Meyer's value to American collectors had far outdistanced the native demand for his art in the lifetime of the artist.

Meyer had remained a *Biedermeier* artist some forty years after *Biedermeier*; his art was a sustained but gentle panegyric to the spirit of *Biedermeier* innocence and it was totally unaffected by the forces that shaped the new Germany in which he lived: revolution, war, industrialization. He lived all his life in a charmed world of his own making—the deeply private sphere of his home where the small joys and tragedies of his children worked a greater spell on his ingenuous mind than the cataclysms of the world around him.

Meyer von Bremen's art belongs to the Golden Age of Düsseldorf. His life's work was dedicated almost exclusively to the representation of the simple events inside the four walls of his quiet home, to the intimate affection between mother and child, to the emotional scene in the family circle, to the thoughtful little life of unspoiled people, of bigger or smaller children. With all its healthy and pure truth to nature, the impression that his pictures convey is that of a heightened idealism that transforms all that it touches in a golden glow. This idealism necessarily resulted from his perennial feeling for the beauty of form and the piety of mind. A steady ability and an absolute command over form, the fruit of his thorough and constant nature studies, always formed the solid basis of his art. After struggles and doubts he turned his artistic creation, equipped as he was with a flawless craftsmanship in the techniques of color and drawing, to what most suited his simple but sensitive nature: to the daily activities he perceived through naive observation. He imparted to these scenes of everyday life the magic of his inner nobility and of his healthy optimism. (Alexander, pp. 11, 13)

BIBLIOGRAPHY
C. E. Clement and L. Hutton, ARTISTS OF THE NINETEENTH CENTURY AND THEIR WORKS, Boston, 1884 (facsimile ed., St. Louis, 1969), Vol. II, p. 113. KUNSTCHRONIK, Old Series (1886–89), Vol. II, pp. 111 ff.; Vol. XXI, p. 602; Vol. XXII, pp. 151, 550 ff. F. W. Alexander, JOHANN GEORG MEYER VON BREMEN, Leipzig, 1910.

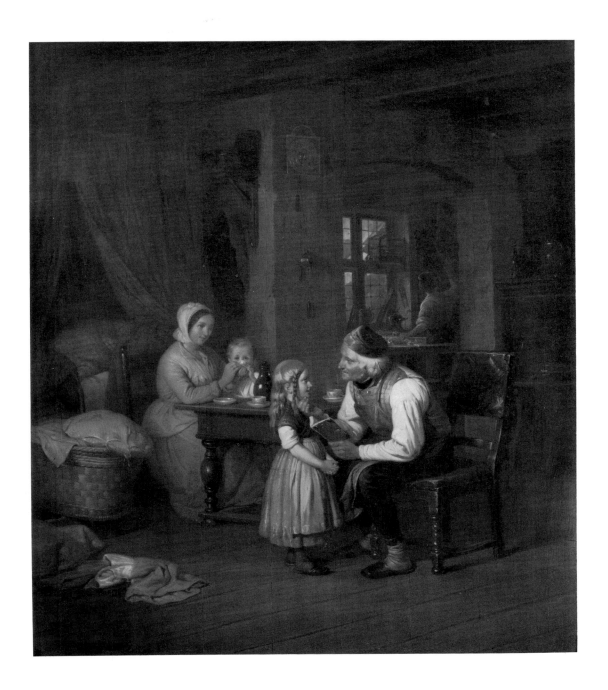

120
Family Gathering
1845

 signed and dated L.L.: Meyer v. Bremen / 1845
 oil on canvas, 16½ × 14 (42 × 35.6)
 MAC cat. no. M 1972.8

All of the following six exhibits (**120–125**) were done by "Kindermeyer" after he had attained recognition with his special forte, intimate domestic genre. All are very tuneful in chiaroscuro and deeply saturated in autumnal colors, and all feature that mellow, "paradisiacal" golden glow for which the artist was celebrated everywhere during his lifetime. *Girl Reading* (**122**) is one of at least two very close versions of the same motif done in 1848, while (**125**) is the first of three pendants titled *Siesta, Trust in God, Forgiveness*, done in 1884.

MEYER VON BREMEN

121
Girl with Knitting (Mädchen mit Strickzeug)
1846

signed and dated U.R.: Meyer von Bremen / 1846
oil on paper mounted on cardboard, 7 × 5⅜ (17.8 × 13.7)
MAC cat. no. M 1962.99

See description under entry **120**.

PROVENANCE
178 Galerie Commeter, Hamburg.

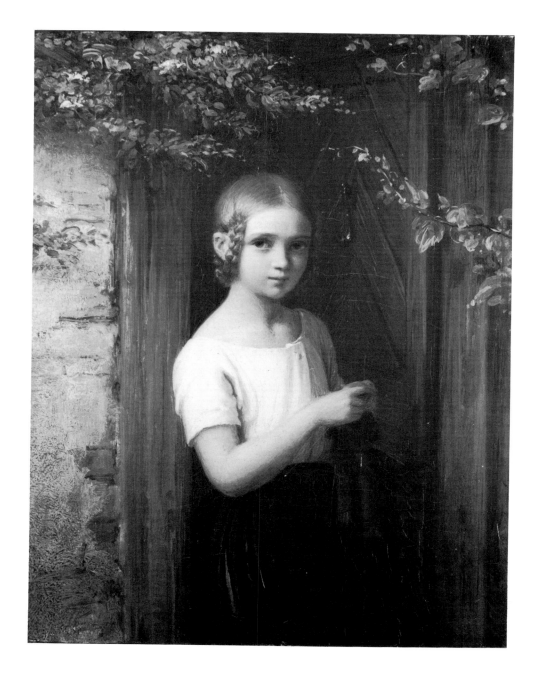

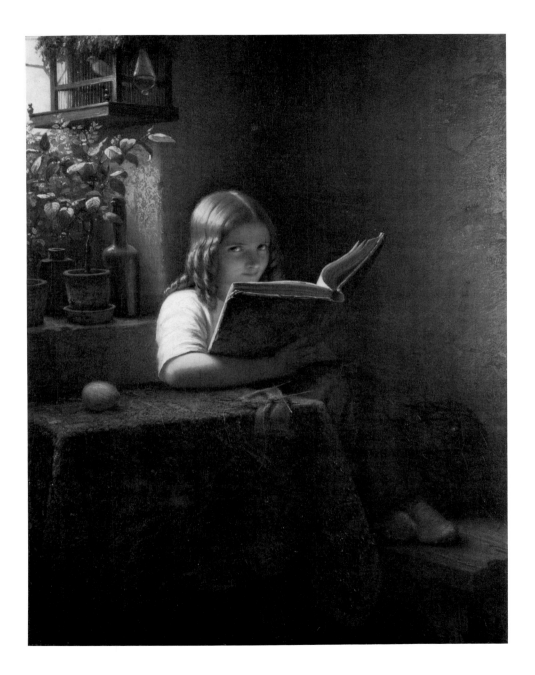

122
Girl Reading ("The Little Mona Lisa") (Das lesende Mädchen)
1848
 signed and dated L.L.: Meyer von Bremen 1848
 oil on canvas, 16½ × 12¾ (41.9 × 32.4)
 MAC cat. no. M 1962.48

See description under entry **120**.

PROVENANCE
Kaiser Wilhelm II. Purchased by donor from Parke-Bernet, 12/5/46, No. 100 in catalogue, illustrated p. 18, listed as property of a Newport, R.I., private collector and titled "Girl Reading."

REFERENCE
See F. von Boetticher, MALERWERKE DES NEUNZEHNTEN JAHRHUNDERTS, Vol. II, Dresden, 1898, p. 37, Nos. 23, 24: "Das lesende Mädchen. Bez. 1848. h. O.42, br. 0.32. Das Lesende Mädchen. Bez. 1848. h. 0.195, br. 0.155. 23 u. 24. E: Kaiser Wilhelm II." 122 is most probably Boetticher, No. 23. S. Wichmann, PAINTINGS FROM THE VON SCHLEINITZ COLLECTION (Catalogue), Milwaukee Art Center, 1968, No. 39, illus. 12. T. Atkinson, "German Genre Paintings from the von Schleinitz Collection," ANTIQUES, Nov. 1969, p. 714, illus. p. 714.

123
Grandmother and Child
1856
 signed and dated L.L.: Meyer von Bremen 1856
 oil on canvas, 9⅞ × 8¼ (25.1 × 21)
 Donor: Mrs. Jesse Hoyt Smith, bequest of (1941)
 MAC cat. no. L1941.10

See description under entry **120**.

PROVENANCE
Layton Art Collection

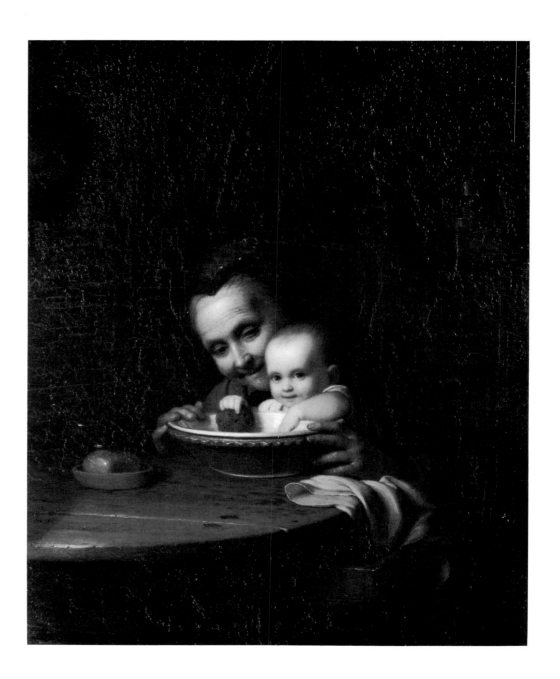

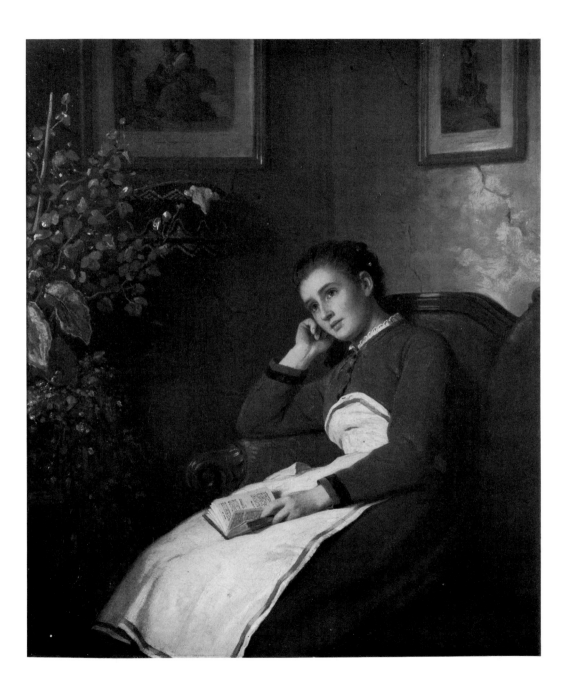

124
Sitting Girl ("Reflecting")
1872
 signed and dated L.L.: Meyer von Bremen / Berlin,
 1872
 oil on canvas, 14½ × 12 (36.8 × 30.5)
 MAC cat. no. M 1970.120

See description under entry **120**.

PROVENANCE
Mrs. Stanley C. Hauxhurst, Milwaukee. Milwaukee Auction Galleries 8/22/70, No. 1365 in catalogue, illus. p. 116. Purchased by donor.

REFERENCE
Mirrors of 19th Century Taste: Academic Painting; Exhibition Handlist, Milwaukee Art Center, 1974, No. 62.

125
Siesta
1884

 signed and dated L.L.: Meyer von Bremen / Berlin
 1884
 oil on canvas, 21½ × 15 (54 × 38.1)
 MAC cat. no. M 1962.120

See description under entry **120**.

REFERENCE
F. von Boetticher, Vol. II, Malerwerke des Neunzehnten Jahrhunderts, Dresden, 1898, p. 39, Nos. 90–92: "Siesta; Gottvertrauen; Verzeihung.–Berl. ak. K. A. 84." *Siesta* is, therefore, the first of three pendants. F. W. Alexander, Johann Georg Meyer von Bremen, Leipzig, 1910, illus. 135. S. Wichmann, Paintings from the von Schleinitz Collection (Catalogue), Milwaukee Art Center, 1968, No. 40.

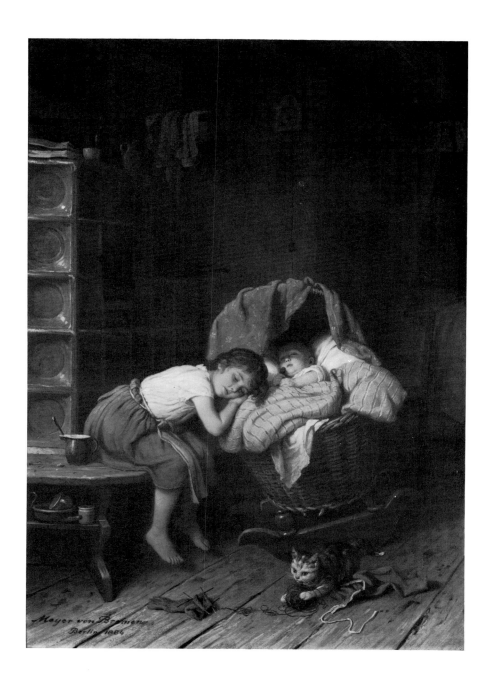

MEYERHEIM, PAUL FRIEDRICH

b. July 13, 1842, Berlin
d. September 14, 1915, Berlin
represented at Aachen, Danzig, Frankfurt, Hamburg,
Hanover, Mainz, Munich; Prague

The large artists' family of the Meyerheims hailed from Danzig, on the Baltic Sea, and produced many fine portraitists, landscapists, and genre painters during the entire course of the nineteenth century. Alongside Eduard, his son Paul Friedrich counted among the most famous members of the clan. After studies with his father and at the Berlin Academy (1852–60), Meyerheim became a noted painter of animal pictures, portraits, and genre subjects, as well as an excellent illustrator and graphic artist. As decorator, he produced acclaimed cycles of wall paintings. His early landscapes, influenced by the Barbizon School, are particularly sought-after by collectors. Meyerheim traveled very extensively throughout Europe and after 1887 he taught at the Berlin Academy.

In his technique, Meyerheim combined a selective precision of detail with a softly unifying chiaroscuro. He specialized above all in painting animals, notably wild beasts. These he arranged in narrative and anecdotal tableaux that often exude a warm sense of humor as well as an intelligent perception of animal psychology as reflective of the ways of man.

However, the importance of Meyerheim's life's work is not exhausted by the qualities of his subjects. He was always counted among the best representatives of Berlin Realism and even during the times of contour art and "philosophical" pretensions stuck to his true observation and solid craftsmanship. (Schumann, p. 23)

Though he claims to be a realist, Meyerheim is ever soaring into the heights of the ideal, letting his thoughts wander unfettered when the subject is such as to give free scope to his vivid imagination, the fertility of which astonishes us in his frescoes on ceilings and walls, and other decorative paintings. Many of these are full of refinement and grace, but his own preference appears to be for the painting of animal subjects. Great, indeed, must have been the perseverance and self-denial which won for Meyerheim the position he now holds as one of the first animal painters of the day. (Pietsch, pp. 84, 86)

BIBLIOGRAPHY
C. E. Clement and L. Hutton, Artists of the Nineteenth Century and Their Works, Boston, 1884 (facsimile ed., St. Louis, 1969), Vol. II, p. 114. L. Pietsch, Contemporary German Art: At the Centenary Festival of the Royal Academy of Arts, Berlin, Vol. I, London, 1888, pp. 84 ff. F. von Boetticher, Malerwerke des Neunzehnten Jahrhunderts, Vol. II, Dresden, 1898, pp. 47 ff. Ausstellung deutscher Kunst aus der Zeit von 1775–1875 in der königlichen Nationalgalerie, Berlin, 1906, pp. 388, 389. P. Schumann, Album der Dresdner Galerie, Leipzig, n.d., p. 23. L. Martius, "Die Villa Borsig in Berlin-Moabit. Über ihren Architekten J. H. Strack und den Maler Paul Meyerheim," Der Bär von Berlin, 1965, pp. 261–80.

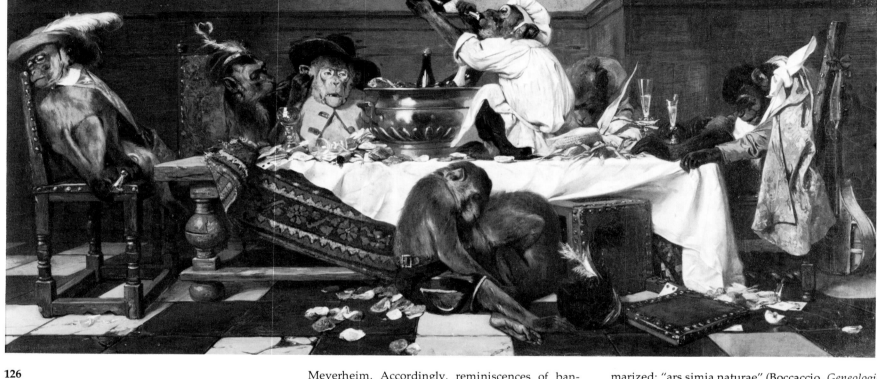

126
A Darwinian Prehistoric Social Party (The Un-evolved Club Man of the Period)
1865

P.
F.
M
E
Y
E
R
H
E
I
M

signed and dated L.L.: Paul Meyerheim 1865 /
 Antwerpen
oil on canvas, 21⅛ × 45 (53.7 × 114.3)
donor: Purchase, Layton Art Collection, sometime
 between 1890–96 (see Provenance, below)
MAC cat. no. L148

A colorful palette of various lakes, mints, and ochres
and the artist's telling draftsmanship enhance the
"opulent" setting and "sybaritic" demeanor of this
masterful primate burlesque of manners by

Meyerheim. Accordingly, reminiscences of ban-
quets by Hals and feasts by Veronese flick through
one's mind mingled with olfactory memories of vis-
its to the zoo. Comical animal genre or *singerie* simi-
lar to this was practiced by numerous painters
everywhere, to say nothing of cartoonists in later
nineteenth-century Europe, and it enjoyed great
popularity. Beyond that, monkey pictures have a
long history going all the way back to the Prome-
thean myth. Because he had molded man out of clay,
Epimetheus, Prometheus's brother, was changed
into a monkey by an irate Jupiter. The ape thus
became the prototype of the artist. Boccaccio sum-

marized: "ars simia naturae" (Boccaccio, *Geneologia
de gli Dei*, 1553; H. W. Janson, *Apes and Ape Lore*,
1952).

PROVENANCE
Lepkes Berliner Kunst-Auction, 1866. Layton Art Collec-
tion, donated 1890–96.

REFERENCE
See F. von Boetticher, MALERWERKE DES 19. JAHRHUNDERTS,
Vol. II, Dresden, 1898, p. 48, No. 9: "Affenbankett. Ent-
standen 1865/66. Abb. 'Illustr. Z.' 70 u. 'Meisterw.' IV.—
Lepke's Berl. K.–Auct. 66." MIRRORS OF 19TH CENTURY
TASTE: ACADEMIC PAINTING; Milwaukee Art Center Ex-
hibition Handlist, 1974, No. 63.

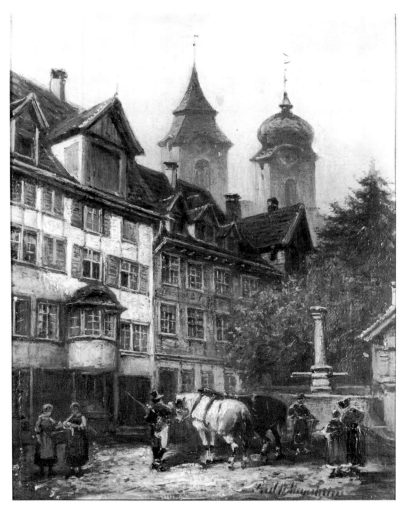

MEYERHEIM, PAUL WILHELM

b. August 6, 1843, Berlin
d. June 12, 1898, Berlin
represented in private collections

Paul Wilhelm was the youngest and least well known member of the prolific artists' family named Meyerheim (see previous Catalogue entry). He was the son of Eduard's brother Wilhelm and thus a first cousin of Paul Friedrich. He was trained by his father, a *Biedermeier* genre and horse painter in Berlin, and influenced by Moritz von Schwind, Wilhelm von Diez, and Karl von Piloty. Active mostly in Berlin, he also lived for a long period (1863–78) in Munich and he traveled extensively. Meyerheim painted some figural genre, but he mostly did architectural views of city scenes with some staffage, as well as landscapes. "Meyerheim traveled to England in 1882 (letter of Paul Meyerheim to Max Gaisser [see entry in Catalogue], July 10, 1882, private collection) where he became acquainted with the PreRaphaelites and their painting technique" (Wichmann). Meyerheim exhibited in the years from 1868 to 1895.

BIBLIOGRAPHY

F. von Boetticher, MALERWERKE DES NEUNZEHNTEN JAHRHUNDERTS, Vol. II, Dresden, 1898, p. 51. Thieme-Becker, KÜNSTLERLEXIKON, Leipzig, 1907–50, Vol. XXIV, p. 448. S. Wichmann, PAINTINGS FROM THE VON SCHLEINITZ COLLECTION (Catalogue), Milwaukee Art Center, 1968.

127
Lindau on Lake Constance
c. 1893
 signed L.R.: Paul Meyerheim
 oil on canvas, 8⅞ × 6⅞ (22.5 × 17.5)
 MAC cat. no. M 1962.112

Although Lindau has not changed much over the years, and in fact today looks essentially the same as when Meyerheim visited it in 1893, the romantic purview of this painting is, for the period in which it was done, conceptually backward-looking, recalling the style of the *Postkutschenzeit* of a Schwind or Spitzweg, his seniors by some four decades. This nostalgia of content, however, is not balanced by the artist's technique, which, with its rough-textured and mottled quasi-impressionistic delivery, seems ill-suited for a near-miniature format. The painting thus strikes a dissonant note; nor is its discord of form and content made any more agreeable by Meyerheim's vitiated, flat brown-gray-black palette.

REFERENCE

S. Wichmann, PAINTINGS FROM THE VON SCHLEINITZ COLLECTION (Catalogue), Milwaukee Art Center, 1968, No. 41.

MORALT, WILLY

b. December 1, 1884, Munich
d. 1931, Munich
represented in private collections

Willy Moralt, a grand-nephew and imitator of Carl Spitzweg (see entry in Catalogue), was trained under Karl Raupp at Munich and specialized in genre and landscapes. He was active in Munich. His great-uncle permitted him the use of his studio, and even encouraged him to develop his (limited) talents.

BIBLIOGRAPHY
Thieme-Becker, KÜNSTLERLEXIKON, Leipzig, 1907–50, Vol. XXV, p. 118.

128
Visit to the Hermit (Besuch beim Klausner)
signed L.L.: Willy Moralt
oil on wood panel, 15⅝ × 10³/₁₆ (39.7 × 25.9)
MAC cat. no. M 1962.98

A fresh, breezy, fragrantly scented little bouquet of viridians, tans, blues, red (woman's skirt), done "in the manner of" Spitzweg (see entry in Catalogue), but leagues away from that master's painterly culture and artistic substance.

PROVENANCE
Galerie Commeter, Hamburg.

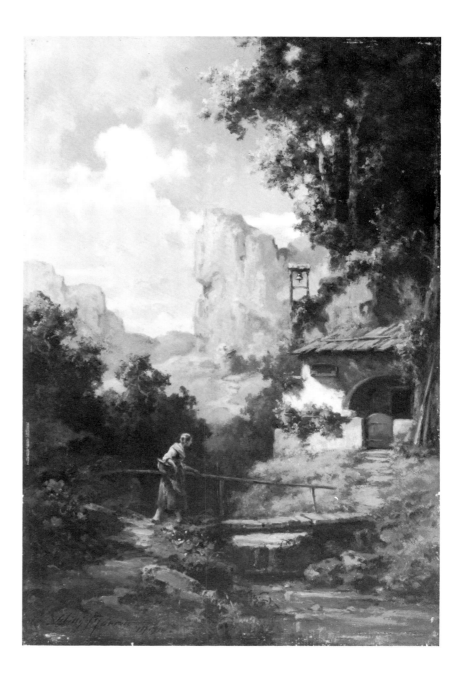

MUNKÁCSY, MIHÁLY VON
(LIEB, MICHAEL)

b. February 20, 1844, Munkács, Hungary
d. May 1, 1909, Endenich, near Bonn
represented at major museums everywhere

Mihály Munkácsy, the scion of a Bavarian family named Lieb, adopted his name (after his Hungarian birthplace) in 1863. He was trained in Budapest and under Karl Rahl in Vienna before coming to Munich in 1866 for further studies in art. After a stay in Paris (1867), where he was impressed by the art of Gustave Courbet, he came to Düsseldorf (1867–70) where Ludwig Knaus (see entry in Catalogue) imparted stimuli decisive to his mature style. It was in that city that Munkácsy began to reap his first triumphs as a painter. In 1872 he relocated in Paris where, for a brief period, he was influenced by Eduard Manet. After overcoming that affectation, he became one of the most celebrated painters of the later decades of the nineteenth century. Munkácsy, who, through his own endeavors and his marriage to a rich noblewoman, had amassed great wealth and had risen to the highest social ranks of Europe, lived out his final years in an insane asylum at Bonn-Endenich, Germany.

Munkácsy created a large harvest of colossal historical, religious, and patriotic canvases, as well as bourgeois genre paintings. These found an enormous audience through their worldwide sales by his dealer Sedelmayer. The influence of the School of Düsseldorf in its more superficially pleasing aspects—the sentimental anecdote, declamatory naturalism, burning colors, scenographic chiaroscuro—explains the foremost characteristics of Munkácsy's style. Conversely, he has also often been compared to Courbet and to Wilhelm Leibl (see entry in Catalogue), with whom he occasionally shared, at least superficially, certain elements of technique. There prevails a critical consensus today that singles out Munkácsy's powerful oil sketches as the best part of his extensive oeuvre. These landscape and genre studies encouraged his penchant for vigorous brushwork, heavily impastoed delivery, and vibrant contrasts of colors and values—especially the opposition of brilliant whites and velvety soft black-browns—to come to the fore most effectively.

Munkácsy mediated between the schools of France and Germany, a two-way exchange that was of no mean value to either nation. It was, moreover, a situation in which Munkácsy himself thrived as the perennial "fascinating foreigner," regardless of which country he happened to be living in. Significantly, Munkácsy influenced, especially with his oil-sketching technique, some of Germany's young Impressionists, such as his students Max Liebermann and Fritz von Uhde. Because he increasingly relied on the aid of his many assistants in the completion of his paintings, Munkácsy's later output suffered from vapidity through overproduction. Although he lived all his life abroad, he was regarded as the father of the modern national School of Hungary, a circumstance for which he was duly honored by the government of his native land with a patent of nobility in 1878. Munkácsy's paintings can be found in major museums throughout the world.

BIBLIOGRAPHY
F. Schaarschmidt, Zur Geschichte der Düsseldorfer Kunst, Düsseldorf, 1902, pp. 272 ff. C. Sedelmeyer, Mihály von Munkácsy, Sein Leben und seine künstlerische Entwicklung, Paris, 1914. K. Lyka, Mihály von Munkácsy, Vienna, 1926. L. Végvári, Munkácsy, Budapest, 1961. F. Novotny, Painting and Sculpture in Europe, 1780–1880, Baltimore, 1970, pp. 144 ff.

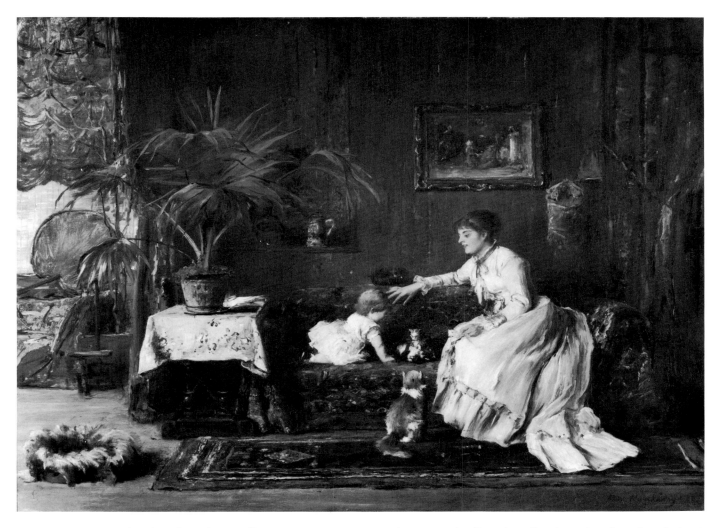

129
The Rivals
 signed L.R.: M—Munkacsy
 oil on wood panel, 34¾ × 45¹¹/₁₆ (88.3 × 116.1)
 donor: Frederick Layton
 MAC cat. no. L 139

This is an abundantly coloristic painting in the best
beaux-arts tradition. It is spirited in delivery, dash-
ing in color scheme, illusionistic in textures, and
luxurious in the patina of finish. Domesticity,
paired with elegance and refinement, is the subject.
A dating in the 1870s is suggested by the "classic"
pictorial structure and a certain "abstract decora-
tiveness" of the palette, pointing to Manet. Colors:
whites (lady's and child's dresses, tablecloth); dark
charcoal-blue (sofa, drapery on the right, rug); crim-
son (wall); ochre (floor); umber (paneling behind
plant); accents of bright mints, yellows, blues.

PROVENANCE
Sedelmeyer Gallery, Paris. Layton Art Collection.

REFERENCE
Mirrors of 19th Century Taste: Academic Painting;
Exhibition Handlist, Milwaukee Art Center, 1974, No. 65.

OEHME, ERNST FERDINAND

b. April 23, 1797, Dresden
d. September 10, 1855, Dresden
represented at Berlin, Dresden, Hamburg; private
collections

The landscape painter Ernst Ferdinand Oehme is an important representative of the Dresden School and of the circle of artists around Caspar David Friedrich. He studied at the Dresden Academy and then under Friedrich's tutelage. He was active in Italy—especially in Rome (1819–25)—and, thereafter, in his hometown. Upon his return there, he became Hofmaler (court painter) and, in 1846, an honorary member of the Dresden Academy.

At first, Oehme was influenced by Friedrich's subjective naturalism, then by Johann Christian Claussen Dahl's objective realism and, finally, by his friend Ludwig Richter's late Nazarene narrative style. In his memoirs Richter called Oehme "the Lenau among painters." He was, no doubt, alluding to the well-known idyllic late Romanticism of the poet, as well as to the feelings of *Weltschmerz*, sadness, loneliness, and pessimism that pervade his writings. Although Oehme also painted numerous Italian landscapes, he repeatedly treated hauntingly Nordic subjects whose gloomy moods well reflect the romantic sentiments named and fully justify Richter's perception of him. Among these subjects we encounter again and again the typical monastery courtyards in the snow, the Gothic churches at sun-

set, the autumn evenings in the woods, and the castle ruins in the mountains.

Since the art of Caspar David Friedrich has reached such dizzying heights of critical acclaim in these past years—to say nothing of its steadily growing popularity—it does not surprise us to find in recent literature on the topic even the lesser among his followers swept upward in the excitement. Brion even goes so far as to equate Oehme with Karl Blechen!

> The names of two painters who are hardly known outside Germany stand out from the body of Romantic landscape painters, thanks to their affinities with the 'Naturphilosophen' and to their imaginative powers which link them directly to Friedrich. First, there is the very original Ernst Ferdinand Oehme, whose *Cathedral in Winter* (Dresden) combines the most striking Romantic themes: high Gothic spires and naves, dead trees, snow, and the dark and strange lights shining behind great windows; secondly, there is Carl Blechen. . . .
> (Brion, *Art of the Romantic Era*, p. 115)

P. F. Schmidt is a bit more cautious:

> Ernst Oehme, a friend of Ludwig Richter's, be-

longed to the adherents of a muted realism. His stay in Italy did not, as it had Richter, derail him, although the old Koch was very dissatisfied with his subjectivism. In his memoirs, Richter describes him as a *Nachtschwärmer* [night-reveler]. His art reaches out toward the elegiac, the tender, dusky spheres. It seems to be more closely related to Friedrich than to the robust Dahl. His pure and precisely rendered evening landscapes affect a diminished Friedrichian romanticism, but he experienced them not nearly as deeply and personally as did Friedrich. (Schmidt, *Biedermeier Malerei*, pp. 54, 55)

BIBLIOGRAPHY
L. Richter, Lebenserinnerungen, Frankfurt, 1890. F. von Boetticher, Malerwerke des Neunzehnten Jahrhunderts, Vol. II, Dresden, 1898, pp. 173 ff. Die deutsche Jahrhundertausstellung Berlin 1906, Munich, 1906, pp. 406, 407. P. F. Schmidt, Deutsche Landschaftsmalerei 1750–1830, Munich, 1922. P. F. Schmidt, Biedermeier Malerei, Munich, 1923. M. Brion, Art of the Romantic Era, New York, 1966, pp. 115, 117. R. Zeitler, Die Kunst des 19. Jahrhunderts, Berlin, 1966, p. 192 (mentioned). K. Kaiser, Der Frühe Realismus in Deutschland, 1800–1850, Nürnberg, 1967.

130
Meissen in Winter
1854
 signed and dated L.L.: E. Oehme / 1854
 oil on canvas, 27 × 23 (68.6 × 58.4)
 MAC cat. no. M 1962.105
Color plate page 34

Oehme's late, mood-laden winter scene seems like a perfect hybrid between a vision by Friedrich and an illusion by Schwind. The Friedrichian cool atmospheric blues and charcoals, the centrally placed solitary, defiant church tower, the lonely *Rückenfigur* of a man in dark purple robes: all these seem momentarily halted as if by a spell, transfixed by the magic of the evening star. A specific and close study of a late evening sky, its natural, deep, glass-like translucency, its unifying aerial incandescence. Yes, but also a haunting, silent, eternal sight in which man and nature become one in suspended animation.

That is where Friedrich would have left it, the question of existence left hanging in the winter air. But Oehme breaks the spell, relieves the loneliness, diminishes the pain of the query. In a cozy oriel glitters the festively emblazoned Christmas tree; outlines of children appear, suggesting the prompt satisfaction and real gratification of spiritual and bodily needs: communion, fellowship, warmth, safety. In compromising the stark demands of the Early German Romantics with the comforts of *Vor-März*, Oehme delivers here the "classic" *Biedermeier* painting.

REFERENCE
"Christmas Exhibit" (exhibition), Women's Club of Milwaukee, November 26–December 30, 1965. "Paintings from the von Schleinitz Collection," Exhibition, Milwaukee Art Center, Sept. 13–Oct. 13, 1968.

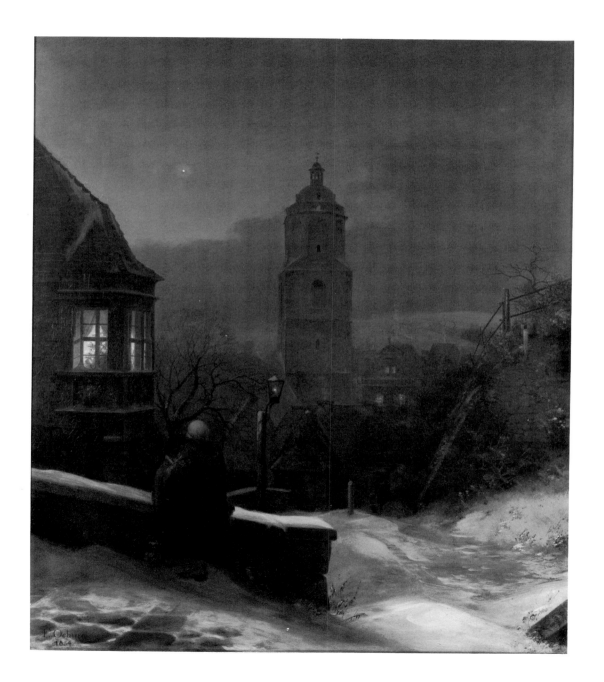

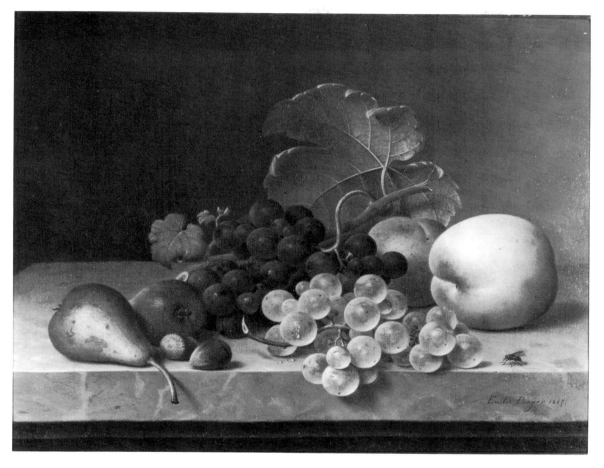

PREYER, EMILIE
b. June 6, 1849, Düsseldorf
d. September 23, 1930, Düsseldorf
represented at Karlsruhe; New York, Philadelphia

Emilie Preyer, the daughter of the still life painter Johann Wilhelm Preyer (see next Catalogue entry), was trained by her father and began her career as a painter of flower pieces. Soon, however, she struck upon her real calling, the specialty of still life with fruit. She was active in Düsseldorf, where, over the years, she produced about 250 mostly small-scale works in that pictorial category. Although her oeuvre shows a high degree of technical competency, she did not reach the level of overall quality attained by her father.

BIBLIOGRAPHY
Katalog der Gemälde Sammlung Morschheuser, Düsseldorf, April 1893, illus. F. von Boetticher, Malerwerke des Neunzehnten Jahrhunderts, Vol. II, Dresden, 1898, pp. 324–25. A. Schubert, "Emilie Preyer zum 80. Geburtstage," Düsseldorfer Nachrichten, June 6, 1929, 2 illus. Thieme-Becker, Künstlerlexikon, Leipzig, 1907–50, Vol. XXVII, p. 393.

131
Fruit Piece
1867
 signed and dated L.R.: Emilie Preyer 1867
 oil on canvas, 10⁵/₁₆ × 13³/₁₆ (26.2 × 33.5)
 donor: Frederick Layton
 MAC cat. no. L1916.3

A very competent still life by Emilie Preyer. On the surface it is misleadingly close to *Still Life* (**132**).

However, scrutiny tends to reveal certain deficiencies when it is measured against the work of her father. Among these comparative faults, these stand out: mechanical repetition of form and light modeling, visible especially in the grapes, the hardness of cast shadows, less translucent glazes, hard sheen of enamel, acidity of chromas, incompatibility of grainy canvas with the smoothness of *matière* desirable in miniature art.

PROVENANCE
Layton Art Collection.

REFERENCE
Mirrors of 19th century Taste: Academic Painting; Exhibition Handlist, Milwaukee Art Center, 1974, No. 71.

PREYER, JOHANN WILHELM

b. July 19, 1803, Rheydt, District of Gladbach, Ruhr
d. February 20, 1889, Düsseldorf
Represented at Berlin, Leipzig, Munich; Chicago,
New York

The landscape and still life painter Johann Wilhelm Preyer was the most important member of an artists' family to which also belonged his brother, the precisionist landscapist Gustav Preyer, and his own daughter Emilie (see previous Catalogue entry; physically, the two brothers were both one meter tall—well-proportioned dwarfs). Preyer was trained at the Düsseldorf Academy under Peter von Cornelius and Wilhelm von Schadow.

Among the formative influences on Preyer's art, mention must be made of a study trip he made to the museums of the Hague and Amsterdam in 1835, and a subsequent stay in Munich. Preyer was a close friend of and influenced the genial humorist painter Johann Peter Hasenclever, in whose company he undertook several journeys. Of the two trips to Italy in 1840 and 1842, the second one was undertaken by him for the sole purpose of studying tropical fruit! The progressively more single-minded application of his fine talent to the miniaturist technique and to the picture category of still life with fruit resulted in great fame for him. He is regarded by all as the foremost master of fruit still lifes of the nineteenth century and as perhaps the most brilliant technician of the whole School of Düsseldorf.

In his earlier years Preyer produced exquisite landscapes with the jewel-like precisionism of his brother and of Jan Bruegel the Elder. In the later 1830s and early forties he created a number of still lifes with landscape backgrounds. Thereafter, he concentrated virtually exclusively on small-scale pure still lifes. The precision of his drawing, the fidelity of all his textures to real nature, the verisimilitude to actuality of even the tiniest of his innumerable details, and the enamel luster of his brilliant colors have hardly an equal in the history of modern art. While his last twenty years registered something of a slackening in quality, the collectors' zeal for his precious little paintings, especially among his many American fanciers, grew constantly throughout his life.

Although Preyer's humble art existed on the periphery of the Düsseldorf art scene in the nineteenth century, all critics agree that he far outreached all the academics in the solidity of his craftsmanship and the degree of realization of his limited but honest goals. A large new audience was introduced to the quiet joys and silent marvels of his humble art when, in 1931, a comprehensive Memorial Exhibition of his works was held in Düsseldorf.

BIBLIOGRAPHY
A. Fahne, Die Düsseldorfer Malerschule in den Jahren 1834–36, Düsseldorf, 1837. G. K. Nagler, Künstlerlexikon, Vol. XII, 1842. J. Maillinger, Bilder-Chronik München, Vols. I/III, 1876. C. E. Clement and L. Hutton, Artists of the Nineteenth Century and Their Works, Boston, 1884 (facsimile ed., St. Louis, 1969), Vol. II, pp. 193, 194. F. von Boetticher, Malerwerke des Neunzehnten Jahrhunderts, Vol. II, Dresden, 1898, pp. 325–26. F. Schaarschmidt, Zur Geschichte der Düsseldorfer Kunst, Düsseldorf, 1902, p. 165. A. Schubert, "Die Preyer-Gedächtnisausstellung," Weltkunst, May 7, 1931, illus. H. Brückner, "Die Preyer-Gedächtnisausstellung," Jan Wellem, Sept. 1931, 5 illus.

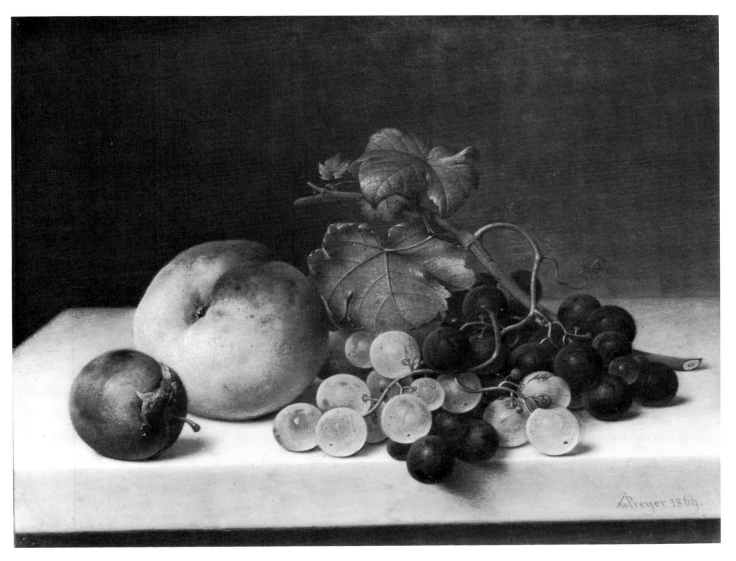

132
Still Life
1869

 signed and dated L.R.: JW. Preyer 1869
 oil on wood panel, 8⅜ × 10½ (21.3 × 26.7)
 MAC cat. no. M 1962.68

An exquisite little Preyer panel! Jewel-like precision of drawing and glazing, the most delicate textural nuances imaginable, an incredibly refined system of cast and reflected lights, body and cast shadows and, seemingly, the whole spectrum of all the shimmering hues, tremulous tones, and opalescent chromas to be found in nature brilliantly interact with each other in this deceptively "humble," diminutive, frugal composition by Preyer at the height of his powers to see, discern, and focus.

REICHERT, CARL

b. August 27, 1836, Vienna
d. April 5, 1918, Graz
represented in private collections

Carl Reichert, one of several members of an Austrian artists' family named Reichert, painted animal pictures, genre, and veduta. He was trained at the Graz *Zeichenakademie*, briefly at Munich (1866), and in Rome under Ludwig Johann Passini and Anton Romako. It was, chiefly, from the latter that he gained his knowledge in veduta painting, an expertise that enabled him to complete, mostly in watercolors, several fine illustrated albums of scenic views and city prospects. However, Reichert was principally a specialist in small-scale animal painting, and within this category he again specialized in dog paintings.

It is somewhat humorous to browse through a list of his painting titles. It reminds one of nothing more than a catalogue of dog breeds. Some of these little paintings are so-called "dog portraits," while others feature several dogs (sometimes also in the company of cats) in one mildly pleasing anecdotal situation after another. Reichert also painted a number of horse pictures.

BIBLIOGRAPHY
C. von Wurzbach, Biographisches Lexikon des Kaisertums Österreich, Vol. XXV, Vienna, 1873. F. von Boetticher, Malerwerke des Neunzehnten Jahrhunderts, Vol. II, Dresden, 1898, p. 373. Grazer Volksblatt, Aug., 26, 1911; Aug., 22, 1915; Aug., 27, 1918.

133
The New Offspring
signed U.L.: Reichert
oil on wood panel, 10¼ × 8¼ (26 × 21)
MAC cat. no. M 1970.119

Bland colors (charcoal, beige, clouded light green) and lack of compositional discernment go hand in hand with the "weighty" subject of *Dackelpsychologie* (dachshund psychology) in this minor effort by Reichert.

REFERENCE
Selections from the von Schleinitz Collection; Exhibition, Paine Art Center, Oshkosh, Wisconsin, Feb. 1–20, 1972.

RIEFSTAHL, WILHELM LUDWIG FRIEDRICH

b. August 15, 1827, Neustrelitz, Mecklenburg
d. October 11, 1888, Munich
represented at Berlin, Breslau, Dresden, Frankfurt,
Karlsruhe, Leipzig, Wiesbaden; Philadelphia

When, in 1843, Wilhelm Riefstahl arrived from the provinces in Berlin, he was sixteen years old. The same year he enrolled at the academy and joined Wilhelm Schirmer's class in landscape and architectural painting. Encouraged by the older master's advice to study nature closely, Riefstahl soon set out on little study trips to the Baltic Sea, the Island of Rügen, and the Teutoburger Forest, as well as, on larger excursions, to the Bavarian, Tyrolean, and Swiss Alps. Eventually, he became totally absorbed by mountain scenery. Well launched on a career and already celebrated as a landscapist, he discovered, while seeking to perfect his occasional figural staffage, his new and abiding life's interest, namely pure genre painting. More and more, landscape began to recede in significance for him, and by about 1864 he had completed the transition to figural compositions from the life of the Alpine peasantry.

Peasant weddings (e.g., *Wedding Procession in the Tyrol*, **134**), religious processions, funerals, and similar events from village life became Riefstahl's repertorial mainstays. Over the next ten to fifteen years, however, his technique underwent substantial changes. It was a transformation of a style characterized by sharp drawing, crisp contours, local color, and a sharply delimited distribution of chiaroscuro to one distinguished by a sketchy overall conception, loosely structured form, and delicate nuances of light and shadow. There can be little question but that the influence of the great Berlin realist Adolf von Menzel was instrumental in bringing about this dramatic reversal in Riefstahl's style.

In 1862 Riefstahl became a member of the Berlin Academy, and in 1868 he relocated in Karlsruhe. The following year he went to Rome, where he was drawn to painting city veduta with local staffage. The succeeding years were punctuated by stints as professor (1870–72) and, later, as director (1875–77) of the Karlsruhe Academy, as well as two more stays in Italy. Finally, in 1878, he settled permanently in Munich, where he continued to broaden his fine reputation as a painter of South German peasant genre.

Riefstahl . . . studied with great earnestness the characteristics of the inhabitants of the scenes he loved to depict. . . . He gives the most minute attention to the landscape and architecture forming the setting of his subjects and his chief characteristic in his later as in his earlier works is strict conscientiousness. But his pictures are genre paintings in the very strictest acceptation of that term, for they give accurate representa-tions of the inner life of the people, whom he shows us in their own homes, or marching in procession, engaged in public worship, or burying their dead. (Pietsch, p. 72)

Riefstahl's long-standing interest in painting architectural prospects, an interest that began with his early Berlin years, in concert with his fine drawing technique and thorough knowledge of the lithographer's craft, well qualified him to execute, with an informative precision that is the nearest equivalent of modern photography, the architectural plates for Kugler's epochal art history *Denkmäler der Kunst* (four volumes, 1845–56) as well as for other deluxe editions of art books.

BIBLIOGRAPHY
C. E. Clement and L. Hutton, ARTISTS OF THE NINETEENTH CENTURY AND THEIR WORKS, Boston, 1884 (facsimile ed., St. Louis, 1969), Vol. II, p. 212. F. Pecht, GESCHICHTE DER MÜNCHNER KUNST DES 19. JAHRHUNDERTS, Munich, 1888. L. Pietsch, CONTEMPORARY GERMAN ART: AT THE CENTENARY FESTIVAL OF THE ROYAL ACADEMY OF ARTS, BERLIN, Vol. II, London, 1888, pp. 71, 72. F. von Boetticher, MALERWERKE DES NEUNZEHNTEN JAHRHUNDERTS, Vol. II, Dresden, 1898, pp. 430–32. DIE DEUTSCHE JAHRHUNDERTAUSSTELLUNG BERLIN 1906, Vol. II, Munich, 1906, pp. 406, 407. KATALOG DER AUSSTELLUNG MÜNCHENER MALEREI, 1850–1880, Munich, 1929, p. 37. R. Darmstaedter, KÜNSTLERLEXIKON, Bern and Munich, 1961, p. 398.

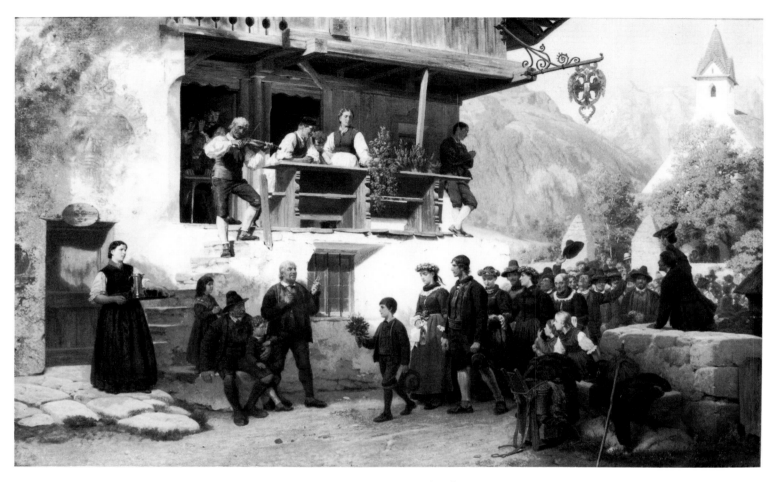

134
Wedding Procession in the Tyrol (Brautzug im Passeyertal)
probably 1866
 signed L.R.: Berlin W. Riefstahl
 oil on canvas, 26¼ × 42¼ (66.7 × 107.3)
 MAC cat. no. M 1962.90

In addition to the fact that it seems identical with Boetticher No. 10, the crisp, draftsmanlike style of this painting also suggests a dating around the middle of the 1860s. This major Riefstahl features natural colors throughout, but the composition is dominated by the sharp contrast between the dark figures (black, brown; bride: green and red) against the very bright surfaces of stones and masonry. Riefstahl does not yet seem to be in complete control of anatomy here and still struggles, despite many very excellent descriptions, with figural movement. Although this canvas is filled with myriad costume and architectural details, it is, nevertheless, well unified in terms of staging, action, color, light.

PROVENANCE
Probably Collection of Johann Meyer, Dresden. (Probably exhibited at the Metropolitan Museum of Art, New York.)

REFERENCE
Probably F. von Boetticher, MALERWERKE DES NEUNZEHNTEN JAHRHUNDERTS, Vol. II, Dresden, 1898, p. 430, No. 10: "Ein Brautzug im Passeyertal (1866), befand sich in der Sammlung Joh. Meyer zu Dresden." ANTIQUES, Nov. 1963, p. 614. S. Wichmann, PAINTINGS FROM THE VON SCHLEINITZ COLLECTION, (Catalogue), Milwaukee Art Center, 1968, No. 42. PAINTINGS FROM THE VON SCHLEINITZ COLLECTION; Exhibition Handlist, Milwaukee Art Center, 1974, No. 73.

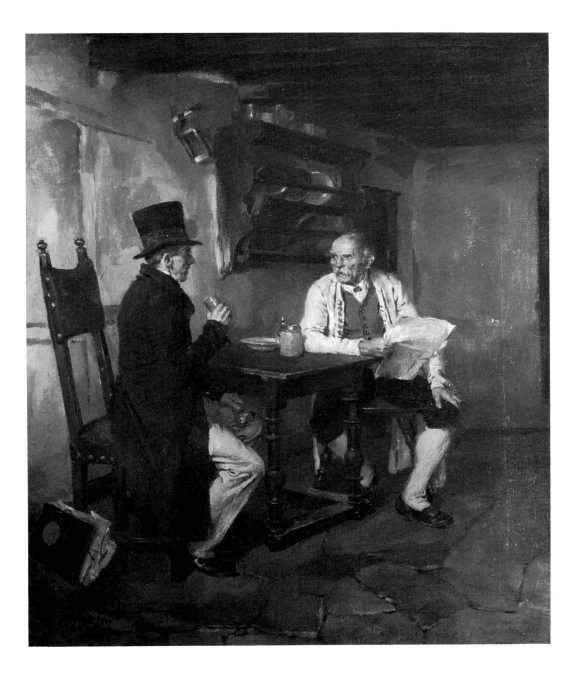

RÖGGE, ERNST FRIEDRICH WILHELM

b. April 28, 1829, Osterkappeln, near Osnabrück,
 Lower Saxony
d. February 11, 1908, Munich
represented at Schloss Herrenchiemsee, Munich;
 private collections

Wilhelm Rögge, a product of the art academies of Munich and Düsseldorf, was a minor painter who specialized in contemporary domestic, bourgeois, and peasant genre. He traveled in Northern Italy and was active in Munich. At the beginning of his career he also completed a number of history paintings. In addition, he was active as a frescoist. In that latter capacity he executed in part by himself and, in part, collaborated on the decorations of the Schloss Herrenchiemsee of King Louis II (Upper Bavaria)—e.g., wall or ceiling frescoes in the Hartschiersaal, Friedenssaal, Kriegssaal, Bedroom, etc.

BIBLIOGRAPHY
F. von Boetticher, MALERWERKE DES NEUNZEHTEN JAHRHUNDERTS, Vol. II, Dresden, 1898, pp. 459, 460. L. von Kobell, LUDWIG II V. BAYERN UND DIE KUNST, Munich, 1900. Thieme-Becker, KÜNSTLERLEXIKON, Leipzig, 1907–50, Vol. XXVIII, p. 484. H. Steinberger, HERRENCHIEMSEE, Munich, n.d., *passim*.

135
The Lawyer's Visit
 signed L.L.: Wilhelm / Roegge
 oil on canvas, 17¼ × 14⅞ (43.8 × 37.8)
 MAC cat. no. M 1970.115

Rögge very skilfully integrated a sharp red-white contrast (peasant vest and jacket) into a tonal ground of umbers and scumbled sienas. The striking characterization here is complemented by a resolute brush stroke and self-assured painterly technique.

SCHLEICH, EDUARD, THE ELDER

b. October 12, 1812, Haarbach, near Landshut, Lower
 Bavaria
d. January 8, 1874, Munich
represented at most German museums of
 consequence

Upon his death, Schleich the Elder was justly called the father of the new Munich school of landscape painting. The justification for this honorary title . . . was that he gave landscape painting in Munich its own direction, a direction that was animated by romantic feeling, on the one hand, but that was, on the other, limited by the *Palettenkultur* [culture of the palette] of the studios. To have found and maintained this direction is Schleich's highest merit. (Uhde-Bernays, *Die Münchner Malerei*, etc., p. 34)

Because of what his teachers perceived as a total lack of talent on his part, Schleich was expelled from the Munich Academy. Ironically, later on in life, he was to become professor and honorary member of the same institution. His earliest veduta, identical with the run-of-the-mill productions at that time, showed little promise for the future. But on his constant solitary walking tours in the environs of Munich Schleich soon developed the astonishing habit of memorizing, without drawing or sketching, the details as well as the realistic scale and proportions of given nature prospects. This extraordinary ability allowed him to return to his studio and paint what he had observed in nature with the greatest amount of precision. The resulting landscape paintings excel in their seemingly perfectly balanced coordination between composition, picture format, and the segment of landscape featured. Schleich was soon able to sell his works to, among others, the Munich *Kunstverein*.

An Italian journey with Christian Morgenstern in 1843 left no visible "Italianate" marks on his art, despite the fact that his basic *modus operandi* all his life was eclecticism. However, his friendship with and the influence he received from Morgenstern is significant, nevertheless, because it points to a heretofore little-appreciated but important development in the history of style, namely the influence of the Hamburg and Copenhagen schools of realistic landscape painting on the evolution of Munich art in general and on Schleich in particular. (See Wichmann, "Bemerkungen, etc.," p. 32. Another significant contact point in this regard was Friedrich Wasmann.)

Schleich's reaction to the revolutionary impact of the Neo-Baroque art of Gallait and de Bièfve on the German artistic scene in the early 1840s was as intelligent as it was original. It was intelligent, because he quickly recognized that to learn from the Belgians and French was circuitous. He, therefore, undertook to study the Flemings, especially Rubens, directly and without the aid of their modern French-Belgian interpreters. It was original, because he was the first one to apply the lessons he had learned in colorism to the painting of landscapes. In 1850, he accompanied his friend, Carl Spitzweg (see entry in Catalogue), to Venice and in 1851 to Paris, where the works of the Barbizon painters (especially Rousseau and Daubigny) confirmed his direction and enriched his then already fully developed personal style.

Although there can be little question that he was an innovator, it is not a simple matter to state very briefly where and, specifically, how Schleich pioneered in landscape painting. Perhaps it is best to proceed by way of comparison with other important landscapists of his times. Dillis, the founder of the Munich School of Landscape Painting, based his approach on the naturalism of the Dutch masters of the seventeenth century. Karl Rottmann, by whom Schleich was briefly influenced in his younger years, painted heroic landscapes in the expansive classicistic and romantic tradition. Johann Christian Claussen Dahl developed a straight-forward Realism. There are two qualities that Schleich shares with all of these as well as with Morgenstern. These

are the direct study of nature and the constant search for the true light of nature; he shared with them the propensity for conceiving reality as a product of a light-giving sky, i.e., for luminism. Schleich goes beyond Dillis and their commonly shared Dutch models (Ruisdael, van Goyen) in the intensity of his luminism and poetic mood. Unlike Rottmann, he painted only the unheroic and unstaged nature prospects of his own native *Heimatlandschaft*: the Isarauen, the Dachauer Moos, and the Upper Bavarian Voralpen plateau. He was not a Realist in the strict and uncompromising sense of the older Dahl, nor did he concentrate as exclusively on the North German, romantic, mood-creating devices employed by Morgenstern.

Perhaps the greatest similarity and also the greatest contrast are those between Schleich and the French Barbizonists. The obvious similarities lie in their common approach to landscape painting as one based on the intimate view, pleinairism (even though Schleich did not actually finish his paintings *après le motif*) and, of course, luminism. The equally obvious difference lies in the general lack of poetry in the art of the Barbizonists, as opposed to Schleich's compelling sense of spiritual sweep from the concrete reality of nature to her transcendent

dimension of infinitude, and the markedly pathetic or elegiac moods with which Schleich is capable of investing his scenes, especially in his larger paintings. Moreover, in the realm of colorism, it can be asserted that Schleich's *Stimmungslandschaft* reaches greater heights of virtuosity, a virtuosity for which not only he but all later nineteenth-century German *Atelierkunst* is justly famous, and especially in Munich. It appears to this critic that what Uhde-Bernays perceives as the "limitation" of *Palettenkultur*, a presumed restriction that arises out of his bias in favor of Realism, can, and indeed should, be considered as a positive strength in our context.

Although on balance it may perhaps be overstating a point somewhat to equate Schleich's historical accomplishment and influence to that of a Johann Georg Dillis or a Wilhelm Kobell, for example—Schleich was distantly influenced by both of them—it would be even more erroneous to give Schleich a position in the history of art that is less than that of a major master of nineteenth-century European landscape painting. "Schleich's greatest strength was the conclusion. He collected the dispersed experiments in order to conquer air, atmosphere, the casualness of the viewpoint; and because he loved his land with all the devotion of the

loner, his time and place responded to him" (Karlinger, p. 43).

BIBLIOGRAPHY
C. E. Clement and L. Hutton, ARTISTS OF THE NINETEENTH CENTURY AND THEIR WORKS, Boston, 1884 (facsimile ed., St. Louis, 1969), Vol. II, p. 242. DIE DEUTSCHE JAHRHUNDERT-AUSSTELLUNG BERLIN 1906, Munich, 1906, pp. 486, 487. DIE KUNST, Vol. XV, 1906; Vol. XXXIII, 1916; Vol. XXXIX, 1919; Vol. XLI, 1920; Vol. XLVII, 1923. KUNSTCHRONIK, New Series, Vol XXX (1918/19), p. 575. H. Uhde-Bernays, MÜNCHENER LANDSCHAFTER IM 19. JAHRHUNDERT, Munich, 1921. P. F. Schmidt, BIEDERMEIER MALEREI, Munich, 1923, pp. 106 ff. and passim. C. Gurlitt, DIE DEUTSCHE KUNST SEIT 1800, Berlin, 1924, p. 278. R. Hamann, DIE DEUTSCHE MALEREI VOM 18. BIS ZUM BEGINN DES 20. JAHRHUNDERTS, Leipzig and Berlin, 1925, p. 226, and passim. H. Uhde-Bernays, DIE MÜNCHENER MALEREI IM NEUNZEHNTEN JAHRHUNDERT, Vol. II, Munich, 1927, pp. 28 ff., and passim. H. Karlinger, MÜNCHEN UND DIE KUNST DES 19. JAHRHUNDERTS, Munich, 1933 (2d ed., 1966), pp. 42, 43, and passim. S. Wichmann, "Eduard Schleich der Ältere 1812–1874," Dissertation, Munich, 1953 (typewritten manuscript). O. Fischer, GESCHICHTE DER DEUTSCHEN MALEREI, Munich, 1956, pp. 401, 406. S. Wichmann, "Bemerkunger zur Münchener Malerei im neunzehnten Jahrhundert" in K. Kaiser, DER FRÜHE REALISMUS IN DEUTSCHLAND 1800–1850, Nürnberg, 1967, passim.

136

Lake Chiem (Chiemsee)
probably 1860s
 signed (scratched into wet paint) L.R.: E. Schleich
 oil on wood panel, 14¼ × 34¼ (36.2 × 87)
 MAC cat. no. M 1970.111
Color plate page 35

E
D
U
A
R
D

S
C
H
L
E
I
C
H

200

A later dating than 1850–60 (suggested in *Look on Nature . . .*) seems reasonable on the basis of stylistic evidence. Although there can be no question that this painting is a minor effort by Schleich, it is also clear that his ability to combine *realism* with *mood,* and *luminism* with the rich *burnish* of Munich *Palettenkultur,* the very ability that made him an avantgarde artist in his own times, is well in evidence here. The low horizontal format of the painting, while unusual, nevertheless is perfectly suited for a panoramic sweep of the Voralpen chain as seen from the adjacent flat and marshy terrain of the Voralpen plateau. While the intensely naturalistic, milky cool sky is the radiant source of illumination, Schleich is paradoxically (and, judging by the pleasant compositional effect he achieves, integrally) able also to indulge, especially in the water and shrubbery passages, in a rich play of warm "Old Master" patinas. The painting succeeds as an atmospheric *and* tonal painting but, above all, it excels as an essay on the lyrical mood of a landscape, as *paysage intime,* as *Stimmungslandschaft.*

REFERENCE
To Look on Nature: European and American Landscape 1800–1874; Exhibition Catalogue, Dept. of Art, Brown University, Rhode Island School of Design, 1972, discussed pp. 51–52, illus. 12, p. 64.

SCHLEICH, ROBERT (also known as ROBERT SCHLEICH THE YOUNGER)

b. July 13, 1845, Munich
d. October 14, 1934, Munich
represented at Augsburg, Baden-Baden, Heidelberg,
Munich; private collections

Robert Schleich was the scion of a well-known Munich family of engravers and lithographers among whose more important members we count his father Adrian Schleich and his grandfather Johann Carl Schleich. Robert was not related to Eduard Schleich the Elder (see previous Catalogue entry). He trained for the parental profession of copper engraving and, on the side, also received instruction in painting from Wilhelm Diez (see entry in Catalogue).

It was through Diez and his unequaled abilities as teacher that Schleich's natural skills for drawing and his fine native sense of color were fostered and brought to the fore in his work. Likewise, it was the influence and manner of his teacher that caused Schleich to enliven his miniaturist landscapes with all kinds of colorful staffage: gamblers, skaters, peddlers, hunters, peasants, etc. Because of his delicate technique, effective figural stagings, and his good eye for atmospherically sweeping views, Schleich was and is very much in demand by collectors. But unlike such pioneers as Diez or Eduard Schleich the Elder, for example, his merit lies in having routinely practiced refined versions of pictorial and compositional models established by others. As with Hans Best (see entry in Catalogue),

another of Diez's many pupils, Schleich seems to have been led by his teacher to pursue an Impressionistic approach. It appears that Wichmann's negative criticism of Hans Best's application of the Impressionist technique to the miniature format applies in equal measure to Schleich.

BIBLIOGRAPHY
F. Pecht. GESCHICHTE DER MÜNCHNER KUNST DES 19. JAHRHUNDERTS, Munich, 1888. F. von Boetticher, MALER-WERKE DES NEUNZEHNTEN JAHRHUNDERTS, Vol. II, Dresden, 1898, pp. 578, 579. DIE KUNST, Vol. XXI, 1910, pp. 532, 537; Vol. XXXVII, 1918, p. 4. MÜNCHENER MALEREI 1860–1880 (Catalogue), Munich, 1915.

137

Haymaking in Upper Bavaria (Heuernte im Bayerischen Voralpenland)

late nineteenth century or early twentieth century
signed L.L.: Rob Schleich
oil on canvas, 3⅛ × 3⅞ (7.9 × 9.8)
MAC cat. no. M 1972.108

These two miniatures (**137**, **138**) done on a white ground in natural but heightened colors, tinted with a silvery overall cast, though competent in their luminist sparkle, are also somewhat crude in technique, dry in coloration, unsophisticated in composition, and casual in theme or content.

PROVENANCE
Purchased by donor at Adolf Weinmüller Auction, No. 87, Catalogue No. 95, Oct. 2–3, 1963, No. 1088 in catalogue, illustration plate No. 105, titled "Heuernte im Bayerischen Voralpenland."

REFERENCE
S. Wichmann, PAINTINGS FROM THE VON SCHLEINITZ COLLECTION (Catalogue), Milwaukee Art Center, 1968, No. 43. Wichmann suggests an earlier date for this painting: "about 1875."

138
Cattle Market on a Meadow in Upper Bavaria (Rindermarkt auf einer Wiese in Oberbayern)
late nineteenth century or early twentieth century
 signed L.L.: Rob Schleich
 oil on wood panel, 4¹¹/₁₆ × 6⁵/₁₆ (11.9 × 16)
 MAC cat. no. M 1972.111

See description under entry **137**.

PROVENANCE
Purchased by donor at Adolf Weinmüller Auction, No. 96, Catalogue No. 104, Sept. 29–Oct. 1, 1965, No. 1521 in catalogue, illustration plate No. 106, titled "Rindermarkt auf einer Wiese in Oberbayern."

SCHLESINGER, FELIX
b. October 9, 1833, Hamburg
d. 1910, Hamburg
represented at Bremen, Hamburg, Lübeck;
Amsterdam

Felix Schlesinger's rather varied artistic background included studies at Hamburg (at the Preparatory School for Artists of the still life and animal painter Friedrich Heimerdinger), Düsseldorf (under the prolific genre painter Rudolf Jordan), Antwerp (under the Belgian humorist genre painter Ferdinandus de Braekeler), and at Paris (under the marine, genre, and architectural specialist Louis-Gabriel-Eugène Isabey). In 1862, after living for several years in the French capital, he settled in Munich.

Schlesinger's oeuvre consists of genre pieces from family life, especially scenes of children, and the bourgeois social and domestic milieux. His casual compositions, reflecting the Hamburg School's preference for undramatic stagings, contrast with the Düsseldorf "formula" for gripping action and striking contrasts in painting. Schlesinger excelled in "photographic" naturalism.

BIBLIOGRAPHY
F. von Boetticher, Malerwerke des Neunzehnten Jahrhunderts, Vol. II, Dresden, 1898, pp. 580, 581. Thieme-Becker, Künstlerlexikon, Leipzig, 1907–50, Vol. XXX, p. 104.

139
Bavarian Inn (?)
possibly 1860s
 signed L.L.: F. Schlesinger
 oil on wood panel, 17½ × 28½ (44.5 × 72.4)
 MAC cat. no. M 1962.88

Although we do not propose to change the adopted title of this painting, the milieu, costume, and accouterments really suggest more a Tyrolean than a Bavarian setting. Far too many excellent "character heads" diffuse the viewer's attention here. The very subtle play of tones of the artist's rich golden-brown palette, furthermore, lacks a determining accent. The story, finally, in which a little beggar boy with an accordion attempts to compete with a professional band seated on the dais in back, is told too tenuously to carry a narrative punch. Only the illusionistic, deep chiaroscuro space seems to have been completed with a sense of resolute directness.

If the painting falters, it is not because of a lack of sensitivity or invention but rather because of too much variegation, too much sensitivity, too much sophistication. An important work by Schlesinger, this genre painting of folksy manners and convivial wit sèrves us with a "textbook example" of how photographic naturalism paired with "the culture of the palette" could offer a feast for the eye while, simultaneously, seeming to languish from a debilitating lack of verve brought on by overindulgence in the potentially limitless variations and permutations of decorative realism.

REFERENCE
S. Wichmann, Paintings from the von Schleinitz Collection (Catalogue), Milwaukee Art Center, 1968, No. 44.

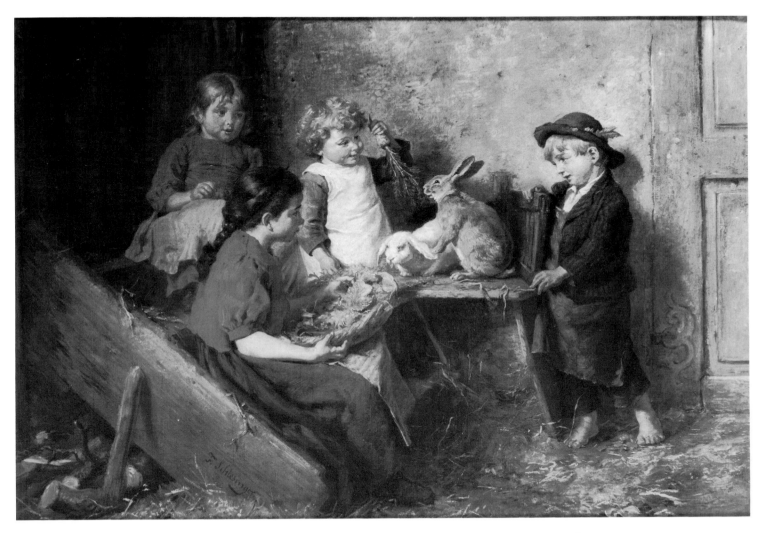

140
Children with Rabbits
probably c. 1895–1900
 signed L.L.: F. Schlesinger
 oil on canvas, 17³⁄₁₆ × 23½ (43.7 × 59.7)
 MAC cat. no. M 1972.117

One of several paintings with children and domestic

rabbits in a barn setting done by Schlesinger in the 1890s, this exhibit places the style of photographic naturalism at the service of a sentimental motif without succumbing to saccharine sweetness. The frontmost girl's bright red blouse effectively offsets the major tones of moss, ochres, browns, and grays. A fresh, crisp, and lively canvas.

REFERENCE
Frequently repeated subject. See F. von Boetticher, MALERWERKE DES NEUNZEHNTEN JAHRHUNDERTS, Vol. II, Dresden, 1898, p. 581, Nos. 39 a, b.

SCHLITT, HEINRICH

b. August 21, 1849, Biebrich-Mosbach, near
Wiesbaden
d. unknown
represented in private collections

Heinrich Schlitt, who, as a young man, served in the
Dutch army, started his art studies in Holland. In
1874 he relocated in Munich, where he became a
pupil in the studio of the history painter and popu-
lar teacher Wilhelm von Lindenschmit the Younger.
Initially, Schlitt worked primarily as illustrator for
such popular journals as *Illustrierte Zeitung*, *Über
Land und Meer*, *Daheim*, and the humor magazine
Schalk. Having thus reached a very wide audience
for his drawing style and brand of humor, he be-
came increasingly active as a painter. In this regard
he specialized in a pictorial type that must surely
have been the most whimsical in the whole array of
nineteenth-century pictorial subcategories: pictures
of gnomes and frogs! He also executed a number of
"gnome frescoes" in public places, the best known
of which—at least to pub crawlers—was the *Sieges-
zug des Gambrinus* (the *Victory Procession of Gam-
brinus*; Gambrinus was the legendary inventor of the
beer brewing process!) in the Munich Ratskeller
(City Hall).

BIBLIOGRAPHY
F. von Boetticher, MALERWERKE DES NEUNZEHNTEN JAHR-
HUNDERTS, Vol. II, Dresden, 1898, p. 583. T. Kutschmann,
GESCHICHTE DER DEUTSCHEN ILLUSTRATION, Gosslar and
Berlin, 1899, Vol. II, p. 415. Thieme-Becker, KÜNSTLERLEXI-
KON, Leipzig, 1907–50, Vol. XXX, p. 112. ZEITSCHRIFT FÜR
BILDENDE KUNST, New Series, No. 30, 1918/19, p. 61

141
*Gnomes Transporting Frogs (Gnomenfroschtrans-
port)*
1917
signed and dated L.R.: Henrich Schlitt / München
1917
oil on wood panel, 11⅞ × 9⅜ (30.2 × 23.8)
MAC cat. no. M 1972.109

More a colored (brown, green, red) illustration than
a painting, this little panel amuses with its
storybook fantasy and roguishness.

S
C
H
L
I
T
T

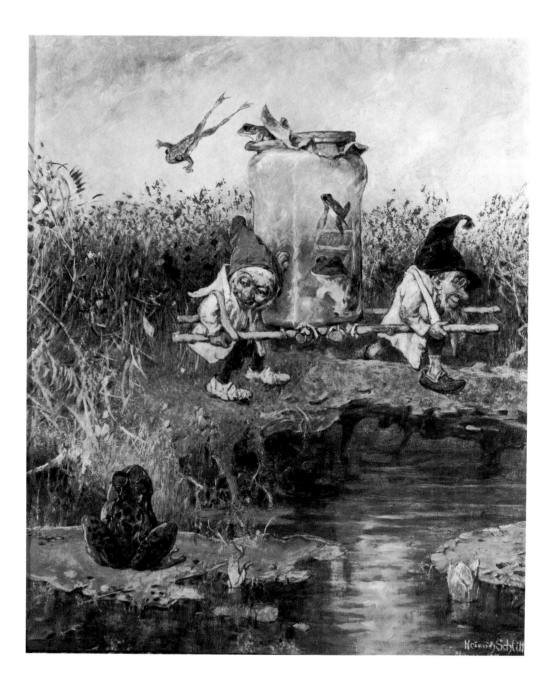

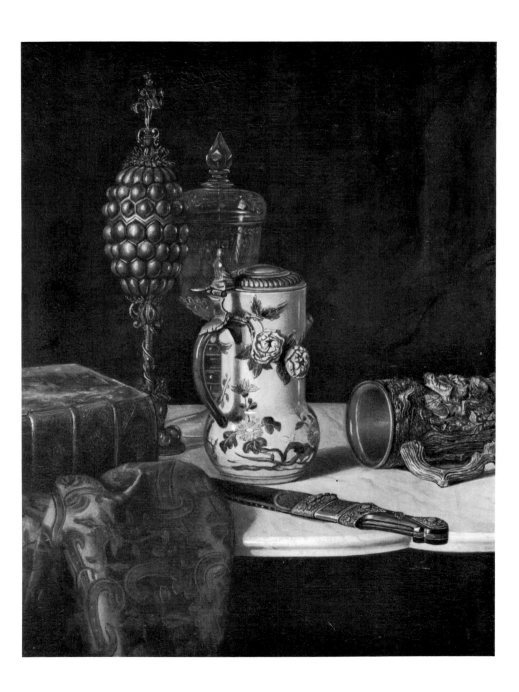

SCHÖDL, MAX

b. February 2, 1834, Vienna
d. March, 1921, Vienna
represented at Munich and in private collections

Max Schödl was a still life specialist who received his training at the Vienna Academy from Friedrich Friedländer, Ritter von Malheim (see entry in Catalogue). After journeying to and studying at Paris, London, and Italy, he settled permanently in Vienna.

BIBLIOGRAPHY
L. Eisenberg, Das Geistige Wien, Vol. I, Vienna, 1893. F. von Boetticher, Malerwerke des Neunzehnten Jahrhunderts, Vol. II, Dresden, 1898, p. 626.

142
Still Life
1883
 signed and dated L.R.: Max Schödl 83
 oil on wood panel, 8½ × 6¼ (21.6 × 15.9)
 MAC cat. no. M 1962.43

This minor painting shows an imbalanced composition of dryly painted unrelated objects. Cleaning of the mat varnish would perhaps rekindle a lost coloristic sparkle here.

REFERENCE
The American-German Review, June 1952, p. 2.

SCHREYER, CHRISTIAN ADOLF

b. July 9, 1828, Frankfurt am Main
d. July 29, 1899, Kronberg im Taunus, Hesse
represented at: major museums everywhere; in the
 United States, at Bayonne, Boston, Brooklyn,
 Chicago, Cincinnati, Kansas City, Minneapolis,
 New York, Philadelphia, St. Louis, San
 Francisco, Toledo, Washington

Adolf Schreyer, who came from a socially well-positioned family, received his earliest training from the genre painter Jakob Becker at the Staedelsche Kunstinstitut in his home town. There are few firm biographical data available on his next movements, which included a brief stint at the Düsseldorf Academy and sojourns at Munich and Stuttgart. In 1849, at the age of twenty, he went to Vienna where, again, precise knowledge of his activities is lacking. It can be assumed that he encountered the single most important source of influence in his art, namely August von Pettenkofen. It is, however, also possible that he met that Austrian artist during his later stay in Paris. (Schreyer did not, as is stated by E. B. Nielsen [*Adolf Schreyer*, p. 15], study in Vienna under Karl Becker, because that artist lived and taught in Berlin.)

Schreyer's personal connection with the princely family of Thurn und Taxis must have enabled him to gain admittance to the regimental retinue of the Prince von Thurn und Taxis in the Hungarian Campaign of 1851 and, somewhat later, in the Crimean War theater (1855). There followed travel to the Near East, Egypt, North Africa, and France. Returning to Frankfurt in 1861, he relocated in Paris the following year and remained there, excepting various journeys, for eight years, until the outbreak of the Franco-Prussian War of 1870 (see Udhe-Bernays). Afterward, he lived in Frankfurt and in his Villa in Kronberg im Taunus.

Among the early influences on Schreyer's art mention must be made of the instruction he received from Jakob Becker, who introduced him to his flexible, Düsseldorf-trained craftsmanship and the anecdotalizing approach to narrative subject matter. From Moritz von Schwind, who was active in Frankfurt during Schreyer's tenure there, i.e., the mid-1840s, he received impulses toward a minstrel-like lyricism, a tendency that can be detected in Schreyer's early works. Thereafter, he gravitated toward a more vivid colorism but specifically toward a stylistic patois of his own devising that mingles somewhat uneasily the delicate silvery blue-grey tonal atmospherics of the Frankfurt landscapists with the exact opposite, namely, the Waldmüller-inspired (see entry in Catalogue) sharpness of lighting contrasts and a brilliant polychromaticism.

In the final analysis, however, it was the coloristically vibrant open-air painting and proto-Impressionism of August von Pettenkofen and his realistic approach to the exotic-romantic subjects of the Balkans that played the decisive role in Schreyer's attainment of a personal style. Lastly, his Parisian experiences and his acquaintance there with the art of Decamps, Fromentin, Marilhat, Delaroche, and Delacroix lent further technical refinements to his manner as well as a strong confirmation of his chosen style. However, Schreyer himself is not known to have specifically aligned himself, ideologically or otherwise, with either Delacroix or Delaroche, Courbet, or, after his return to Germany, with the French Impressionists.

Contemporary critics of Schreyer's art (see Clement and Hutton, p. 245) as well as more recent writers repeatedly point out the "synthesis" between the German and the French that occurs in his mature art. Uhde-Bernays suggests that the French characteristics can be discerned in certain compositional aspects, the dramatic accents, and the technical effects of his paintings. Conversely, he sees the German character of the artist—a character that also distinguishes him from the Austrian Pettenkofen—surface in the unmistakably literary-anecdotal and genre-like treatment of subject matter as well as, most significantly, in what he perceives as the fusion of fantasy and feeling in the complexion of his works.

On his extensive trips that took him to the "colorful" backwaters of Europe—Wallachia, southern Russia, Turkey—and to "exotic" Africa—Algeria, Morocco, Tunisia, Syria, Egypt—Schreyer gathered many notebooks of ethnographic studies, and his knowledge of Arabic provided him with further valuable insights into the culture of the Bedouins. It was, above all, their life—their hunt, combat, migrations—that he painted most often, captured with the most vivid immediacy, perceived with the greatest authenticity, and interpreted with the most rhapsodic abandon. In the field of horse painting in particular, Schreyer has few equals in art history.

Schreyer's depiction of momentary impressions of characters and movements—the quick action, the telling attitude—his brilliant and fluid colorism which, in his later years, became ever more sophisticated and muted, resembling the rich textures of oriental rugs, the supple elegance of his technical delivery, his flair for decorative effects, his great creativity in motivic invention, and, above all, his unequaled ability to combine a fervent romantic imagination with the most disciplined factual reporting: these qualities earned for him the accolade of greatest German *Orientmaler*. He was, indeed, one of the most exciting narrators of exotic adventure tales in the art of the nineteenth century.

Although Schreyer was highly honored by all his contemporaries (e.g., he became court painter to the Grand Duke of Mecklenburg-Schwerin, was a member of the academies of Antwerp and Rotterdam, and received numerous high medals at exhibitions in Paris, Vienna, and Brussels), it was above all in France and America that he reached the pinnacle of fame during his lifetime.

BIBLIOGRAPHY
F. Reber, GESCHICHTE DER NEUEREN DEUTSCHEN KUNST, Stuttgart, 1876. C. E. Clement and L. Hutton, ARTISTS OF THE NINETEENTH CENTURY AND THEIR WORKS, Boston, 1884 (facsimile ed., St. Louis, 1969), Vol. II, pp. 244, 245. FINE ARTS JOURNAL, Vol. XXX (1914), nos. 25, 27, 39, 41. AMERICAN ART NEWS, Vol. XX (1921/22), No. 14, p. 1; No. 17, pp. 1, 4; No. 24, p. 2; Vol. XXII (1923/24), No. 15: Vol. XXIII, Nos. 10, 15; Vol. XXV, No. 13; Vol. XXX, No. 36; Vol. XXXII, No. 10. KÜNSTLERISCHER NACHLASS ADOLF SCHREYER, Introduction by H. Uhde-Bernays, Frankfurt, 1922. E. Bénézit, DICTIONNAIRE DES PEINTRES . . . Vol. III, Paris, 1924. E. B. Nielsen, ADOLF SCHREYER; Exhibition Catalogue, Paine Art Center, Oshkosh, Wisconsin, 1972.

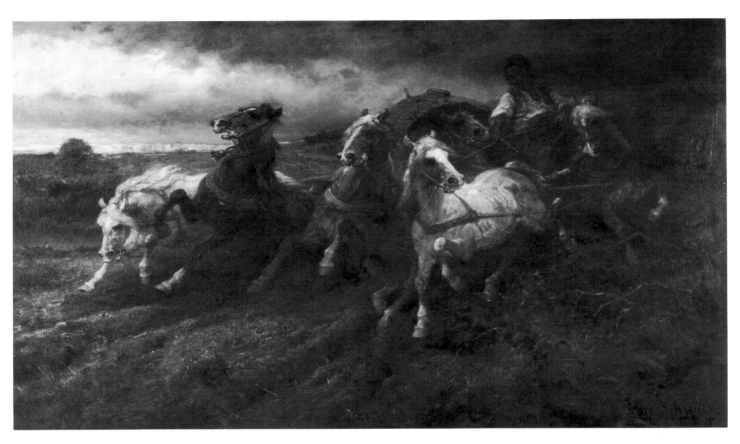

143
The Wallachian Post-Carrier
1860s (?)
 signed L.R.: Ad. Schreyer
 oil on canvas, 48 × 79½ (121.9 × 201.9)
 donor: Washington Becker, probably 1891
 MAC cat. no. L 108

The Schreyer exhibits (**143**, **144**, **145**) are all master canvases belonging to the mature and accomplished period of the artist. They brilliantly exemplify the general traits, as outlined in the essay above, characterizing his personal style after the full attainment of his creative powers. Owing to the somewhat darker palette of *The Wallachian Post-*

Carrier (**143**), it appears to be the earliest of the three and could date from the early 1860s. A slightly different but excellent version of this painting belongs to the collection of the Pfister Hotel in Milwaukee, where it can be seen dominating the opulent lobby. The most accomplished of the three paintings is *Arab Warrior* (**145**) in which a profusion of delicate values and chromas palpitate in an exciting, shimmering looming of variegated bluish-green veils. While he does not tend to build up impastoes, his fluid and painterly alla prima method, as seen in these exhibits, is marvelously productive for him in yielding form from color and transmuting color into form. (The pursuit of "borrowings" by Schreyer,

such as, for example, the left figure in *Arab Cavaliers* (**144**) from A. G. Decamps [cf. *Turkish Patrol*, Wallace Collection, London; see E. B. Nielsen], is instructive.)

PROVENANCE
From the Georg I. Seney sale, 2/11–13, 1891, No. 300 in catalogue; sale held in the Assembly Room of the Madison Square Garden building, New York, under the management of the American Art Association. Layton Art Collection.

REFERENCE
E. B. Nielsen, Adolf Schreyer; Exhibition Catalogue, Paine Art Center, Oshkosh, Wisconsin, 1972, p. 65 (N.B.: painting is erroneously listed as owned by J. H. Stebbins).

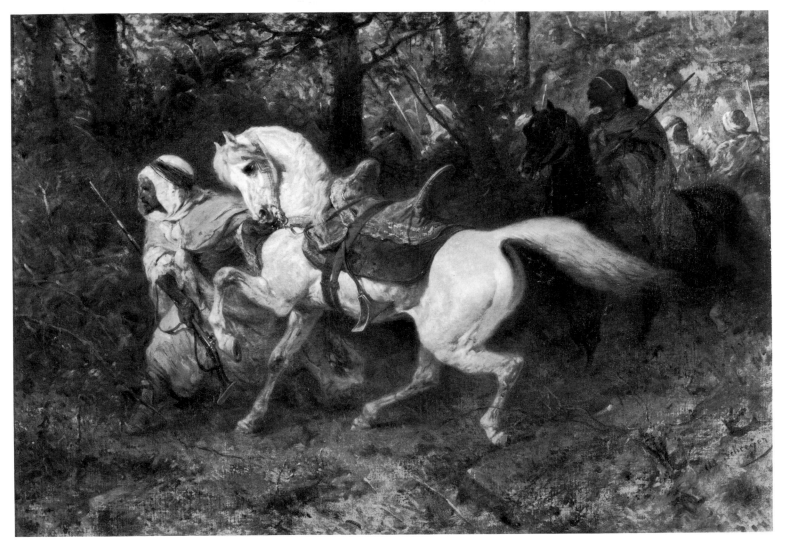

See description under entry **143**.

144
Arab Cavaliers
1870s (?)
 signed L.R.: Ad. Schreyer
 oil on canvas, 23½ × 32½ (59.7 × 82.6)
 donor: Mrs. Jesse Hoyt Smith
 MAC cat. no. L1941.2

REFERENCE
MILWAUKEE INDUSTRIAL EXPOSITION ART GALLERY
(Catalogue), Milwaukee, Wisconsin, 1900, No. 112, p. 20,
illus. p. 39. E. B. Nielsen, ADOLF SCHREYER; Exhibition
Catalogue, Paine Art Center, Oshkosh, Wisconsin, 1972, p.
39. MIRRORS OF 19TH CENTURY TASTE: ACADEMIC PAINTING;
Exhibition Handlist, Milwaukee Art Center, 1974, No. 74.

145
Arab Warrior
1880s (?)
 signed L.R.: Ad. Schreyer
 oil on canvas, 31 × 25 (78.7 × 63.5)
 MAC cat. no. M 1962.36
Color plate page 36

See description under entry **143**.

REFERENCE
S. Wichmann, Paintings from the von Schleinitz Col-
lection (Catalogue), Milwaukee Art Center, 1968, No. 45,
illus. 17. E. B. Nielsen, Adolf Schreyer; Exhibition
Catalogue, Paine Art Center, Oshkosh, Wisconsin, 1972,
color illus. on cover. Mirrors of 19th Century Taste:
Academic Painting; Exhibition Handlist, Milwaukee Art
Center, 1974, No. 75.

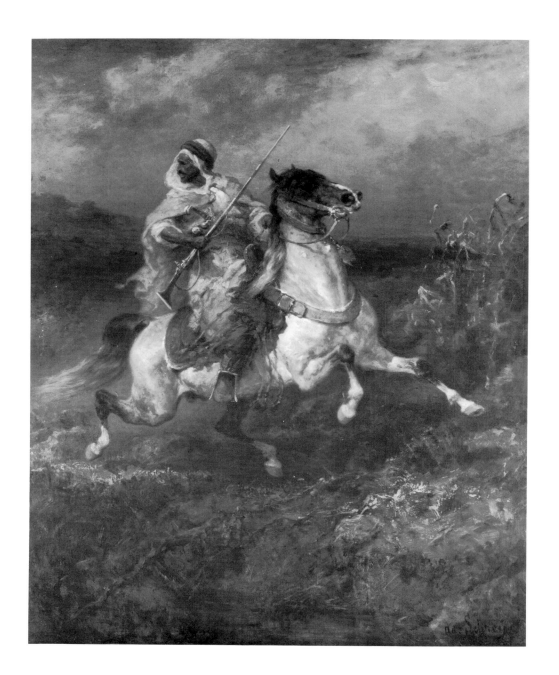

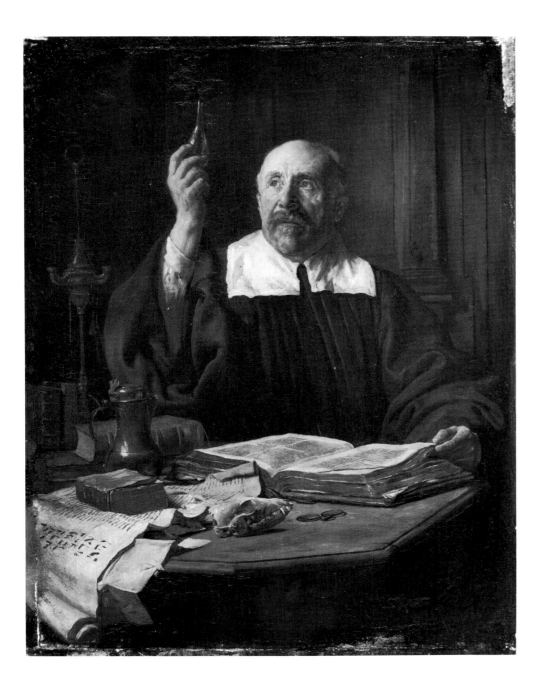

SCHRÖTTER, ALFRED VON

b. February 12, 1856, Vienna
d. unknown
represented at Graz, Magdeburg, Vienna

A genre painter, landscapist, illustrator, and decorator, Alfred von Schrötter received his training from Hans Canon in Vienna and Ludwig Löfftz at Munich. He was active in Munich and, later, in Graz, where he taught art at the Landeskunstschule.

BIBLIOGRAPHY
ZEITSCHRIFT FÜR BILDENDE KUNST, Vol. XVIII, 1883, pp. 99, 393. F. Pecht, GESCHICHTE DER MÜNCHNER KUNST DES 19. JAHRHUNDERTS, Munich, 1888. F. von Boetticher, MALERWERKE DES NEUNZEHNTEN JAHRHUNDERTS, Vol. II, Dresden, 1898, p. 664. T. von Frimmel, STUDIEN UND SKIZZEN ZUR GEMÄLDEKUNDE, Vol. III (1917/18), p. 21.

146
The Alchemist
1884
signed and dated L.R.: Schrötter / München 1884
oil on wood panel, 8¼ × 6⁷⁄₁₆ (21 × 16.4)
MAC cat. no. M 1953.3

Solid craftsmanship and a direct composition distinguish this panel in harmonies of black, mist brown, umber, flesh, and white, done *en miniature* in the Old Master technique.

REFERENCE
SELECTIONS FROM THE VON SCHLEINITZ COLLECTION; Exhibition, Paine Art Center, Oshkosh, Wisconsin, Feb. 1–20, 1972.

SEILER, CARL WILHELM ANTON

b. August 3, 1846, Wiesbaden
d. February 26, 1921, Munich
represented at Dresden, Leipzig, Munich

After completing his examinations in architecture at the Berlin Bauakademie, Carl Seiler took up art studies at Karl Raupp's studio in Munich, as well as at the academy there. He developed a style in small-scale genre painting that is characterized by precise drawing, minute detail, authentic milieu descriptions, and unusually exacting architectural settings in scenes that excel in their "life-likeness," even though his figures may appear somewhat arrested in their movement or frozen in their immediacy. His subjects include events from German eighteenth-century history, "period set pieces" from the life of the military and the bourgeoisie, as well as architectural views, such as church interiors, for example.

Seiler's style can be compared to that of Franz Simm (see entry in Catalogue) but resembles even more closely the stylistic blend of Wilhelm Löwith (see entry in Catalogue). In turn, both Seiler's and Löwith's work can be likened to the minutely executed history genre of the famous French Salon painter Ernest Meissonier. Occasionally, these artists' enthusiasm for a sense of actuality was carried by them to such a degree of verisimilitude as to break the bonds of stylistic unity in painting. The "wax works facsimiles" that sometimes resulted, the product of that debilitating all-out naturalism, serve as constant reminders of a sense of artistic purpose gone awry.

Following the tragic death of Christian Ludwig Bokelmann (see entry in Catalogue), Seiler succeeded him for a brief period of time (1894–95) as professor at the Berlin Academy. Thereafter, Seiler was active in Munich, exhibited at the *Kunstverein*, and became an honorary member of the academy of that city.

BIBLIOGRAPHY
F. Pecht, Geschichte der Münchner Kunst des 19. Jahrhunderts, Munich, 1888. L. Pietsch, Contemporary German Art: At the Centenary Festival of the Royal Academy of Arts, Berlin, Vol. II, London, 1888, pp. 27–29. Kunstchronik, New Series, Vol. V (1894), pp. 448, 517; Vol. VI (1895), pp. 250, 425; Vol. XXXII (1920/21), p. 467. A. Heilmeyer, "K. Seiler," in Kunst unserer Zeit, Munich, 1907, Vol. II, pp. 137–70. H. Uhde-Bernays, Die Münchner Malerei im Neunzehnten Jahrhundert, Vol. II, Munich, 1927, p. 206.

147
The Raid on the Secret Revolutionary Printing Press (Aufhebung einer revolutionären Geheimdruckerei)
1886
signed and dated L.L.: C. Seiler / 1886
oil on wood panel, 10½ × 15¼ (26.7 × 38.7)
MAC cat. no. M 1962.117

In his lengthy disquisition on *The Raid on the Secret Revolutionary Printing Press*, L. Pietsch concludes by saying that

> It is really astonishing how much Seiler has managed to convey in the very small dimensions of his crowded canvas. Not only is every tiny detail of the costume of each figure perfectly distinct, but not one characteristic feature of the room has been omitted. It is, to all intents and purposes, a typical secret printing office, and we are so impressed with the reality of the whole scene that we confess to a certain anxiety lest the soldiers should look up and discover the proofs, fresh from the press, hanging up to dry on the left. (p. 29)

Richly scumbled textures, an overall silvery patina, light-filled shadows, sparkling, blond chromas accentuated by black and red: these lend vivacity to Seiler's virtuoso technique as well as panache to his otherwise closely naturalistic style in both of these eighteenth-century set pieces, which are first-rate specimens of his art. In *The Raid*, a Prussian police agent, with cloak and dagger, has seized the incriminating evidence and motions to the king's troopers in full battle gear to arrest the pleading printer and his dejected assistants. In *The Conversation*, two aristocratic dandies in fine silks while away the time in distracted talk on the grand stair landing of a palace.

REFERENCE
F. Pecht, Geschichte der Münchner Kunst des 19. Jahrhunderts, Munich, 1888, illus. L. Pietsch, Contem-

S
E
I
L
E
R

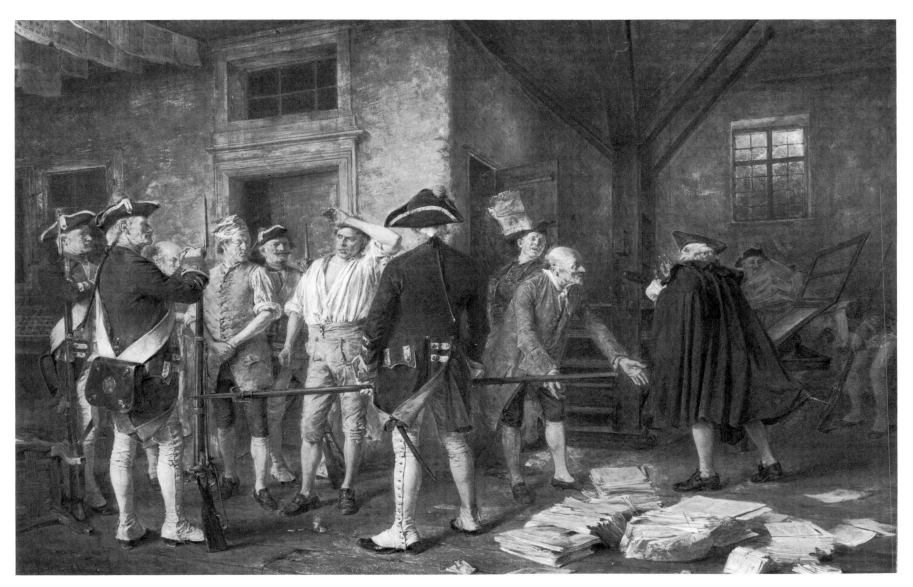

porary Gᴇʀᴍᴀɴ Aʀᴛ: Aᴛ ᴛʜᴇ Cᴇɴᴛᴇɴᴀʀʏ Fᴇꜱᴛɪᴠᴀʟ ᴏꜰ ᴛʜᴇ Rᴏʏᴀʟ Aᴄᴀᴅᴇᴍʏ ᴏꜰ Aʀᴛꜱ, Bᴇʀʟɪɴ, Vol. II, London, 1888, illus. p. 28. F. von Boetticher, Mᴀʟᴇʀᴡᴇʀᴋᴇ ᴅᴇꜱ Nᴇᴜɴᴢᴇʜɴᴛᴇɴ Jᴀʜʀʜᴜɴᴅᴇʀᴛꜱ, Vol. II, Dresden, 1898, p. 731, No.

12: "Aufhebung einer revolutionären Geheimdruckerei (Zopfzeit). Bez.: C. Seiler 1886. Abb. in Pecht's 'Geschichte der Münchener Kunst im 19. Jahrhundert.' Berl. Jub.-A. 86, Abb. im Kat." S. Wichmann, Pᴀɪɴᴛɪɴɢꜱ ꜰʀᴏᴍ ᴛʜᴇ ᴠᴏɴ

Sᴄʜʟᴇɪɴɪᴛᴢ Cᴏʟʟᴇᴄᴛɪᴏɴ (Catalogue), Milwaukee Art Center, 1968, No. 46, illus. 26. T. Atkinson, "German Genre Paintings from the von Schleinitz Collection," Aɴᴛɪǫᴜᴇꜱ, Nov. 1969, illus. p. 715.

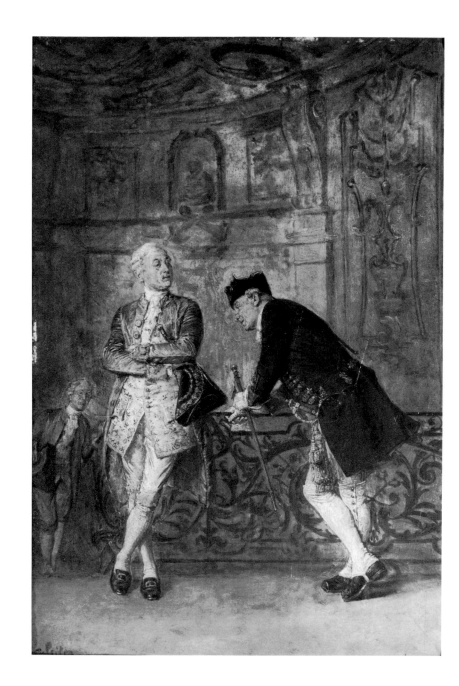

148
The Conversation
 signed L.L.: C. Seiler
 oil on wood panel, 12 × 7⅞ (30.5 × 20)
 MAC cat. no. M 1962.127

See description under entry **147**.

SEITZ, ANTON

b. January 23, 1829, Roth, near Nürnberg, Bavaria
d. November 27, 1900, Munich
represented at Cologne, Leipzig, Mainz, Munich,
Nürnberg; New York, Prague

Anton Seitz, whose contemporaries nicknamed him the "German Meissonier" (an accolade that carries mixed connotations), began as a pupil of the copper engravers Friedrich Wagner and Albert Christof Reindel in Nürnberg. Later he relocated in Munich, where he studied painting with Gisbert Flüggen, a competent genre specialist from Cologne. Eventually, he became quite successful with his own brand of mostly small-scale genre paintings. These little works, which usually contain only a few figures from the ranks of the contemporary middle class, low life, the peasantry, or clergy, are characterized, above all, by solid craftsmanship, fastidious execution, engaging characterizations and, not seldom, a gentle sense of humor. Seitz became a professor and honorary member of the Munich Academy, received several honorific awards at exhibitions, and had a number of pupils who continued his popular direction in art.

Uhde-Bernays places Seitz's art between that of Heinrich Bürkel, on the one hand, and that of Wilhelm Diez, on the other (for both, see entries in Catalogue). He does so on grounds of their respective stylistic points of departure, namely seventeenth-century Dutch art, and the historical line of development that connects them.

In his miniaturistically fine paintings . . . Seitz well proved his taste, a taste that was formed in the manner of Ostade and Teniers. His was always a completely substantial, painterly culture whose not quite personal content was made visible more through his conception of a milieu rather than through figural representation. However, his perception was not always able to rise to a personal, independent, and lucid point of view, a circumstance that robs his typical productions of the charm found in the dramatically vivid paintings of Alpine pastures by Bürkel or in the scenes of marauders by Diez. Seitz's oeuvre, once having reached a stage of perfection early on in his career, was no longer subject to progressive change later on in his life. (pp. 60, 61)

BIBLIOGRAPHY
C. A. Regnet, Münchner Künstlerbilder, Munich, 1871, Vol. II, pp. 262–68. F. Pecht, Geschichte der Münchner Kunst, Munich, 1888. F. von Boetticher, Malerwerke des Neunzehnten Jahrhunderts, Vol. II, Dresden, 1898, pp. 733–35. Katalog Ausstellung "Münchner Malerei von 1850–1880," Gallery Heinemann, Munich, 1922. H. Uhde-Bernays, Die Münchner Malerei im Neunzehnten Jahrhundert, Vol. II, Munich, 1927, pp. 60, 61, and passim. Katalog Ausstellung von Werken der Münchener Schulen von Beginn des 19. Jahrhunderts, Gallery Helbing, Munich, 1929, p. 11.

149
The Zither Player
 signed L.R.: Ant. Seitz, München
 oil on wood panel, 13¾ × 10½ (35 × 26.8)
 MAC cat. no. M 1972.14

The form and modeling of the zitherist as well as her finely tuned black, gray, white, green costume stand out in the first of these two otherwise uneventful compositions (**149, 150**).

PROVENANCE
Adolf Weinmüller Auction No. 96, Catalogue No. 104, Sept. 29–Oct. 1, 1965, No. 1531 in Catalogue, illus. plate No. 91.

REFERENCE
S. Wichmann, PAINTINGS FROM THE VON SCHLEINITZ COL-LECTION (Catalogue), Milwaukee Art Center, 1968, No. 47.

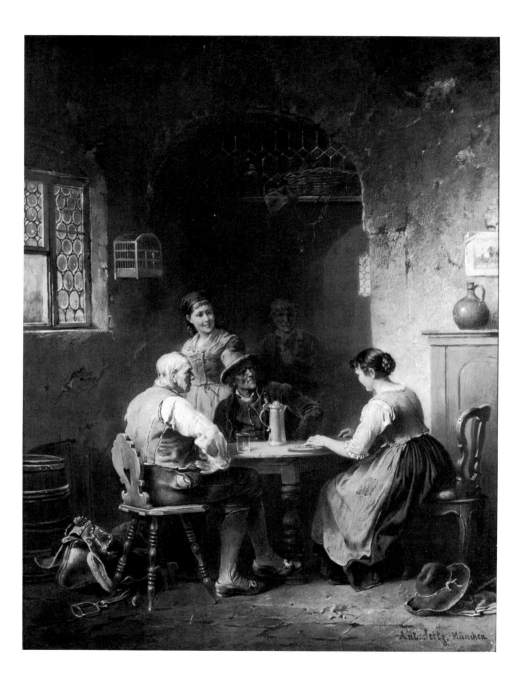

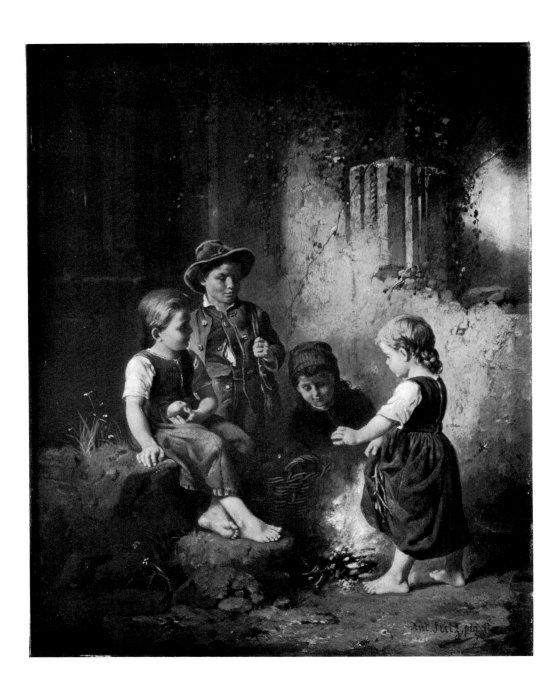

150
Children Warming Their Hands
 signed L.R.: Ant. Seitz, pinxit
 oil on wood panel, 10 × 7^{15}/$_{16}$ (25.4 × 20.2)
 MAC cat. no. M 1970.113

See description under **149**.

PROVENANCE
Purchased by donor from Melvin Mallon, Milwaukee, 1969.

REFERENCE
SELECTIONS FROM THE VON SCHLEINITZ COLLECTION; Exhibition, Paine Art Center, Oshkosh, Wisconsin, Feb. 1–20, 1972. MIRRORS OF 19TH CENTURY TASTE: ACADEMIC PAINTING; Exhibition Handlist, Milwaukee Art Center, 1974, No. 76.

SIMM, FRANZ XAVER

b. June 24, 1853, Vienna
d. February 21, 1918, Munich
represented at Berlin, Graz, Munich

While studying at the Vienna Academy, Franz Simm enjoyed the lessons of several quite famous artists. Of these, Anselm Feuerbach seemed to have had the least influence on him. But Hans Makart imbued him with a Neo-Baroque sense for movement and decoration in the flamboyant interpretation of subjects from history. The Nazarene Josef Führich, in addition to teaching him the fresco technique, also instilled in him an appreciation for structural clarity in large-scale compositions, as well as a knowledge of religious painting. He also received instruction from the German-Roman history painter and portraitist Eduard von Engerth.

In 1876 Simm was awarded the coveted Rome Prize which enabled him to study in Italy for the next five years. It was there that he met and married Marie Simm-Meyer (1851–1912), an accomplished painter from the school of Ludwig Löfftz at Munich. She collaborated with her husband on most of his later colossal painting cycles and dioramas. In 1881 he obtained a commission to decorate with a series of large-scale wall paintings from the Promethean and Jason myths the stair hall of the Caucasian Museum in Tiflis (Tbilis, Georgian Russia). After completing this task abroad, Simm settled permanently in Munich. In the course of the following years he executed a number of illustrating commissions (e.g., scenes from *Faust* and *West-Östlicher Diwan* for Hallber's new Goethe edition), colossal panoramas and dioramas (e.g., *An Interior of a Harem* for the Crystal Palace in Leipzig; *Death of Emperor Wilhelm I*, 1888), as well as various ceiling decorations (e.g., for the Archeological Hall of the Vienna Art Museum) and numerous religious works. In the time between such assignments, he painted sensitive and modest small-scale genre pieces with bourgeois staffages whose subjects are often derived from the Second Empire Period. He received many high medals for artistic distinction, including the Chicago Medal in 1893.

BIBLIOGRAPHY
C. von Wurzbach, Biographisches Lexikon des Kaisertums Österreich, Vol. XXXIV, Vienna, 1877, p. 316. F. Pecht, Geschichte der Münchner Kunst des 19. Jahrhunderts, Munich, 1888. F. von Boetticher, Malerwerke des Neunzehnten Jarhhunderts, Vol. II, Dresden, 1898, pp. 752, 753. H. Uhde-Bernays, Die Münchner Malerei im Neunzehnten Jahrhundert, Vol. II, Munich, 1927, p. 206. Kunstchronik, New Series, Vol. XXXIII (1921/22), p. 503.

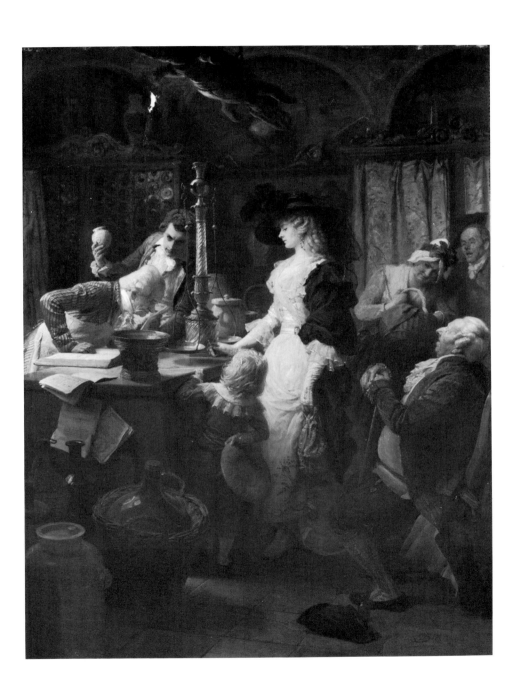

151
At the Apothecary
 signed L.R.: Simm
 oil on wood panel, 20 × 14¾ (50.8 × 37.5)
 MAC cat. no. M 1972.113

Baroque movement, flair for historical costuming, superb drawing, a dynamic brush, visible especially in such passages as hair, lace, fabric, and a fine sense for the decorative potential of color (boy in red, lady in white and dark blue, drapery in rose, greenish overall tint): these qualities contribute to the sensual enjoyment of this most effectively staged Rococo-period set and costume piece by Simm.

REFERENCE
The Inner Circle; Exhibition Handlist, Milwaukee Art Center, 1966, No. 87. S. Wichmann, Paintings from the von Schleinitz Collection (Catalogue), Milwaukee Art Center, 1968, No. 48. Mirrors of 19th Century Taste: Academic Painting; Exhibition Handlist, Milwaukee Art Center, 1974, No. 77.

S
I
M
M

221

SPIELTER, CARL JOHANN

b. February 1, 1851, Bremen
d. June 26, 1922, Bremen
represented in private collections

Carl Johann Spielter was a pupil in the master class
of Gabriel Max, a late Romanticist and disciple of
Karl von Piloty, and was also in the class of the
Neo-Baroque decorator Hans Makart at Vienna.
Spielter, who painted "situation-genre" from con-
temporary society, experimented with cool hues
and chromatic details that seem related to English
Pre-Raphaelite techniques, which count among the
sources of Max's art. His concern for fidelity to the
contemporary milieu and to topical situations
drawn from the daily life of the middle class of his
own day gives a sense of reportorial urgency to his
canvases but also contrasts with the historical and
decorative bent of the Munich School, among whose
ranks, however loosely, Spielter should be counted!

He lived at Vienna, Munich, Charlottenburg, and
Bremen.

BIBLIOGRAPHY
H. A. Müller, BIOGRAPHISCHES KÜNSTLERLEXIKON DER
GEGENWART, Leipzig, 1884. KUNSTCHRONIK, Old Series
(1886–89), Vol. XXI, p. 30; Vol. XXIII, p. 476. F. von Boet-
ticher, MALERWERKE DES NEUNZEHNTEN JAHRHUNDERTS,
Vol. II, Dresden, 1898, p. 785. Thieme-Becker, KÜNSTLER-
LEXIKON, Leipzig, 1907–50, Vol. XXXI, p. 372.

152
The Auction
1900
> signed and dated U.L.: Spielter 1900
> oil on canvas, 25 × 33½ (63.5 × 85.1)
> MAC cat. no. M 1968.95

The subject of the art auction, the sale of art, or the
artist's studio were favorite settings with Spielter
(see Boetticher, *Malerwerke des 19. Jahrhunderts*,
Dresden, 1898, Volume II, p. 785: Nos. 4, 6, 9, 10, 13,
14, 15). Black, gold, and brown are the dominant
colors in this unbelievably detailed, overladen,
overworked, photographically precise paean to the
Gilded Age. While it seems to lack all discernible
traces of artistic will to order and clarity, the paint-
ing can easily absorb one for an hour or more, as one
follows the artist's fanatically executed descriptive
peregrinations. The grief of the young widow (?)
and the sympathy expressed by those flanking her is
drowned out by the mass of microscopic detail de-
scribing the dozens of *objets d'art* of her (late hus-
band's?) estate.

PROVENANCE
Estate of Abner Silver, New York, via Parke-Bernet Gal-
leries (3/2/67), No. 134 in Catalogue, illus. No. 43.

REFERENCE
Parke-Bernet, ART AT AUCTION, 1966–67, illus., p. 168.
Parke-Bernet, AUCTION MAGAZINE, Dec. 1967, detail illus.,
on cover. S. Wichmann, PAINTINGS FROM THE VON
SCHLEINITZ COLLECTION (Catalogue), Milwaukee Art Cen-
ter, 1968, No. 49 (shown there incorrectly as 11″ × 33″).

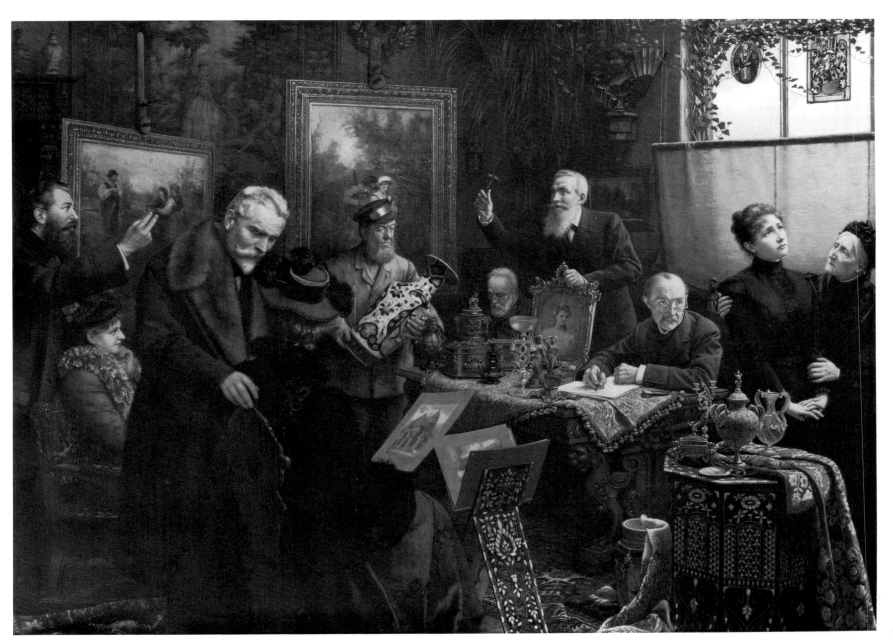

SPITZWEG, CARL

b. February 5, 1808, Munich
d. September 23, 1885, Munich
represented at all major German museums; Bern,
 Prague, Riga, Vienna, Zurich

After finishing Latin School and a period of apprenticeship as apothecary in Munich and Straubing, Carl Spitzweg, whose father was a rich trader in spices, foods, and variety goods and member of the Bavarian Parliament, obtained a degree in pharmaceutics from the University of Munich, class of 1832. The following year, while recuperating from a serious case of typhoid fever at Bad Sulz, he made the acquaintance of several artists, including the then well-known Christian H. Hansonn from Altona (Hamburg), who awakened his interest in art and instructed him in the use of the painter's tools. Spitzweg decided to become an artist, but, feeling too old to start all over again with formal training in an academic situation, he resolved to train himself by copying the Old Dutch Masters at the Alte Pinakothek museum of his home town. Among the Munich painters who belonged to his widening circle of friends and who would, on occasion, collaborate with him on paintings, we count Christian Morgenstern, Eduard Schleich the Elder (see entry in Catalogue), Dietrich Langko, and Friedrich Voltz (see entry in Catalogue); later on he also stood close to Moritz von Schwind and Eduard Grützner (see entry in Catalogue).

In the 1830s and forties Spitzweg was already actively at work as an illustrator, producing humorous drawings and cartoons for, among other journals, the popular *Fliegende Blätter* in Munich. A peripatetic bachelor, Spitzweg traveled constantly and extensively well into the 1860s in Germany, Austria, and Italy; he also undertook important study trips to Prague (1849), Paris, the Belgian cities, and London (1851). From about 1860 onward and to the end of his life, Spitzweg resided permanently in Munich, spending many of his summers at nearby Benediktbeuren. Spitzweg began selling his paintings from the 1830s onward and 480 sales in all were recorded by him during his lifetime. At first neglected or ridiculed by the artistic establishment, he saw his artistic reputation in his hometown grow in his later years, when he received distinguished medals and an honorary membership (1868) in the Academy. Since his death Spitzweg's critical standing in art history—to say nothing of the lively art market in Spitzwegs—has been steadily on the rise.

A point of consensus has now been reached: Spitzweg was among the very best representatives of the Munich School; he was the greatest German genre painter and one of her finest landscapists; he was a painter of exceptional genius; his art belongs to the gallery of the foremost masters of the nineteenth century.

Spitzweg's earliest paintings, and his drawings as well, were mincing in their detailed, draftsmanlike execution, and they placed the highest stress on the clear articulation of the humorous or anecdotal situation depicted. Spitzweg used his characteristic "S-within-a-rhombus" signum after 1836, virtually from the very beginning in his career as painter. It is actually a witty play on words, i.e., on *Spitzwecken*, a pretzel-shaped pastry made in Munich. Moreover, he could thus hide his disappointment over the disastrous reception accorded his second entry at the Munich *Kunstverein* exhibition (the original version of *Der arme Poet*, finished 1837, exhibited 1839) under the cover of "anonymity."

The most pressing current problem of Spitzweg scholarship today concerns the clarification of those artistic influences that enabled him to overcome his early illustrational style and to arrive at his own, remarkably original painterly mature style. The following touches on the major channels of this process, while it avoids drowning the reader in the welter of currents hinted at by the very extensive literature on Spitzweg. The influence of Morgenstern's Copenhagen-trained outdoor realism on the Munich painters, already alluded to elsewhere (e.g., regarding Eduard Schleich the Elder; see entry in Catalogue) must be mentioned here as having been influential on Spitzweg. Through Schleich he was drawn to the scenic possibilities of the Bavarian countryside and of composition in landscape painting in general. Karl Rahl, who visited Munich in the years from 1848 to 1850 and lectured on the colorism of the French School, acted less as an

influence than as a catalyst for change, a change away from the tightly controlled realism of the Old Munich School and toward a loose and painterly approach.

Perhaps more significant than any of these influences on Spitzweg's stylistic evolution were his experiences in Prague. On the basis of personal diaries by Spitzweg that have surfaced only quite recently, Siegfried Wichmann, a noted authority on Spitzweg, suggested that this study trip—it had not been known until 1963 that Spitzweg had even undertaken such a journey!—was the single most decisive stimulus in finally confirming the artist's development toward his progressive form of Realism. (See *Spitzweg auf der Reise nach Prag; Spitzweg und sein Freundeskreis*.) It was in Prague that he was drawn into the circle of Czechoslovakian artists, foremost among whom were August Piepenhagen, Josef Mánes, and Josef Navrátil. Of these, it was, above all, Navrátil who must have exerted the strongest influence on him. This painter's proto-Macchiaiolesque and proto-Impressionistic style is characterized by broad, planar color surfaces that provide the basic formal structure for his paintings, pure color accents that act as electrifying contrasts, and, finally, tonal atmospherics and luminism that furnish the overall pictorial unities. The broken brushwork and sketchily handled masses, movements, lights, and shadows of Piepenhagen are of

further bearing on this matter.

In a circuitous way (via Vienna and Prague) Spitzweg also learned from the English School of landscape painting. (His later trip to London, where he was delighted with Turner's and Constable's works, can be counted as a further formative influence here, although by that time Spitzweg was already in possession of his personal style.) In view of these recent insights into the artist's crucial breakthrough period, his later contact with the art of Paris and his acquaintance with the Barbizonists (Diaz, Daubigny, Rousseau, et al.) and Delacroix, despite his professed love for them, would, in the present context, appear at best diminished in significance (beyond having reconfirmed a sense of direction which he had found some years earlier); at worst, it seems almost beside the point.

These varying but kindred approaches to technique were first absorbed by Spitzweg, and then, on his own, synthesized and perfected into a genuine personal style. Most significantly, he brought his original form into beautiful balance with his unique subject matter: scenes from Munich and the surrounding countryside replete with his well known characters—sleepy soldiers, contemplative monks, nubile farm girls, eccentric scholars, traveling folk—who can only be described as unforgettable *Spitzwegmenschen*. (Trips to Dalmatia and Bosnia provided Spitzweg with first-hand experience and,

as with all his study trips, wherever they took him, with sketches, specifically those for his "Turkish" subjects; see Wichmann, *Orientdarstellungen im Werk von Carl Spitzweg*.) Progressively, the purely anecdotal aspect of his art faded to the periphery of his attention until it merely whispers with gentle intimations of a possible narrative content. Correspondingly, his formerly sharp and specifically aimed wit underwent a transmutation toward an ever milder sense of irony, an ever more universal sense of humorous *Weltanschauung*.

Parallel with these developments in the content of his paintings, Spitzweg steadily evolved toward pleinairism and formalism: toward more light-filled atmospheres, more luminous shadows, broader brush strokes, heavier impasto. Eventually, he attained a total freedom, composing entirely in terms of coloristic harmonies and contrasts and abstract formal structure. Although he used small formats virtually exclusively, often employing cigar box tops as painting surfaces, his pictures grew in their sense of formal significance as his figures increased in their monumentality.

The extraordinary multiplicity of values and meanings attached to it by critics of differing persuasions and times is a solid testimonial to the depth and range of Spitzweg's oeuvre. There is Spitzweg the shy poet (he was, in fact, a writer of fine verses) and retiring painter of romantic

Träumereien; Spitzweg the passive but witty chronicler of *Biedermeier* foibles; Spitzweg the sage, the philosopher-psychologist; Spitzweg the balladier of frugality, individualism, and the quiet charms of Munich *Gemütlichkeit*. But, apart from all this, there now emerges ever more forcefully a different portrait of the artist: he was a widely traveled cosmopolitan, a man of initiative, action, and experience, who in life stood with both his feet firmly planted on the ground and who had a very positive, even enthusiastic attitude toward all aspects of change, whether they were in art or in technology.

The progressive nature of the purely formal aspect of Spitzweg's mature style has, in its wider ramifications, only recently become subject to renewed assessment, although the duality of Spitzweg the genial story teller and Spitzweg the serious painter has been apparent and much discussed ever since the epochal Berlin Centenary Exhibition of 1906, where Spitzweg appeared with thirty-three works. Depending on one's personal inclinations, therefore, it is possible to see in Spitzweg and his art a symbol of a hidebound *Biedermeier* society or else one of the foremost manifestations of the artistic *avant-garde* in nineteenth-century Germany. As to the former, however, we can see perhaps a bit more clearly today that the artist's subjects, in the final analysis, never did really belong to the mainstream of German Romantic imagination. Rather, it would appear, they

functioned more directly as the means to an end for him. Specifically, they were merely practical (if largely "sentimental") *motifs* which lent themselves to an assimilation into *style*, stakes in an evolutionary process of conquering reality through style. As to the latter, alongside his paintings, the development of his style in drawing—an evolution toward an impressionistic fixing of the totality of a motif—must be cited as further prima facie evidence. His little-known but huge and excellent body of sketches and drawings from his innumerable study trips explode the theory that Spitzweg's sum total of artistic knowledge was the "mental" product of a reclusive *Ateliermaler*. Moreover, in connection with his formal experiments, Spitzweg must also be credited with the invention of the collage technique in art. (It may interest connoisseurs of Picasso's early *papiers collés* that Spitzweg combined bits and pieces of newsprint, cooking recipes, wood cuts, and his own drawings in highly effective *Wort- und Bildspiele* [word and picture games] as early as 1860!)

One consequence of Spitzweg's popularity in his own lifetime and of the subsequent growth in the collector's value of his paintings has been a thriving business in imitations and copying of the master's works. And then there is the problem of outright forgery. Philipp Sporrer, Willy Moralt (for both see entries in Catalogue), Karl Happel, and Karl Splitgerber belong among those in the first category, while a notorious workshop in Hamburg (see bib-

liographies in Roennefahrt and Thieme-Becker) belongs to the latter. None of their works ever reached the level of the master's. The fact that his painted oeuvre consists of an amazing 1,543 pictures (see Roennefahrt's "Werkverzeichnis"), many of which he himself executed in various versions and "copies," further contributes to making the ordering and authentication of Spitzweg's works a vexing problem.

BIBLIOGRAPHY
H. Uhde-Bernays, SPITZWEG, Munich, 1915; H. Uhde-Bernays, CARL SPITZWEG, DES MEISTERS LEBEN UND WERK, Munich, 1919. M. von Boehn, CARL SPITZWEG, Leipzig, 1921. F. von Ostini, AUS CARL SPITZWEGS WELT, Barmen, 1924. F. von Ostini, DER MALER CARL SPITZWEG, Bielefeld, 1924. E. Kalkschmidt, CARL SPITZWEG UND SEINE WELT, Munich, 1945. A. Elsen, CARL SPITZWEG, Vienna, 1948. R. von Schleinitz, "Carl Spitzweg, the Painter Poet," THE AMERICAN-GERMAN REVIEW, Oct./Nov. 1954, pp. 19–23, 6 plates. W. Spitzweg, DER UNBEKANNTE SPITZWEG, Munich, 1958. G. Roennefahrt, CARL SPITZWEG: BESCHREIBENDES VERZEICHNIS SEINER GEMÄLDE, ÖLSTUDIEN U. AQUARELLE, Munich, 1960. S. Wichmann, SPITZWEG AUF DER REISE NACH PRAG, Munich, 1963; S. Wichmann, CARL SPITZWEG UND SEIN FREUNDESKREIS; Exhibition Catalogue, Haus der Kunst, Munich, 1968. M. Albrecht, CARL SPITZWEGS MALERPARADIES, Stuttgart, 1968. R. Bisanz, "The Schack Gallery in Munich: German Painters, 1850–1880," ART JOURNAL, Vol. XXXIII, No. 3, 1974, pp. 211–18, 10 plates. S. Wichmann, ORIENTDARSTELLUNGEN IM WERK VON CARL SPITZWEG, Munich, 1975. K. R. Langewiesche, CARL SPITZWEG, Königsstein im Taunus, n.d.

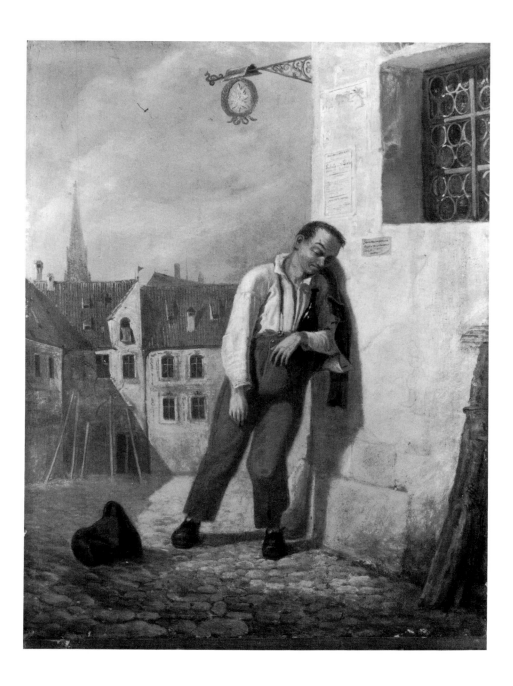

153
The Drunkard (Ein Betrunkener)
1836

> signed and dated L.R.: signum / 1836
> oil on wood panel, 11⅜ × 8⅜ (28.9 × 21.3)
> MAC cat. no. M 1962.73

The subject of drinkers or men coming home from revels occupies a field of some twenty paintings by Spitzweg. An oil study (see Roennefahrt, "Werkverzeichnis," No. 710) exists in which this composition is blocked out in its essentials. The early dating of this panel is commensurate with the stylistic evidence here: hard modeling, uncertainties in anatomy, mincing detail, draftsman-like execution, cartoon-like conception. Light, "milked-out" shades of ochre and mist brown (masonry) predominate; white shirt, slate-blue trousers, gray-blue sky. A handbill posted on the wall immediately above the profligate's head announces Schiller's play of 1783, *Cabale und Liebe* (intrigue and love), a circumstance which may cast the apparent wastrel in the role of serious hero who, in an oblique allusion to the play, cannot marry a noblewoman because of aristocratic conceit and corruption, and therefore goes on a suicidal binge.

PROVENANCE
Collection Professor Rothmund, Munich. Gallerie G. A. Sturm, Munich. Kunsthandlung Schöninger, Munich.

REFERENCE
R. von Schleinitz, "Carl Spitzweg, the Painter-Poet," THE AMERICAN-GERMAN REVIEW, Oct./Nov. 1954, illus. p. 22. G. Roennefahrt, "Werkverzeichnis," in CARL SPITZWEG, Munich, 1960, No. 711, illus.: "EIN BETRUNKENER an die Ecke des Wirtshauses gelehnt; in Hose und offenem Hemd. Über der linken Schulter hängt seine Jacke, der Hut liegt auf der Strasse, die in einen grösseren Platz mündet. An der Hauswand verschiedene Anklebezettel, darunter einer mit der Aufschrift 'Kabale und Liebe.' Ö auf Holz, 29,2:22,2 cm, rechts (auf einem Holzstück) signiert und die Jahreszahl 1836. Aus der Slg. Prof. Rothmund, München, an die Gal. Sturm gekommen. V.: Helbing, München, 24.10.1911, Nr. 151; Abb. Tafel 61, aus dem Bestande der Galerie G. A. Sturm, München. Bis etwa 1946 in süddeutschem Besitz, dann von der Galerie Schöninger, München, erworben. Besitz: René von Schleinitz, Milwaukee (Wisc., USA)."

154
Reading the Newspaper in the Garden (Zeitungsleser im Garten)
1847 (?)
 signed L.L.: signum
 oil on canvas, 12½ × 10¹¹/₁₆ (31.8 × 27.2)
 MAC cat. no. M 1972.245a

The approximately ten paintings by Spitzweg dealing with the subject of reading the newspaper in the garden are a part of a much wider cycle of works that portray the figure of a man, or a gardener, in a garden, and are known collectively as the *Kaktusliebhaber* (cactus fancier). In this masterful little painting the viewer has difficulty in deciding what to do first: to chuckle at the predicament of the gentleman who tries to make up his mind between his cherished newspaper and the nubile lass—a quandary conveyed so well by the contrapposto of his "figuration"—and ponder the psychological and philosophical implications of his eventual decision, whatever that may turn out to be; or to thrill to the beautiful color chord described by the man's deep prussian-blue morning coat and the lush profusion of the cool, moist veridians and mints of the foliage enframing him. Already by 1847 Spitzweg seems to have attained a mastery not only of striking a balance between content and form in his art but also of pushing both to their full potentials. The painting is unmistakably No. 887 in Roennefahrt (see Reference, below). Although a date cannot be found in the painting, Roennefahrt unaccountably states that "the number 47 appears unclearly near the signum."

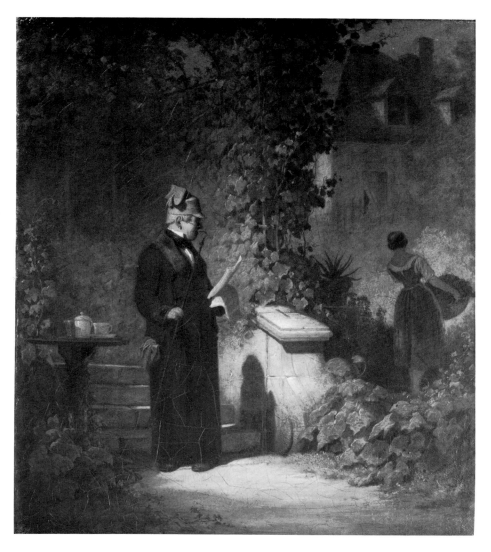

PROVENANCE
Kunsterverein Strassburg. H. B., Winterthur. 1956 private possession, Munich. Purchased by donor from Adolf Weinmüller, Munich, auction No. 87, Catalogue No. 95, Oct. 2–3, 1963, No. 1103 in Cat., illus. in color on cover and in plate no. 9.

REFERENCE
Examined by Dr. Hanfstaengl and Dr. Buchner, Munich, 5/2/57. G. Roennefahrt, "Werkverzeichnis," in CARL SPITZWEG, Munich, 1960, No. 887, illus. colorplate p. 88: "ZEITUNGSLESER IM GARTEN in langem Morgenrock, mit Mütze und langer Pfeife, steht neben dem kleinen Kaf-

feetisch auf der Terrasse unter einem Spalier mit Weinlaub. Rechts im Garten eine Magd mit einem grossen Korb— von rückwärts gesehen. Öl, 31,5:26,5 cm, unten links Signum und die Jahreszahl 47 (undeutlich). Wahrscheinlich V.V.Nr. 70, im Jahre 1847 an den Kunstverein Strassburg, m.T.: 'Politikus im Gärtchen beim Kaffee' verkauft. War im Besitz von H.B. in Winterthur; der Vorbesitzer gab an, das

Bild in Strassburg erworben zu haben; es wurde 1956 in Münchner Privatbesitz (v.K.) festgestellt und ist jetzt ebenda in anderem Besitz." S. Wichmann, PAINTINGS FROM THE VON SCHLEINITZ COLLECTION (Catalogue), Milwaukee Art Center, 1968, No. 50, illus. 14. K. Strobl, "Die Sammlung von Schleinitz," KUNST IM VOLK, Nos. 3/4, 1968/69, pp. 80–87, color plate p. 84.

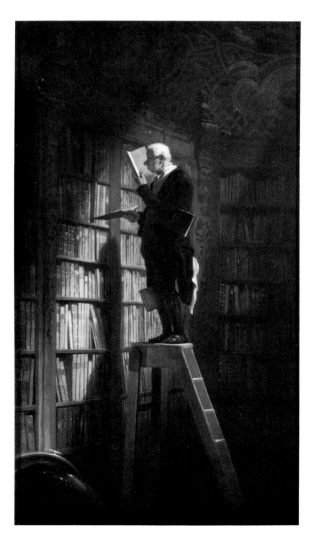

154a
The Bookworm (Der Bücherwurm)
c. 1853

 signed obverse: signum
 oil on canvas, 19 × 10½ (48.3 × 26.7)
 originally a part of the René von Schleinitz Collection,
 this painting is now owned by the Milwaukee
 Public Library

The Bookworm is part of a corpus of nearly twenty paintings by Spitzweg dealing with scholars or booklovers in their studies or libraries, and it is one of at least three slightly different versions of this particular composition which were executed by the artist. The picture is one of the most popular in the whole repertory of Spitzweg's variations on this whimsical, absent-minded, intensely absorbed *Biedermeier* type invented by the painter, and in fact it is one of his best paintings.

 The scholar's purplish-black trousers and blackish-mint cutaway provide a powerful middle-ground *repoussoir* for the rich glazes done in various orange-toned ochres and sienas appearing in the section of bookshelves. These are spotlighted by a light source located outside the picture on the upper right—probably a round or oval window, a customary feature of the late Baroque architecture depicted here. A partial globe (dark green), a stepladder, a portion of a shallow-domed Rococo ceiling with rocaille and fretwork ornaments and a cartouche containing the word "METAPHYSIC" complete this simple but highly affective vertical composi-

tion. Among the most arresting characteristics distinguishing this painting are its smoothly gliding chiaroscuro, unified space, cohesive atmosphere, and brilliant coloration. The humorous element is subdued. The nearsighted scholar, unmindful of his precarious position on the high perch, clutching four tomes at once, does not in the least presume upon the viewer or detract from the painterly charms of this masterful canvas by Spitzweg.

PROVENANCE
Bearing the title *Bibliothekar* (librarian), the picture was sold to an unknown party in New York in 1853. Purchased in 1951 from the art dealer Victor D. Spark, New York.

REFERENCE
R. von Schleinitz, "Carl Spitzweg, the Painter-Poet," THE AMERICAN-GERMAN REVIEW, Oct.–Nov., 1954, pp. 19–23, illus. "Malerei deutscher Meister des 19. Jahrhunderts in Milwaukee," DIE WELTKUNST, Vol. XV, Nov. 1956, p. 17, illus. G. Roennefahrt, "Werkverzeichnis," in CARL SPITZWEG, Munich, 1960, No. 1353: "Wiederhohlung des Motivs von Nr. 1352. Hier zahlreiche Abweichungen bei den Bucheinbänden und in der Stellung des Globus. Öl auf Leinwand 49:26.5, rücks. signum. V.V.: Nr. 107, im Jahre 1853 nach New York m.T.: 'Bibliothekar (Grösse wie 102)' verkauft. War 1951 bei Kunsth. Victor D. Spark in New York. Jetzt im Besitz von René von Schleinitz, Milwaukee, Wisc., U.S.A. Lit. 'Weltkunst, 1956, H. 22, S. 17.' S. Wichmann, PAINTINGS FROM THE VON SCHLEINITZ COLLECTION (Catalogue), Milwaukee Art Center, 1968, No. 51, plate No. 16. T. Atkinson, "German Genre Paintings from the von Schleinitz Collection," ANTIQUES, Nov. 1969, pp. 712–16, illus.

S
P
I
T
Z
W
E
G

155
A Visit (The Unexpected Interruption) (Ein Besuch)
c. 1855
 signed L.L.: signum
 oil on cardboard, 10^{7}/$_{16}$ × 8^{9}/$_{16}$ (26.5 × 21.8)
 MAC cat. no. M 1962.72

At its various earlier exhibitions this painting was shown under these different titles: *The Scholar in His Garret*, *Scholar and Blackbird*, *The Scholar*. A label appearing on the painting (verso) even suggests the apt *Der gefiederte Störenfried* (the feathered marplot). Spitzweg's brush asserts itself here more visibly and authoritatively than in the previous exhibits. Lighting, too, addresses the problem of description as much as it does pictorial structure. Spitzweg's beautiful scumble technique conveys less a notion of textures here than a delicate feeling for color harmonies. Scholars in their chambers and libraries form a substantial part of Spitzweg's thematic repertoire. But none of his other similar paintings really exceeds this one in literary charm, coloristic sensitivity, and painterly culture. Colors: lavender to black (scholar's coat); mint to bottle green (chair); black to dark green (coat on wall); sparing lake and blue accents (e.g., rug); the rest is an incredibly variegated and yet harmonious webbing of coolish bays, toasts, sands, and choice verts.

PROVENANCE
Fr. von Lachner, Munich. M. Riemerschmid, Munich. Frau von Besserer-Zumbusch (Munich ?)

REFERENCE
Exhibition, Nationalgalerie Berlin, Nov.-Dec., 1886, No. 107. Gedächtnisausstellung; Exhibition, Kunstverein, Munich, 1908, No. 45. M. von Boehn, CARL SPITZWEG, Leipzig, 1921, illus. p. 51. Exhibition, Schönemann & Lampl, Munich, May-June, 1927, No. 40. Exhibited, Neue Pinakothek, Munich, 1934. K. R. Langewiesche, CARL SPITZWEG, DREISSIG GEMÄLDE, Leipzig, n.d., illus. 31. THE GERMAN-AMERICAN REVIEW, Oct. 1951, illus. EXCLUSIVELY YOURS, Feb. 1957, p. 10, illus. G. Roennefahrt, "Werkverzeichnis," in CARL SPITZWEG, Munich, 1960, No. 1342, illus. p. 121: "EIN BESUCH. Im Giebelzimmer sitzt ein Gelehrter im Hausrock bei der Arbeit. Er blickt über die Brillengläser hinweg zu einer Amsel, die sich am Fenster

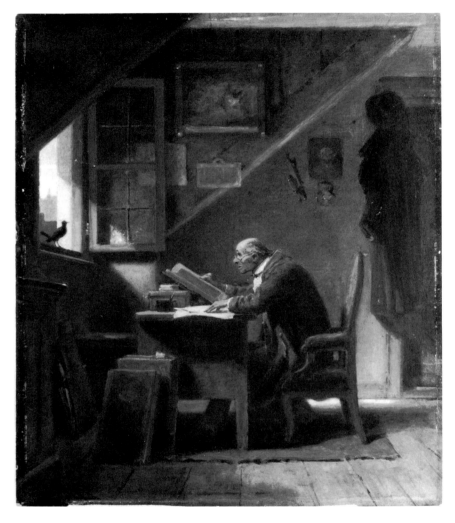

niedergelassen hat. Öl auf Pappe, 26,5:22 cm, unten links Signum. A.: Nationalgalerie Berlin, November bis Dezember 1886, Nr. 107, m. T.: 'Der Gelehrte im Dachstübchen,' aus Besitz Fr. v. Lachner, München. Kunstverein München, Ged.-Ausst. Juni 1908, Nr. 45, m.T.: 'Gelehrter und Amsel,' aus Besitz M. Riemerschmid, München. Schönemann & Lampl, München, Mai bis Juni 1927, Nr. 40; Abb. T. 7, m.T.: 'Der Gelehrte.' Original hing vor 1934 einige Zeit als Leihgabe in der Neuen Pinakothek Mün-

chen. Im Juli 1949 im Besitz von Frau v. Besserer, Tochter des Malers Zumbusch; jetzt im Besitz von René von Schleinitz, Milwaukee, Wisc., USA. V.V.: Nr. 431, im Jahre 1882 an Franz v. Lachner, München, m.T.: 'Stubengelehrter mit Amsel.'" S. Wichmann, PAINTINGS FROM THE VON SCHLEINITZ COLLECTION (Catalogue), Milwaukee Art Center, 1968, No. 52. MIRRORS OF 19TH CENTURY TASTE: ACADEMIC PAINTING; Exhibition Handlist, Milwaukee Art Center, 1974, No. 82.

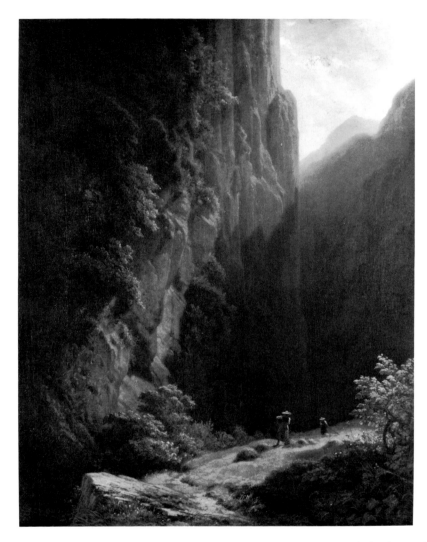

156
Women Mowing in the Mountains (Harvest in the Tyrolean Alps) (Mäherinnen im Gebirge)
1858
 signed and dated L.L.: signum / 1858
 oil on canvas, 22¼ × 17 (56.5 × 43.2)
 MAC cat. no. M 1962.54
Color plate page 37

One of the best of Spitzweg's approximately ten paintings dealing with the subject of harvesting, this exhibit is also one of the master's finest landscapes. The radiance and delicacy of the light as it filters through the scene from the upper right, illumines the bottom of the gorge, and then pervades even the deepest recesses and shadows of the chasm in the lower left, cannot be described with words. Nor can written commentary convey the magic of the graduated scaling of greens, blues, grays. The composition absorbs the viewer with its mysterious, deeply receding atmospheric space just as much as it strikes him with its simple, magisterial design.

PROVENANCE
Altgraf Franz zu Salm-Reifferscheid, Prague. Sammlung Zitzmann. Collection Max Stöhr, New York.

REFERENCE
SPITZWEG AUSSTELLUNG; Exhibition Catalogue, Rudolfinum, Prague, 1887, No. 45. Gedächtnisausstellung; Exhibition, Kunstverein, Munich, 1908, No. 68. K. R. Langewiesche, CARL SPITZWEG, Königstein i. T., DES MEISTERS LEBEN UND WERK, Munich, 1919, illus. 112. F. von Ostini, AUS CARL SPITZWEGS WELT, Barmen, 1924, illus. p. 4. R. von Schleinitz, "Carl Spitzweg, the Painter-Poet," THE AMERICAN-GERMAN REVIEW, Oct./Nov. 1954, illus. p. 20. DIE WELTKUNST, Vol. XV, Nov. 1956, p. 17, illus. G. Roennefahrt, "Werkverzeichnis," in CARL SPITZWEG, Munich, 1960, No. 439, illus. p. 50: "MÄHERINNEN IM GEBIRGE. Wiese im Hochgebirge zwischen steilen Felswänden. In der Mitte der sonnenhellen Wiesenfläche zwei Mädchen beim Heuen, beide von vorn gesehen. Öl auf Leinward, 59:45 cm, unten links Signum und 1858. A.: Rudolfinum, Prag, Spitzweg-Ausst. 1887, Nr. 45 aus dem Besitz des Franz Altgrafen zu Salm. Kunstverein München, Ged.-Ausst. Juni 1908, Nr. 68, aus Besitz M. Kriegl, München, m.T.: 'Heuende Mädchen.' V.: Fleischmann, München, 11./12.9.1888, Nr. 83, aus Slg. Altgraf Franz zu Salm-Reifferscheid, Prag, m.T.: 'Heuernte auf einer Gebirgswiese.' Bangel, Frankfurt a.M., 16.5.1922, Nr. 367. Cassirer-Helbing, Berlin, 3./4.3.1925, Nr. 144; Abb. Tafel 62, aus Slg. Zitzmann. V.V.: Nr. 133, im Jahre 1858 an Graf Salm-Reifferscheid verkauft, m.T.: 'Im bayerischen Hochland (Heurechende).' 1951 Privatbesitz in Aadorf (Schweiz), dann über New Yorker Kunsthandel in Slg. Max Stöhr, New York; seit Februar 1954 im Besitz von René von Schleinitz, Milwaukee." S. Wichmann, PAINTINGS FROM THE VON SCHLEINITZ COLLECTION (Catalogue), Milwaukee Art Center, 1968, No. 53, illus. 15 (color). MIRRORS OF 19TH CENTURY TASTE: ACADEMIC PAINTING; Exhibition Handlist, Milwaukee Art Center, 1974, No. 79.

157
The Morning Reading (Morgenlektüre)
c. 1860
 signed L.R.: signum
 oil on pressed board, 15 × 9 (38.1 × 22.9)
 MAC cat. no. M 1962.84
Color plate page 37

Thematically, this painting is closely related to *Reading the Newspaper in the Garden* (**154**) and is also similar to it in its range of greens in the lush foliage, and the blue of the reader's morning coat. But the ochre and bay tones of masonry here contribute to making this painting a coloristically even more varied and richer composition than the other work. Of course, the contribution of the brush stroke to the surface structure of this painting is also larger and more decisive. Finally, the anecdote here appears to be suppressed to a point where, if it exists at all, it depends wholly on the viewer's own imagination.

PROVENANCE
Collection Max Stöhr, New York.

REFERENCE
E. Kalkschmidt, Carl Spitzweg und seine Welt, Munich, 1945, illus. 15. R. von Schleinitz, "Carl Spitzweg, the Painter-Poet," The American-German Review, Oct./Nov. 1954, illus. p. 19. G. Roennefahrt, "Werkverzeichnis," in Carl Spitzweg, Munich, 1960, No. 876, illus. p. 84: "Morgenlektüre. Auf der Terrasse seines Hausgartens steht ein alter Herr hinter der die Treppe einfassenden Mauerbrüstung und liest einen Brief. Vor der Hauswand rechts (mit einigen Vogelkästen) steht ein runder Tisch mit dem Frühstücksgeschirr; auf ihm pickt eine Amsel die Krumen auf. Hinten eine Mauer mit rankendem Blattwerk und einem Brunnen. Um 1860 gemalt. Öl auf Malpappe, 38:22,5 cm, unten rechts Signum. Aus Slg. Max Stöhr, New York, über den New Yorker Kunsthandel in den Besitz von René von Schleinitz in Milwaukee, Wisc., gelangt; das Bild ist seit etwa 25 Jahren in den USA." S. Wichmann, Paintings from the von Schleinitz Collection (Catalogue), Milwaukee Art Center, 1968, No. 54., illus. 13 (color). Mirrors of 19th Century Taste: Academic Painting; Exhibition Handlist, Milwaukee Art Center, 1974, No. 80.

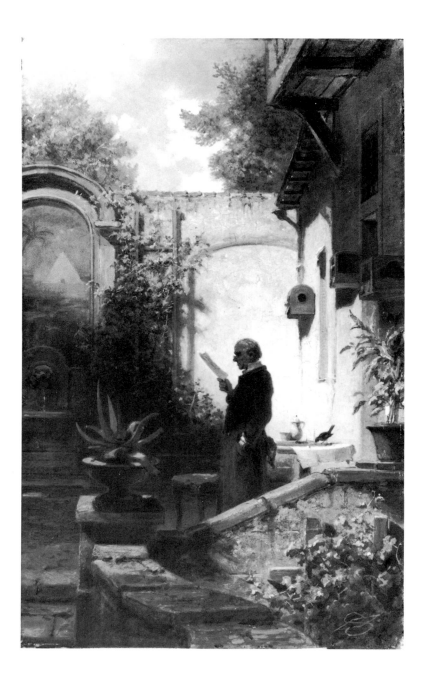

158

This Is Your World (Das ist deine Welt)

c. 1865–70

 signed L.L.: signum
 oil on paper mounted on canvas, 22½ × 13¾ (57.2 × 34.9)
 MAC cat. no. M 1962.136

As was so often the case with Spitzweg, the art market has been only too obliging in inventing ever newer and more "stimulating" titles for his works. Spitzweg's own meticulously kept *Verkaufsverzeichnis* (record of sales) lists this painting simply as *Naturforscher* (scholar of Natural Sciences). At the Helbing Auction of 1911 in Munich it was offered under the humble designation of *Scholar*. It was, no doubt, owing to Otto Bernheimer's poetic inclinations and knowledge of Goethe that the now accepted title, *Das ist deine Welt*, was coined.

 Mit Gläsern, Büchsen, ringsumstellt,

 mit Instrumenten vollgepfropft,

 Urväter Hausrat daringestopf,

 Das ist deine Welt! Das heisst eine Welt! (*Faust*)

The opinion is widespread that *This Is Your World* can be ranked among the very finest and most important paintings by Spitzweg. Although it contains objects of every description, the composition is totally unified by means of color and light. The seemingly monochromatic basic tone of the painting ranges in the field of browns from light cream all the way to raw umber with myriad shades of sand, cinnamon, bay, walnut, auburn, coffee, and tobacco tints in between. The chair upholstery is cerulean blue; various greens describe the lampshade, scholar's visor, drapery on globe, and plants in the background. Mustard ochres filter through the windows in the upper center. A tiny strip of carmine flickers under the vitrine on the right. But the *pièce de résistance* is the scholar's robe and carpet underneath his chair: crimson-magenta-rose. This painting attests the artist's pinnacle of mastering representation of the visible, objective world while simultaneously creating the most decorative, abstract-painterly rhapsodies in pure color and form.

In reading about this painting one often encounters the view that in this scholar and in the environment that he provided for him Spitzweg expressed the idea of medieval learning. Accordingly, the artist is believed to have presented here a picturesque pastiche of allusions to scholasticism allied with alchemy and even exorcism—or its reverse, diabolism—in short, a quasi-Faustian concoction. But no matter how quaint, fantastic, untoward, or, indeed, "inexact" the *mise-en-scène* may strike some viewers, I hold to a different interpretation of the picture. I recognize in it the embodiment of modern nineteenth-century sciences and the philosophy underlying their synthesis in *Naturphilosophie*.

Through the numerous objects shown in his painting, Spitzweg identifies for us the scholar's multifarious interests and thereby highlights the concept of the well-rounded nineteenth-century naturalist, metaphysicist, and philosopher in the ideal and holistic sense of, for example, a Friedrich Schelling or a Goethe. Here is an inventory of the objects and of the various branches of learning and research they symbolize: the exotic palm-like vegetation and jungle-like climbing vines in the green-house—botany; the human and ape skeletons and their highlighted skulls—anthropology, primatology, phrenology, evolutionism, darwinism; the globe—geography; the stuffed eagle—ornithology, the mechanics of flight; the funerary steles, headstones, assorted finds in the box and on the floor (at bottom left)—history, archaeology, genealogy; the coral branch (on the desk below the animal skull)—study of submarine flora, oceanography; the objects in the glass jar and the vitrine—preservation of specimens and the art of embalming; the mummy case—Egyptology, history and psychology of religious life; the crocodile (suspended from the ceiling)—zoology and the apothecary arts. Spitzweg himself was a trained pharmacist. The crocodile was once used by apothecaries (and alchemists) for curative (?) powders; in stuffed form, it later mystified and awed the gullible who visited their shops. (Compare Franz Xaver Simm's *At the Apothecary* [**151**]). Finally, the desk, books, papers, and writing stylus in the scholar's right hand symbolize the recording of scientific data, their classification into orders, their interpretation, and the dissemination of systematic learning in print.

Spitzweg completed about twenty pictures with motifs similar to this one. These paintings feature scribes, scholars, antiquarians, and bookworms in their studies or libraries (e.g., **155**). But *This Is Your World* is unique among them in terms of the range of scientifically interesting objects shown, as well as in its exhaustive iconography detailing various branches of learning. Moreover, the painting contrasts with the other, more whimsical or humorous,

presentations of their subjects in the pronounced seriousness of the scholar's absorption in his activity as well as in Spitzweg's greater earnestness in treating the composition as a whole.

PROVENANCE
Rentner Barlow, Munich. Frau M. Barlow, Munich. Konsul Otto Bernheimer, Munich. Purchased by donor at Otto Bernheimer estate sale, Adolf Weinmüller Auction Gallerie, Munich, December 9–10, 1960, Auction No. 75, Catalogue No. 83, No. 933 in cat., illus. color plate No. 157.

REFERENCE
DIE DEUTSCHE JAHRHUNDERTAUSSTELLUNG BERLIN 1906; Exhibition Catalogue, Munich, 1906, No. 1684. Gedächtnisausstellung; Exhibition, Kunstverein, Munich, 1908, No. 16. H. Uhde-Bernays, CARL SPITZWEG, Munich, 1913, illus. 78. M. von Boehn, CARL SPITZWEG, Leipzig, 1921, illus. p. 25. F. von Ostini, AUS CARL SPITZWEGS WELT, Barmen, 1924, illus. p. 32. E. Kalkschmidt, CARL SPITZWEG UND SEINE WELT, Munich, 1945, illus. 106. KUNSTVEREINS-AUSSTELLUNG; Exhibition Catalogue, , Munich, 1960, No. 100, illus. 22. G. Roennefahrt, "Werkverzeichnis," in CARL SPITZWEG, Munich, 1960, No. 1344, illus. p. 122: "DAS IST DEINE WELT. Umgeben von den Kuriositäten aus aller Welt, sitzt ein Gelehrter mit weissem Haar, im Hausrock an seinem Arbeitsplatz vor ausgebreiteten Manuskriptblättern. Öl auf Leinwand, 58,5:34,5 cm, unten links Signum. A.: Nationalgalerie Berlin, Jahrh.-Ausst. 1906, Nr. 1684, aus Besitz Frau M. Barlow, München (nur im Kl. Katalog aufgeführt). Kunstverein München, Ged.-Ausst. Juni 1908, Nr. 16, aus gleichem Besitz. Heinemann, München, 14.10.-12.11.1933, Nr. 93; ebenda September 1935, Nr. 42. V.: Helbing, München, 17.6.1911, Nr. 123; Abb. T. 24, m.T.: 'Der Geleherte,' aus Slg. Barlow, München. Besitz: Konsul Otto Bernheimer, München. V.V.: Nr. 368, im Jahre 1879 an Rentner Barlow, München, m.T.: 'Naturforscher.'" MILWAUKEE JOURNAL, Feb. 3, 1961, illus. CONNOISSEUR, March, 1961, p. 56. ANTIQUES, Nov. 1963, p. 612. S. Wichmann, PAINTINGS FROM THE VON SCHLEINITZ COLLECTION, Milwaukee Art Center, 1968, No. 55, illus. color frontispiece (detail).

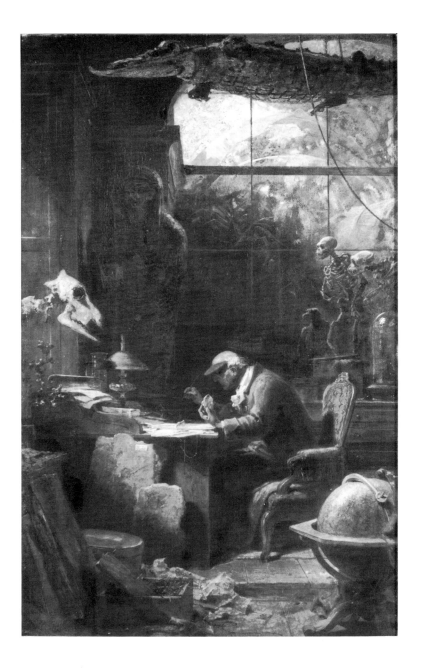

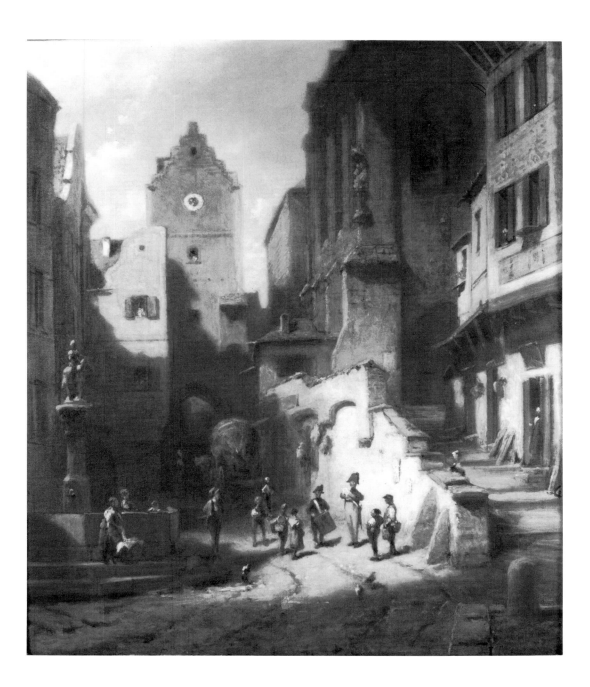

159
The Town Crier (The Announcement) (Die Bekanntmachung)
oil on canvas, 15¼ × 13 (38.7 × 33)
MAC cat. no. M 1962.80

A light-filled deep space, dramatic light-dark contrasts, an effectively luministic, light blue sky and a marvelous range of ochre, siena, khaki, manila, fallow, and umbers contribute to making this exquisite Spitzweg a feast for the eyes.

The languid small-town milieu is superbly captured. Thematically the work belongs to a larger body of works by Spitzweg comprising several dozen different versions of groups of militia guards and watchmen in cityscapes.

PROVENANCE
Spitzweg Heirs. Collection Rich. Braun, Munich. Galerie Caspari, Munich. Carl Bach, Munich. Galerie Zinckgraf, Munich.

REFERENCE
K. Kalkschmidt, CARL SPITZWEG UND SEINE WELT, Munich, 1945, illus. 34. R. von Schleinitz, "Carl Spitzweg, The Painter-Poet," THE AMERICAN-GERMAN REVIEW, Oct./Nov. 1954, illus. p. 23. DIE WELTKUNST, Vol. XV, Nov. 1956, p. 17, illus. G. Roennefahrt, "Werkverzeichnis," in CARL SPITZWEG, Munich, 1960, No. 777, illus. p. 73: "DIE BE-KANNTMACHUNG. Strassenbild mit Herold und Tambour, die vor der hellen Rampenmauer einer rechts ansteigenden Gasse stehen. Der Herold liest aus einem vorgehaltenen Blatt vor, zu seiner Rechten der kleine Trommler. Im Halbkreis um sie stehen Erwachsene und Kinder; an dem links auf dem kleinen Platz stehenden Brunnen halten Wäscherinnen mit der Arbeit inne, während dicht am Brunnen ein Zivilist nach vorn kommt. Öl auf Leinward, 39, 5:33 cm rücks. Nachlassstempel und Bestätigung eines Neffen Spitzwegs. Bis kurz vor 1900 im Besitz der Erben Spitzwegs. In dem von Eugen Spitzweg 1905 angelegten Nachlassverzeichnis unter Nr. 65, m.T.: 'Ausrufer in kleiner Stadt' aufgeführt. V.: Fleischmann, München, 29.3.1901, Nr. 40; Abb. im Katalog, m.T.: Im Namen des Königs,' aus Slg. Rich. Braun, München. 1916 von der Galerie Caspari, München, an Carl Bach, München, später durch die Galerie Zinckgraf, München, in anderen Münchner Privatbesitz verkauft, wo es bis 1945 verblieb. Jetzt im Besitz von René von Schleinitz, Milwaukee (Wisc., USA), seit 1954." S. Wichmann, PAINTINGS FROM THE VON SCHLEINITZ COLLECTION (Catalogue), Milwaukee Art Center, 1968, No. 56.

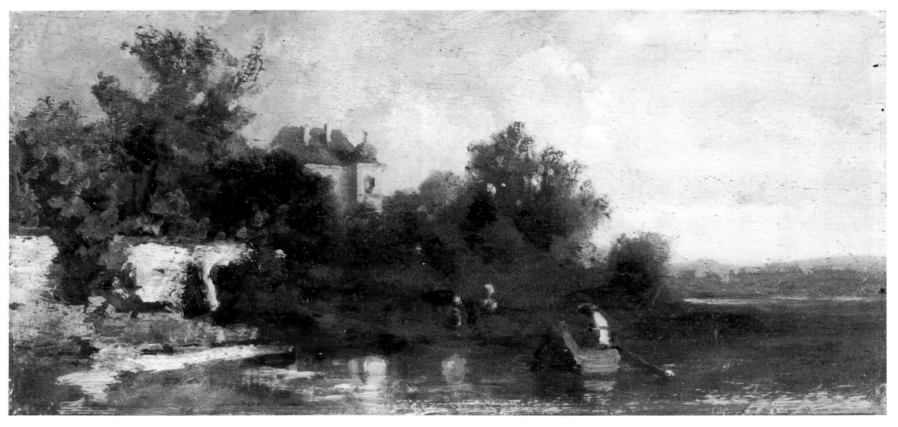

160
Garatshausen Castle (Schloss Garatshausen)
1878 (?)
 dated (with pencil, verso): 6. August, 1878
 oil on wood panel, 4 × 8¼ (10.2 × 21)
 MAC cat. no. M 1962.106

As was also the practice of his friend Eduard Schleich the Elder (see entry **136**), Spitzweg conceived his landscapes partly in terms of luminism and partly in terms of "decorative" studio practice. If anything, this exhibit suggests a greater degree of objectivity in Spitzweg's *Freilichtnaturalismus* than is present in Schleich. This work exemplifies his late style, in which an increasingly authoritative brush stroke tended to reduce his objects to macchia, i.e., to semi-abstract, boldly struck planes of color suggesting the basic structure and momentary appearance of things rather than their textures or surface details. The painting is part of a body of some one hundred or more pure land- and cityscapes by Spitzweg.

PROVENANCE
Collection Professor F. J. Meder, Munich. Helbing, Munich. Purchased by donor from Stuttgarter Kunstkabinett, R. N. Ketterer, Stuttgart, No. 327.

REFERENCE
Gedächtnisausstellung; Exhibition, Kunstverein, Munich, 1908, No. 146. G. Roennefahrt, "Werkverzeichnis," in CARL SPITZWEG, Munich, 1960, No. 39, illus.: "SCHLOSS GARATSHAUSEN. Links Ufermauer, im linken Drittel zwischen Parkgrün das Schloss. In der Mitte vor dem offenen Tor in der Mauer zwei Figuren. Ein Kahn mit einer hellen Gestalt. Hellbewölkter Himmel. Späte Arbeit. Öl auf Holz, 10:21 cm, rücks. Bleistiftnotiz: 'Carl Spitzweg 6.8.78.' A.: Kunstverein München, Ged.-Ausst. Juni 1908, Nr. 146, m.T.: 'Landschaft. Links Schlossturm und Hausgiebel.' V.: Helbing, München, 11.6.1912, Nr. 158; Abb. Tafel 40, aus Slg. Prof. Fr. J. Meder, München, m. T.: 'Garatschausen.' Ketterer, Stuttgart, 30.10.1956, Nr. 327; Abb. Tafel 18; angekauft von René von Schleinitz, Milwaukee."

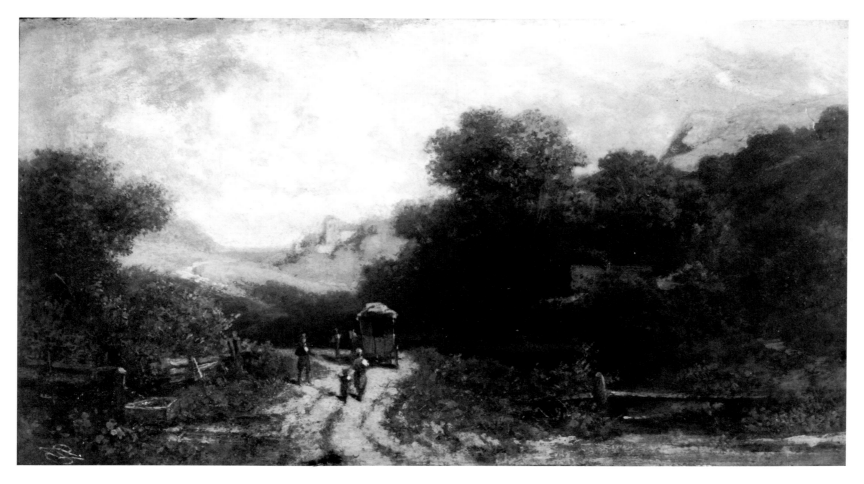

161
Travelers (Landscape with Stage Coach) (Landschaft mit Postwagen) (Fahrendes Volk)
signed L.L.: signum
oil on wood panel, 6 × 11⅛ (15.2 × 28.3)
MAC cat. no. M 1962.115

Spitzweg loved to depict travelers on their overland journeys and repeated the theme in a variety of compositions dozens of times. *Travelers* is an especially fine example of his ability to fully integrate staffage as an organic part of landscape. Although the scene appears to be drenched in sunlight, or, specifically, in the light emitted by the luminous sky, that "naturalness" is counterbalanced by a "staged" and "decorative" displacement of color (mostly umbers and terre vertes) and chiaroscuro harmonies in the best tradition of Munich *Stimmungslandschaft*.

PROVENANCE
Purchased by donor at Auction of Math. Lempertz, Kunstversteigerungshaus, Cologne, Nov. 21–25, 1957, Auction Cat. No. 448, No. 373 in cat., illus. plate No. 38.

REFERENCE
G. Roennefahrt, "Werkverzeichnis," in CARL SPITZWEG, Munich, 1960, No. 1005, illus.: "LANDSCHAFT MIT POSTWAGEN. Burg im Hintergrund. Wiederholung des Motivs von Bild Nr. 1004, überzeugt als Arbeit Spitzwegs mehr als das zuvor abgebildete Werk aus der Liechtenstein-Galerie. Öl auf Karton, 16,7:29,9 cm, unten links Signum. V.: Lempertz, Köln, 21.-25.11. 1957, Nr. 373. Besitz: René von Schleinitz, Milwaukee." MIRRORS OF 19TH CENTURY TASTE: ACADEMIC PAINTING; Exhibition Handlist, Milwaukee Art Center, 1974, No. 81.

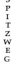

162
Mother and Child or *Interior (Mutter und Kind)*
 signed L.L.: estate stamp (signum and signature)
 oil on wood panel, 8¼ × 4 (21 × 10.2)
 MAC cat. no. M 1962.60

This probably quite late oil study is uncharacteristic because of Spitzweg's choice of motif. Conversely, it has all the salient technical and stylistic earmarks of the accomplished master. Colors: ochres, sienas, umbers, dark green accents.

PROVENANCE
Ludwigs-Galerie, Munich.

REFERENCE
G. Roennefahrt, "Werkverzeichnis," in Carl Spitzweg, Munich, 1960, No. 1459: "Mutter und Kind. In einem hohen, engen Raum mit angedeuteten Dekorationen sitzt rechts auf einer Bank eine Frau. Im Hintergrund auf einer Querbank ein Kind, eine Puppe im rechten Arm. Ölstudie auf Holz, 21 × 10 cm, unten links Nachlassstempel. Original war im September 1929 bei der Ludwigs-Galerie München, unter Nr. 794."

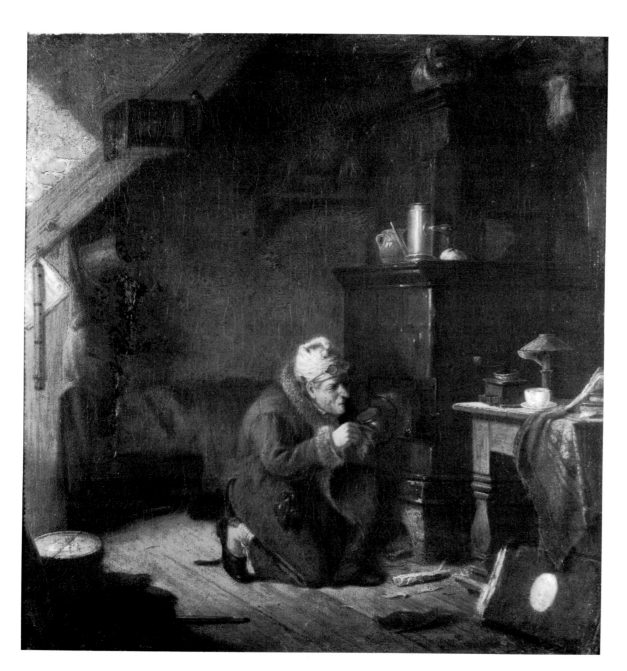

163
attributed to Spitzweg
Garret Life
 inscription L.R.: apparent remains of a signature by
 another artist
 oil on paper mounted on canvas, 15½ × 14¹⁄₁₆ (30.4
 × 35.7)
 MAC cat. no. M 1972.129

There are a few reasons militating against attribution: the motif is not "Spitzwegian," nor is the characterization of the crouching man. The painting suggests Spitzweg's early style, but appears to be too smooth and solidly layered for that, especially with respect to Spitzweg's delicate scumble technique, which is in evidence quite early on in his career. Technically, pitting deficiencies (as in the face) seem incompatible with Spitzweg's solid craftsmanship. The colors, while variegated, fail to transmit Spitzweg's characteristic sense of brio.

164
attributed to Spitzweg
Fatherly Admonishment
 oil on canvas, 10½ × 7¾ (26.7 × 19.7)
 MAC cat. no. M 1972.130

Because of its unstructured and incomplete nature
this composition appears to be a cutout from a larger
canvas. Neither an oblique architectural element
(the oriel) as the main portion of a composition nor
the stippling in evidence around faces and drapery
is characteristic of Spitzweg's style. Nor is the nearly
worm's-eye perspective. Conversely, color, light,
and the delicate gradations of umbers and cinna-
mons do suggest the hand of a very sensitive artist
here.

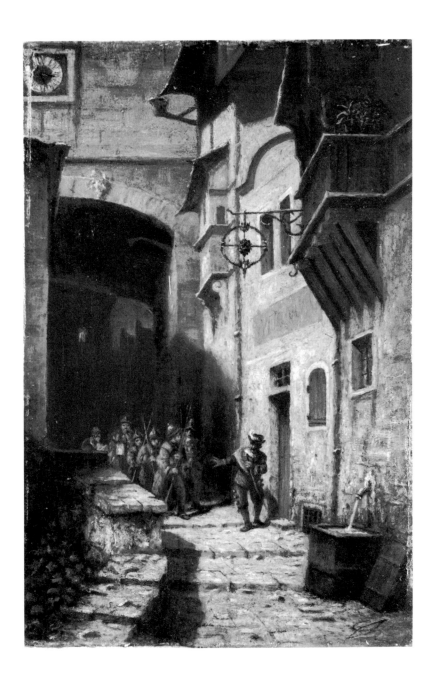

165
attributed to Spitzweg
Troops of the Watch or *Guardsmen (Die Schar-wache* [?]*)*
 signed L.R.: signum
 oil on canvas, 10⅜ × 6½ (26.4 × 16.5)
 MAC cat. no. M 1972.131

There are approximately twenty paintings by Spitzweg (featuring guardsmen in a cityscape) basically similar to this work in theme. Of these, three are nearly identical to *Troops of the Watch* (**165**) (see Roennefahrt, "Werkverzeichnis," Nos. 766, 767, 768). The exhibit is closest to Roennefahrt No. 767 (which is identical to *Scharwache*, p. 21 in M. V. Boehn, *Carl von Spitzweg*). It reveals, however, several obvious discrepancies in the inventory of objects shown. Most significantly, the muddy colors in evidence throughout this painting and, especially, the lack of a simple understanding of form (see, among other passages, the leaves in the lower left and details of architecture in the upper right) make **165** a very questionable attribution.

SPORRER, PHILIPP

b. May 1, 1829, Murnau, near Munich
d. July 30, 1899, Munich
represented at Munich

Philipp Sporrer, who taught at the Technische Hochschule in Munich after 1871, received his training in art at Albert Gräfle's School of Portraiture in that city, and from Moritz von Schwind at the Academy. Another professor of his, the frescoist and disciple of Cornelius, Philipp Foltz, influenced his taking up mural decoration. Although he did execute some frescoes (e.g., in the Old Bavarian National Museum), Sporrer was unable to establish a reputation in that field. It was rather with his graphics that he struck a responsive chord in an audience.

Of the artists of his generation, Sporrer eventually became one of the outstanding illustrators of popular storybooks and collections of songs and proverbs (e.g., *Münchhausens Reisen und Abenteuer, Deutsche Sprichwörter bildlich dargestellt,* etc.). But he is perhaps best remembered as a friend and imitator of Spitzweg (see previous Catalogue entry). Several of his small or medium-sized panels or canvases in the "Spitzwegian" manner admirably capture that master's flair for narration (see Uhde-Bernays, p. 58). But, owing to his essentially draftsmanlike temper, they are, with some exceptions, conceived less as paintings than as illustrations. (In a witty allusion to Spitzweg's practice of signing his paintings with a cipher, Sporrer signed his pictures with a "spur," the rebus for his name, which translates as "Spurmaker.")

BIBLIOGRAPHY
F. von Boetticher, MALERWERKE DES NEUNZEHNTEN JAHRHUNDERTS, Vol. II, Dresden, 1898, p. 791. DIE KUNST, Vol. XXXIII, 1916, p. 121, illus. DER CICERONE, Vol. VIII, 1915/16, pp. 141–43, illus. H. Uhde-Bernays, DIE MÜNCHNER MALEREI IM 19. JAHRHUNDERT, Vol. II, Munich, 1927, p. 58.

166
Surprised while Bathing
1892

signed L.R.: signum (a spur)
signed on reverse: Ph. Sporrer / [several
undecipherable letters, possibly] Mün. . . . 1892
oil on canvas, 7¾ × 10 (19.8 × 25.5)
MAC cat. no. M 1972.22

This little canvas is surprisingly painterly in execution and, coloristically, much more sensitive than the work of Willy Moralt (see entry in Catalogue), another follower of Spitzweg. Sporrer's economical means of generating thin veils of graduated tones (ochres, verts, blues) and his quasi-pointillist stippling method is abundantly productive for him in creating this fresh and breezy, delightful landscape with an unobtrusive anecdote.

PROVENANCE
Galerie Schöninger, Munich.

REFERENCE
S. Wichmann, PAINTINGS FROM THE VON SCHLEINITZ COLLECTION (Catalogue), Milwaukee Art Center, 1968, No. 57. (Date 1880 here is in error.) MIRRORS OF 19TH CENTURY TASTE: ACADEMIC PAINTING; Exhibition Handlist, Milwaukee Art Center, 1974, No. 83.

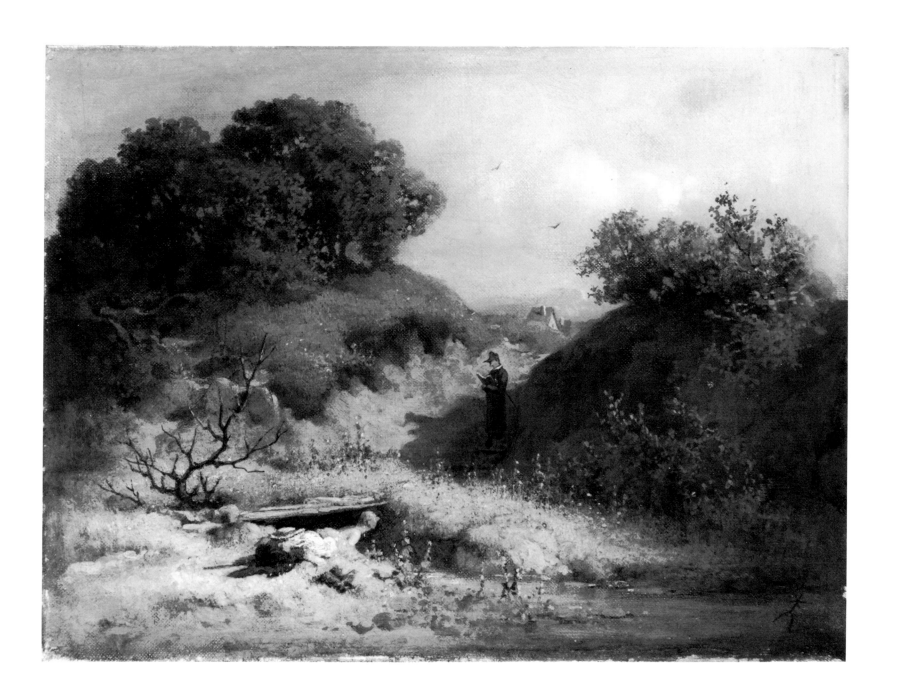

SPRING, ALFONS (ALPHONS)

b. May 18 (?), 1843, Libau, Kurland, East Prussia
d. July 14, 1908, Munich
represented at Berlin, Munich; Chicago

Another of the many pupils of the large School of Wilhelm von Diez (see entry in Catalogue) in Munich, mentioned throughout this Catalogue, was the genre painter Alfons Spring. After studies at the Art Academy of St. Petersburg, Russia, he relocated and remained in the Bavarian capital, where he received further training from Diez. He also studied the French genre painters and, in part, adopted their classically delicate technique of transparent colors. He found a steady market for his genre paintings, which feature a mixture of subjects from the life of peasants, monks, and townsfolk. Some of these works affect a brand of covert "psychological" humor reminiscent of Spitzweg (see entry in Catalogue), and occasionally he even did variations on his themes, but on the whole he failed in this endeavor. Conversely, he succeeded admirably in the painterly conception of compositions, a trait that was, no doubt, developed in him by Diez and furthermore brings to mind comparisons with Wilhelm Leibl (see entry in Catalogue).

BIBLIOGRAPHY
F. von Boetticher, Malerwerke des Neunzehnten Jahrhunderts, Vol. II, Dresden, 1898, p. 791. W. Neumann, Baltische Maler und Bildhauer des 19. Jahrhunderts, Riga, 1902. Bericht des Kunstvereins München, Munich, 1908, p. 22. Die Kunst, Vol. XXXIII, 1915/16, p. 126, illus. H. Uhde-Bernays, Die Münchner Malerei im Neunzehnten Jahrhundert, Vol. II, Munich, 1927, pp. 110, 114.

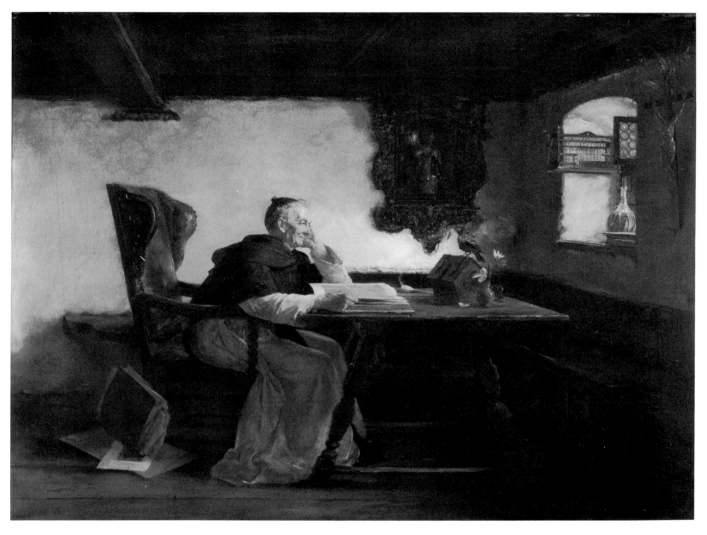

167
The Feathered Intruder
c. 1890
 signed U.R.: A. Spring / München
 oil on wood panel, 8⅛ × 10⁹⁄₁₆ (20.6 × 26.8)
 MAC cat. no. M 1972.107

"Alfons Spring depicted interiors of painterly rich-

ness done in a clear and secure style. He also did landscapes of a shimmering transparency and a certain formal significance. . . ." (H. Uhde-Bernays, p. 114). The author's views are well embodied by these two exhibits, particularly in *The Feathered Intruder* (**167**), a pleasant elaboration on Spitzweg's *A Visit* (see entry in Catalogue). But where the latter

would also liberate the abstract qualities of color and form to let them vibrate freely, independently of the motif as such, Spring's creative powers are held captive by visual reality, by the subject alone.

REFERENCE
S. Wichmann, Paintings from the von Schleinitz Collection (Catalogue), Milwaukee Art Center, 1968, No. 58.

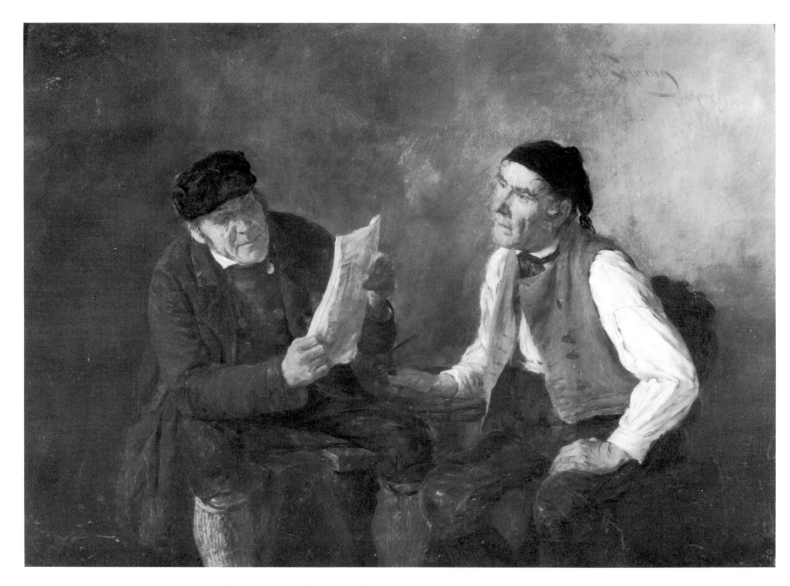

See description under entry **167**.

See description under entry **167**.

168
Reading Peasants
 signed U.R.: A. Spring / München
 oil on wood panel, 7¹¹/₁₆ × 10⁹/₁₆ (19.6 × 26.9)
 MAC cat. no. M 1971.70

REFERENCE
SELECTIONS FROM THE VON SCHLEINITZ COLLECTION; Exhibition, Paine Art Center, Oshkosh, Wisconsin, Feb. 1–20, 1972.

VAUTIER, LOUIS BENJAMIN, THE ELDER

b. April 27, 1829, Morges, on Lake Geneva,
 Switzerland
d. April 25, 1898, Düsseldorf
represented at most major German museums

The scenes that Vautier places before us are never superficially treated; he never expects us to be satisfied with the costumes in place of the characters of the people he represents; on the contrary, his figures, in their faces and in every line of detail, express their peculiar individualities with market force. . . . The wine-merchant on the Rhine differs from the beer merchant in Bavaria, and the *Spiessbürger* of a Westphalian middle city, who is happily placed between beer and wine, is again a different person. Vautier has so well hit this characteristic trait-painting that he proves himself not only to have studied closely, but that he has given rein to a natural genius for such conceptions. Moreover, he has a full vein of humor which is all his own, but he only gives way to this when it accords with the subject he represents. He is not one of those who, by reason of vanity, add to their representation their own conceits, like some actors who on the side play their own farces; but he is a true interpreter of the poet whom he represents. Just this beautiful moderation brings out the meaning of the composition as if in a concentrated light, so that the delight of originating and that of showing forth the intention must almost be united in one emotion. (W. L., *Zeitschrift für bildende Kunst*, 1866; quoted from Clement and Hutton, p. 313)

Within the limits of the goals which he had set for himself, Vautier reached the pinnacle. As with any artistic individuality who has come to the full fruition of his powers, he will maintain a place of honor in the history of German art. If the principles of art history do not lie, the reproach leveled against him by the shortsighted criticism of our times that he was more a storyteller than a painter will in future be counted among the credits to his fame. We have seen how it was precisely the "narrators" among the Florentine, Venetian, and Flemish painters of the fifteenth century, who described their contemporaries with naiveté, lack of bias, and faithfulness, who have reached such a high standing in our days because their creations are at the same time valuable records in the history of manners and morals of their century. Vautier's, as also Defregger's, paintings will claim such esteem even sooner, because he described the world, as we who are still alive can attest, with an imperishable truth not only outwardly but in its innermost essence; and this world now stands at the brink of destruction. (Rosenberg, pp. 97, 98)

None exceeded Vautier. Perhaps one or the other painter may have possessed stronger colors or may have gone deeper in the characterization of the individual figures which occasionally had become typical with him. But the tonal mood of Vautier's paintings, the peculiar well-being which they exude and of which the viewer partakes involuntarily, that feeling was and remains his studio secret. (Schaarschmidt, p. 264)

Along with Ludwig Knaus, whose close friend he was for many years, and Franz Defregger (for both see entries in Catalogue), Benjamin Vautier was one of the most celebrated genre painters of his times. The general literature on the arts frequently cites the names of these three masters as a triad in art history.

Vautier was the son of a pastor who discouraged him from planning on an artistic career, a career that, in the minds of most Swiss in those days, amounted to little more than a life of vagabondage. After attending the Gymnasium at Lausanne, Vautier relocated in Geneva, took drawing lessons from a painter named Jules Hébert, and, to make a living, apprenticed himself at an enameler's shop. Within two years he had earned enough money decorating clocks, watches, and various *objets d'art* to be able to devote himself full-time to art.

Through his contacts at the Musée Rath, where he attended life drawing classes, Vautier met some of French Switzerland's famous painters: the romantic landscapists François Diday and Alexandre Calame, the history painters Lugardon and Joseph Hornung. After brief studies with the last named, he finally found in a genre painter from Lausanne, Jacques Alfred van Muyden, a kindred soul and compatible counselor. He advised him to choose either Munich or Düsseldorf for his further training. Deciding on the latter (1850), Vautier immediately ran afoul of Wilhelm von Schadow, who dismissed his contour and chiaroscuro drawings of nudes as "useless French stuff" necessitating "starting from scratch" (Rosenberg, p. 6). Instead of doing the director's bidding, however, Vautier continued painting on his own. His luck ran well, and at the next academic competition he was admitted to the painting class by a jury of professors.

About eight months later he left the academy and received private instruction from Rudolf Jordan, a then very famous Düsseldorf painter of dramatic genre subjects from the North Sea coast. It was, above all, Jordans's close observation of nature and his original gray-scaling of atmospherics that Vautier adapted to his own purposes. However, unlike him, Vautier never forsook polychromatic local colors. On the occasion of a trip home, he met the

painter Karl Girardet who, just as had van Muyden earlier, urged him to dedicate his genre to his native country. A subsequent brief stay in Paris (1856) remained without effect on his art. He then took a German wife and settled permanently in Düsseldorf. Soon thereafter he discovered the Black Forest and Alsace-Lorraine as his artistic métier. Their folk and peasant customs were to remain for the rest of his life the dominant subject matter of all his paintings.

Vautier began to register his first successes in 1858. Interestingly, these early master works, despite their generally very favorable reception by critics, were taken somewhat to task by them for their lack of one quality, a quality for which he was later to be so highly celebrated and for which, in the usual ironic twist of fate, he was to be posthumously so severely castigated: a gripping "narrative moment." Wishing to accommodate his critics, he soon overcame that "shortcoming." And he did so with a vengeance. What followed in his life is a story of successive triumphs, a career that has few equals in the history of nineteenth-century art, either in terms of brilliance or the sustained continuity of fame.

Once Vautier had found his mature expression in the early 1860s, his art was no longer subject to further stylistic development either in terms of change or a decline into routine. He was very meticulous in preparing—Vautier was a superb draftsman—and executing his compositions, and his production was small, rarely exceeding four or five canvases per year. His peasant genre has been highly acclaimed for his ability to bring out the qualities of sincerity and informality in his subjects. For the same reasons—his intuitive understanding of the untutored mind—his many paintings of children have received the warmest praise. But his de-

tractors often claim that he did not really bring us any closer to an understanding of the peasants he painted, despite their excellent psychological interaction, because he only showed them at play, on holidays and in their Sunday best.

Because he shunned all unpleasantness, to say nothing of his aversion to serious drama, and because he assumed a slightly "superior," if gently humorous, attitude toward his subjects, Vautier has been reproached for a lack of truth in his interpretations and the genuineness of his motivations has been doubted. A further criticism is leveled against his illustrational, draftsman-like style as well as his uneventful sense of color. At no time, however, has any twentieth-century critic ever cast aspersion on his mastery in conveying the anecdotal gist, in telling a story with signal effectiveness. It is in that capacity that Vautier's contribution to art will, ultimately have to be sought. He always knew how to avoid the saccharine or trivial in his paintings, a virtue that cannot very often be claimed for the legions of his followers, who span two generations of artists.

BIBLIOGRAPHY
L. Pietsch, CONTEMPORARY GERMAN ART: AT THE CENTENARY FESTIVAL OF THE ROYAL ACADEMY OF ARTS, BERLIN, Vol. II, London, 1888, pp. 24 ff. A. Rosenberg, VAUTIER, Leipzig, 1897. F. Schaarschmidt, ZUR GESCHICHTE DER DÜSSELDORFER KUNST, Düsseldorf, 1902, pp. 258 ff., and passim. H. H. Heer, DIE SCHWEIZER MALEREI DES 19. JAHRHUNDERTS, Leipzig, 1906, pp. 70 ff. E. Waldmann, DIE KUNST DES REALISMUS UND DES IMPRESSIONISMUS IM 19. JAHRHUNDERT, Berlin, 1927, pp. 18, 19. F. Novotny, PAINTING AND SCULPTURE IN EUROPE, 1780–1880, Baltimore, 1970, pp. 169 ff., and passim.

169
The Homecoming
1881
signed and dated L.R.: B. Vautier 81
oil on canvas, 37 × 55 (94 × 139.7)
MAC cat. no. M 1962.100

A major canvas by Vautier, this rustic scene of a homecoming in a Württemberg village well exemplifies the artist's beloved peasant genre. He preferred to populate his carefully observed milieux with figures that are somewhat larger relative to the overall size of his paintings than those usually found in the works of his friend Ludwig Knaus (see entry in Catalogue). This feature, in addition to the sharp contours and naturalistic precision—a precision aided, no doubt, by photography—lends his figures a kind of *tableau vivant* urgency and counterfeit "monumentality." The dramatic and yet static ponderations of the figures seem too intense and theatrical. The muted, not to say drab, colors are scumbled throughout. One unusual aspect of this painting is the overlay of carmines in short strokes on the flesh tones. Compositionally, Vautier managed to combine here the geometric stability of an equilateral triangle (described by the two figural groups and the male figure near the top of the stairs) with a rotational "narrative" movement conveyed by the various reactions of the *dramatis personae*.

REFERENCE
S. Wichmann, PAINTINGS FROM THE VON SCHLEINITZ COLLECTION (Catalogue), Milwaukee Art Center, 1968, No. 59, illus. 24. T. Atkinson, "German Genre Paintings from the Von Schleinitz Collection," ANTIQUES, November 1969, pp. 712–16, illus. p. 712. MIRRORS OF 19TH CENTURY TASTE: ACADEMIC PAINTING; Exhibition Handlist, Milwaukee Art Center, 1974, No. 85.

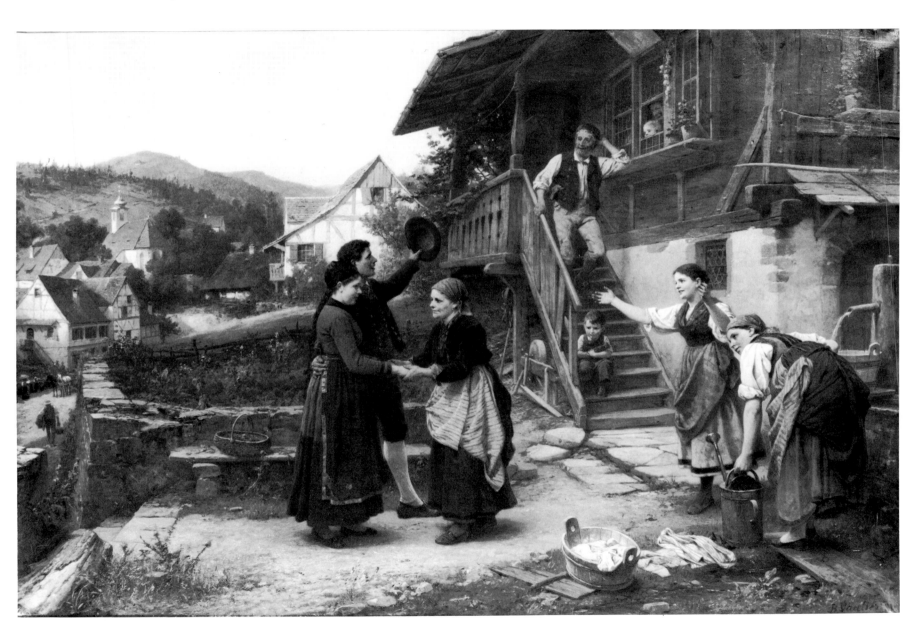

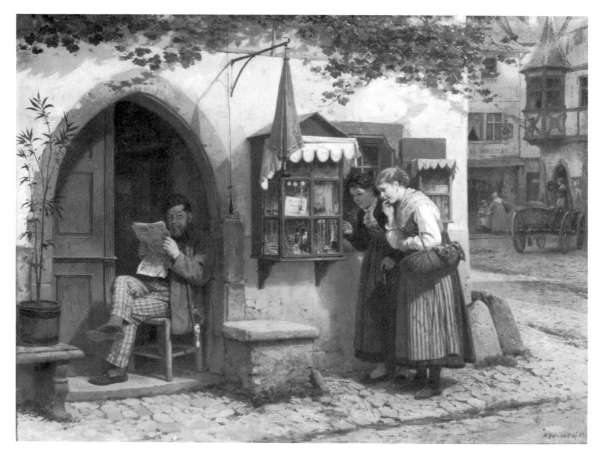

170
At the Shop Window (Am Schaukasten)
1883
> signed and dated L.R.: B. Vautier 83
> oil on canvas, 25¹⁵/₁₆ × 33½ (65.9 × 85.1)
> MAC cat. no. M 1972.115
> Color plate page 38

In this jewel of a painting we see, in a small town in the Black Forest, a little shopkeeper "who, possessing everything needed by the country folk, sits in his doorway like a spider in its web to better catch the window shoppers" (Rosenberg, p. 45) and two peasant girls eyeing the merchandise in the display case, unaware of his surveillance. A beautiful, sunny atmosphere fills this warmly patinaed, inti-

mate scene done in tones of creamy white (the masonry), browns, and grays. The umbrella suspended from the sign post provides the sole, bright red accent marker and the pivot for the composition. A flawless masterpiece by Vautier, this famous painting epitomizes the best of naturalistic narrative genre produced in the nineteenth century.

PROVENANCE
Purchased by donor at Adolf Weinmüller Auction No. 30, Catalogue No. 138, September 23–25, 1970, No. 1871 in catalogue, illus. plate No. 85.

REFERENCE
A. Rosenberg, VAUTIER, Leipzig, 1897, p. 45, illus. 34. F. von Boetticher, MALERWERKE DES NEUNZEHNTEN JAHRHUNDERTS, Vol. II, Dresden, 1898, p. 915, No. 79: "Am Schaukasten. Zwei Elsässer Landmädchen am Schaukasten eines Ladens, dessen Inhaber dieselben in Erwartung eines guten Geschäfts beobachtet. H. O,29, Br. 0,37.- Lepke's Berliner K.-Auct., 1. Dez. 84. Abb. 'Über Land u.M.', 1885." Numerous color reproductions of the painting were made. Note: The reference in Boetticher cited above is either incorrectly sized or is to a variant of this painting.

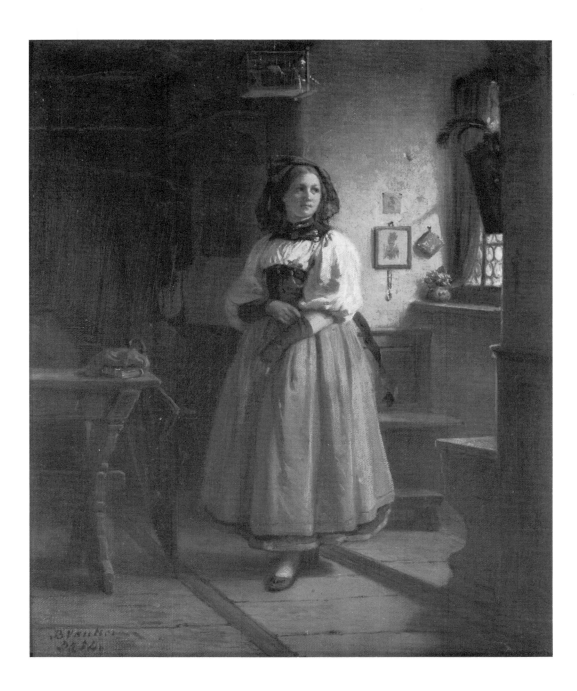

171
Ready for Church (Junge Bernerin vor dem Kirch-gang)
 signed L.L.: B. Vautier; date undecipherable,
 possibly 82
 oil on canvas, 10¾ × 9⅛ (27.3 × 23.2)
 MAC cat. no. M 1972.15

In this deceptively unassuming little composition, the first impression of humble means soon gives way to a growing fascination with the great riches of drawing, modeling, chiaroscuro, and tone bestowed upon it by the artist. A perfect Vautier, the painting is also uncommonly pure in coloration as a result of the artist's use of a French transparent layering of pigments and the contribution of the grounding to the final effect. The young woman wears the black headdress and gloves, white blouse, brown and black bodice, gray-blue skirt, and red-bordered petticoat of the traditional Sunday costume of the Bernerland.

PROVENANCE
Purchased by donor from Galerie Jurg Stuker, Bern, Switzerland, Auction No. 73/74, November 10–20, 1965, No. 73, November 13, No. 1583 in catalogue, illus., plate No. 63.

REFERENCE
S. Wichmann, Paintings from the von Schleinitz Collection (Catalogue), Milwaukee Art Center, 1968, No. 60. Mirrors of 19th Century Taste: Academic Painting; Exhibition Handlist, Milwaukee Art Center, 1974, No. 86.

172
The Red Umbrella
 signed L.L.: illegible initials
 oil on canas, 16⅜ × 13¼ (41.6 × 33.7)
 MAC cat. no. M 1972.126

This minor effort by Vautier (?) is marred by an uncharacteristically "flat" facial expression and deficient drawing (but drawing was Vautier's special forte!) and modeling of the woman's face and neck. The red umbrella in all the subdued monochromes is much too facile and obvious a device here to focus the composition. Conversely, the lively brush stroke suggests the panache of a very knowledgeable hand. An uneven painting and problematical attribution.

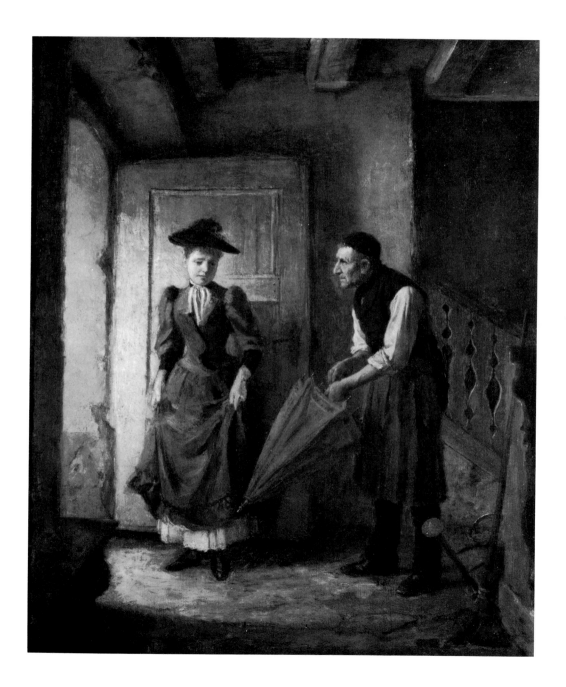

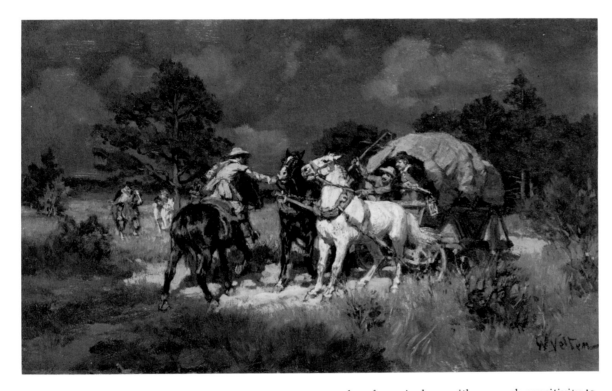

173
The Ambush
c. 1898 (?)
 signed L.R.: W. Velten
 oil on wood panel, 6 × 9¼ (15.2 × 23.5)
 MAC cat. no. M 1962.56

The Ambush represents Velten's style at its best and his subject matter at its most typical. It also exemplifies features listed in the accompanying essay. The artist's "rushed" wet and dry technique and seemingly "rough" brush stroke, resembling plas-tered surfaces, is done with so much sensitivity to form and fine draftsmanship as not to interfere with the requirements of the near-miniature format employed by him. The brio of colors (white, black, chestnut, fallows, verts, azures) and the sparkling outdoor luminism are in the finest tradition of the *Freilichtnaturalismus* of the Diez School.

REFERENCE
S. Wichmann, Paintings from the von Schleinitz Collection (Catalogue), Milwaukee Art Center, 1968, No. 61.

VELTEN, WILHELM
 b. June 11, 1847, St. Petersburg, Russia
 d. July 4, 1924, Munich
 represented at Munich; Prague

After relocating to Munich from St. Petersburg, where he had studied at the Art Academy (1867–69), Wilhelm Velten received further training (starting in 1870) at the studio of Wilhelm Diez (see entry in Catalogue). Subsequently, he followed in the footsteps of the older master in the choice of his subject matter—the hunt, horsefairs, hold-ups, etc., and, above all, scenes of riders and horses from the military camp and trek life of the Thirty Years' War—but he enlivened his mostly small-scale paintings with his own personal touches of colorism and an effective lighting technique. Velten, who settled permanently in Munich, produced historical genre paintings that skillfully blend elements of a painterly technique, acuity of observation, empathy with equestrianism, and a fine antiquarian knowledge of various historical military accessories.

BIBLIOGRAPHY
F. von Boetticher, Malerwerke des Neuzehnten Jahrhunderts, Vol. II, Dresden, 1898, p. 921. Thieme-Becker, Künstlerlexikon, Leipzig, 1907–50, Vol. XXXIV, p. 209. Der Cicerone, Vol. X, 1918, pp. 97 ff.

VOLTZ, JOHANN FRIEDRICH

b. October 31, 1817, Nördlingen,
Baden-Württemberg
d. June 25, 1886, Munich
represented at most important German museums

Friedrich Voltz, the most important member of a prominent artists' family (he was the brother of Amalie, Karl, and Ludwig, and the father of Richard), received his earliest training from his father, Johann Michael Voltz. Subsequently (winter of 1834–35), he studied at the Munich Academy. Although he was influenced by a number of other painters, he was essentially a self-taught artist who preferred roaming the Bavarian *Voralpenland* in pursuit of inspiration and nature studies *après le motif* to the remote and rarefied studio life of the city artist. Voltz made journeys to northern Italy (1843), Belgium, and Holland (1846) while painting mostly Alpine landscapes in the 1840s. From about the mid-fifties onward, he painted almost exclusively landscapes with cattle staffage set along the banks or in the immediate vicinity of Lake Starnberg, south of Munich, the locale he had chosen as his permanent working place.

In evolving his personal style, Voltz initially absorbed influences from Albrecht Adam and later from Eduard Schleich the Elder and Carl Spitzweg (see entries in Catalogue). It should be noted, however, that both of these last mentioned were in turn influenced by him. As a matter of fact, they not seldom collaborated on paintings with him. He would either paint in, or furnish them with drawings of, animals. Conversely, it is known that

Schleich would reciprocate by providing some of his paintings with sky backdrops. There can be little question that, while he was in Belgium (and certainly somewhat later on his Parisian trip), Voltz absorbed the styles of the French Barbizon painters. The example in farm animal painting set by Constant Troyon at the Forest of Fontainebleau acted as a stimulus on him to continue his own interest in that bucolic genre. The impact of Karl von Piloty's coloristic style, finally, while it was as indirect as that of Troyon, probably was also felt by him and eventually helped lead to the full liberation of his own richly saturated and deeply resonating palette.

Voltz continued a tradition of animal painting that was begun by Max Josef Wagenbauer and Johann Adam Klein in Munich. He outdistanced his contemporary Anton Braith (see entry in Catalogue) in that genre and reaped the encomium of greatest animal painter of his generation and one of the finest specialists in farm subjects anywhere in the nineteenth century. Because he invested it with "heart and soul" (but not, as had some others, with maudlin sentiment), his interpretations of bovine life strike a more profound note than those by Heinrich Zügel (see entry in Catalogue) whose impressionistic style, in part, he anticipated.

Voltz possessed

a peculiar psychological talent for animal

painting that afforded him the rare ability to empathize with the individual differentiation and even to penetrate into the inner life of the animals he depicted. This cannot be explained by any art lessons that he may have taken but only by his own native, deeply felt goodwill. . . . In his best works Voltz appears to us like a portraitist of the animal world who, through faithful observation, absorbed detail upon detail which, later on in the studio, he transformed into his effective compositions. (Uhde-Bernays, p. 74)

Voltz, who eventually became a Royal Bavarian Professor of art and received medals of high distinction, also practiced etching and lithography in his later years.

BIBLIOGRAPHY
C. E. Clement and L. Hutton, Artists of the Nineteenth Century and Their Works, Boston, 1884 (facsimile ed., St. Louis, 1969), Vol. II, p. 329. F. Pecht, Geschichte der Münchner Kunst des 19. Jahrhunderts, Munich, 1888. P. F. Schmidt, Biedermeier Malerei, Munich, 1923, pp. 106, 233. C. Gurlitt, Die deutsche Kunst seit 1800, Berlin, 1924, p. 278. H. Karlinger, München und die Kunst des 19. Jahrhunderts, Munich, 1933 (2d ed., 1966), pp. 38–41, and passim. P. Schumann, Album der Dresdner Galerie, Gemälde des 19. Jahrhunderts und der Gegenwart, Leipzig, n.d., p. 39.

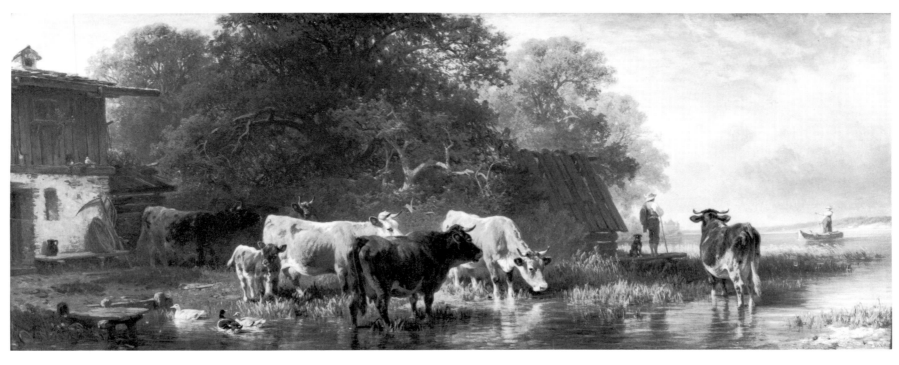

174
Cow Herd at Lake Starnberg
1871
 signed and dated L.R.: F. Voltz 71
 oil on wood panel, 13½ × 34 (34.3 × 86.4)
 MAC cat. no. M 1962.49

Of the following three exhibits (**174**, **175**, **176**) each one individually is a worthy representative of Voltz at his best as a craftsman, as a naturalistic artist portraying nature in the out-of-doors, and as an animal psychologist respectful of animal person-

ality. *Cows in Pasture* (**175**) has a particularly fine, billowy, and luminous sky suggesting perhaps Schleich's collaboration. All colors are "natural" but keyed to a green (*Cow Herd at Lake Starnberg* [**174**] and *Cows in Pasture* [**175**]), or mistbrown (*Cattle and Landscape* [**176**]) tone. The colors of the native Bavarian species—redbrown, and spotted white and tan—predominate in the cattle shown. Of all nineteenth-century painters of animals, Voltz managed most authoritatively and convincingly to create the strong impression that his animals are not pro-

jections of human psychology, of maudlin sentiment, but rather creatures, however lowly, possessing their own consciousness—distinct beings endowed with their own mute rights in God's kingdom.

REFERENCE
S. Wichmann, PAINTINGS FROM THE VON SCHLEINITZ COLLECTION (Catalogue), Milwaukee Art Center, 1968, No. 62, illus. 6.

175
Cows in Pasture
 signed L.R.: Fr. Voltz
 oil on wood panel 10½ × 9⅞ (26.7 × 25.1)
 MAC cat. no. M 1970.121

See description under entry **174.**

PROVENANCE
Mrs. John H. van Dyke, Milwaukee. Mrs. Stanley C. Hauxhurst, Milwaukee.

REFERENCE
Milwaukee Auction Galleries, 8/22/70, No. 1380 in Catalogue, illus. p. 120 (titled: "Landscape Summer with Cattle and Figure of Woman and Dog").

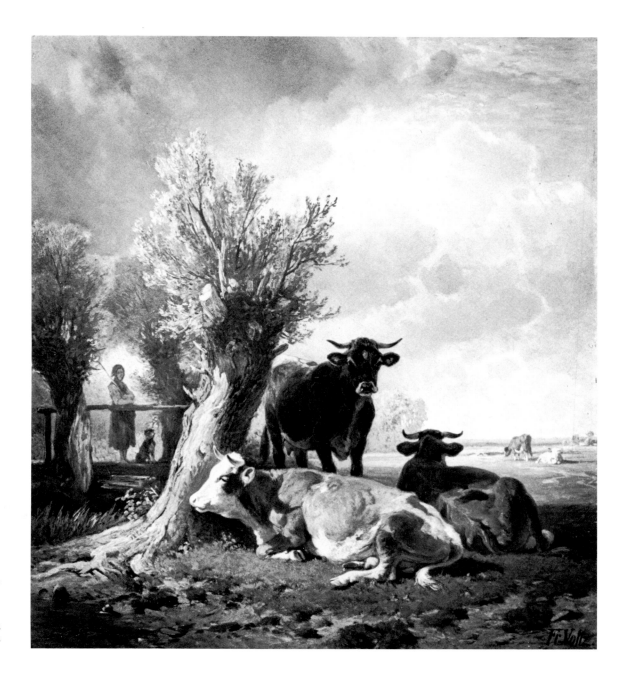

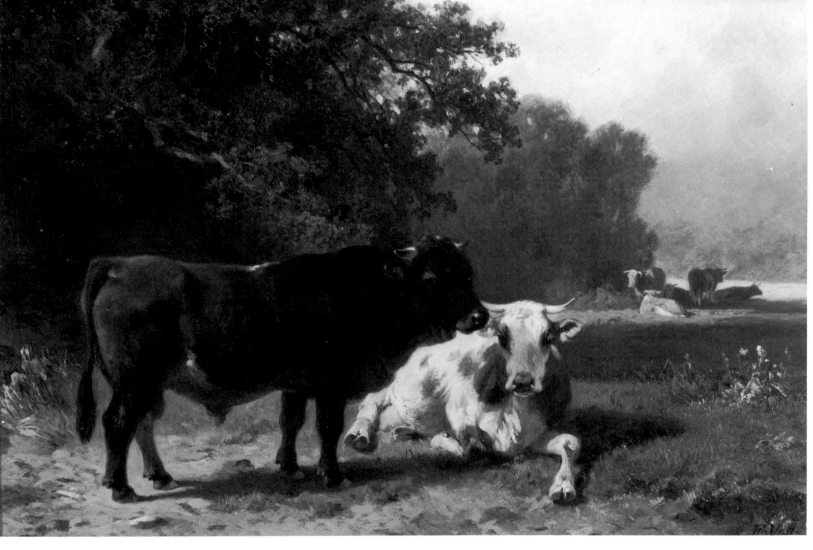

See description under entry **174**.

176
Cattle and Landscape
　　signed L.R.: F. Voltz
　　oil on wood panel, 6⅝ × 9¾ (16.8 × 24.8)
　　MAC cat. no. M 1962.49a

REFERENCE
MIRRORS OF 19TH CENTURY TASTE: ACADEMIC PAINTING;
Exhibition Handlist, Milwaukee Art Center, 1974, No. 89.

VOLTZ

WALDMÜLLER, FERDINAND GEORG

b. January 15, 1793, Vienna
d. August 23, 1865, Helmstreitmühle in der
 Hinterbrühl, near Baden
represented at most German and Austrian Museums;
 Budapest, Prague

Ferdinand Georg Waldmüller, the son of a steward, was destined to become a cleric. But he chose differently. Lessons from the flower painter Zintler enabled him to earn a small living as an illustrator of candy boxes and attend, at irregular intervals, the Vienna Academy (1807–13). Hubert Maurer and Johann Baptist Lampi were among his teachers. Waldmüller then did portrait miniatures. On the occasion of a trip to Pressburg (Czechoslovakia), Waldmüller obtained, through the good offices of Baron von Perényi, an appointment as art teacher in the house of the ruler of Croatia, Count Gyulay of Agram. After marrying the opera singer Katharina Weidner, Waldmüller accompanied her on her singing engagements in various cities while painting stage decorations. In 1817, the couple returned to Vienna and he took painting lessons from Josef Lange and Johann Nepomunk Schödlberger while copying the Old Masters at the Vienna museums.

The year 1822 saw Waldmüller make his debut at the Academic Exhibition with five paintings. In 1825 he went on his first of twenty trips to Italy. Two years later he painted, on commission of the court, a portrait of Emperor Francis I, thereby opening the way for his professorship at the Academy in 1829. The following year Waldmüller made his first trip to Paris. Strapped for funds, Waldmüller accepted an invitation from Philadelphia but got only as far as London, where he sold all of the thirty-one canvases he had taken along. He sold many of them to Queen Victoria and Prince Albert. In the last years of his life, Waldmüller received high medals of merit from the king of Prussia and the Austrian emperor. Tragically, in these same years his eyesight weakened considerably. Tossed about quite a bit during his lifetime and the decades thereafter by the torrents of criticism, Waldmüller is now universally regarded as the greatest Austrian painter of the nineteenth century and among the foremost artists of the world. As portraitist, landscape and peasant genre painter, he is comparable to and the equal of Ingres, Corot and Courbet, respectively.

Waldmüller's painted oeuvre consists of 1,016 pictures (see Grimschitz-Richter, "Oeuvreverzeichnis"). These divide mostly into portraits, landscapes, and figure compositions; still lifes make up another discrete part of his oeuvre. Of the numerous anti–academic writings on naturalistic art theory and art education published by Waldmüller, mention must be made of the following: "Das Bedürfnis eines zweckmässigen Unterrichts in der Malerei und plastischen Kunst" (1846), "Vorschläge zur Reform der österreichisch-kaiserlichen Akademie der bildenden Kunst" (1849), "Andeutungen zur Belebung der vaterländischen bildenden Kunst" (1857), and "Imitation, Reminiszenz, Plagiat. Bemerkungen über krankhafte Zustände der bildenden Kunst" (1857).

As portraitist, Waldmüller was the chronicler of Viennese *Biedermeier* society, whose values he not only faithfully reflected but, in fact, embodied. His mature portraits are jubilant paeans to spontaneity, elegance, and a sense of luxuriant materialism.

As landscape painter, Waldmüller concentrated on the *Heimatlandschaft* (native landscape), mostly from the Vienna Woods and the Salzkammergut region. In these paintings he conquered reality in nature by a unique system of staggered planes that lead into deep space, the geometric massing of forms, a volumetric solidification of sharp sunlight, and crisply defined shadows and a faithful reproduction of detail.

After about 1840, Waldmüller underwent a further significant development: he shifted his interest from the portrayal of city society to the rural *Sittenbild* (picture of morals and manners); simultaneously, he animated his figures with vigorous movement and, especially in his later years, staged his figures in the brilliantly lighted out-of-doors. It is in these paintings of everyday rural life, of peasants and their children in commonplace situations, that Waldmüller's conquest of objective reality culminates. Here his art reaches its greatest immediacy of vision, its widest universality of meaning: in the sudden movement of a playing child, in the voluptuous presence of a simple peasant girl, in the instinctive rush of gestures and telling attitudes when country folk gather, in the characteristic human interactions of daily life in the village. All figures spring to real life in a palpably real habitat of coarse dwellings, sun-drenched fields, lush, cool woods.

As an art theorist, Waldmüller's uncompromising commitment to truth and sincerity in art made him the conscience of naturalists everywhere and the mortal enemy of all academic pretension and conservatism. His painted oeuvre, spanning the epoch from Neo-Classicism to Impressionism, exhausts the full potential the style of realism was destined to achieve in the period of *Biedermeier*.

The following quotations are a sampling of views expressed by some of the foremost writers on Waldmüller and Austrian art in the nineteenth century.

> Since the end of Old German art none in Vienna painted either portraits or landscapes with such powerful realism, like that which distinguishes the works of Cranach, Altdorfer, and Wolf Huber. Waldmüller was active three centuries after these masters of the Danubian School, which discovered visible reality. As did none of his contemporaries, he reached out for universal values and showed "a great totality of the earthly visible." Doing so with a commoner's art that has a classical bent, he was representa-

tive not only of Austria but of the whole German-speaking world. The art of no other realist master immortalized the condition of civil life in the decades from 1830 to 1860 in its spiritual and material sweep so comprehensively, absolutely, and perfectly. (Grimschitz, p. 80)

Waldmüller felt a strong kinship for the people and he understood what delighted, grieved, and comforted the common folk. He observed everything compassionately and painted all masterfully. The becoming, being, and passing of natural man—the peasant—was his preferred subject matter. He evolved it in many variations and he showed how beauty is always a part of our life. (Roessler and Pisko, p. 45)

Waldmüller never enthused about eternity. He never painted an ideal picture of nature, but always only her concrete forms. Thus, he contrasted with Koch, who studied the geological and botanical details in order to construct from these fragments a representation of a "sublime nature." To be sure, Waldmüller is not always free of idyllicism, but, in the main, his genre paintings . . . do not conceal the hardships of existence. His peasant scenes differ from those of the Düsseldorf painters who praised contentment and the simple order of rural life, a state of affairs that did not, in fact, coincide with the real situation in the countryside. [In portraiture] Waldmüller utilized the formula of a sentimental English tradition that was brought into the country with Thomas Lawrence at the time of the Vienna Congress. . . . He was no soothsayer. His concept of art led him, in his portraits, to a form of behaviorism. He gives us an obviously unvarnished picture

of the middle-class society of his contemporary Vienna. (Zeitler, pp. 102–4)

Waldmüller's Prater meadows, with their magnificent blue-green harmonies, are the most beautiful painterly experiences of nature. They are perhaps even more unaffected than the pictures of the School of Barbizon. In his later genre paintings in the out-of-doors, which are so abundantly filled with light and luminous colors, though he may have occasionally polished some of his surfaces, he invented, in his own right, the method of painting *en plein-air*. (Waldmann, p. 17)

If we want to summarize it, Waldmüller's art always continued to obey the "content" and not the direct language of reality. Ideality of conception and the ideal picture in nature form the framework of fanciful *Biedermeier*. (Feuchtmüller, "Romantik, Biedermeier, Impressionismus," unpaginated)

Waldmüller must be given first place not only as the most typical of the circle, but also because, more than any other artist, he publicly proclaimed his conviction of the necessity of embarking upon new tasks. Compared with the theoretical utterances of others, Waldmüller's declarations are admirably clear. Indeed, their uncompromising nature and polemical acrimony in the end brought him many unrelenting enemies and resulted in an open breach with the Viennese academy, in which Waldmüller had been a professor since 1830. What he maintained can be summed up in a few words: the study of nature is the one and only aim of painting. In genre pictures and landscapes painted during his last years, Waldmüller certainly used on occasion a looser,

flaky technique, but this remained a relatively superficial phenomenon and made no fundamental difference to his treatment of light. The gap between this and Impressionism could not be bridged. Only in two of his last landscapes . . . are there signs of a change: in the midst of a gently veiling, pale tonality individual objects recede as they had never done before in his painting. This spirit of a new way of seeing nature touched these landscapes and pervades them with a moving, dreamy tranquility. (Novotny, pp. 110–112)

BIBLIOGRAPHY
A. Roessler and G. Pisko, Ferdinand Georg Waldmüller, Vienna, 1908, Vol. I; Vol. II contains F. G. Waldmüller's collected writing. A. Roessler, Ferdinand Georg Waldmüller, Vienna, 1912. W. Kosch, Ferdinand Georg Waldmüller, Leipzig, 1917. E. Waldmann, Die Kunst des Realismus und des Impressionismus im 19. Jahrhundert, Berlin, 1927, pp. 14, 17, 18, 195–97, 612. K. K. Eberlein, Ferdinand Georg Waldmüller, Das Werk des Malers, Berlin, 1938. B. Grimschitz, Ferdinand Georg Waldmüller, incl. Oeuvreverzeichnis by B. Grimschitz and E. Richter, Salzburg, 1957. R. Zeitler, Die Kunst des 19. Jahrhunderts, Berlin, 1966, pp. 102 ff. and passim. F. Novotny, "In Erinnerung an den Todestag Ferdinand Georg Waldmüllers am 23. August 1866," Mitteilungen d. österr. Galerie, Vol. X (1966), No. 54, pp. 41–52. R. Feuchtmüller, et al., "Romantik, Biedermeier, Impressionismus," Vom Biedermeier zum Expressionismus, Österreichische Meisterwerke aus Privatbesitz, Salzburg, 1967. F. Novotny, Painting and Sculpture in Europe, 1780–1880, Baltimore, 1970, pp. 110 ff.

177
St. Nicholas Day (Die Nikolobescherung)
1851
> signed and dated L.R.: Wald / mueller / 1851
> oil on wood panel, 25½ × 32½ (64.8 × 82.6)
> MAC cat. no. M 1962.124
Color plate page 39

Waldmüller often painted groups of country children in a domestic milieu such as this. He would often strike a fine balance between the peculiar expression, movement, and setting, on the one hand, and the typical or universal, on the other. This quality of a "classical realism" is present in the masterful *St. Nicholas Day* and lends a pronounced sense of dignity, significance, and even monumentality to this composition of "studied" casualness. The presumed "chaos" of actions and attitudes— each child is absorbed in examining or playing with the little gifts received on St. Nick's day—in fact obeys the laws of a very strict, even classical, compositional ordering: the main echelon of figures appears virtually in one plane. This "frieze" is nearly parallel to the picture plane. It describes the form of a near-pediment. The plan and elevation of the whole group, moreover, suggest the shape of a stable pyramid. A beautiful feeling of formal movement, a swelling and ebbing rhythm, unite the sixteen parts of this figural group. The architectural setting accompanies, enhances, and further orders the whole ensemble.

Sincere truth to nature combined with formal restraint, naturalism tempered by idealism, movement balanced with serenity: these are the rare qualities of Waldmüller's art, as well as of this sensitively variegated and magisterially unified masterpiece. The enamels are smooth and polished green, blue, white (clothes), neutral sand to gray (background), and crimson (several kerchiefs, drapery on left).

PROVENANCE
(Gustav Freiherr von Springer, Vienna?)

REFERENCE
HISTORISCHE KUNST-AUSSTELLUNG; Exhibition Catalogue, Vienna, 1877, No. 2921 (?). JUBILÄUMS-KUNST-AUSSTELLUNG; Exhibition, Vienna, 1898, No. 134 (?). There are two virtually identical versions of the painting. Catalogue No. 177 could be the original version and identical with No. 757 in Grimschitz "Oeuvreverzeichnis": "Die Nikolobescherung, Oel/Holz, 65 × 83 cm, Bez., u.r.: Waldmüller, 1851. Histor. Kunst-Ausst. 1877, No. 2921.-Jubil.-Kunst-Ausst. 1898, No. 134. Ehem. in der Galerie der Akademie der bildenden Künste in Wien. Unbek. Besitz". The second version is Grimschitz "Oeuvreverzeichnis" No. 758: "Die Nikolobescherung, Öl/Holz, 70 × 87 cm, Bez., u.r.: Waldmüller 1851, Wiederholung des Gemäldes vom gleichen Jahr, Nr. 757, Wien, Privatbesitz." Grimschitz No. 758 is identical with A. Roessler and G. Pisko, No. 216: "Nikolobescherung, Ölgemälde auf Holz, Höhe 70 cm, Breite 87 cm. Bezeichnet: Waldmüller 1851, Besitz: Gustav Freiherr von Springer." S. Wichmann, PAINTINGS FROM THE VON SCHLEINITZ COLLECTION (Catalogue), Milwaukee Art Center, 1968, No. 63, illus. 3. K. Strobl, "Die Sammlung von Schleinitz," KUNST IM VOLK, Nos. 3/4, 1968/69, pp. 80–87, illus. p. 82. T. Atkinson, "German Genre Paintings from the von Schleinitz Collection," ANTIQUES, Nov. 1969, pp. 712–16, illus. p. 715. MIRRORS OF 19TH CENTURY TASTE: ACADEMIC PAINTING; Exhibition Handlist, Milwaukee Art Center, 1974, No. 90.

W
A
L
D
M
Ü
L
L
E
R

178
The Interruption (Die Überraschten)
1853

> signed and dated L.C.: Waldmüller / 1853
> oil on wood panel, 25½ × 20½ (64.8 × 52.1)
> MAC cat. no. M 1962. 126

The content of this striking panel conveys a moving sense of drama. Its composition is staged for maximum visual impact. Warm sunlight and an azure sky emblazon the lovers as they follow the brilliant shaft of light to the dank vault at the foot of the steps. Even as their eyes begin to adjust to the dimness, they become aware of a looming third presence below. Scenic and psychological effects interact with and reinforce each other in this "painting within a painting" and *tour de force* of value contrasts by Waldmüller. A forceful brush stroke, rich doughy layers of paint, impasto, concrete textures, and the colors of umber and maize (masonry), dark prussian blue (lower woman's skirt), and red and green accents further distinguish this important exhibit.

PROVENANCE
Queen Victoria and Prince Albert of England; Lady Patricia Ramsey; Franz E. Loes, New York.

REFERENCE
World Exposition, Paris, 1855, No. 48. Exhibition, Buckingham Palace, London, 1856. B. Grimschitz, Ferdinand Georg Waldmüller, *Oeuvreverzeichnis* by B. Grimschitz and E. Richter, Salzburg, 1957, No. 789: "Öl/Holz, 66, 5 × 52 cm, Bez., M. u.: Waldmüller 1853. Geschenk der Königin Victoria an den Prinzgemahl Albert zu Weihnachten 1857. Weltausstellung Paris 1855, Nr. 48.—Ausst. Buckingham Palace, London 1856. New York, Franz E. Loes." S. Wichmann, Paintings from the von Schleinitz collection (Catalogue), Milwaukee Art Center, 1968, No. 64, illus. K. Strobl, "Die Sammlung von Schleinitz," Kunst im Volk, Nos. 3/4, 1968/69, pp. 80–87, illus. (color) p. 81. Mirrors of 19th Century Taste: Academic Painting; Exhibition Handlist, Milwaukee Art Center, 1974, No. 91.

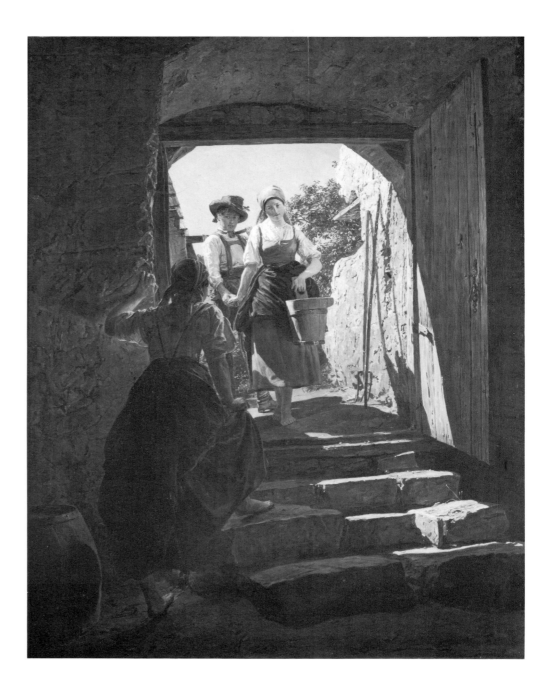

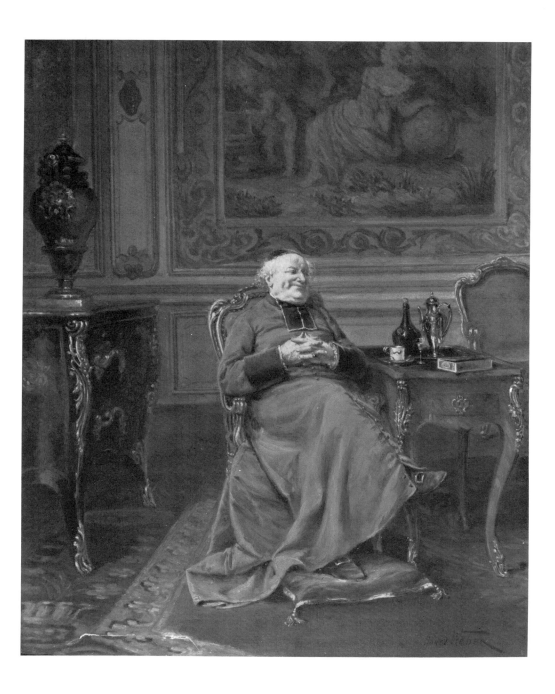

WEBER, ALFRED

b. June 8, 1859, Schaffhausen
d. unknown, but after 1913
represented in private collections

The Swiss Alfred Weber was trained under L. Pétua
and, at the Munich Academy, under the Diez (see
entry in Catalogue) pupil Ludwig Herterich and the
Piloty disciple W. Lindenschmit. He received
further instruction from the distinguished salon
painters Jules Lefebvre and Gustave-Rodolphe-
Clarence Boulanger in Paris. After 1891 Weber was
no longer active as an artist.

BIBLIOGRAPHY
C. Brun, SCHWEIZER KÜNSTLER-LEXIKON, Vol. 3, 1913.
Thieme-Becker, KÜNSTLERLEXIKON, Leipzig, 1907–50, Vol.
XXXV, p. 214.

179
The Cardinal
signed L.R.: Alfred Weber
oil on wood panel, 13¹³/₁₆ × 10½ (35.1 × 26.7)
MAC cat. no. M 1962.108

Vitriolic accents (cardinal red robes, emerald foot
pillow) against more mute shades (green and ochre
wall and floor), fuzzy modeling, fussy details, and
an unpleasantly virulent characterization do not en-
rich this self-conscious little panel by a minor
painter.

WERNER, ADOLF FRIEDRICH

b. May 26, 1827, Frankenmühle, near Hirschfeld,
District Elsterwerda, Saxony
d. August 23, 1904, place uncertain [Dobrilynk?]
represented in private collections

Adolf Werner, a minor genre painter, was active in Düsseldorf and exhibited at the Berlin Academic Shows after 1864. Werner received his training at the Dresden Academy and then, still in that city, from the Düsseldorf-trained Adolf Ehrhardt and the Nazarene history painter Eduard Bendemann. Finally, he studied at the academy of Antwerp. Werner never really evolved the distinguishing traits of a personal style but was, however competent technically, a rather bland eclectic who synthesized elements from Bendemann (in his atmospherically conceived romantic landscapes) and, in his historical genre, the detail of the Little Dutch Masters, the colorism of the modern Belgian School, and the flair for theatrical staging of the School of Düsseldorf in general.

BIBLIOGRAPHY
VERZEICHNIS DER BERLINER AKADEMISCHEN AUSSTELLUNG (Catalogue) Berlin, 1864, p. 67. H. A. Müller and H. W. Singer, ALLEGEMEINES KÜNSTLERLEXIKON, Vol. V, Frankfurt, 1901. Thieme-Becker, KÜNSTLERLEXIKON, Leipzig, 1907–50, Vol. XXXV, p. 402.

180
The Two Art Lovers (The Antique Dealer) (Die Beiden Kunstliebhaber)
c. 1876 (?)
signed L.L.: A. F. Werner
oil on panel, 18 × 13¹³⁄₁₆ (45.7 × 35.1)
MAC cat. no. M 1962.81

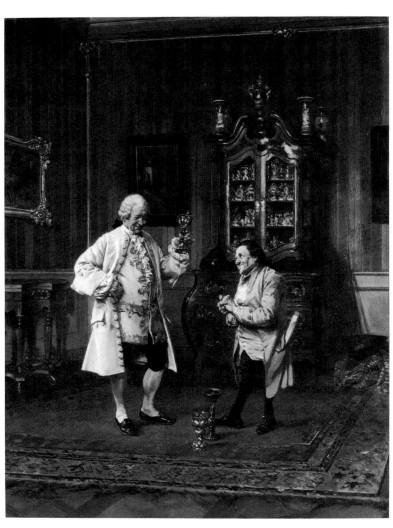

A very fine example of Werner's eclectic method. Lively staging, telling characterization, a flair for decoration, and his "scientific" understanding of the effect of light on objects lend vigor, charm, and a very sharp, three-dimensional or "stereoptic" effect to this little panel. The colors are very ornate. The left figure, costumed in a cream-colored coat with red decoration on his vest, contrasts with and complements the gray of the dwarf's coat. A mint-and-silver striped wallpaper enhances the sophisticated color ensemble here. The title *The Antique Dealer* (as listed in both Wichmann and *Mirrors*; see below, under Reference) paraphrases most tellingly the meaning of the action: a servile antique merchant (the dwarf) rubs his hands in gleeful anticipation of the sale of a goblet to an aristocrat.

REFERENCE
S. Wichmann, PAINTINGS FROM THE VON SCHLEINITZ COLLECTION (Catalogue), Milwaukee Art Center, 1968, No. 65. MIRRORS OF 19TH CENTURY TASTE: ACADEMIC PAINTING; Exhibition Handlist, Milwaukee Art Center, 1974, No. 92.

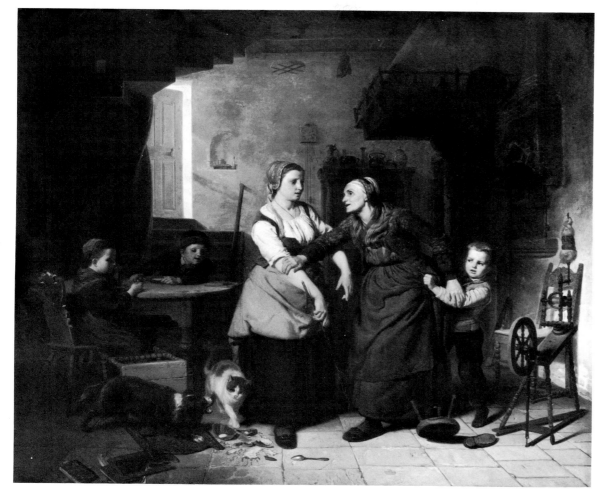

181
The Protective Grandmother
 signed L.L.: F. Wieschebrink / Düsseldorf
 oil on canvas, 30 × 35 (76.2 × 88.9)
 MAC cat. no. M 1962.111

Excellent craftsmanship and an amiable knack for storytelling with images but a lack of creative independence or originality as artist characterize these two affectionate works by Wieschebrink (**181**, **182**)

done in the manner of Vautier (see entry in Catalogue). *The Protective Grandmother* (**181**), a major Wieschebrink, is toned green and accented with victoria blue, crimson, and maize. *Good Friends* (**182**) is toned to mist brown and highlighted by crimson and naphthol emerald.

REFERENCE
S. Wichmann, PAINTINGS FROM THE VON SCHLEINITZ COLLECTION (Catalogue), Milwaukee Art Center, 1968, No. 66.

WIESCHEBRINK, FRANZ
 b. March 14, 1818, Burgsteinfurt, near Münster,
 Westphalia
 d. December 13, 1884, Düsseldorf
 represented at Münster; Breslau, Trieste

After studying at the Düsseldorf Academy (1832–40), Franz Wieschebrink made his artistic debut with biblical subjects. He then turned his attention and talents to humorous genre, depicting the family life of peasants and artisans, and especially scenes of children. In the course of his career he acquired a fine reputation as illustrator for such journals as the *Düsseldorfer Monatsblätter*. Wieschebrink's technical abilities as painter were of the highest quality, and they compare very favorably with those of the best genre painters of his time—a Defregger or a Knaus (see entries in Catalogue). But in the final analysis it cannot be denied that "he traveled in the entourage" of Vautier (see entry in Catalogue), of whose hugely successful style his seems to be a sentimentalized reflection.

BIBLIOGRAPHY
W. Müller von Königswinter, DÜSSELDORFER KÜNSTLER, Düsseldorf, 1854. A. Rosenberg, GESCHICHTE DER MODERNEN KUNST, Vol. II in Deutsche Kunst, 2d rev. ed., Leipzig, 1894, p. 442. F. von Boetticher, MALERWERKE DES NEUNZEHNTEN JAHRHUNDERTS, Vol. II, Dresden, 1898, pp. 1014, 1015.

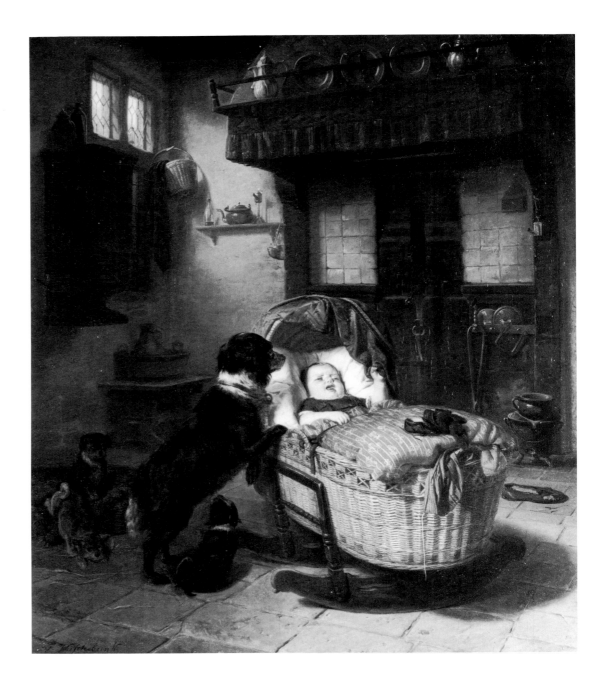

182
Good Friends (The Best of Friends)
 signed L.L.: F. Wieschebrink
 oil on canvas, 24³/₁₆ × 21³/₈ (61.4 × 54.3)
 MAC cat. no. M 1970.118

See description under entry **181**.

PROVENANCE
Balaban and Katz Management Corp.; purchased by donor
at Chicago Art Galleries, Auction No. 13, May 13, 1970,
illus. in catalogue.

WOPFNER, JOSEPH

b. March 19, 1843, Schwaz, near Innsbruck, Tyrol
d. July 23 (22 ?), 1927, Munich
represented at Lübeck, Munich; Prague, Zurich;
 private collections

As a youth, Joseph Wopfner worked for his father as a baker while sculpting on the side. He then went off to Munich (1860), where he first took up house painting and, thereafter, the lithographer's trade. In 1864 he enrolled at the Munich Academy and five years later was admitted to Karl von Piloty's master painting class. He remained there until 1872 while simultaneously taking lessons from Eduard Schleich the Elder (see entry in Catalogue). Wopfner, who stood on friendly terms with Wilhelm Leibl, preferred to concentrate his attention on small-scale landscapes from the Chiemsee region of Upper Bavaria. He habitually combined views of the countryside with seascapes while fully integrating his genre staffages to the requirements of the nature prospect at hand and subordinating all to his dramatic sense of handling natural light.

Unfortunately, Wopfner wasted a lot of time repeating his compositions, some of them dozens of times (!) because a ready and eager market awaited them. Furthermore, he restricted his thematic repertory too much. These limiting circumstances prevented him from ever realizing the full potential of his superb talent.

BIBLIOGRAPHY

L. Pietsch, CONTEMPORARY GERMAN ART: AT THE CENTENARY FESTIVAL OF THE ROYAL ACADEMY OF ARTS, BERLIN, Vol. II, London, 1888, pp. 78 ff. F. Pecht, GESCHICHTE DER MÜNCHNER KUNST DES 19. JAHRHUNDERTS, Munich, 1888. F. von Boetticher, MALERWERKE DES NEUNZEHNTEN JAHRHUNDERTS, Vol. II, Dresden, 1898, p. 1038. H. Uhde-Bernays, DIE MÜNCHNER MALEREI IM NEUNZEHNTEN JAHRHUNDERT, Vol. II, Munich, 1927, pp. 202, 203. H. Karlinger, MÜNCHEN UND DIE KUNST DES 19. JAHRHUNDERTS, Munich, 1933 (2d ed., 1966), p. 60. DIE WELTKUNST, Vol. XIV, 1940/41, p. 60.

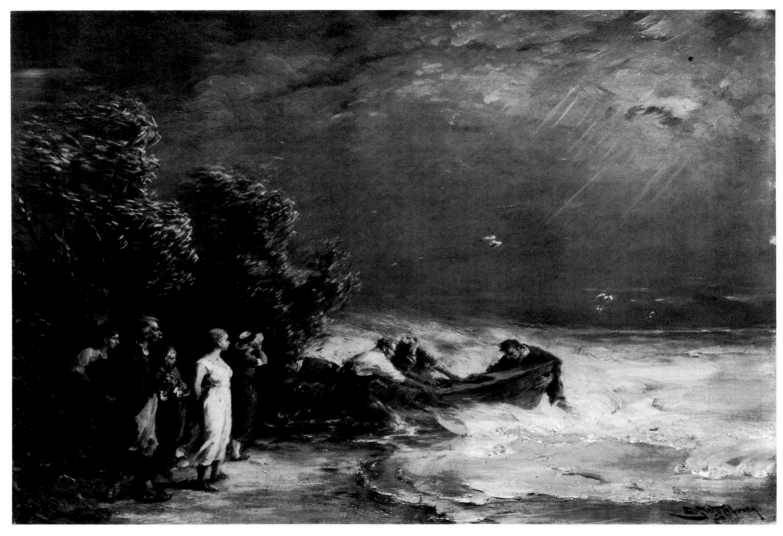

183

Storm on Lake Chiem (Sturm am Chiemsee)
 signed L.R.: J. Wopfner
 oil on wood panel 12¾ × 18 (32.4 × 45.7)
 MAC cat. no. M 1970.112

268 It is true that Wopfner's excellent powers of observ-

ing and recreating natural color and lighting condi-
tions are in evidence in the sulphurous yellow-
greens of the surf, the graduated slate grays of the
sky, and the electric incandescence of this stormy
scene. Conversely, his all too facile brush stroke
does not enrich the structure, nor do his careless

drawing and modeling augment the painting. In the
final analysis it must be regarded as journeywork.

REFERENCE
SELECTIONS FROM THE VON SCHLEINITZ COLLECTION; Ex-
hibition, Paine Art Center, Oshkosh, Wisconsin, Feb.
1–20, 1972.

ZIMMERMANN, ERNST KARL GEORG

b. April 24, 1852, Munich
d. November 15, 1901, Munich
represented at Dresden, Hanover, Leipzig, Munich,
 Stuttgart, Wiesbaden, Würzburg; Chicago,
 Zurich

"Romantic and yet strong, realistic and yet, on occasion, open to tender moods, Ernst Zimmermann, painter of genre and still lifes but, above all, the most excellent portraitist among the pupils of Diez [see Catalogue], stood at the head of that school" (H. Uhde-Bernays, p. 110). From his father and first teacher, the popular portraitist and painter of humorous genre Reinhold Sebastian Zimmermann, Zimmermann inherited a penchant for wit in art. Studies at the Munich Academy (beginning in 1868) under Strähuber and Anschütz prepared him for work in the studio of Wilhelm von Diez (1870–72; see entry in Catalogue). Extensive travel in the 1870s to Italy (especially Venice), Vienna, Paris, Holland, and Belgium rounded out his artistic education, notably his skills in colorism. During those years Zimmermann perpetuated his father's bequest: humorous genre. But, following the success of his *Christ in the Temple* (1879), he specialized more and more in religious works; portraits, landscapes, still lifes and genre remained subsidiary interests of his. Zimmermann, who exhibited regularly at the Munich Glaspalast shows, became a professor (1886) and honorary member (1887) of the Academy.

Zimmermann's gift of penetrating to the deeper layers of human psychology through wit and his significant contribution to the evolution of Munich's humorous genre have been recognized (see Wichmann). His renewal of modern religious art with realistic representations of Jesus (see Pietsch, p. 89), his Rembrandtian depth in the conception of interior spaces, and the mystery inherent in his portraits have been noted (see Uhde-Bernays, pp. 110 ff.); the similarity of his figural compositions and portraits to those of Wilhelm Leibl have been observed (see Thieme-Becker, *Künstlerlexicon*, Vol. XXXVI, p. 509).

Yet there remains a further dimension to Zimmermann's art that seems to have escaped attention. And that is his painterly vigor, effective use of black, broken and gestural brushwork, closed forms, and caricaturistic "shorthand" in his facial characterizations. Regardless of his basic realism, he experienced reality as a product of abstract notations of color. His distortions of forms and his conception of them as quasi-abstract color ciphers—qualities he shares with Lovis Corinth, for example—are a clearly visible part of some of his paintings. All these attributes anticipate, however unconsciously, Expressionism.

BIBLIOGRAPHY
L. Pietsch, CONTEMPORARY GERMAN ART: AT THE CENTENARY FESTIVAL OF THE ROYAL ACADEMY OF ARTS, BERLIN, Vol. I, London, 1888, pp. 87 ff. F. Pecht, GESCHICHTE DER MÜNCHNER KUNST DES 19. JAHRHUNDERTS, Munich, 1888. F. von Boetticher, MALERWERKE DES NEUNZEHNTEN JAHRHUNDERTS, Vol. II, Dresden, 1898, pp. 1056–57. KUNSTCHRONIK, New Series, Vol. XIII (1902), p. 109. A. Graves, THE ROYAL ACADEMY OF ARTS, No. 8 (1906); A CENTURY OF LOAN EXHIBITIONS, No. 4 (1914). H. Uhde-Bernays, DIE MÜNCHENER MALEREI IM NEUNZEHNTEN JAHRHUNDERT, Vol. II, Munich, 1927, pp. 110 ff. KATALOG DER AUSSTELLUNG "GEMÄLDE DER MÜNCHNER SCHULEN VOM BEGINN DES 15. JAHRHUNDERTS BIS ZUR GEGENWART," Aug./Sep. 1929, Galerie Helbing, Munich, illus. with 2 plates. H. Karlinger, MÜNCHEN UND DIE KUNST DES 19. JAHRHUNDERTS, Munich, 1933 (2d ed., 1966), p. 59.

184
The Tippler
c. 1880 (?)
 signed U.R.: E. Zimmermann
 oil on wood panel, 10¹/₁₆ × 7¾ (25.6 × 19.7)
 MAC cat. no. M 1962.76

A minor but very fine miniaturist panel in what
superficially looks like the manner of Hals. Scrutiny
reveals, however, that something a bit more com-
plex than the Dutchman's impressionistic approxi-
mation or perceptual illusionism is at work here.
Zimmermann's small brush stroke, which is at once
agitated, layered, and crystalline, models form as it
structures the matière. Far from being "dashed off"
in speedy, cavalier fashion, the strata of pigments
have great depth, subtlety, and nuance. Characteri-
zation—it is telling and affective—coexists with the
autonomy of colored bits of form. (Black vest and
trousers, white shirt, black to chestnut jacket, crim-
son cap, red feather, gray scumbled cinnamon back-
ground, gray pewter.)

PROVENANCE
Galerie Zincgraf, Munich (No. 21977).

REFERENCE
S. Wichmann, PAINTINGS FROM THE VON SCHLEINITZ COL-
LECTION (Catalogue), Milwaukee Art Center, 1968, No. 67,
illus. 31.

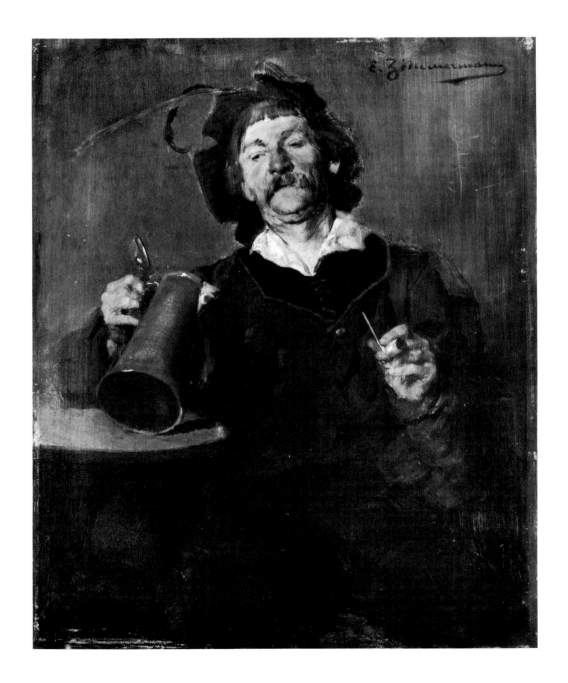

ZÜGEL, JOHANN HEINRICH VON

b. October 22, 1850, Murrhardt, Württemberg
d. January 30, 1941, Munich
represented at nearly all German museums;
Bucharest, Buffalo, Chicago, Cincinnati,
Florence, Montreal, New York, Philadelphia,
Prague, Trieste, Vienna, Venice

The name Zügel is inseparably linked with the great rise of our modern art since the decade of the 1870s. Like a giant endowed with primordial powers, he resisted gloriously and steadily all evolutions and revolutionary experiments. He followed the lonely path assigned him by fate, undaunted by the deceptions of his times. In the narrower sense animal painting celebrates with Zügel its resurrection. (Biermann, pp. 113, 114)

Here begins the original province of the painter who is not beholden to lines but involved with color. Zügel was deeply moved by the painterly Eros who, once he has taken possession of you, never lets you go. Zügel learned more and more how to see variations of the same basic colors which were unknown to the eye before. He learned to comprehend how colors change under the influence of the atmosphere: how they differ in their appearance under cloudy skies or sunlight, in calm weather or in a storm, in dry air or rain. He knew how colors constantly change, depending on how they receive and reflect light. Zügel was a pathfinder of art, a magician in the realm of the elements and of light, a mediator of noble creativity. (Rohnert, pp. 56, 132)

Among the leaders of the Secessionist movement, Zügel was the outspoken representative of Impressionism. . . . He pursued the impastoed delivery of the Impressionists and had a special liking for broad light effects whose many-colored nature is intensified by a brownish-violet that he modified progressively toward reddish tonalities. Violence of move-ment, preference for frontality, experiments in colors that resulted from year to year in stronger effects—these qualities led toward the height of Zügel's art. (Uhde-Bernays, pp. 260, 261)

Heinrich Zügel is regarded by most critics as the most important German painter of animal subjects in the nineteenth century. He stood at the conclusion of a development in that genre in the Munich School, a development that began with Wagenbauer and Klein, continued with Bürkel, spanned the oeuvres of Hartmann and Gebler, as well as of Zügel's fellow Swabians Jutz and Braith, and crested in Voltz. (For the last six artists, see entries in Catalogue.) But Zügel went beyond all of them by divesting the subject of farm animals of all sentimental, anecdotal, "psychological," and (ultimately) "dramatic" inflections and presenting it as a purely painterly and formal problem. In short, he went beyond the last stages of the novelistic Munich tradition as well as beyond the most refined phase of studio realism practiced in the 1870s. He became an Impressionist. As such he was, however, more concerned with the structural qualities of color than with the nuances of reflected light.

Zügel was the son of a fairly well-to-do sheep farmer and, from his childhood on, felt a deep love for and interest in all kinds of animals, particularly cows and sheep. On the strength of drawings he had submitted, he received a state scholarship and was admitted to the Stuttgart Academy (1867–69). Neher and von Rustige were among his teachers. After he relocated in Munich, Zügel stood on friendly terms with practically all the studios there but was drawn most closely to that of Anton Braith, from whom he received some informal instruction. In the final analysis, however, Zügel was a self-trained artist. As early as 1873 he received his first silver medal (Vienna); subsequently, he was to garner a total of fourteen gold medals at various European exhibitions, in addition to innumerable lesser medals, distinguished state honors, and a professorship. He received the patent of nobility in 1907.

Zügel's early period falls within the stylistic perimeter of the painterly realism of the Munich School. His sense of objectivity in that tradition climaxed in the early seventies. On the one hand, his style at that time was indebted to Diez (see entry in Catalogue), while, on the other, it anticipated Leibl (see entry in Catalogue) at his most accomplished. But further experimentation with painterly refinements led Zügel in the later eighties away from pleinairism and toward Impressionism. (His trip to Paris in 1887 and stay in the Low Countries in 1890 must have served as confirmations of his sense of direction.) Subsequently, his paintings became increasingly centered in problems of color and form. Progressively, his compositions resulted in structures of color, patchwork systems of flat color plains.

The natural movement of animals and that of light became increasingly an integral part of the abstract movement of the elements of form for Zügel. Ultimately, however, he did not forsake his basic sense of three-dimensional space or, for that matter, of the volume of objects, however abstract his handling of these properties became in his later years. Zügel, who painted before the motif and *en plein-air*, also sketched continually, and his drawings of house and farm animals in the out-of-doors are masterful. He was a highly regarded teacher and his many students span two generations of artists.

BIBLIOGRAPHY
C. E. Clement and L. Hutton, ARTISTS OF THE NINETEENTH CENTURY AND THEIR WORKS, Boston, 1884 (facsimile ed., St. Louis, 1969), Vol. II, p. 372. G. Biermann, H. VON ZÜGEL, Leipzig, 1910. O. Fischer, SCHWÄBISCHE MALEREI DES 19. JAHRHUNDERTS, 1925, pp. 74 ff. H. Uhde-Bernays, DIE MÜNCHNER MALEREI IM NEUNZEHNTEN JAHRHUNDERT, Vol. II, Munich, 1927, pp. 261 ff., and passim. H. Karlinger, MÜNCHEN UND DIE KUNST DES 19. JAHRHUNDERTS, Munich, 1933 (2d ed., 1966), pp. 58, 78, 81. E. T. Rohnert, HEINRICH VON ZÜGEL, EIN MALERLEBEN, Berlin, 1941. E. Diem, HEINRICH VON ZÜGEL, LEBEN, SCHAFFEN, WERK, Recklinghausen, 1975.

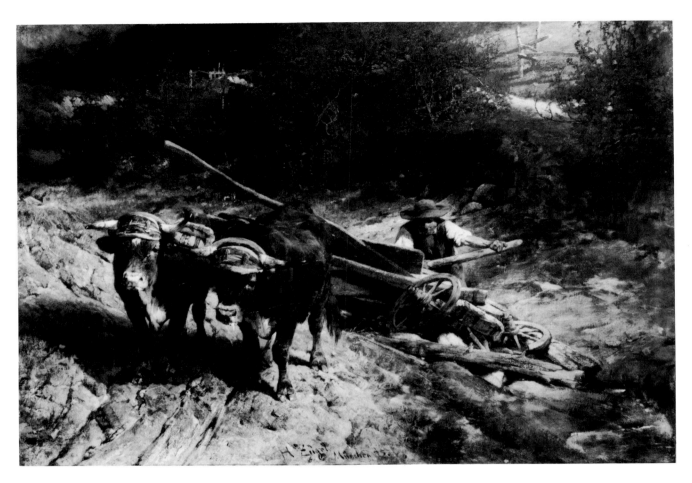

185
The Overturned Oxcart (Der umgestürzte Karren)
1875
 signed and dated L.C.: H. Zügel / München 75
 oil on canvas, 18¾ × 26½ (47.6 × 67.3)
 MAC cat. no. M 1967.68

The Overturned Oxcart shows us Zügel at the height of his early period, his painterly realism of the Munich School. Although color is used objectively here—i.e., to describe form first and foremost—the canvas also reveals clues to the artist's later habit of *structuring* form out of color. But the warm lighting and dark permutations of green and brown still adhere very much to the decorous practices of the grand studio tradition of Munich.

PROVENANCE
Purchased by donor at Weinmüller, Munich, Auction No. 101, Catalogue No. 109, Sept. 28–30, 1966, No. 1359 in Catalogue, illus. color plate No. 3.

REFERENCE
Most likely F. von Boetticher, MALERWERKE DES NEUN- ZEHNTEN JAHRHUNDERTS, Vol. II, Dresden, 1898, p. 1064, No. 23: "Landschaft mit einem Bauern, der den umgestürzten Karren seines Ochsengespannes aufzurichten sucht. h. 0, 49, br. 0, 67.-Lepke's Berl. K.-Auct., 20, Nov. 23." S. Wichmann, PAINTINGS FROM THE VON SCHLEINITZ COLLECTION (Catalogue), Milwaukee Art Center, 1968, No. 69, illus. 29 (color). To LOOK ON NATURE: EUROPEAN AND AMERICAN LANDSCAPE, 1800–1874; Exhibition Catalogue, Dept. of Art, Brown University, Rhode Island School of Design, 1972, pp. 53–54, illus. 14, p. 65. E. Diem, "Werkverzeichnis," HEINRICH VON ZÜGEL, LEBEN, SCHAFFEN, WERK, Recklinghausen, 1975, No. 150, illus.

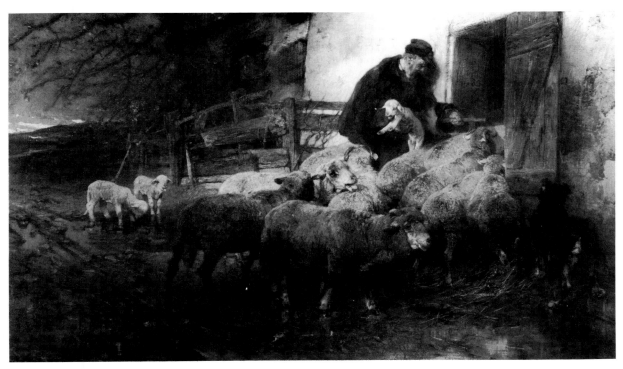

186
The Shepherd's Return
1882
 signed and dated L.L.: Heinrich Zügel / München
 1882
 oil on canvas, 15 × 26 (38.1 × 66)
 MAC cat. no. M 1962.62
Color plate page 40

"A mysterious force, painterly beauty in concert with formal clarity, a sensitivity to the infinite gradations of light, an incorruptible eye for the simple processes in the life of animals: these traits distinguish Zügel" (Diem, p. 9). These traits also characterize this exhibit, in which Zügel's creative powers appear fully matured in the course of his second stylistic period. It exemplifies a degree of refinement in his pleinairism that eventually led to the final phase of his development, namely his important

contribution to Germany's *Sonderimpressionismus.* Zügel's depiction of animals here is not sentimental, as it still is in Braith or Gebler (see entries in Catalogue), for example. Nor is it concerned with an objective psychology of animals as it is in Voltz (see entry in Catalogue). Rather, it would seem, the animal has become for Zügel an atavism. However compelling to his subconscious mind the subject may have been, the animal in his paintings really acts merely as a passive vehicle—any object in nature could have served him as well—for the distillation of purely painterly mysteries, the solution of purely artistic problems: form as function of color, color as function of light, light as function of atmosphere.

The paint layers of this canvas are thin but highly variegated. The visible gesture of the brush stroke is expressive of a long habit of "thinking in color," of

comprehending and visualizing and communicating in the language of color. The sheep and turf tones range from white to black with innumerable shades of beige, fallow, bay, and brown in between. The white to gray range is visible in the wall and sky; very sparing accents of vert and red. Zügel painted numerous versions of this motif in the late 1870s and 1880s. Close variants of *The Shepherd's Return* (**186**) appear in Diem (see "Werkverzeichnis," No. 205) and Rohnert (ibid., No. 40).

REFERENCE
"Malerei deutscher Meister des 19. Jahrhunderts in Milwaukee," DIE WELTKUNST, Vol. XV, Nov. 1956, p. 17, illus. S. Wichmann, PAINTINGS FROM THE VON SCHLEINITZ COLLECTION (Catalogue), Milwaukee Art Center, 1968, No. 68, illus. 20. T. Atkinson, "German Genre Paintings from the von Schleinitz Collection," ANTIQUES, Nov. 1969, pp. 712–16, illus. p. 714.

ZUMBUSCH, LUDWIG VON

b. July 17, 1861, Munich
d. February 28, 1927, Munich
represented at Aachen, Bremen, Würzburg; private
collections

Ludwig von Zumbusch was a minor portraitist, painter of children, and illustrator who gained a modicum of success in the last decade of the nineteenth century. But art historians now tend to attach a larger measure of importance to his name, owing to the fact that Zumbusch was a member of the avant-garde break-off group from the academy, namely the Secessionists, and because he contributed art to the seminal new journal *Jugend*. That magazine was the intellectual clearing-house for all new and revolutionary ideas in art in the closing years of the nineteenth century; it was also the stage on which the drama of the only "original" nineteenth-century style, namely *Jugendstil*, was played out.

Zumbusch's career always stood under the shadow of his famous father, the renowned sculptor and professor at the Vienna Academy, Kaspar Clemens Ritter von Zumbusch. Endowed with the best cultural advantages of an upbringing in a famous artist's household, Zumbusch received the finest training a young artist could have desired. His father was his first teacher. Then he became a pupil at the Vienna Academy and studied under Christian Griepenkerl and Karl Wurzinger. In Munich, he received instruction from Wilhelm Lindenschmit the Younger, a very successful teacher and notable history painter from the circle of Karl von Piloty. While in Paris, he gained, through work under the great religious and genre painter Adolphe William Bouguerreau, knowledge of the most refined academic techniques of the French School. There also, Tony Robert-Fleury, the history painter and pupil of Delaroche, mediated for him the tradition of the great French *romantique* Baron Gros.

And yet, except for carrying on their collective penchant for a richly coloristic art, the most ambitious tendencies of all his teachers were somehow deflected by him into a pleasant patois of traditional forms laced with some progressive nuances, and into subjects centering in pleasant, humorous little children scenes and largely uneventful painted novelettes. As for the *Jugendstil* inflection of his style, that tendency evolved slowly and surfaces in an overall decorativeness, strong color areas, accentuation of contours, compositions conceived as softly linear armatures, and a tendency toward a certain flatness of "design." His late pastel landscapes count among his finest accomplishments.

BIBLIOGRAPHY
Katalog der Glaspalast-Ausstellung, Munich, 1888, 1892. Katalog der Sezession, Munich, 1894 (and successive years). F. von Boetticher, Malerwerke des Neunzehnten Jahrhunderts, Vol. II, Dresden, 1898, pp. 1064, 1065. F. von Ostini, Ludwig von Zumbusch, Fröhliche Kindheit, Munich, 1922. H. Uhde-Bernays, Die Münchener Malerei im Neunzehnten Jahrhundert, Vol. II, Munich, 1927, p. 189.

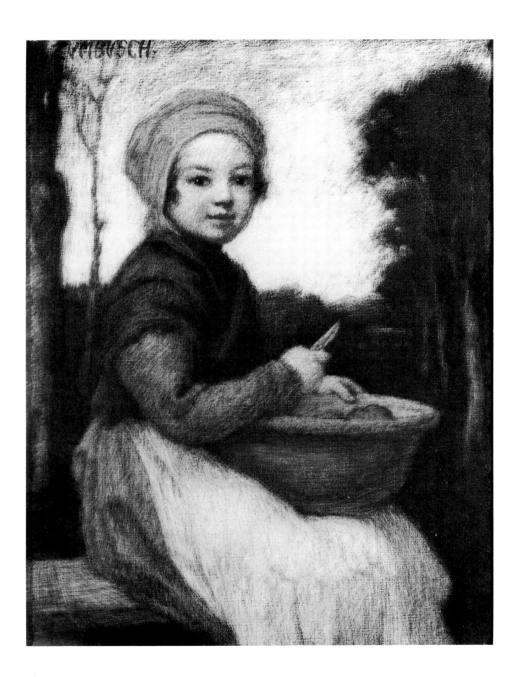

187
Girl Peeling Fruit
 signed U.L.: L. v. Zumbusch
 oil on canvas, 11¹/₁₆ × 8¾ (28.1 × 22.2)
 MAC cat. no. M 1972.121

A slight experiment in very lean, "pastel" alizarin crimson (cap, dress), umber, and degraded blue and white, hatched throughout with a dry, coarse brush. Reduction of form and modeling to their simplest aspects as well as a strong composition replete with a definite sense of *Jugendstil* "sinuation," characteristic of his style in general, stand out in this minor work by Zumbusch.

REFERENCE
S. Wichmann, PAINTINGS FROM THE VON SCHLEINITZ COLLECTION, Milwaukee Art Center, 1968, No. 70.

VARIOUS ARTISTS

(listed in the clockwise order of their appearance in
Artists' Fan, entry No. **188**)

SCHEUERER, JULIUS

b. 1859, Munich
d. 1913, Planegg, near Munich

Although Scheuerer attended the Munich Academy for a time, he was essentially a self-taught artist. He specialized in the painting of poultry.

TOMINZ, ALFREDO

b. 1854, Trieste
d. 1936, Trieste

Tominz was a pupil of Emil Adam in Munich and lived in Trieste, where he was active as a museum director. He specialized in the painting of horses.

KOSLER, FRANZ XAVER

b. 1864, Vienna
d. date unknown

A noted painter of oriental subjects, Kosler frequently resided in Egypt. He was also a fine portraitist sought by the aristocracy. Most of his paintings are in private collections in England.

SCHRAM, ALOIS HANS

b. 1864, Vienna
d. 1919, Vienna

A gifted pupil of Makart, Schram acquired fame as a frescoist of numerous state and public buildings in Vienna (e.g., Neue Hofburg, Vienna City Museum). He did history, genre, and portrait paintings and was also an accomplished sculptor.

NOWAK, ERNST

b. 1851, Troppau
d. 1919, Vienna

After studies at the Vienna Academy, Nowak became a portraitist and painter of genre as well as of religious works for churches.

HAMZA, JOHANN

b. 1850, Teltsch
d. date unknown, Vienna

Hamza studied at the Vienna Academy and specialized in miniatures set in the Rococo period. The literary flair, fine illusionism, and frequent reproductions of his works established him as a significant force in Viennese genre art in the 1880s.

KINZEL, JOSEPH
b. 1852, Silesia
d. 1925, Spitz a.d. Donau

Kinzel studied at the Vienna Academy and was active in that city; he was among the last notable representatives of the picture category of "folk morals and manners" (*Sittenbild*) in the tradition of Waldmüller (see entry in Catalogue).

MÜLLER, EMMA VON, EDLE VON SEEHOF
b. 1859, Innsbruck
d. date unknown

Scarcely any biographical material is obtainable on this noble painter, who was active in Munich.

REICHERT, CARL
See entry in Catalogue.

FRIEDLÄNDER, ALFRED, RITTER VON MALHEIM
b. 1860, Vienna
d. date unknown

The son of Friedrich Friedländer (see entry in Catalogue), Friedländer studied under Diez (see entry in Catalogue) at Munich and was active there as well as in Vienna. He specialized in romantic and picaresque small-scale pirate pictures and war scenes from the Thirty Years' War. He was influenced by Pettenkofen.

KAUFMANN, ADOLF
b. 1848, Troppau
d. 1916, Vienna

Kaufmann, who was self-taught and very widely traveled, had a successful career as owner of a painting school in Vienna. Influenced by French *paysage intime*, he exhibited his landscapes extensively at shows in Munich, Vienna, and Paris. He also painted dioramas—i.e., very large-scale panoramic scenes.

BIBLIOGRAPHY
F. von Boetticher, Malerwerke des Neunzehnten Jahrhunderts, Vol. I, Dresden, 1891. Eisenberg, Das Geistige Wien, Vienna, 1893. Kosel, Deutsch-Österreichische Künstler und Schriftsteller Lexikon, Vienna, 1902. Thieme-Becker, Künstlerlexikon, Leipzig, 1907–50. Hevesi, Österreichische Kunst des 19. Jahrhunderts, Vienna, 1909.

188
Artists' Fan
between 1885 and 1900
> signed: each panel is signed individually
> oil on panel, each panel 10⅛ × 3 (25.7 × 7.6), overall
> size 16 × 25 (40.6 × 63.5)
> MAC cat. no. M 1962.64

An amiable artists' "souvenir" in the shape of a fan, mounted on a very fine neo-Baroque ormolu frame. A favorite late nineteenth-century shape for a "wall hanging," the fan-form is of definite East Asian origin. This work of mixed styles is notable for excellent craftsmanship in the technique of miniature painting, striking little scenes executed in the best manner of the respective artists' areas of specialization, and a very pleasing, richly colorful, decorative, if quite synthetic, overall effect.

NOTE
The Panels (clockwise):
Julius Scheuerer: *Cockfight*
Alfredo Tominz: *Two-Horse Carriage*
Franz Xaver Kosler: *Portrait of a Woman*
Alois Hans Schram: *Idealized Woman*
Ernst Nowak: *Monk with Glass of Beer*
Johann Hamza: *Gypsy Girl with Tambourine*
Joseph Kinzel: *Man Smoking Pipe*
Emma von Müller: *Young Peasant Girl*
Carl Reichert: *Dog and Bee*
Alfred Friedländer: *Travellers in a Classical Landscape*
Adolf Kaufmann: *Sailboat and Windmill*

The René von Schleinitz Collection includes nine paintings by non-German artists. To furnish a complete inventory of the collection, they are listed here.

189
EVERSEN, ADRIANUS
Dutch, b. 1818, d. 1897

Street Scene
oil on wood panel, 7⅜ × 6⅛ (18.7 × 15.6)
MAC cat. no. M 1972.104

190
GRISON, FRANÇOIS ADOLPHE
French, b. 1845, d. 1914

The Connoisseur
oil on wood panel, 9½ × 7½ (24.1 × 19.1)
MAC cat. no. M 1962.53

191
MARATTI (MARATTA), CARLO
Italian, b. 1625, d. 1713

Portrait of a Man
oil on copper panel, 9¾ × 7½ (24.8 × 19.1)
MAC cat. no. M 1952.3

192
MARATTI (MARATTA), CARLO

Portrait of a Woman
oil on copper panel, 9¹¹/₁₆ × 7½ (24.6 × 19.1)
MAC cat. no. M 1952.4

193
QUADRONE, GIOVANNI BATTISTA
Italian, b. 1844, d. 1898

After the Show
oil on wood panel, 11⅜ × 18⅝ (28.9 × 47.3)
MAC cat. no. M 1962.63

194
ROCKWELL, NORMAN
American, b. 1894, d. 1978

Latest Styles
oil on canvas, 26 × 22⅛ (66 × 56.2)
MAC cat. no. M 1962.57

195
ROTTA, ANTONIO
Italian, b. 1828, d. 1903

The Retarded Child
dated 1885
oil on wood panel, 20⅝ × 26 (52.4 × 66)
MAC cat. no. M 1962.110

196
VERBOECKHOVEN, EUGÈNE
Belgian, b. 1799, d. 1881

Sheep in Barn
dated 1871
oil on wood panel, 8⁷/₁₆ × 12½ (21.4 × 31.8)
MAC cat. no. M 1971.68

197
ZIEM, FÉLIX FRANÇOIS GEORGES PHILIBERT
French, b. 1821, d. 1911

Scene of Venice
oil on wood panel, 12⅝ × 17½ (32.1 × 44.5)
MAC cat. no. M 1962.125

Index

281

Geyer, Johann: taught J. E. Gaisser, 79
Gilded Age: and Lenbach, 164; depicted by Spielter, 222
Giles, Mr.: provenance of *Falstaff Mustering Recruits* (**37**), 90
Girardet, Karl: advised Vautier, 248
Girl at Wall Clock (H. W. Kauffmann, **78**), 131
Girl Peeling Fruit (Zumbusch, **187**), 275
Girl Reading ("The Little Mona Lisa") (Das lesende Mädchen) (Meyer, **122**), 179
Girl with Knitting (Mädchen mit Strickzeug) (Meyer, **121**), 178
Give Us This Day Our Daily Bread (Heyn), mentioned, 105
Glaspalast (Munich): exhibitions at, 17; Hermann Kauffmann exhibited at, 115; Köhler exhibited at, 148; Zimmermann exhibited at, 269
Glaspalast Ausstellung (Munich): Best exhibited at, 50
Gnomenfroschtransport. See Gnomes Transporting Frogs
Gnomes: depicted by Schlitt, 206
Gnomes Transporting Frogs (Gnomenfroschtransport) (Schlitt, **141**), 206
Geothe, Johann Wolfgang von: *Werthers Leiden*, illustrated by Bosch, 56; wrote of Juncker, 108; and Lessing's painting, 169; concept of the scholar, 233; *Faust*, 233
Gold Medal, Great (Berlin Academy): awarded Bokelmann, 53
Good Friends (The Best of Friends) (Wiesebrink, **182**), 266
Goyen, Jan van. *See* Van Goyen, Jan
Graff, Anton: foreshadowed *Biedermeier* art, 19; compared with Juncker, 109
Gräfle, Albert: taught Lenbach, 164; Sporrer studied at school of, 242
Grandmother and Child (Meyer, **123**), 180
Graphic art: by P. F. Meyerheim, 183; by Sporrer, 242
Grassi, Josef: foreshadowed *Biedermeier* art, 19
Graz, Austria: Schrötter in, 213
Greek Wars of Liberation: depicted by Hess, 103
Greece: accession of Wittelsbach monarchy in, depicted by Hess, 103
Griepenkerl, Christian: taught Löwith, 173; taught Zumbusch, 274
Grimmelshausen, Hans Jakob Christoffel von: Diez compared with, 71
Grimschitz, Bruno: quoted, on Waldmüller, 259
Grison, François Adolphe, 280
Gros, Antoine Jean, Baron: and Zumbusch, 274
Gründerjahre [founding years (of German nation)]: artistic currents during, 21; and Bokelmann's art, 53
Gründungsschwindel [swindles during *Gründerjahre*]: depicted by Bokelmann, 54
Grützner, Eduard, 89–90; painter of literary genre, 15; and Munich *Biedermeier* art, 20; Baumgartner a forerunner of, 47; Uhde-Bernays on, 154; friend of Spitzweg, 224; mentioned, 13
Guardsman. See Troops of the Watch

Guardsmen: depicted by Spitzweg, 241
Gurlitt, Cornelius: quoted, on Knaus, 137
Gypsy Girl with Tambourine (Hamza panel, **188**), 278
Gyulay of Agram, Count: Waldmüller taught in house of, 258

Haeckel, Baron von: Juncker studied collection of, 108
Hague, The: J. W. Preyer in, 192
Haider, Karl: in Leibl Circle, 162
Hallber,—: edition of Goethe, illustrated by Simm, 220
Hals, Frans: P. F. Meyerheim's painting reminiscent of, 184; compared with Zimmermann, 270
Hamburg: Nazarene artists in, 19; Hermann Kauffmann in, 115; landscape style influenced Munich art, 198; Schlesinger studied in, 204
Hammer, Heinrich: quoted, on Defregger, 68
Hamza, Johann, 276
Hansonn, Christian H.: friend of Spitzweg, 224
Happel, Karl: copied Spitzweg, 226
Hartmann, Ludwig, 101; animal genre of, in Munich School, 271
Harvesting: depicted by Spitzweg, 231
Harvest in the Tyrolean Alps. See Women Mowing in the Mountains
Hasenclever, Johann Peter: *Biedermeier* artist in Düsseldorf, 20; J. W. Preyer influenced, 192
Hauber, Josef: Munich portraitist, 16
Haushofer, Max: Munich *Kleinmaler*, 16
Hauxhurst, Mrs. Stanley C.: provenance of *Sitting Girl* (**124**), 181; provenance of *Cows in Pasture* (**175**), 256
Haymaking in Upper Bavaria (Heuernte im Bayerischen Voralpenland) (Robert Schleich, **137**), 202
Hébert, Jules: taught Vautier, 247
Heem, Jan Davidsz de. *See* De Heem, Jan Davidsz
Heidelberg: *Biedermeier* art in, 20
Heifers at Play (Braith, **12**), 59
Heimatlandschaft [native landscape]: in Old Munich School, 19; of Heidelberg, 20; used by Richter, 20; of Eduard Schleich, 199; depicted by Waldmüller, 258
Heimerdinger, Friedrich: taught Schlesinger, 204
Helbing, Munich: provenance of *Garatshausen Castle* (**160**), 232
Henrici's Restaurant (Chicago): provenance of *The Card Players* (**39**), 92
Heroic genre: in Düsseldorf, 169
Herrenchiemsee Palace: decorated by Rögge, 197
Herterich, Ludwig: taught Weber, 263
Hess, Carl Ernst Christoph: father of Peter von Hess, 103
Hess, Heinrich Maria: at Munich Academy, 17; *Biedermeier* artist in Düsseldorf, 20; taught Becker, 48; brother of Peter von Hess, 103; taught Kaltenmoser, 113
Hess, Peter von, 103; painter of military genre, 15; Munich *Kleinmaler*, 16; in transition from *Biedermeier* art, 21; may have taught Bürkel, 63; mentioned, 13

Hesse, Germany: depicted by Knaus, 137, 142
Hessische Kirmess. See Dance under the Linden Tree
Hessischer Bauerntanz. See Dance under the Linden Tree
Hessischer Bauerntanz unter den Linden (Knaus), mentioned, 142
Heuerente im Bayerischen Voralpenland. See Haymaking in Upper Bavaria
Heydeck, Carl von: Munich *Kleinmaler*, 16
Heyn, August, 105
Highwaymen (Beraubt) (Diez, **22**), 72
Hildebrandt, Theodor: taught at Düsseldorf Academy, 15; *Biedermeier* artist in Düsseldorf, 20; taught Bosch, 56
Hiltensperger, Georg: taught Grützner, 89; taught Kronberger, 154
Hirschberg, —: Grützner a protégé of, 89
Hirt, Heinrich, 106
Hirth du Frênes, Rudolf: in Leibl Circle, 162
Historical genre: Becker, 48; Defregger, 66; Diez, 71; Friedländer, 76; Keller, 134; Werner, 264
History painting: by Lessing, 169; by Munkácsy, 187; by Seiler, 214; by Schram, 276
Hölzl, Gregor: provenance of *Sunday Afternoon* (**20**), 69
Hofner, Johann Baptist: taught Lenbach, 164
Hohe Kunst [idealistic, "high" art]: at Munich, 16
Holdup, The (Räuberüberfall im Hohlweg) (Gauermann, **33**), 85
Holdup, The (Strassenräuber) (Bürkel, **16**), 64
Holland: seventeenth-century artistic currents in, 13; genre painting in, 14; seventeenth-century painting in, 14; depicted by Max Gaisser, 80; Schlitt studied in, 206
Holmberg, August Johann, 107
Homecoming, The (Vautier, **169**), 248–49
Hooch, Pieter de. *See* De Hooch, Pieter
Hornung, Joseph: Vautier acquainted with, 247
Horses: depicted by Diez, 71; depicted by Gedlek, 87; depicted by Hartmann, 101; depicted by Reichert, 194; depicted by Schreyer, 209; depicted by Tominz, 276
Horses and Soldiers (Gedlek, **35**), 87
Horses and Soldiers (Gedlek, **36**), 88
Humanistic education: influenced German art, 13
Hummel, Johann Erdmann: materialistic art of, 19
Humoresque, in painting: Baumgartner used, 47
Humorous genre: Bosch, 56; Kronberger, 155; Zimmermann, 269
Hungary, School of: Munkácsy the father of, 187
Hunt, the: depicted by Bosch, 56; depicted by Eberle, 75; depicted by Gauermann, 84; depicted by Gedlek, 87; depicted by Velten, 253
Hunter, The (Hermann Kauffmann, **61**), 115
Hunter and Peasant Girl. See Flirting
Huss, John: depicted by Lessing, 169
Hutton, Laurence. *See* Clement, Clara Erskine
Huysum, Jan van. *See* Van Huysum, Jan

by Zumbusch, 274; by Kaufmann, 277
Landscape with Stage Coach. See *Travelers*
Landschaft mit Postwagen. See *Travelers*
Lange, Josef: taught Waldmüller, 258
Langer, Johann Peter: director of Düsseldorf and Munich academies, 16
Langer, Robert: Munich academic artist, 16
Langko, Dietrich: friend of Spitzweg, 224
Latest Acquisition, The (Holmberg, **56**), 107
Latest Styles (Rockwell, **194**), mentioned, 280
Latin School (Munich): Spitzweg graduated from, 224
Lausanne, Switzerland: Vautier studied in, 247
Lawyer's Visit, The (Rögge, **135**), 197
Layton, Frederick: provenance of *The Zither Player* (**66**), 121; provenance of *Winter in Russia* (**93**), 153
Layton Art Collection: provenance of *Fish Market at Ostend* (**2**), 45; provenance of *The Latest Acquisition* (**56**), 107; provenance of *Grandmother and Child* (**123**), 180; provenance of *A Darwinian Prehistoric Social Party* (**126**), 184; provenance of *The Rivals* (**129**), 188; provenance of *Fruit Piece* (**131**), 191; provenance of *The Wallachian Post-Carrier* (**143**), 210
Learned Dachshund, The (Der gelehrte Dackel) (H. W. Kauffmann, **72**), 126
Lefebvre, Jules: taught Weber, 263
Legends: depicted by Baumgartner, 47; depicted by Bosch, 56
Leibl, Wilhelm Maria Hubertus, 162; School, at Bad Aibling, near Munich, 17; Pecht discussed, 116; Circle of, 162, 163; compared with Lenbach, 166; compared with Munkácsy, 187; compared with Spring, 244; friend of Wopfner, 267; influenced Zimmermann, 269; and Zügel's style, 271
Leistler, Herr: provenance of *The Holdup* (**33**), 85
Lempertz Kunstversteigerungshaus: provenance of *After the Meal* (**50**), 99; provenance of *Ducks at Pond* (**59**), 112
Lenbach, Franz Seraph von, 164; used *Prunkstil*, 132; mentioned, 13
Lepkes Berliner Kunst-Auction: provenance of *A Darwinian Prehistoric Social Party* (**126**), 184
Lesende Mädchen, Das. See *Girl Reading*
Lessing, Carl Friedrich, 169; taught at Düsseldorf Academy, 15, 16; co-founder of Association for Landscape Composition (Düsseldorf), 16; *Biedermeier* artist in Düsseldorf, 20; taught Achenbach, 43; mentioned, 13
Lichtenfels, Eduard Peithner, Ritter von. See Peithner, Eduard, Ritter von Lichtenfels
Lieb, Michael. See **Munkácsy, Mihály von**
Liebermann, Max: student of Munkácsy, 187
Lier, Adolf: Munich *Kleinmaler*, 17; School, at Munich, 17; *Biedermeier* artist in Munich, 21; friend of Bürkel, 63
Lindau on Lake Constance (P. W. Meyerheim, **127**), 185
Lindenschmit, Wilhelm von, the Younger: School of, 17; influenced Keller, 134; taught Löwith, 173; taught Schlitt,

206; taught Weber, 263; taught Zumbusch, 274
Linderhof Castle: Breling decorated, 61
Lindlar, Johann Wilhelm, 172
Literary genre: Diez, 71
Lithographer: Bosch as, 56; Kaltenmoser as, 113; Riefstahl as, 195
Little Darling, The (Meyer), mentioned, 176
Little Dutch Masters. See Dutch Masters, Little
"Little Mona Lisa, The." See *Girl Reading*
Löfftz, Ludwig von: School of, 17; pupil of Diez, 80; taught Max Gaisser, 80; taught Koehler, 149; taught Schrötter, 213; taught Marie Simm-Meyer, 220
Löwith, Wilhelm, 173; compared with Seiler, 214
Louis I, king of Bavaria: acceded to throne, 17; and Hess, 103
Louis II, king of Bavaria: palace of, decorated by Rögge, 197
Love's Sorrows (Heyn), mentioned, 105
Ludovician Monumentalism, 16
Ludwigs-Galerie: provenance of *Mother and Child* (**162**), 238
Ludwig Viktor, archduke of Austria: patron of Kern, 136
Lugardon, Jean Léonard: Vautier acquainted with, 247
Luminist painting: by Hartmann, 102
Luther, Martin: depicted by Lessing, 169

Macchiaiolism, proto-: in Navrátil's style, 225
Mäherinnen im Gebirge. See *Women Mowing in the Mountains*
Maientag, Ein. See *May Day, A*
Makart, Hans: influenced Kaulbach, 132; used *Prunkstil*, 132; taught Simm, 220; taught Spielter, 222; taught Schram, 276
Making a Sale (H. W. Kauffmann, **64**), 119
"Malerei deutscher Meister des 19. Jahrhunderts in Milwaukee" (signed "F"), 13
Malerfürsten [painter princes]: in Munich, 17; Grützner among, 89; Lenbach as, 164
Malheim, Ritter von. See **Friedländer, Friedrich, Ritter von Malheim**
Mali, Christian Friedrich: friend of Braith, 58; similar to Gebler, 86; as animal painter, 101
Malkasten [painting association]: founded at Düsseldorf, 16
Malkultur [painting culture]: in Munich, 17
Mallon, Melvin: provenance of *Removing the Fallen Tree* (**17**), 65; provenance of *Children Warming Their Hands* (**150**), 219
Man Drinking Beer (Kronberger, **104**), 160
Mánes, Josef: influenced Spitzweg, 225
Manet, Edouard: influenced Munkácsy, 187; style of, in Munkácsy's painting, 188
Mannlich, Christian: director of Ducal Painting Gallery, Munich, 16
Man Smoking Pipe (Kinzel panel, **188**), 278

Man Smoking Pipe (Löwith, **118**), 175
Man with a Tassel Cap (H. W. Kauffmann, **65**), 120
Maratti (Maratta), Carlo, 280
Marées, Hans von: patronized by Schack, 164
Marilhat, Prosper: influenced Schreyer, 208
Maurer, Hubert: taught Waldmüller, 258
Max, Gabriel: influenced Kaulbach, 132; taught Spielter, 222
Maximilian I, king of Bavaria: and founding of Munich Academy, 16
Maximilianeum (Munich): opened, 17
Maxwell Galleries: provenance of *The Artists' Visit*, 114
May Day, A (Ein Maientag) (Kaulbach, **79**), 133
Mecklenburg-Schwerin, Grand Duke of: Schreyer court painter to, 209
Meder, F. J.: provenance of *Garatshausen Castle* (**160**), 236
Medieval art: influenced Kaulbach, 132
Meissen in Winter (Oehme, **130**), 190
Meissonier, Ernest: compared with Löwith, 173; compared with Seiler, 214
"Meissonier, German": nickname of Seitz, 217
Menzel, Adolf von: member of Berlin School, 19; Diez compared with, 71; Knaus compared with, 137; compared with Koehler, 149; influenced Riefstahl, 195
Mészöly, Géza von: influenced Böhm, 52
Metternich, Victor Emmanuel von: provenance of *The Prize Horse* (**19**), 68
Metz, Germany: Lindlar exhibited at, 172
Meyer, Johann, collection of: provenance of *Wedding Procession in the Tyrol* (**134**), 196
Meyer, Johann Georg (Meyer von Bremen), 176; children genre of, 15
Meyerheim, Eduard: father of P. F. Meyerheim, 183
Meyerheim, Paul Friedrich, 183; first cousin of P. W. Meyerheim, 185
Meyerheim, Paul Wilhelm, 185
Meyer von Bremen. See **Meyer, Johann Georg**
"Midday Nap." See "Siesta" or "Midday Nap"
Middle-class society: artists a part of, in nineteenth-century Germany, 12; and patronage of German art, 13; Dutch and American patronage of art, 14; supported academic art in Germany, 14; patronized post-*Biedermeier* German art, 21; depicted by Seiler, 214. See also *Biedermeier*, society
Military life: depicted by Seiler, 214; depicted by Velten, 253
Milwaukee, Wisconsin: Koehler in, 149
Milwaukee Auction Galleries: provenance of *Sitting Girl* (**124**), 181
Miniature painting: by Braith, 58; by J. E. Gaisser, 79; by Max Gaisser, 80; by Hermann Kauffmann, 115; by Köhler, 148; by Kronberger, 154; by J. W. Preyer, 192; by Robert Schleich, 201; by Waldmüller, 258; by Hamza, 276

DESIGNED BY GARDNER R. WILLS
COMPOSED BY GRAPHIC COMPOSITION, INC., ATHENS, GEORGIA
FOUR-COLOR WORK BY THE NORTH CENTRAL PUBLISHING CO., ST. PAUL, MINNESOTA
MANUFACTURED BY KINGSPORT PRESS, KINGSPORT, TENNESSEE
TEXT AND DISPLAY LINES SET IN PALATINO

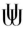

Library of Congress Cataloging in Publication Data
Bisanz, Rudolf M
The René von Schleinitz collection of the Milwaukee Art Center
Catalog of the collection.
Includes bibliographical references and index.
1. Genre painting, German—Catalogs.
2. Genre painting—19th century—Germany—Catalogs.
3. Genre painting—Wisconsin—Milwaukee—Catalogs.
4. Von Schleinitz, René—Art collections—Catalogs.
5. Milwaukee. Art Center—Catalogs. II. Title.
ND1452.G35B57 754'.0943'0744017595 78–53284
ISBN 0–299–07700–4